Archiving the Unspeakable

Critical Human Rights

Series Editors
Steve J. Stern ❧ Scott Straus

Books in the series **Critical Human Rights** emphasize research that opens new ways to think about and understand human rights. The series values in particular empirically grounded and intellectually open research that eschews simplified accounts of human rights events and processes.

While in power, the Khmer Rouge established a network of detention facilities in which they brought suspected "enemies" for interrogation, torture, and in most cases murder. The most famous of these is Tuol Sleng in the capital, Phnom Penh, where prison officials took mug shots of detainees. Years later, the resulting photographs emerged as iconic images of the terror that the Khmer Rouge inflicted on Cambodia. Michelle Caswell places those haunting images at the center of her account, examining the different kinds of agency that shaped the creation and the aftermath of the visual archive. In so doing, she brings human rights scholarship into a revealing conversation with archival studies—and vice versa.

Archiving the Unspeakable

Silence, Memory, and the
Photographic Record in Cambodia

Michelle Caswell

The University of Wisconsin Press

The University of Wisconsin Press
1930 Monroe Street, 3rd Floor
Madison, Wisconsin 53711-2059
uwpress.wisc.edu

3 Henrietta Street
London WC2E 8LU, England
eurospanbookstore.com

Printed in the United States of America

Library of Congress Cataloging-in-Publication Data

Caswell, Michelle, author.
Archiving the unspeakable: silence, memory, and the photographic record in Cambodia / Michelle Caswell.
 pages cm. — (Critical human rights)
 Includes bibliographical references and index.
 ISBN 978-0-299-29754-1 (pbk.: alk. paper)
 ISBN 978-0-299-29753-4 (e-book)
 1. Tuol Sleng (Prison: Phnom Penh, Cambodia) 2. Prisons—Cambodia—Archives.
 3. Political atrocities—Cambodia—Archives. 4. Genocide—Cambodia—Archives.
 5. Political prisoners—Cambodia—Archives. 6. Cambodia—History—1975–1979—Archives.
 7. Archives—Cambodia. 8. Parti communiste du Kampuchea. I. Title. II. Series: Critical human rights.
DS554.8.C385 2014
959.604′2—dc23
2013027988

 In memory of the victims of the Khmer Rouge,
photographed and unphotographed,
identified and unknown,
and the archivists who preserve their traces.

Contents

Illustrations

 Acknowledgments

I have been blessed with much support and encouragement while writing this book. Youk Chhang and the staff of the Documentation Center of Cambodia have graciously answered my questions, read drafts of my work, sent copies of publications to the University of Wisconsin–Madison Libraries, and assisted me in conducting research. Their hard work and unrelenting dedication honor the memory of the victims of the Khmer Rouge. I have also received enormous help from archivists at the National Archives of Cambodia and the Bophana Audiovisual Resource Center. These Cambodian archivists, who work professionally in difficult political and financial climates with little material reward, are a true inspiration to memory workers everywhere.

I will forever be grateful to Christine Pawley, Kristin Eschenfelder, Alan Rubel, Michele Hilmes, and Anne Gilliland, who have helped me beyond measure with their thoughtful questions, gentle prodding, and sustained encouragement. Much gratitude is also due my colleagues in the Department of Information Studies department at UCLA, whose commitment to social justice and interdisciplinary inquiry make me feel right at home.

I would not have embarked on this project without the generous support of a Building the Future of Archival Education Doctoral Fellowship from the Institute of Museum and Library Services. Much gratitude is due to Anne Gilliland and Elizabeth Yakel for conceiving this important program, which sustained me intellectually, financially, and socially during my doctoral work and continues to sustain me as a faculty member. I was also lucky enough to receive travel grants to conduct research and attend conferences from the Holtz Center for Science and Technology Studies, the Vilas Travel Fellowship, and the Linda B. Richardson Fund for Student Travel at the University of Wisconsin–Madison.

Gwen Walker, my editor at the University of Wisconsin Press, expressed interest in this project in its very early stages. Her expert guidance and encouragement saw me through this entire process. David Chandler and Andrew Flinn provided detailed feedback that greatly improved this work. Emily McNish, Michelle Hamers, and Nathan Sowry provided expert help in preparing the manuscript.

I am grateful to my interview subjects for generously sharing their time and experiences with me: David Chandler, John Ciorciari, Paul Conway, Craig Etcheson, Helen Jarvis, Judy Ledgerwood, Ben Kiernan, and David Walls, as well as several who asked to remain anonymous.

It has been a pleasure learning from and working with my colleagues in archival studies over the past few years. I am particularly grateful for the wisdom and camaraderie of Andrew J. Lau and Ricky Punzalan, my partners in crime, whose imprint is all over this manuscript. Katrin de Boer and Erin Collins provided much-needed help in and about Cambodia. Over the past few years, my lifelong friends—Emily Drabinski, Cassie Adcock, Samip Mallick, Ann Putnam Marks, Heather McClean, Sumayya Ahmed, Berta Bustamante, Bridgette Farrer, Sarah Roberts, and Melissa Adler—have listened patiently as I depressed them with tales of genocide. I promise I'll be a bit more upbeat now that the book is done.

My sister, Cherie Caswell Dost, first had the bright idea that we Caswell girls could go to college. She and my brother-in-law, Hagen Dost, have always encouraged me to pursue my dreams, even when the road was rocky. My parents, David and Florence Caswell, made the best decision in the world thirty years ago when they bussed me to magnet schools on the other side of Chicago, where I was taught by magnificently dedicated teachers who opened up a world of possibilities for me. I will forever be grateful to them.

Last but not least, I am indebted to Tomer Begaz, who tried really hard (usually successfully) not to interrupt me while I was writing and correctly assured me that nobody gets sick in Cambodia on his watch. He will always be the sun and moon and stars in my book.

 Archiving the Unspeakable

 # Introduction

Silence, Agency, and the Social Life of Records

Let us stop thinking of photographs as nouns, and start treating them as verbs, transitive verbs. They *do* things. We need to ask not only what they are *of*, and what they are *about*, but also what they were created to *do*. And when they are preserved or digitized, published, or in other ways repurposed and recirculated, we must ask how their material nature has been altered, and in the process, how the relationships embedded in them have changed, why, and to what end. Archival lessons from these alternative narratives teach that we must . . . expand the range of questions we ask, so that we may better understand and account for the movement of photographs and changes in their meaning across temporal and spatial, discursive and institutional boundaries.

<div align="right">

Joan M. Schwartz, "The Archival Garden: Photographic Plantings,
Interpretive Choices, and Alternative Narratives"

</div>

Some information about the past can be provided only by visual images.

<div align="right">

Hayden White, "Historiography and Historiophoty"

</div>

The story of the Tuol Sleng mug shots is perhaps best introduced with the story of one woman and one record. On October 12, 1976, a young Cambodian woman, Hout Bophana, was arrested by the Khmer Rouge secret police and sent to Tuol Sleng prison (known also by the code name S-21), the regime's central torture facility in the evacuated

city of Phnom Penh.[1] Before the Cambodian civil war, Bophana was an edu-
cated, French-speaking, middle-class teenager, the daughter of a teacher living
in a prosperous town.[2] After the civil war began, Bophana was raped by soldiers
from the Lon Nol regime and became pregnant. Like many of her neighbors,
she moved from the country to the capital city of Phnom Penh to escape US
air raids. When the Khmer Rouge invaded Phnom Penh on April 17, 1975, she
was evacuated and placed on a communal farm, where she was forced into
heavy labor. Her husband joined the Khmer Rouge, and they secretly com-
municated through letters that were smuggled across great distances and at
great risk. In 1976, the Khmer Rouge secret police found Bophana's letters in
her husband's barracks, arrested him, and sent him to Tuol Sleng prison, where
he was executed. They then arrested Bophana and brought her to Tuol Sleng.

On arrival at Tuol Sleng, Bophana was pinned with a tag indicating her
group's processing batch number and photographed by a teenage Khmer
Rouge soldier who was part of the prison's documentation unit (figure 1).
Bophana's mug shot then became part of an elaborate Khmer Rouge filing
system used by Tuol Sleng staff to report arrests up the chain of command.[3]
Over the next six months, she was kept in deplorable conditions with thou-
sands of other prisoners, tortured mercilessly with whips, electric shocks, and
waterboarding, and forced to sign false statements confessing her alleged ties
to the CIA and naming supposed conspirators back on the farm. She was exe-
cuted on March 18, 1977.

Yet, while Bophana died, her Tuol Sleng mug shot has taken on a life of its
own, being used in ways in which her Khmer Rouge torturers could not have
predicted.[4] Since 1979, the mug shot has been exhibited (along with thousands
of others) at Tuol Sleng, now the Tuol Sleng Genocide Museum, where it has
been viewed by hundreds of thousands of Cambodians and foreigners. In
1982, the American human rights activist David Hawk photocopied Bophana's
mug shot in an effort to collect evidence to put the Khmer Rouge on trial, and
archivists at Tuol Sleng later sent copies of the mug shot negatives to Hawk's
home in New York for safekeeping.[5] Also in 1982, the American journalist
Elizabeth Becker viewed the mug shot, together with Bophana's extensive
prison file, in the Tuol Sleng archive. Becker used Bophana's story as a central
narrative in her book *When the War Was Over: Cambodia and the Khmer Rouge
Revolution* and later featured the mug shot on the cover of her 2010 book
Bophana.[6] Both English and Khmer versions of the book are now sold by
vendors at the Tuol Sleng Genocide Museum, the Choeung Ek mass gravesite,
and Phnom Penh International Airport. In 1993, two American photojournal-
ists cleaned a negative of Bophana's photograph, and, in 1997, they organized
an exhibition of other Tuol Sleng mug shots like it at the Museum of Modern

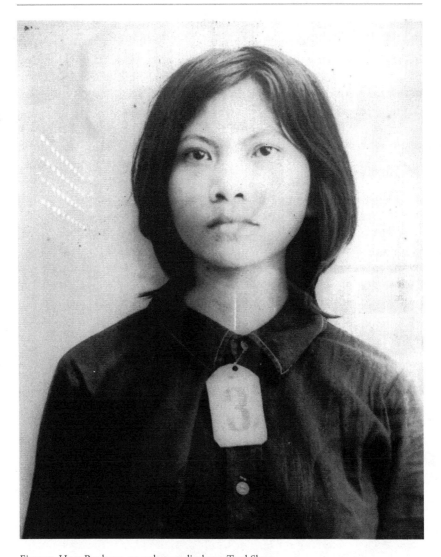

Figure 1 Hout Bophana, mug shot on display at Tuol Sleng.

Art in New York. In 1996, Bophana's mug shot (together with Becker's account of her life) inspired the Cambodian-French film director Rithy Panh (himself a survivor of the regime) to make the documentary *Bophana: A Cambodian Tragedy*, which tells her life story. The documentary, which features the mug shot prominently, now shows twice a day at the Tuol Sleng Genocide Museum. Panh later founded the Bophana Audiovisual Resource Center, a Phnom Penh–based archive that collects and preserves Cambodian film, and named it after

her. A painting by the (now-deceased) Tuol Sleng survivor Vann Nath that depicts Bophana both as a happy teenager and as a Tuol Sleng prisoner hangs in the archive's stairwell. In 1997, staff at the Documentation Center of Cambodia (DC-Cam) digitized Bophana's mug shot, entered information about it and the other then-known 5,189 Tuol Sleng mug shots in a database, and made that database freely accessible online, where people all over the world have since viewed it.[7] In September 2000, the photo was printed next to an article addressing rape as a war crime and crime against humanity as defined by the United Nations in DC-Cam's newsletter, *Searching for the Truth*, which is distributed free of charge throughout Cambodia and is also freely available on DC-Cam's website. In 2001, it was reprinted on the back cover of *Searching for the Truth*, along with dates for Bophana's arrest and "smashing" by the Khmer Rouge. The photo reappeared in the first two 2011 issues of the magazine, this time along with other Tuol Sleng mug shots in a full-page advertisement soliciting names of those to be included in the forthcoming *Book of Memory of Those Who Died under the Khmer Rouge.* In 2010, Bophana's mug shot was included as legal evidence in the case file of Duch, former head of Tuol Sleng prison, who was convicted of crimes against humanity and war crimes by the Extraordinary Chambers in the Courts of Cambodia (ECCC), a tribunal operated jointly by the United Nations and the Royal Government of Cambodia. While Duch was fairly low ranking and by no means the mastermind behind the regime, his trial marked the first time a Khmer Rouge official was ever brought to justice in a credible, internationally recognized court of law.

Bophana, embodied by her mug shot, has become an icon of the Khmer Rouge's brutality in Cambodia. As Elizabeth Becker reports, Bophana has become a "folk heroine," "the Anne Frank of Cambodia," "a national figure" who "looms so large in the public imagination" that she has transcended her individual narrative.[8] Her mug shot and its many reuses constitute a complexly layered archive, documenting not only the Khmer Rouge's abuses but a multitude of nuanced reactions to it from Cambodian survivors of the regime, their children, and the international community.

What is it about Bophana's mug shot and the thousands of mug shots like it from Tuol Sleng prison that continues to speak to us? What do these records tell us, and why do we continue to be haunted by them? This book examines these questions through the lens of archival studies. By situating my research within this emerging field, I hope to contribute to the ways in which the mug shots are seen, not just as objects, photographs, and images (all of which they undoubtedly are) but, above all, as records.[9] Records, according to the prevailing definition in archival studies, are "persistent representations of

activities" that travel through space and time.[10] While records contain information, they are distinct from other forms of documents in that they serve primarily as evidence of action. Through a records-centered approach, I hope to both introduce scholars from other fields to the potential contributions of archival theory to the ongoing discussion about evidence, power, and historical production and challenge archivists to embrace their own power to counter the silences embedded in records, particularly records that document human rights abuse.

By tracing the social life of one collection of mug shots taken by the Khmer Rouge at the notorious Tuol Sleng prison, a complex layering of silences is revealed: the silences of the soon-to-be-dead victims looking back at us in the photographs, the silences of the overwhelming majority of victims who were not photographed, and the silences of those victims whose Tuol Sleng mug shots disappeared in the chaotic aftermath of the regime. Yet, while we are confronted by these unbearably heavy silences in the photographs, a community has developed around these records that asserts a sense of agency in their exhibition, reception, and reuse. This "community of records," consisting of archivists, survivors, and victims' family members, has strategically deployed the mug shots in legal testimonies, documentary films, and still photographs of Cambodians and tourists looking at them, essentially creating a new archive of responses to the Khmer Rouge.[11] These new records perform human rights by memorializing the dead, holding those responsible legally accountable, and warning the current regime that such abuses will not be tolerated in the present.[12] Through the use of these photographs, Cambodians are supplanting a narrative of victimhood with a narrative of witnessing, transforming records that document an unspeakably violent past into agents of social change for the future.

Background:
The Khmer Rouge Regime and
Its Elaborate Archive

From 1965 to 1973, the United States launched a massive bombing campaign in Cambodia. More than one-half million Cambodians were killed in this illegal military intervention. Over the course of these eight years, the United States dropped a greater tonnage of bombs on Cambodia than was dropped by the entire Allied Forces during World War II, making it possibly "the most heavily bombed country in history," according to new findings by the historians Taylor Owen and Ben Kiernan.[13] Many Cambodians,

terrified and outraged by the bombings, joined the Khmer Rouge, a radical Maoist regime engaged in a civil war with Cambodia's US-backed Lon Nol regime.

With its numbers swelling, the Khmer Rouge gained significant ground, seizing control of the capital city of Phnom Penh on April 17, 1975. From 1975 to 1979, the regime radically restructured Cambodian society, evacuating urban populations, enslaving people on rural farm communes, and abolishing private property and all educational, religious, and cultural institutions. The regime sought to obliterate all prior history in the hope of ushering in a new era, free from external influence. With this goal in mind, it turned the Cambodian National Library and Archives into a pigsty and outlawed all time-keeping devices. Society was divided between new people—the formerly urban and/or educated population, who were assigned to the hardest labor—and old or base people—former peasants who were appointed commune leaders. Over the next three years, eight months, and twenty days, roughly 1.7 million people—approximately 25 percent of the total population of Cambodia—died from execution, starvation, or disease.[14]

Marked by secrecy, the Khmer Rouge was said to be led by the mysterious, faceless Angkar or "the organization," until September 1977, when Pol Pot publicly revealed himself to be the country's leader. French educated, middle class, and well connected to the royal family, Pol Pot was a far cry from the feudal peasant that his regime idealized.[15] Ruling with absolute authority and total consolidation of power, Pol Pot waged war with Vietnam and demanded unquestioning loyalty from his inner circle. He cultivated a culture of suspicion, paranoia, and violence from the highest echelons of the Khmer Rouge on down. Throughout Pol Pot's rule, "purges" of anyone deemed suspicious, including in some cases entire villages, were commonplace.

The regime's secret internal police force, known as the Santebal (Khmer for "security police"), were obsessive record keepers, meticulously documenting orders, keeping detailed logbooks of torture sessions, compiling draft after draft of forced confession statements, and taking mug shots of prisoners. While the Santebal maintained 196 prisons throughout the country, Tuol Sleng prison (also known as S-21), located in a former school in the evacuated city of Phnom Penh, served as its headquarters and central interrogation facility. The majority of the prisoners brought to Tuol Sleng were themselves Khmer Rouge members accused of treason and included high-level officials, along with their families.[16] Under the direction of Kaing Guek Eav (most commonly known by his nom de guerre, Duch), workers in Tuol Sleng's Documentation Unit photographed prisoners eerily staring into the camera upon arrival as part of the registration process.[17] Prisoners were then tortured and forced into signing detailed confession statements listing their alleged crimes against

the regime. All but 202 of these prisoners would be murdered—some at Tuol Sleng but most at the nearby killing fields at Choeung Ek, where they were forced to dig their own shallow mass graves before being bludgeoned to death with the butts of guns and other instruments.[18] Their mug shots, 5,190 of which remain, provide the last trace of victims before their executions.

Today, more than three decades after the toppling of the regime, archivists at the Documentation Center of Cambodia (DC-Cam) are preserving, providing access to, and digitizing an extensive cache of Khmer Rouge records with the help of international training and funding. While original negatives and photographs of the S-21 mug shots are in the archives of what is now the Tuol Sleng Genocide Museum, the images have been copied (both digitally and through microfilm) and repurposed by other institutions and individuals throughout time, most notably by DC-Cam. DC-Cam maintains the world's largest collection of Khmer Rouge records, consisting of more than a million pages of documents, including detailed accounts of interrogations, photographs, forced confession statements, and high-level party directives. Since its founding in 1995 as a field office of the Cambodian Genocide Program at Yale, DC-Cam has launched numerous efforts to digitize, publish, and conduct outreach with Khmer Rouge records—including its copies of the S-21 mug shots—through its website; its newsletter, *Searching for the Truth*, and other publications; and displays during public events. Though it is funded from international sources, DC-Cam is now a Cambodian-run organization; its director, Youk Chhang, is a survivor of torture under the Khmer Rouge, and its forty-five-member staff is composed of a generation of Cambodians who are too young to directly remember the regime but whose parents are survivors.[19]

DC-Cam is also providing most of the physical evidence used in a tribunal operated jointly by Cambodia and the United Nations that has tried high-ranking Khmer Rouge officials for crimes against humanity, war crimes, and, in some cases, genocide. Plagued by setbacks, diplomatic wrangling, and corruption allegations, these trials are the first time Khmer Rouge leaders have ever been brought to justice in a credible court of law and are a major milestone for reconciliation in the country.[20] Together with other records, mug shots play a prominent role in the trial, serving as both documentary evidence and visual aids that prompt survivors to give narrative testimony about their experiences during the Khmer Rouge regime.

Given their prevalence in discussions about violence, how are we to understand the ongoing impulse to save, reprint, and talk about these mug shots, and why are there so many efforts to document their reuses? What is the focus of the discussion of these mug shots, and what is missing from it? What light can anthropology, history, visual studies, and archival studies shed on these prolific photographs?

Trouillot's Four Silences as Framework

In the book *Silencing the Past: Power and the Production of History*, the anthropologist Michel-Rolph Trouillot examines the relationship among power, archival sources, and the creation of historical knowledge. Trouillot posits that silences are encoded in historical production at four key moments: "the moment of fact creation (the making of *sources*); the moment of fact assembly (the making of *archives*); the moment of fact retrieval (the making of *narratives*); and the moment of retrospective significance (the making of *history* in the final instance)."[21] Not all events are recorded; not all records are incorporated into archives; not all archives are used to tell stories; not all stories are used to write history. Power is implicated in each of these moments; which stories get told, which get forgotten, when, and by whom, is inextricably linked to the power to tell and to remain silent.[22]

Although, as Trouillot acknowledges, these four moments are not universally present in all instances of history making, they provide a concrete framework to "help us understand why not all silences are equal and why they cannot be addressed—or redressed—in the same manner."[23] At each stage, the silences are compounded, so that "any historical narrative is a particular bundle of silences," with silences reflecting specific instances of the assertion of power.[24] We can use these four moments of silence as a framework in which to tease out the power relationships in any story about the past, but they are particularly useful when examining contested histories.

The first three of Trouillot's four moments of silence are helpful in examining the Tuol Sleng mug shots: record creation (the moment of fact creation in Trouillot's terminology), archives creation (the moment of fact assembly), and narrative creation (the moment of fact retrieval). In each of these moments, silences are encoded and compounded as the process of historical production progresses from fact creation to fact assembly to fact retrieval. Trouillot's fourth moment, the making of history in the final instance, is as of yet undetermined, as Cambodians are still grappling with historical production.

In the context of Trouillot's work, a host of silences marks the Tuol Sleng mug shots at the moment of their creation. First, not every Khmer Rouge victim was processed through a prison system; the vast majority of the 1.7 million victims died from exhaustion, malnutrition, or untreated disease and not from outright execution. Even most of those who were executed were killed in rural areas and not processed in prisons. For these victims, the Khmer Rouge left no written record; bones serve as their only material trace. Furthermore, Tuol Sleng was only one of 196 Khmer Rouge prisons; because

photographic documentation units did not exist to the same degree at the other sites, no parallel set of mug shots were left at other locations. These instances are rife with silences in that no or very few records are left behind, making the task of creating credible facts about these victims difficult. Without documentation, we simply do not have the evidence to be sure exactly how many people were tortured at Khmer Rouge prisons or how many people died in other ways during the regime; the best scholars can do is estimate on the basis of forensic evidence (i.e., bones) and population projections. Furthermore, as the pinnacle of the national prison system, Tuol Sleng disproportionately housed the elite of both pre-Communist Cambodian society (professors, doctors, government officials) and the Khmer Rouge regime itself (commune leaders, high-ranking officials). To focus solely on the iconic images from Tuol Sleng is to render silent all of the nameless victims who died in other ways.

But, in addition to the silences created by all of the victims who were not photographed at Tuol Sleng, there is the overwhelming silence of the 5,190 Tuol Sleng victims whose mug shots we have.[25] These mug shots are evidence of their silence, despite our repeated attempts to project voices onto them. They stare at us, unable to fully voice the horrors they are about to experience. Photos are always mute, but in this case the silence is deafening.

In Trouillot's second moment, the moment of fact assembly, we see how precarious the leap from record to archive can be; even when events are recorded, not all records are incorporated into archives. The inclusion of some records in the archives at the expense of others effectively silences those voices deemed unworthy of historical attention. For the Tuol Sleng mug shots, the gap between the estimated thousands of prisoners photographed and the 5,190 mug shots that exist today in archives represents a silence of thousands of Tuol Sleng victims whose faces we do not know, for whose deaths we do not have documentary evidence.[26] These silences result not from archival appraisal decisions (indeed, archivists have launched an active campaign to recover the missing mug shots) but from the destruction of records in the chaos of the aftermath of civil war. And yet the effect is the same; for those Tuol Sleng victims for whom we do not have records, our histories remain silent, our facts about their lives not yet assembled.

At Trouillot's third moment, the moment of fact retrieval, another layer of silence happens as narratives are created in that only certain archival records get used to tell stories about the past. Tuol Sleng mug shots are now being used as powerful catalysts—"touchstones," in the language of recent archival theory—to spark memories and stories about the regime.[27] Yet many mug shots remain unidentified, the full weight of their evidence unexamined, their facts unretrieved, the stories of those depicted conspicuously absent from our

narratives. These silences result from many factors; perhaps all the people who could identify those portrayed in the mug shots were themselves killed by the Khmer Rouge, perhaps they simply do not have access to the mug shots, perhaps they don't want the stories of their loved ones made public. Regardless of these reasons, the voices of those unidentified victims in the mug shots remain unheard, effectively silenced from our stories about the regime. Furthermore, when we focus on a few of these iconic images (that of Hout Bophana, for example) that are reproduced time and time again at the expense of others, we inadvertently silence the other victims, demanding these icons stand in for all the Tuol Sleng victims, despite the singularity of their stories.

Yet, despite this complex layering of silences, some of the silences encoded in these photographs at the moment of their creation need not be perpetuated at the moment they are assembled into archives, nor at the moment they are used to create narratives. A "community of records," comprised of survivors, victims' family members, and archival institutions like DC-Cam, is creating new sources that reassert agency in the making of both archives and narratives about the Khmer Rouge.[28] By digitizing and preserving the mug shots, documenting the act of bearing witness to them, and then preserving these witness-bearing records, this community is inserting the voices of survivors and victims' family members into the moments of fact assembly and fact retrieval. This community is, in effect, replacing the silences of the dead with the voices of witnesses.

By using records to reunite disparate information, hold mass murderers accountable, and memorialize the dead, archivists and survivors are, in the language of Trouillot, retrieving facts in ways unimaginable to those who created the original sources and subversive of their aims. These reuses of the past reflect the ever-changing needs of the present; in this case, archivization is fulfilling the contemporary goals of identification, accountability, and memorialization. In the examined reuses of the mug shots, Trouillot provides a framework to examine how archivists can give voice to silences previously encoded at the creation of the records in their collections.

The Contribution of Archival Theory: Trouillot in the Records Continuum

Although Trouillot recognizes the importance of archival labor in the process of historical production, archivists have developed more complex models to describe what Trouillot terms the making of sources, archives, and narratives. Indeed, in its traditional Western conception, the making of

archives involves a whole host of functions (such as appraisal, arrangement, description, and preservation) that are not addressed by Trouillot (nor are they acknowledged by much humanities scholarship on "the archive"). Furthermore, archival theorists rooted in postmodernism and deconstructionism would object to Trouillot's demarcation between archivists as fact assemblers and archival users as narrative creators, instead arguing that archivists themselves are storytellers and that archival functions inherently involve elements of narrative creation.[29] The records continuum model, first developed in Australia by Frank Upward and Sue McKemmish, provides one archival studies alternative to Trouillot's approach.[30] The continuum proposes a multidimensional model of concentric circles through which records are *created* as the by-product of activity, *captured* as evidence (disembedded from their creation and extracted into systems that allow them to be used), *organized* into personal or institutional archives as memory (migrated into systems that allow their use across an organization), and *pluralized* as collective memory (migrated into systems that allow their use across society).[31] The focus in this model (and in the prevailing archival studies discourse as a whole) is on records as evidence of human activity. As McKemmish summarizes, "archiving processes *fix* documents which are created in the context of social and organizational activity . . . and preserve them as evidence of that activity by *disembedding* them from their immediate context of creation, and providing them with ever broadening layers of contextual metadata."[32] The continuum model is characterized by the dynamic and transformative nature of records and recordkeeping within multiple and interacting dimensions such that, "while a record's content and structure can be seen as fixed, in terms of its contextualization, a record is 'always in a process of becoming.'"[33] In this view, the archives is not a stable entity to be tapped for facts but, rather, a constantly shifting process of recontextualization.

In the continuum approach, Khmer Rouge mug shots are (1) "documents-as-trace" created by the Tuol Sleng staff as documentary traces of the act of photographing inmates; (2) "records-as-evidence" captured within the context of incarceration; (3) "records-as-evidence" organized within the Tuol Sleng bureaucratic apparatus; and (4) "records-as-collective-memory" pluralized such that they are used by survivors and by victims' family members.[34] The many contemporary reuses of the mug shots add layers of contextual metadata to them as the originals are repurposed and pluralized through space and time.

While Trouillot's approach is linear (silences move progressively through four moments of silence), the continuum model is multidimensional, interactive, and circular. Furthermore, Trouillot sees history as having a *final* instance, whereas the records continuum model stresses the endless layering

and contextualization of records. Despite these differences, the two approaches have much to add to the exploration of Tuol Sleng mug shots. Although Trouillot's framework is more useful for tracing issues of silence and agency in the Tuol Sleng mug shots, the continuum model's insistence on the layered contextualization of records best reflects the many reuses of the Tuol Sleng mug shots, placing them in motion, in a constant state of becoming rather than in final disposition in the archives.[35]

The Social Life of Records

Complementing these two approaches is the notion that material objects are agents with a social life. Scholarly work from a range of disciplines has taken a turn for the material over the past twenty-five years. Arjun Appadurai's groundbreaking edited volume *The Social Life of Things: Commodities in Cultural Perspective,* first published in 1986, heralded the new era of the object in anthropology and history.[36] In this focus on material items, Appadurai shifts the methodological attention away from people and toward objects. He encourages scholars to "follow the thing" and writes, "even though from a *theoretical* point of view human actors encode things with significance, from a *methodological* point of view it is the things-in-motion that illuminate their human and social context."[37] Thus the social life of objects approach provides both a theoretical framework (that objects are imbued with certain power) and a methodological framework (that we can ask certain types of questions to uncover that power).

As early as 1996, experts in information studies began taking a similar approach to the study of documentation. In a seminal article in the inaugural issue of the internet journal *First Monday,* John Seely Brown and Paul Duguid traced the mobility of documents at the dawn of the information age. A document, they write, "plays . . . valuable social roles because it mediates and temporizes, records traces and fixes spaces, and demands institutions as well as technologies of distribution."[38] This social life persists, even as Internet technologies enable new forms of documentation.

Scholars in visual culture have since refined the social life of objects approach, turning attention to visual "things" in particular. In the second edition of her book *Visual Methodologies,* which appeared in 2007, the geographer Gillian Rose describes how Appadurai's anthropological approach, which she describes as "directly observing the social life of visual objects," stems from anthropology's recent turn toward the exchange of material objects and the social relationships produced by such exchanges.[39] Yet, unlike

Appadurai's, Rose's focus is not just on any kind of object but on *visual* objects. She asks, "What happens if . . . we start to think of visual materials less as texts to be decoded for their meaning, and more as objects with which things are done?"[40] Rose then outlines three key elements of this approach: materiality, or how images "look and feel" within particular places and times; performativity, or how images are activated by and/or interact with people, what Rose also calls "the co-constitution of image and observer"; and mobility, or how images are recontextualized and reimagined as they travel.[41]

Similarly, the historian and anthropologist Elizabeth Edwards interrogates the performative nature of photographs, particularly those on display in anthropological museums. She asks, "Do photographs have their *own agency* . . . ?"[42] Central to Edwards's question is the claim that photographs are agents that not only embody but also enact or perform certain meanings for their viewers. She writes, "Like the social saliency of the material object, active agency implies a level of performance, projection, and engagement on the part of the object. In the idea of performance . . . is implied a presentation that constitutes a performative or persuasive act."[43] Here, we are introduced to the possibility of photographs, through their creation, content, and ever-shifting reception, performing in service of political or social goals.

Adding to Rose's and Edward's treatment of photographs as agents is the work of the cultural theorist W. J. T. Mitchell. Building on a career spent exploring the magical power of iconography, in 2005 Mitchell invited us to think as if photographs had desires. "What do pictures want?" he asks in a book of that same title. "Magical attitudes" toward images proliferate, Mitchell insists, reminding us that pictures are imbued with an unprecedented power, despite (or maybe because of) their mutability through media.[44] Furthering Rose's discussion of materiality, Mitchell makes a crucial distinction among images, objects, and media. An image is "any likeness, figure, motif or form that appears in some medium," an object is "the material support in or on which an image appears," and a medium is "the set of material practices that brings an image together with an object to produce a picture." Together, images, object, and media form pictures, "complex assemblages of virtual, material, and symbolic elements."[45] Adding to Mitchell's distinction among images, object, and media is the notion of record; the image and the record persist as the object, media, and meaning change.

For Mitchell, pictures not only have a social life but are so much like "living organisms" that they have desires, as well. It is "not just what they mean or do" but what "claim they make upon us, and how are we to respond" that interests Mitchell.[46] When pressed, Mitchell asserts that, although he really does not believe that images want things, he invites us to play along in the

"thought experiment" of asking the question of what they want (even if it seems "impossible to begin with") because "we cannot ignore that human beings . . . insist on talking and behaving as if they *did* believe" that pictures had wants.[47] Mitchell also plays on the double meaning of "want," asking not only what pictures desire but what they *want for*, or lack, as well. For Mitchell, images are simultaneously powerful and powerfully incomplete. One of the things pictures lack, in Mitchell's view, is a voice. Speaking of a particular piece of art, Mitchell writes, "above all, it wants to be *heard*—an impossibility for the silent, still image."[48] It is up to us, the human viewers, to "break [their] silence, making [them] speak and resonate" with our own concerns.[49]

Though not explicitly identified as such, this social life of objects approach is compatible with recent developments in archival theory such as the records continuum model, deconstructionism, and postmodernism.[50] Influenced by postmodernism and continuum thinking (though not a continuum theorist per se), the Dutch archivist Eric Ketelaar sees records as dynamic objects in motion, continually shifting with each new use and contextualization. He traces the changing ways in which records are used to construct meaning and posits that records are "activated" with each use. For Ketelaar, such activations then become part of the records' "semantic genealogy," influencing all future activations of each record. He writes, "Every activation of the archive not only adds a branch to what I propose to call the semantic genealogy of the record and the archive. Every activation also changes the significance of earlier activations. . . . Current uses of these records affect retrospectively all earlier meanings, or to put it differently: we can no longer read the record as our predecessors have read that record."[51] Resonating with the work of Appadurai, Bruno Latour, and Upward, Ketelaar's work focuses on the record moving through space and time, influencing human behavior and culture, and accruing meaning along the way.

Ketelaar's conception of the activation of records is particularly useful; each use, each moment of meaning construction, constitutes archival activation. Ketelaar writes, "Every interaction, intervention, interrogation, and interpretation by creator, user, and archivist is an activation of the record. The archive is an infinite activation of the record. Each activation leaves fingerprints which are attributes to the archive's infinite meaning."[52] In this way, Ketelaar maintains a focus on records as a lens through which to examine the meanings people place on them. For Ketelaar, the record itself is changed by the ever-changing context of its use; as the record's "semantic genealogy" changes with each new activation, the record itself changes.[53] In this way, Ketelaar's semantic genealogy approach is an archival response to Appadurai and Latour, allowing

us to trace the record as an object with agency moving through a network of human actions, interpretations, and activations.

Taking Ketelaar's claim a step further, the Tuol Sleng mug shots are performative agents with a distinct social life. By combining a social life of records methodology with archival studies' emphasis on records as evidence of human activity, we can trace how records perform in specific contexts at various points in space and time and expose the moments in which silences get embedded in stories about the past.

More specifically, by examining Khmer Rouge mug shots as objects with a social life, we can trace transformations in the format, uses, and meaning of these photographs through space and time. The Tuol Sleng mug shots are activated in a multitude of contexts, where they construct meaning for particular groups of people (human rights activists, Khmer Rouge survivors, the family members of Tuol Sleng victims, tourists who visit Tuol Sleng) at particular times (the tribunal, the retrospective shaping of collective memory thirty years after the regime) and in particular realms (legal, political, cultural, economic, and religious). As Ketelaar would agree, these activations influence all future activations, so that our future readings of them are inherently bound to their current and past activations; knowing that they have been used as legal evidence in the tribunal or to help the family members of victims achieve closure through identification and religious ritual, or that they are being used as part of the marketing materials through which Tuol Sleng survivors are literally selling their stories, we can not read the mug shots in the same way as before. Through the infinite archive of their future reuses, the Tuol Sleng mug shots are always in the process of becoming.

Adding to this theoretical discussion of the social life of records is their recent transformation from the material to the digital. Here, Geoffrey Bowker's work on memory, time, and information infrastructure proves helpful. Bowker asserts both that objects are transformed by migration into new formats and that these migrations represent deliberate choices made in the present for future use. Furthermore, such migration poses significant ethical and political challenges, as Bowker's work with Susan Leigh Star reminds us. Bowker suggests we read the information infrastructures that enable such digitization "both discursively and materially," as a "site of political and ethical as well as technical work."[54] Digitization of paper records is not a value-neutral activity but rather one with significant political and ethical consequences. Echoing Mitchell, Bowker and Star remind us that the picture lives on while the medium changes; we can continue to trace the social life of the images despite the absence of the material object enabled by digitization.

Societal Provenance, Co-Creatorship, and Archival Whispers

The Tuol Sleng mug shots can also be examined in light of an ongoing discussion within archival theory about the concept of provenance, the notion of co-creatorship, and the possibility of reading records "against the grain" in order to uncover the voices of those previously silenced. In this way, the question of who has ownership of and gets to speak through the reuses of this particular collection of photographs is informed by and has larger implications for archival theory and practice.

Provenance (and its namesake principle) is a central theoretical and practical tenet in archival studies, where it is more narrowly conceived than in museum studies.[55] Within the mainstream Western archival tradition, provenance has been defined as "the origin or source of something" or as "information regarding the origins, custody, and ownership of an item or collection."[56] The principle of provenance traditionally prescribes both that records made by different creators be kept separately and that their original order be maintained. By this narrow reading of the concept, the provenance of Khmer Rouge records can be traced back solely to the regime that created them; the Tuol Sleng mug shots are the work of a few Khmer Rouge photographers, fixing their provenance to the settled, finished, and finite functions of a singular bureaucratic agency that existed in a particular place (Tuol Sleng prison) and date range (1975–1978). In this configuration, the Tuol Sleng mug shots are government records, whose custody can be confined to the current government of Cambodia as the successor state to the Khmer Rouge, under the doctrine of inalienability.[57]

However, this traditional conception of provenance has been challenged on several fronts within archival studies over the past two decades. New reconceptions of provenance view it not merely as an "organizing principle" or a "physical and intellectual construct" but as a "sociohistorical context," in the words of Jennifer Douglas.[58] Tom Nesmith, for example, defines provenance as "the social and technical processes of the records' inscription, transmission, contextualization, and interpretation, which account for its existence, characteristics, and continuing history."[59] In this new reconceptualization, provenance is an ever-changing, infinitely evolving process of recontextualization, encompassing not only the initial creators of the records but also the subjects of the records themselves, the archivists who acquired, described, and digitized them (among other interventions), and the users who constantly reinterpret them. Similarly, Laura Millar, influenced by the conceptualization of provenance in museum studies, posits that archival conceptions of provenance should include creator history, or "the story of who created, accumulated, and used the

records over time"; records history, or "the story of the physical management and movement of the records over time"; and custodial history, or "the explanation of the transfer of ownership or custody of the records from the creator or custodian to the archival institution and the subsequent care of those records."[60] In this estimation, archivists and users are active participants in the provenance of records and are therefore important stakeholders in their custody, mediation, and uses. Provenance is about not only the past but also the future of the records; like Ketelaar's semantic genealogy, this postmodern approach to provenance "opens out into the future" by including all possible potential activations in its scope.

Furthermore, many of these recent reinterpretations open provenance up to broader community-based configurations. Joel Wurl, for example, has posited that, in the context of a multicultural society, ethnicity, rather than origin in an organization or governmental agency, forms a meaningful basis on which to trace provenance.[61] Similarly, Jeannette Bastian has urged archivists to expand the scope of provenance to include subjects of records and not just their creators—an arrangement that, in Bastian's case study, balances custody of colonial records between postcolonial nations and their former colonial rulers.[62] For Bastian, provenance and community are intertwined, so that "the content, context and structure of record creation [are] inextricably bound together in a vision of provenance and community that seeks, weighs, and accommodates all the voices of a society."[63] In Bastian's expansive interpretation, provenance becomes a tool for community inclusion, rather than one of limitation, for hearing the voices of those previously silenced, rather than amplifying the voices of the powerful.

In some cases, these reinterpretations of provenance collapse previous distinctions between the creator and the subject of records, so that both become co-creators of the record. Central to this discussion is the definition not just of provenance but of creatorship. Recently, a host of Australian archival theorists, influenced by indigenous Australian philosophies, have posited that not only should records' subjects be included in provenance but also that the subjects of records themselves should be seen as co-creators. Writing about the records of Australian colonization, the theorist Chris Hurley has described a "parallel provenance," that is, two differing claims to the origins of records—one provenance tracing records back to the colonizers who created the records and one provenance tracing the records back to the colonized subjects of them—resulting from diverging conceptions of creatorship.[64] Building on Hurley's work, Livia Iacovino advocates for a participant model of provenance in which all participants in the creation of records are deemed co-creators and as such enter into a relationship marked by a series of rights and responsibilities, with

important implications for ownership, access, and privacy.[65] In this conception, not only should provenance be expanded to include the society from which the records emerge(d) but also the notion of creatorship is expanded to include the subjects of records.

If we accept these radical reconceptualizations of provenance and creatorship, not only would both archivists and users of the Tuol Sleng mug shots become part of their evolving provenance but the subjects of the Tuol Sleng mug shots would become co-creators of the records. These two points have important implications for our attempts to hear their voices through the silence of the photographs. Writing about attempts to uncover the voices of the colonized within records created by colonizers, Bastian writes that, by extending the notion of provenance to include the societal context of records creation, "the voiceless population is not the silent witness but a full partner in the record-creating process." Given the active participation of the colonized in records creation, Bastian advocates that archival users "read against the grain" of the archives to uncover the voices of those previously marginalized so that we may find "the whispers of the colonized in the records of the colonizers."[66] While the Khmer Rouge context is not literally one of colonizer and colonized, the power differential between Tuol Sleng staff and prisoners was such that parallels can be drawn in this context. Like the colonizers' records of the colonized, Khmer Rouge records of prisoners are rife with the silences of the marginalized. Yet, what do we stand to gain by envisioning the Tuol Sleng victims as co-creators of the mug shots? Does seeing Tuol Sleng victims as co-creators project a false sense of agency on those photographed, prisoners who clearly had no choice in the situation? Is there a way that we can uncover the voices of the victims in these mug shots? To restate the postcolonial theorist Gayatri Chakravorty Spivak's famous question, can the subaltern speak?[67] Returning to Bastian's example, can the human cargo, long dead, ever have a voice through records created to subjugate them?

Given the totality of the Khmer Rouge bureaucracy and the victims' lack of agency, we would be hard pressed to deem the victims co-creators of their mug shots. Though we may never be able to uncover the whispers of the Tuol Sleng victims through the deafening silence of their photographs, we *can* (and should) hear the voices of Khmer Rouge survivors and the victims' family members who use the records and form an integral part of their provenance. Again, we must stretch the focus of provenance from the past (the dead victims depicted in the mug shots) to the future (the two living Tuol Sleng survivors and the surviving family members of the victims who activate the records through reuse). By expanding our conception of provenance to include these

active participants in the ongoing and constantly shifting "community of records" formed around the mug shots, we can hear not the whispers of the victims, but the voices of witnesses. Through their varied use of the Tuol Sleng mug shots and the creation of new records that document this use, archivists, survivors of the regime, victims' family members, and tourists who visit Tuol Sleng are constructing a complexly layered archive, adding narratives of witnessing, memorialization, and protest over the silences of the original records. These new narratives form part of the provenance of these records, making the archivists, survivors of the regime, victims' family members, and tourists co-creators in an ongoing process of remembering the victims of the regime. Reframing provenance to acknowledge the unique political, economic, social, and cultural contexts of post–Khmer Rouge Cambodia, we can develop a pluralist approach to archives that can accommodate the diversity of memory keeping practices in societies around the world.[68] In this reinterpretation, Trouillot's four moments of silencing are not linear but simultaneous and porous, as new records, archives, and narratives are constantly being made through the reuse and reinterpretation of records, with each newly created record "opening out into the future" for other unanticipated uses. It is here, in this liminal space, that the archivist's infinite future resides.

Silences and Agency as Complementary Approaches within Archival Studies

Yet, while the archives are infinite, this book (thank goodness) is not. The aforementioned theoretical approaches are complementary and imperfect heuristic devices. By following documents from the moment of their creation to their subsequent incorporation into archives and deployment in the construction of narratives, we can track both silence and agency throughout the record's many uses in a way that is manageable, organized, and finite. In this way, Trouillot's four moments during which silences are encoded in history correspond to key moments in the social life of the records, namely their creation, archivization, deployment for the formation of narratives, and deployment for the writing of history. Here, silence and agency are two sides of the same coin; the archived mug shots being used to spark narratives are agents with a social life, yet complex layers of silences (of those victims not recorded, those records not archived, those archives not used) are encoded in each moment within this social life. Employing multiple theoretical frameworks (silences in the production of history, the records continuum, and the

social life of objects) allows us to explore the Tuol Sleng mug shots as the embodiment of a series of contradictions: presence and absence, voice and silence, agency and victimhood.

Using these records in different ways tells different stories, sometimes overlapping, sometimes conflicting, about the Khmer Rouge period. While each activation provides, in the words of South African archivist Verne Harris, "just a sliver of a window into the event," the archives are a glass house, made entirely of windows.[69] There is room for multiple slivers (and multiple stories) here. As always, archives are dynamic, contested spaces through which meaning is constructed and memory is shaped.[70] Archivists actively contribute to this shaping of meaning and memory by providing context to these now-familiar texts and, as this book uncovers, in some cases actively create new records that allow victims and survivors to insert a voice of witnessing where previously a silence was encoded.

Summary of Chapters

Chapter 1, which seeks to understand the social and political context of Tuol Sleng and its recordkeeping bureaucracy, is based on historical research conducted, in part, in archives in Phnom Penh. It explores the creation of the Tuol Sleng mug shots, including both their history as a genre and their function within Khmer Rouge bureaucracy. After giving some background information on who the Khmer Rouge were and how they came to power, this chapter traces the history of the mug shot in Cambodia, from its roots in the French colonial police force to its use by the Khmer Rouge to both record and create criminal bodies within the regime's secret police system. This chapter explores why the Khmer Rouge took mug shots of the Tuol Sleng prisoners, what social function these photographs served, and how bureaucratic documents like mug shots helped streamline the administration of mass murder. The primary sources used for this chapter include the oral histories of Tuol Sleng survivors, guards, and a photographer that were collected and translated by DC-Cam and documentary filmmakers; translations of printed memoirs written by survivors; and archival records such as colonial-era mug shots, Tuol Sleng mug shots, and Tuol Sleng organization charts. This chapter also relies on secondary materials written by historians of Cambodia as the basis for its analysis. Using Hannah Arendt's conception of the banality of evil, this chapter addresses how such obsessive documentation in a totalitarian bureaucracy helped facilitate mass murder by alienating decision makers from the violence

of their decisions. This chapter also addresses the silences encoded in the moment of document creation, pointing toward the unheard voices of the vast majority of those Khmer Rouge victims who were not photographed at Tuol Sleng. Through this examination, this chapter furthers scholarly understanding of the social function of Khmer Rouge documentation and makes a theoretical contribution to inquiries into recordkeeping practices in totalitarian regimes.

Chapter 2 explores the archivization of these mug shots, or the moment of fact assembly, following Trouillot's framework, paying particularly close attention to their use by DC-Cam. This chapter uses interviews I conducted with people central to the creation of DC-Cam, as well as texts written by them, to trace how Khmer Rouge mug shots became incorporated into archival institutions in both their paper and their digital formats. It traces the transformation of the mug shots into archival collections, from the creation of the Tuol Sleng Museum of Genocide to international attempts to preserve and collect them as scholarly material and legal evidence to DC-Cam's use of the mug shots in its recent digitization and publication projects. Each moment in this history of archival collecting is marked by shifting international alliances, competing claims to truth, and the politics of who gets prosecuted for human rights violations. After tracing this complicated history, this chapter examines how archives in general and this archival collection in particular are linked to silences, power, and politics. Again, the voices of the thousands of Tuol Sleng victims whose mug shots are not preserved in archives are silent.

In Chapter 3, I explore how Khmer Rouge survivors, the family members of Tuol Sleng victims, and archivists at DC-Cam are using the Tuol Sleng mug shots to tell narratives about the regime, narratives that then become records, contributing to an ever-evolving multilayered archive. In this chapter, I analyze how the tribunal, documentary filmmakers, and DC-Cam are using mug shots to shape collective memory by inspiring narratives from these survivors. These narratives take many forms: legal testimonies; interviews conducted by documentary filmmakers; interviews, articles and family-tracing correspondence published in the DC-Cam newsletter; memoirs written by Tuol Sleng survivors; and photos of survivors and victims' family members looking at the mug shots in DC-Cam publications. Across many formats, mug shots are used as a touchstone for people to tell stories about the regime, bear witness to abuse, and assert that such injustice should never happen again, constituting what some anthropologists and scholars of visual culture refer to as "the performance of human rights."[71] These newly generated stories about the regime then become part of the archive, constituting a layering

of archival records that is constantly expanding and opening out into the future.

This chapter also details how the mug shots are gaining another life in reprints (both digital and paper) of photographs of people looking at them, inspiring narratives through which people can document bearing witness to the crimes of the Khmer Rouge. In the context of Trouillot's four moments of silence, these photos of survivors and victims' family members looking at the mug shots reintroduce an active voice, inserting a voice of witnessing where previously the silence of victims was encoded. Yet, as this chapter uncovers, the performance of human rights engendered by these stories happens in a complex global and local political milieu in which the predominant international conception of human rights as framed by the Khmer Rouge past does not entirely map onto more immediate Cambodian struggles against land grabbing, corruption, and labor exploitation.

Chapter 4 concerns the commodification of memory and the ethics of looking in the context of Tuol Sleng as a tourist attraction. It uses ethnographic fieldwork in which I observed Tuol Sleng survivors and tourists, as well as visual analysis of tourist photographs available via social media websites. Detailing how the two known adult survivors of Tuol Sleng have started lucrative businesses selling their memoirs and posing for tourists' cameras in the courtyard of the museum, this chapter reveals how memory work is not only inherently political but commercial as well. The creation and circulation of these tourist images reveal a point of conflict between global human rights rhetoric and the more local right of the survivors to earn a living. In this way, the snapshots of the survivors with tourists simultaneously perform human rights and injustice by documenting both survival from a horrific past and the economic inequity and neglect that has led the survivors to sell their stories and images at Tuol Sleng in the present. This chapter traces the social life of the mug shots as they are incorporated into new digital photographs taken by tourists and uploaded to social media websites and posits that archival context is key to understanding how these new tourist-generated photographs perform in a digital environment.

I conclude by exploring how archival institutions can respond to and counter silences encoded in records at the moment of their creation. The conclusion addresses how the creation of records, archives, and narratives is leading to the production of history about the Khmer Rouge. It also includes a significant section reflecting on my own involvement in this research as an archivist by professional training and an American by birth. There, I explore the ethical responsibilities associated with writing about, presenting, and teaching such gruesome and culturally sensitive images and reflect on how my

own interaction with these records has become part of their provenance. While the future uses of these records are hard to predict, we can be certain that their active social life will continue as long as we continue to try to make sense of the horrific actions of the Khmer Rouge.

1

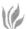

The Making of Records

To photograph people is to violate them, by seeing them as they never see themselves, by having knowledge of them they can never have; it turns people into objects that can be symbolically possessed. Just as the camera is a sublimation of the gun, to photograph someone is a sublimated murder—a soft murder, appropriate to a sad, frightened time.

Susan Sontag, *On Photography*

In history, power begins at the source.

Michel-Rolph Trouillot, *Silencing the Past: Power and the Production of History*

The first stage in the social life of the Tuol Sleng mug shots is their creation as bureaucratic records within the Khmer Rouge prison system. Tuol Sleng prison was situated at the pinnacle of the Khmer Rouge regime, and photography was situated at the center of the Tuol Sleng bureaucracy. Although the regime inherited the practice of taking mug shots from the French colonial police, the Khmer Rouge adapted the genre to fulfill its own bureaucratic and administrative functions. Viewed through the lens of archival studies, these mug shots both discursively produced the criminals they claimed to document and enabled the administration of mass murder within the Khmer Rouge bureaucracy. In light of Trouillot's work, a series of silences was encoded in these records at the moment of their creation, and, despite recent archival attempts to uncover the whispers of the marginalized in records, such silences can never be decoded to uncover the voices of the Tuol Sleng victims.

Tuol Sleng's Role within the Khmer Rouge, Photography's Role within Tuol Sleng

As any archivist would agree, in order to best understand administrative records, one must first understand the organization that created them. As expertly detailed in David Chandler's foundational book *Voices from S-21*, Tuol Sleng was crucial for the function of the larger Khmer Rouge bureaucracy and the practice of photography was crucial for the function of Tuol Sleng's administration.

Tuol Sleng was one of 196 Khmer Rouge prisons dispersed throughout Cambodia, but it also served as the national headquarters of the regime's secret police. David Hawk, a human rights activist, accurately described Tuol Sleng as the "apex" of a "pyramid of death" orchestrated by the Khmer Rouge. In Hawk's construction, at the bottom, the vast majority of Cambodian deaths during the regime can be attributed to starvation, disease, and exhaustion; moving up the pyramid, a smaller but significant number of deaths can be attributed to targeted killings of specific groups selected on the basis of class, ethnicity, or political affiliation; and at the top of the pyramid are those victims executed by the regime's "nation-wide prison-execution system," for which Tuol Sleng served as the centerpiece.[1] Thus, while only a small number of people relative to the entire population of roughly 1.7 million victims were held at Tuol Sleng, the prison serves as an important symbol of the larger crimes of the regime. There are no exact figures for the number of prisoners held at Tuol Sleng, with estimates ranging from 12,273 (the tribunal's estimate) to 20,000 (DC-Cam's estimate).[2] Because much of the documentation kept at Tuol Sleng was destroyed (as is detailed in chapter 2), it is unlikely that exact figures will ever be known. The documentation that does exist reveals a steady increase in the number of prisoners at Tuol Sleng that corresponds to major "purge" episodes within the party. Indeed, as Chandler reports, two events in 1976 led to a surge in the prison population: one was the alleged mutiny of a Khmer Rouge military unit whose members were then all arrested, and the other, which took place in the wake of Chairman Mao's death, was infighting between pro- and anti-Vietnamese factions within the regime that led to the arrest of Pol Pot's perceived challengers.[3] In 1977 and 1978, ongoing party directives to "purge" the northern areas of the country of suspected traitors within the Khmer Rouge kept an ever-expanding stream of prisoners flowing to Tuol Sleng. Vann Nath, a Tuol Sleng survivor who is now deceased, wrote that in September 1978, as the regime spiraled into deepening levels of paranoia, many of the Tuol Sleng guards themselves were arrested on suspicion of treason.[4] Chandler notes that, in the brutal distrust that marked the end of

1978, even Son Sen, the Khmer Rouge's deputy prime minister for defense under whose jurisdiction Tuol Sleng fell, was brought under intense suspicion and might have been arrested at Tuol Sleng had the regime not collapsed.[5] On the basis of existing records, Chandler estimates that at least 2,700 prisoners were processed at Tuol Sleng in 1976, 6,500 in 1977, and 5,000 in 1978. These figures include women and children, who were often brought to the facility with their arrested husbands or parents.

Tuol Sleng operated under a system of absolute secrecy that was reinforced by the killing of virtually all prisoners and witnesses.[6] Like all of Phnom Penh, the area surrounding Tuol Sleng was cleared of residents. While many scholarly and press accounts report that only seven prisoners survived Tuol Sleng, recent evidence compiled by DC-Cam reveals that 179 prisoners were released between 1975 and 1978. Yet only twenty-three of them are known to have survived past 1979, and all but two of these twenty-three have since died, are missing, or do not wish to be publicly and continuously identified as Tuol Sleng victims.[7]

While Cambodians accused of lesser crimes by the regime may have been sent to local-level prisons within the network, the regime designated Tuol Sleng as the central holding facility for prisoners thought to be of national importance, including many high-ranking Khmer Rouge officials.[8] As Chandler describes, prisoners were brought to Tuol Sleng if they were directly accused of traitorous activities by the secret police or if commune leaders at the rural level gave their names to the national secret police.[9] Son Sen oversaw the secret police force at a distance and was also tasked with internal party surveillance. Son Sen designated Duch, a former math teacher with a reputation for meticulously following orders, as Tuol Sleng's head.[10] As the Cambodia scholar George Chigas asserts, Duch originally ran the prison out of an abandoned chapel in Phnom Penh but moved the operation to the Tuol Sleng complex, a former high school, in May 1976 as the number of prisoners increased.[11] Tuol Sleng was large enough to accommodate 1,500 prisoners at one time. The complex comprises four three-story white concrete buildings, each divided into classrooms connected by long outdoor hallways that serve as open-air balconies running the length of the buildings in a style that is common in Cambodia. In the middle of the courtyard between these buildings is a small wooden house, which during the Khmer Rouge period was used to store documents.[12] The complex is also referred to as S-21, with some scholars positing that the S referred to the Santebal secret police and 21 to the walkie-talkie number of prison personnel.[13]

Tuol Sleng was simultaneously a prison, a torture facility, a holding pen, and an extermination center. As a DC-Cam report explains, prisoners were

first executed en masse at the complex, but "the volume and stench of the corpses rapidly increased and became unbearable," and alternative arrangements were made.[14] While officials continued to kill some prisoners during torture sessions at Tuol Sleng, the majority were sent to the killing fields at Choeung Ek, some fifteen kilometers away, where they were forced to dig their own shallow mass graves, hit on the back of the head with blunt instruments, and left for dead.

Under Duch's command, Tuol Sleng was divided into interrogation, documentation, and defense units and was staffed with guards, medics, truck drivers, interrogators, torturers, and administrators.[15] The Documentation Unit was an important part of daily operations; Chandler describes how an undated internal Tuol Sleng telephone directory names forty-six staffers, fourteen of whom were employed by the Documentation Unit.[16] Duch deliberately picked teenagers from poor rural backgrounds to serve as guards and interrogators, knowing they would be less likely to question his authority.

At Tuol Sleng, the regime created a systematic prison bureaucracy that hinged on documentation. Indeed, the entire complex was organized around extracting detailed confession statements from prisoners that described their alleged involvement with the CIA or KGB or other acts of treason against the Khmer Rouge; in brutal torture sessions that could include the use of water-boarding, electric shock, and scorpions, guards (per Duch's instructions) made prisoners refine and edit their statements until a sufficiently traitorous act was confessed and the appropriate number of accomplices was named. Some of these statements carry on for more than two hundred pages.[17] Recordkeeping became more systematized with time; typewriters were introduced in 1977, adding typed records to the growing pool of handwritten records. Other forms of documentation at the prison included prisoner registration files, daily log-books of arrests, organizational charts, memos between Duch and Son Sen summarizing operations, reports describing torture methods, daily execution schedules, and execution orders.[18] Photographs were just one part of a larger culture of record creation at Tuol Sleng. Furthermore, mug shots are only one type of photograph taken at Tuol Sleng; photographs were also taken of prisoners during torture sessions and after they were killed and of guards and other staff for personnel files.[19] Within the Documentation Unit, Suos Thy led the photography subunit. Within this subunit, the taking of mug shots primarily fell on the shoulders of Nhem En.[20] While En has named five other photographers, only one other photographer has come forward or publicly claimed responsibility.[21] Vann Nath recognized En as the photographer of his mug shot.[22]

Nhem En joined the Khmer Rouge at the age of ten, becoming part of an elite children's performance troupe that sang the regime's propaganda songs at

events. At twelve, he received his first gun and was deployed to the front lines. Having distinguished himself as a soldier, in 1975, when he was fifteen, En was sent to Shanghai to study photography for six months. He was assigned to take mug shots at Tuol Sleng on his return. As En told the journalist Peter Maguire, "When I was first at Tuol Sleng I was scared, but after seeing the same thing every day, I got used to it. It became normal, like feeling numb."[23] In accordance with the strict division of labor at Tuol Sleng, En was forbidden to ask questions of the prisoners or to touch them, except for removing their blindfolds. As they arrived by the busload, prisoners were lined up in a small wooden building in the courtyard of the complex. As En removed their blind-folds, many prisoners were stunned by the camera's flash and disoriented. Given that snapshot photography was reserved for the elite in pre–Khmer Rouge Cambodia, it was the first time that many prisoners were photographed, and some might have been distracted by the novelty of it.[24] En instructed prisoners to sit in a specialized chair with a metal rod that held their heads in place and asked them not to blink or move as he took the photograph.[25] In most cases, En took profile pictures as well as front views. Sometimes, the prisoners' height and head circumference was measured.[26] Sometimes, other facial and corporeal features, like color of hair or depth of voice, were noted.[27] Talking to a *New York Times* reporter in 2007, En explained his work: "I was alone in the room, so I am the one they saw. They would say, 'Why was I brought here? What am I accused of? What did I do wrong?' . . . 'Look straight ahead. Don't lean your head to the left or the right.' That's all I said. . . . I had to say that so the picture would turn out well. Then they were taken to the interroga-tion center. The duty of the photographer was just to take the picture."[28] One day in 1977, En's cousin was arrested and brought to Tuol Sleng. En took his mug shot, saying nothing. In a story that illustrates the "grey zone" that Tuol Sleng staffers like En occupied, Chandler reports that in 1977 En was accused of deliberately taking bad photographs after a mark appeared on an image of Pol Pot he developed and was temporarily sent to a reeducation camp.[29] When asked by Maguire why he took the photographs, En responded, "I made them because I was ordered to."[30] In another news story, En is quoted as saying, "I was only one screw of the machine. I did nothing wrong except taking photos at the superior's orders."[31]

The mug shots were developed each night in a nearby building using chemicals and equipment looted from abandoned photography labs in Phnom Penh. En delivered the mug shots directly to Duch. The numbering system in the photographs developed over time, as the number of prisoners escalated; in 1975, none of the prisoners in the mug shots had numbered tags, in 1976 and 1977 the prisoners had numbered tags but no names, and by 1978 the prisoners

held placards with numbers, their names, and the date. Thus, as Chandler reports, the prisoners photographed before 1978 are unidentified, while those photographed in 1978 are named.[32] Furthermore, the numbers pinned to prisoners in the mug shots correspond to processing batches and not individual prisoner identification numbers. En explained to Maguire, "We set up the numbers every twenty-four hours. For example, if we had ten prisoners today, we would start from one to ten, and tomorrow if we had 1,500 prisoners we would start with one and go up to 1,500."[33] Curiously, while some mug shots were stapled to prisoner biographies or labeled, others were found in separate photograph files. It is unclear why the regime would go to such great lengths to take the mug shots if they were often separated from information about who was depicted in them. This absence of names encodes a silence in the documents, coupled with the unbearably heavy silence of those voiceless prisoners captured in the images—prisoners who (for the most part) would not live to tell their stories.

A few of Tuol Sleng's survivors have described their experiences being photographed at the prison. Norng Chanphal, one of five child prisoners found when the Vietnamese liberated Tuol Sleng, was interviewed by DC-Cam staff in 2009. He related, "When we arrived in the prison . . . a photographer and note taker were there. They took photographs both in the front and sideways and gave us a number written in white. . . . I also saw them kick my mother. . . . They pushed her against the wall. I felt so terrified."[34] Another survivor, Chum Mey, told a DC-Cam staff member that when he arrived at Tuol Sleng, "They took [a] photograph of me and measured my height" before shackling him to other prisoners in a cell.[35] Another survivor, Bou Meng, recalls in detail:

> The guards escorted me and my wife to the compound of S-21 prison. About 10 minutes later, I knew that I was in a room. "Sit down!" a security guard ordered me. I searched for a chair with my hands and sat. A security cadre untied the black handkerchief from my face, but my hands were still handcuffed. I tried to look for my wife with dazed eyes. She was still blindfolded and handcuffed. I saw new guards in the room. I knew that I was in a photo room; there were a lot of materials such as a camera, a height measuring tool, documents, and typing machines. A 20-year-old cadre ordered me to walk up to the wall to measure my height. He then ordered me to sit in front of the camera. He put a number plate on my chest. It read 570. Another cadre asked me a few questions about my background and he recorded my answers on a worksheet while security guards walked back and forth. Soon I was blindfolded again. After that, I never learned what happened to my wife.[36]

Meng also recalls seeing the photography subunit chief, Suos Thy, arranging documents in the same room where his mug shot was taken. Similarly, Vann Nath has described how his mug shot was taken. Blindfolded, Nath was transported by bus to Tuol Sleng from a rural area, arriving at 3 a.m. He was shackled to other prisoners and led into a room. He recalled:

> "You, guy! What's your name? What did you do during the Sihanouk regime? The Lon Nol regime?" They'd already asked us these questions when we got off the trucks. Why were they asking us again? Every prisoner was interrogated again and then it was my turn. Afterwards, I felt someone undoing my blindfolds. At first my eyes were out of focus but then my vision cleared. In front of me was a chair with a camera set across from it. "Go sit on that chair," the guard said, pointing at me. The others handcuffed to me went with me but they sat on the floor as I was photographed. The guard took a picture of the front of my face, and then the side. Another guard measured my head and then they made an ID card. After me, they photographed the other people attached to me. Then they put our blindfolds back on.[37]

Almost everyone else who sat in front of En's camera was killed. The differences in the location and styles of the photographs—some very formal, some exceedingly violent, revealing that prisoners had already been beaten—may be attributed to the prisoner's assignment into one of three groups: the "smashed" group, who would be killed as soon as possible; the "hot" group, who would be tortured intensely during interrogation; and the "cold" group, who were treated slightly better in the prison hierarchy.[38]

Why did the Khmer Rouge so meticulously document images of the prisoners they were about to kill? Why did they choose the mug shot as a photographic genre in which to perform this documentation? What is the history of this particular genre in Cambodia and what can this history tell us about the roles the mug shots performed at Tuol Sleng? To answer these questions, we must turn to Cambodia's history as a French colonial protectorate and the role of police photography within France and its colonies.

French Colonial Police Photography and Its Legacy in Cambodia

The mug shots taken at Tuol Sleng can be seen as documentary traces of the French colonial legacy inherited by Cambodia. Tracing the origins of the mug shot as a genre in France and subsequently in Cambodia reveals

the prehistory of the Tuol Sleng mug shots, following their evolution from instruments of colonial bureaucracy to their role in a postcolonial reign of terror. It is especially ironic that the Khmer Rouge regime, which outwardly shunned all artifacts of colonialism, the West, and modernity, would so extensively adopt a system of police photography so thoroughly entrenched in French colonialism. Given this backdrop, the prehistory of the mug shot in Cambodia becomes an essential component of the complexly layered social life of the Tuol Sleng mug shots.

In 1863, Cambodia became a protectorate of France. Surrounded on both sides by hostile neighbors and threatened by French military aggression, Cambodia, led by King Norodom, entered into this protectorate agreement in an effort to stop Vietnamese and Thai expansion within its borders. While the agreement was successful in this aspect, France soon overstepped the boundaries of the initial protectorate agreement and gradually transformed Cambodia into a French colony. Over the next ninety years (until 1953), Cambodia would be under French rule.[39] While France eroded the political power of the Cambodian monarch, there was no large-scale effort to remodel Cambodian culture in the mold of France. As the historian John Tully posits, at the beginning of the Protectorate, the French were preoccupied with their more profitable colonies elsewhere (namely Vietnam), and generally maintained an official policy of "indifference" to Cambodia.[40] There was considerable variety in the degree to which France controlled its colonies and protectorates in Southeast Asia, and Cambodia was never under the intense cultural, political, and social influence of France in the same way Vietnam was.[41] Indeed, as Tully notes, very few French oversaw the colonization of Cambodia, with only five hundred Europeans in Cambodia in 1901.[42]

Nevertheless, the French had a lasting influence on the Cambodian legal and penal systems. As Peter Zinoman notes in his comprehensive book on imprisonment in French colonial Vietnam, "The establishment of a colonial prison system in French Indochina during the nineteenth century coincided with the emergence of the modern penitentiary in Europe and the United States."[43] New European techniques for policing and imprisonment, together with their subsequent bureaucracies, had a tremendous influence on Europe's colonies in Asia, Africa, and Latin America. Cambodia was no exception.

Prior to French colonization, the Cambodian legal code allowed for public torture and execution, despite Buddhist precepts forbidding such violence.[44] As Tully details, in 1911, a special French commission on penal reform enacted widespread changes to the Cambodian legal system that discouraged torture and execution in favor of imprisonment, which was touted as a more humane punishment.[45] However, the French colonial police force in Cambodia ignored

their own reforms, sometimes using, in Tully's words, "almost unbelievably sadistic tortures against political opponents."[46] By the 1920s, the French government in Cambodia had become "a dictatorship of police and civil servants," marked by an obsession with police surveillance, lack of basic rights like freedom of speech and assembly, "appalling" prison conditions, and rampant torture.[47] As Tully describes, "[King] Sisowath's Cambodia, in common with Indochina as a whole at the time [1904 to 1927], can be described as a colonial police state, ruled with an iron hand by a strict hierarchy of power with its apex in Hanoi."[48]

Yet, despite this attention to incarceration, the population in French colonial prisons in Cambodia remained relatively small until the 1940s, when the Vichy French regime controlled Cambodia; Tully reports, "In 1936, there were 917 prisoners in all the jails of Cambodia. By 1943, this number had grown fourfold."[49] Tully explains that, despite the relatively small number of French nationals in Cambodia, France maintained tight political control over the country through its domination of the police force and prison system until Cambodian independence in 1953.[50] Despite important differences in the way France administered its colonies in Cambodia and in Vietnam, Zinoman's astute observation about Vietnamese colonial prisons—namely that local traditions of corporal punishment, the development of colonial prisons out of prisoner-of-war camps, and institutionalized French racism, combined to create a "hybrid prison system" marked by "coercion and control"—can also be applied to Cambodia.[51]

Meanwhile, back in the metropole, the French penal system was undergoing a radical transformation in the nineteenth century, evolving from a system based on torture and execution to one based on discipline, punishment, and reform through imprisonment.[52] While a more detailed account of other aspects of the transformation of the penal system is beyond the scope of this investigation, it is important to note that new attention to disciplining and categorizing the criminal body, coupled with technological advances such as photography, paved the way for the invention of techniques to more scientifically and systematically track criminals and to predict criminal recidivism. Key to this evolution was the classification of criminals into two groups: first-time offenders, who were singled out for reform, and repeat offenders or career criminals, who were designated for longer terms of incarceration.[53] These changes would have enormous impact on policing and incarceration not only in the French colonies but throughout the world.

While the French police had photographed criminals almost since the invention of photography, they at first lacked a standardized format and systematic indexing and retrieval system.[54] As both the size of the Parisian police force and the number of arrested criminals grew, the force could no

The Making of Records

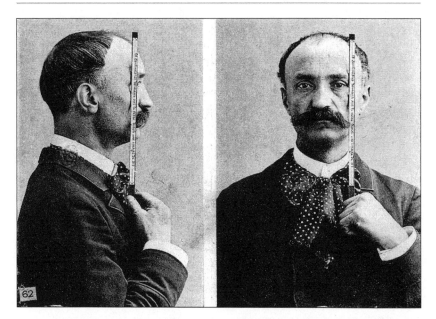

Figure 2 Standardized photograph of Alphonse Bertillon in both the front and the profile views in the Bertillon style. (From Alphonse Bertillon, *La Photographie Judiciaire*, Department of Special Collections, Charles E. Young Research Library, UCLA)

longer rely on the ability of officers to recognize and remember individual criminals from the thousands of unorganized photographs documenting them.[55] In 1879, Alphonse Bertillon, a French police clerk and the son of an anthropologist, introduced a new comprehensive system for identifying and classifying criminals.[56] Called *signaletics* or *bertillonage*, the system was marked by four key components: meticulously documented anthropometric measurements of eleven facial and bodily features using a series of standardized measuring furniture and uniformly calibrated instruments such as calipers, rulers, and compasses; a "verbal portrait" that described "marks, scars, and moles," as well as tattoos; standardized photographs of subjects in both front and profile views (which would document the shape of the ear) against a solid background (figure 2); and an elaborate filing system, including the file cabinets themselves, called "Bertillon cabinets," in which complete measurement cards could be systematically divided, filed, and retrieved.[57] (By 1900, fingerprints were also commonly added to the cards.) The cards were organized according to sex; head length; head breadth; length of middle finger, foot, forearm, and little finger; height; and eye color. They were then arranged within discrete file drawers according to ear length.[58] The indexing system worked well. As one author described, "Bertillon awed visitors to the Paris police department with

his ability to retrieve matching cards in minutes from a vast archive containing tens of thousands of criminal records."[59]

The system was described in detail in an 1885 edition of 95 pages but was elaborated and extended into a 260-page volume by 1896. This 1896 edition features eighty-one illustrative plates, including drawings of measurement equipment (figure 3); diagrams instructing readers on how measurements should be taken (figure 4); photographic charts showing the different types of facial features such as noses, eyebrows, and head shapes (figure 5); seven charts consisting of twelve photographs each dedicated to the "peculiarities of the ear"; and two fold-out charts, one consisting of a synoptic table of signaletic terms and one full-color chart detailing the fifty-four distinct colors of the human iris. Perhaps most importantly, Bertillon's handbook contains a five-page chapter entitled, "Special Posing Chair Mechanically Assuring a Uniformity of Reduction between Full-Face and Profile Photographs" and a diagram entitled "Measuring the Trunk," in which a suspect is shown sitting on one such "special posing chair" to which a ruler and measuring tool are attached (figure 6).[60]

The purpose of the system was to separate first-time offenders from repeat criminals so that different types of punishment could be enforced—reform and release for the first-time offenders and perennial incarceration for the recidivists. As Bertillon himself wrote, "Nobody disputes the fact that it would be losing time and money to try to regenerate an individual who has already foiled two or three attempts at moral salvation."[61] In this way, the Bertillon system (which ironically hinged on individuation of measurements) was part of a larger effort to classify criminals into types using the new field of "criminal science" (*criminalistique* in French); other categories to which criminals were commonly assigned included idiots, imbeciles, morons, lunatics, degenerates, delinquents, criminaloids, and born criminals.[62] In its dependence on classification through scientific rationalism, the Bertillon system was intimately linked to both anthropological classification that sought to document, measure, and categorize racial difference (which often deployed photography to justify the logic of imperialism) and zoological and botanical classification that sought to order the planet's species.[63] As Bertillon explained the impetus for his system, "There was a need of a method of elimination analogous to that employed in the sciences and of botany and zoology."[64] Indeed, in 1883, the same year the Parisian police department put Bertillon's system into effect, Bertillon, a member of the Société d'Anthropologie de Paris, published an anthropological book, *Ethnographie Moderne: Les Races Sauvages* (or, translated, *Modern Ethnography: The Savage Races*). The book delineated the physical characteristics of the people of Africa, South America, and Oceania and included several

MEASURING THE LENGTH OF HEAD (d)

to reproduce its arrangement as regards the fingering.
Point of view from which this figure should be studied by a *measurer* desiring
*

SECOND STAGE.—*Special view*, taken from above, for the study of the fingering to be employed for immobilizing the branches of the compass at the apparent length.

*

Point of view of an *observer*.

THIRD AND LAST STAGE, CALLED THE VERIFICATION.—The operator, having fixed the compass, replaces it on the head of the subject and verifies the accuracy of the figure found the first time by assuring himself that the friction of the right branch against the back of the head is satisfactory (For the general position turn to plate 8).

Figure 3 "Measuring the Length of the Head," drawing of calipers for measurement. (From Alphonse Bertillon, *Signaletic Instructions including the Theory and Practice of Anthropometrical Identification*, plate 11)

Figure 4 "Abstract of the Anthropological Signalment." (From Alphonse Bertillon, *Signaletic Instructions including the Theory and Practice of Anthropometrical Identification*)

Figure 5 "Synoptical Table of the Forms of the Nose." (From Alphonse Bertillon, *Signaletic Instructions including the Theory and Practice of Anthropometrical Identification*, plate 33)

MEASURING THE TRUNK

(Height of a man seated)

Make the subject sit squarely on the stool, see that he holds himself erect, and place and manipulate the portable square in the same manner as in measuring the height (*Instr.*, p. 105).

Figure 6 "Measuring the Trunk." (From Alphonse Bertillon, *Signaletic Instructions including the Theory and Practice of Anthropometrical Identification*, plate 7)

illustrations of colonial subjects in front and profile view alongside markers measuring their height (figure 7).[65] For his criminal indexing system, Bertillon merely applied the logic of colonial anthropology inward, toward the "undesirable" element within French society.

By the end of the 1890s, the Bertillon system was widely adopted, transformed, and simplified by police departments throughout the world.[66] The rhetoric surrounding its adoption spoke of the global and inevitable march of progress, modernity, and science. In an impassioned plea to the attendees of the Congress of the National Prison Association in Pittsburgh in 1891, Joseph Nicholson, president of the Wardens' Association, asserted that the Bertillon system "demonstrated beyond a question its absolute certainty for purposes intended" and "urgently solicited the hearty cooperation of every prison manager on this continent" in adopting it.[67] In the 1896 preface to the American edition of *The Bertillon System of Identification*, the publisher wrote, "As improved and developed with the aid of so many years of practical experience the system has reached a high degree of perfection, and its absolute efficiency is recognized by all competent authorities throughout the world."[68] Writing two decades later, soon after Bertillon's death, Raymond Fosdick posited, "[Bertillon's] system was adopted in nearly every civilized country. England, Germany, Austria, Russia, Switzerland, and many states in the United States applied it in their police departments, and the Bertillon cabinet became the distinguishing mark of the modern police organization."[69] However, as the system traveled, it was not only adopted but adapted. Simon A. Cole explains: "Most identification bureaus, too proud to simply adopt Bertillon's system wholesale, took it upon themselves to modify various aspects of the system. Foreign bureaus modified the number of type of measurements to be taken, added and deleted categories from the physical description, switched the measuring scale from metric to English, and even altered the design of the instruments themselves. Not surprisingly, the accuracy of the anthropometric identification decreased proportionally with the distance from Paris. . . . Whereas Bertillon had envisioned an internationally standardized system controlled and calibrated, . . . in Paris, instead an international patchwork of incompatible anthropometric systems developed."[70] By the 1920s, the Bertillon system was replaced throughout much of the United States and Europe by fingerprinting, for which the British colonial police (and their native clerks) in India had developed an indexing system.[71] However, while the anthropometric and indexing aspects of Bertillon's system largely became obsolete, his standardized use of photography and the subsequent slang label "mug shots" remain to this day.[72] For others, Bertillon's legacy is not just in the mug shot genre but in the prevailing culture of surveillance and documentation; as the visual

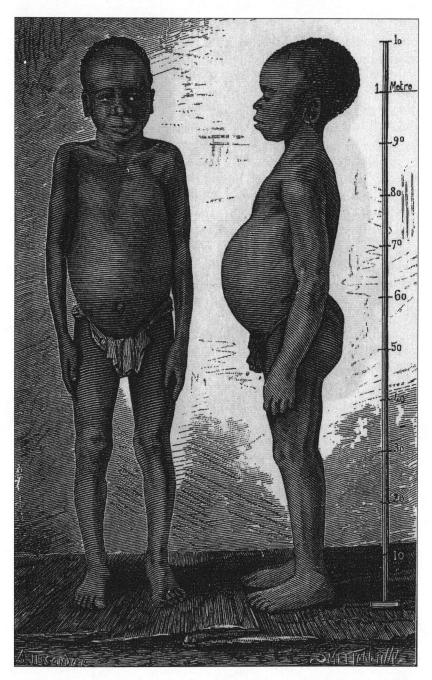

Figure 7 "Jeune Akka de face et de profil," Bertillon illustration of an African youth in front and profile view alongside markers measuring height. (From Alphonse Bertillon, *Ethnographie Moderne: Les Races Sauvages*, 57)

culture scholar Allan Sekula writes, "'Bertillon' survives in the operations of the national security state, in the condition of intensive and extensive surveillance that characterizes both everyday life and the geopolitical sphere."[73] Here, Bertillon's global and enduring reach is apparent.

Despite significant destruction of archives during Cambodia's civil war, some documentation remains on the use of the Bertillon system in French Cambodia.[74] A 1905 article published in the American magazine *Public Opinion* reveals how the previously mentioned characterization of the French Protectorate of Cambodia as a police surveillance state was linked to the implementation of the Bertillon system in Cambodia. The article, which can be justly classified as anti-Chinese propaganda in the wake of Chinese immigration to the United States, details how the French colonial government in Cambodia required Chinese immigrants to "submit to the indignity of the Bertillon system of identification." The article continues, "This is done in a remarkably thorough manner, and a careful record is kept of every immigrant up to the time of his death or his departure from the colony. When the coolie is hired under yearly contract the contractor or employer may receive from the authorities copies of the Bertillon record. This admits of absolute identification."[75] Here, the evidence is of the system being used not just to document criminals but to classify the ethnicity of and to keep track of migrant laborers in the Protectorate. Similarly, a monograph on the growth of rubber plantations in colonial Cambodia published in 2007 by the historian Margaret Slocomb confirms this use of Bertillon's system in the Protectorate. The book includes two mug shots of migrant Tonkinese laborers (or "coolies," as they were called) taken in the 1920s by the colonial police force in Cambodia, confirming the adaptation of at least some aspects of the system as an instrument of colonial control in the region in the 1920s.[76] Most significant, while earlier mug shots are missing, the National Archives of Cambodia has ample documentation to show that aspects of the Bertillon system were fully in place in the French colony in the 1930s and 1940s.[77] Approved order request forms for new supplies of photographic identity cards in order to document the Chinese residents of the Cambodian provinces of Kampong Cham (1936) and Kampot (1937) confirm the use of bertillonage to keep track of ethnic minorities in the French protectorate.[78] By 1940, there is clear evidence that parts of the system were in use in prisons in Phnom Penh. Twenty-nine extant Bertillon cards from 1939 and 1940 in the National Archives of Cambodia show that, while the Bertillon cards were in widespread use, as were the standardized mug shot and fingerprints, little information other than birth date and height was recorded on the Bertillon cards themselves; the spaces to record measurements of body parts remain curiously blank (figures 8 and 9).[79] The mug shots on

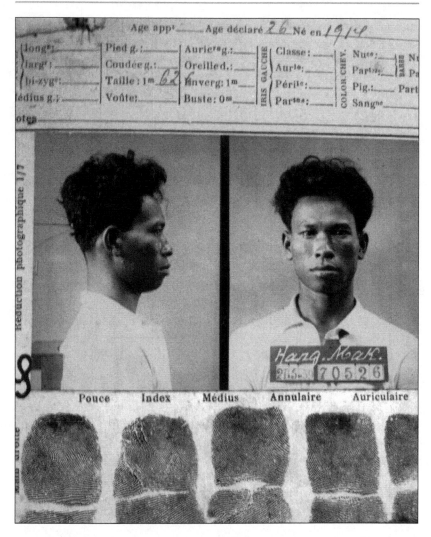

Figure 8 Hang Mak, identification card, 1939. (Courtesy of the National Archives of Cambodia, Folder PA1)

these cards show the prisoners in both front and side views, head resting in a metal arm (arising from a Bertillon measuring chair, as is visible in figure 9), the prisoners wearing placards that show a registration number, the date of arrest, and, very often, a name. The empty spaces for measurements are at the top of the card, the photos were attached to the middle, and the bottom has the prisoner's fingerprints. Each Bertillon card itself was also formerly attached to a more detailed arrest record that included history of previous arrests and time served, profession (overwhelmingly listed as "coolie"), and "particularités,"

The Making of Records

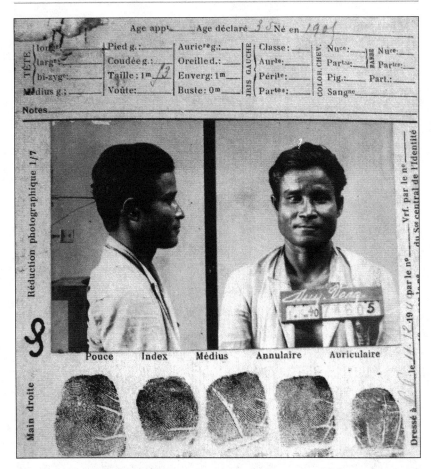

Figure 9 Muy Vong, identification card, 1940. (Courtesy of the National Archives of Cambodia, Folder PA1)

detailed descriptions of features such as the size and placement of facial warts.[80] The collation of the Bertillon cards with the larger arrest record sheets reveals that Bertillon's indexing system, in which the cards were to be organized alone in special file cabinets, was not in place in Cambodian prisons by 1940. Yet, despite the loss of some aspects of bertillonage, it is clear from these archival traces that the use of standardized mug shots taken in a specialized Bertillon chair and measurements of the height of prisoners were in place in colonial Cambodia.

Visual evidence and eyewitness accounts directly link aspects of the Bertillon system to the Khmer Rouge's documentation of prisoners. Clearly the vestiges of Bertillon are apparent wherever a standardized mug shot is found, but,

Figure 10 Measurement chair in display case at Tuol Sleng with Chan Kim Srun mug shots, December 2011. (Photo by author)

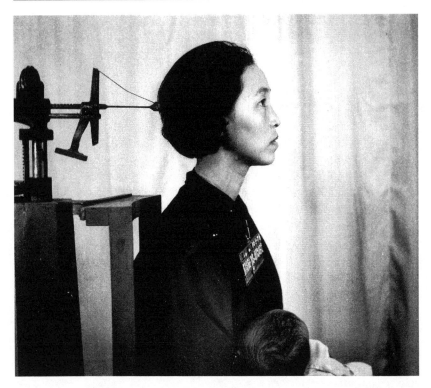

Figure 11 Tuol Sleng mug shot of Chan Kim Srun showing measurement chair in use. (Courtesy of Documentation Center of Cambodia Archive)

more specifically, the Tuol Sleng mug shots show an adherence to Bertillon's recommendations for photographs in terms of their standardization. Furthermore, the Khmer Rouge's taking of measurements (as previously detailed in the testimony by Tuol Sleng survivors Chum Mey, Bou Meng, and Vann Nath) and the actual instruments and furniture used for such measurements (figures 10 and 11) can be traced back to bertillonage.[81] Similarly, other administrative elements at Tuol Sleng can be traced to French colonial policing techniques; Chandler writes that the confession statements extracted from prisoners at Tuol Sleng "resemble prerevolutionary Cambodian police reports . . . [that] draw on the French police tradition of the *procès verbale* . . . [and] include such colonial-era idiosyncrasies as spelling out dates, calling the prisoner 'the named,' and so on."[82] Given all of this historical, visual, and testimonial evidence, it is clear that the Tuol Sleng mug shots trace their lineage back to the Bertillon system of identifying and indexing criminals.

The Social Function
of Khmer Rouge Mug Shots

Scholars of the Khmer Rouge from a range of fields have theorized about the social function the Tuol Sleng mug shots performed within the prison bureaucracy. For example, David Chandler has proposed that, in light of the Khmer Rouge's restarting of time, the detailed records created at Tuol Sleng were to be used as archival sources for the creation of an extensive history of the regime.[83] Others, like the anthropologist Alexander Hinton, have suggested that Khmer Rouge documentation reveals the combination of a modernist faith in bureaucracy and a uniquely Cambodian cultural tradition of "disproportionate revenge."[84] I neither refute nor deny these claims but rather add to this conversation by investigating the function of the Tuol Sleng mug shots in light of two main bodies of theory: a Foucauldian analysis of the state's discursive creation of the criminal body applied to photographic archives as influenced by the work of John Tagg and Allan Sekula, and Hannah Arendt's conception of bureaucracy, mass murder, and the banality of evil. As both of these bodies of theory illuminate, the mug shots played an important social function within Tuol Sleng, both by transforming the suspects depicted in them into criminals and by creating a layer of bureaucracy that separated the administrative order to kill from actual violence, thereby enabling Tuol Sleng staff to commit mass murder.

Two visual culture scholars—John Tagg and Allan Sekula—have written extensively about the social function the Bertillon system in general and mug shots specifically played within police departments in the United States, the United Kingdom, and France. Both of these authors link the indexical function of photography with a Foucauldian analysis of the discursive power of the state to create criminal subjects. Building on the foundation set by Foucault in *Discipline and Punish*, both Tagg's and Sekula's work speaks to the power of discourse to produce subjectivity through institutional practice.[85] Through a set of rhetorical claims and institutional practices, discourses are created that determine not only how certain subjects are thought of and spoken about, but how they are acted upon. Thus, for example, the practices embedded within the modern prison create a category of people—prisoners—who are then talked about and acted upon in particular ways: reformed, punished, disciplined, watched, corrected, and or made docile.[86] Similarly, in the late nineteenth century, the discourse surrounding photography as an instrument of realism created a particular "regime of truth" that produced our notion of photographs as scientific evidence.[87] Extending Tagg's and Sekula's Foucauldian analysis to the function of the mug shots taken at Tuol Sleng, we see that the

mug shots, as an integral part of a larger bureaucratic institution, served a discursive function in turning arrestees brought to Tuol Sleng into criminal subjects.

Tagg's and Sekula's work on the function of the Bertillon system in the American and European contexts sheds light on the production of mug shots at Tuol Sleng. Tagg posits that in bertillonage we see a confluence of science, the state, and the image, such that, "In a tightening knot, the local state pulled together the instrumentalities of repression and surveillance, the scientific claims of social engineering, and the humanistic rhetoric of social reform."[88] The use of photography by institutions such as the prison, the hospital, and the school, here exemplified by the codified genre of the mug shot, was key to this process of scientific classification.[89] Building on Tagg's work, Sekula reveals how the early adoption and practice of photography by penal, medical, and colonial institutions are embedded within a scientific truth regime such that photography became an institutional technology for the construction of particular types of human subjectivities such as the criminal, the ill, the poor. Sekula writes:

> With the rise of the modern social sciences, a regularized flow of symbolic and material power is engineered between fully-human subject and less-than-fully-human object along vectors of race, sex, and class. The social-scientific appropriation of photography led to a genre I would call *instrumental realism*, representational projects devoted to new techniques of social diagnosis and control, to the systematic naming, categorization, and isolation of an otherness thought to be determined by biology and manifested through the "language" of the body itself. Early anthropological, criminological, and psychiatric photography . . . constitute ambitious attempts to link optical empiricism with abstract, statistical truth, to move from the specificity of the body to abstract, mathematical laws of human nature. Thus photography was hitched to the locomotive of positivism.[90]

For Sekula, the camera was constructed as a truth apparatus firmly placed within a larger system of "archival rationalization." Through its central place in logical systems of measurement, classification, indexing, and retrieval, the camera became a scientific instrument constructed to record the truth.

In this examination of mug shots, photography historian Brian Wallis's distinction between portrait and type is key; though of individuals, mug shots are meant to produce objective, scientific, publically accessible types rather than individual, private, humanistic portraits. Unlike portraits, the types produced by the mug shots are "fundamentally nonreciprocal . . . the subject [in them] already positioned, known, owned, represented, spoken for, or

constructed as silent."[91] Of course, not every subject depicted in a mug shot conforms to this silencing; as Peter Doyle explores in his study of Australian police photographs from the 1910s and 1920s, many depicted criminal suspects find ways to assert their selfhood, transforming mug shots into portraits in defiance of the police photographers.[92] Still, the growth and standardization of police photographs signaled a switch in photography's history; as Tagg writes, "It was no longer a privilege to be pictured but the burden of a new class of the surveilled."[93]

Both Tagg and Sekula emphasize the discursive power of the Bertillon mug shots, detailing how photography not only documents reality but creates it, simultaneously recording arrests and producing subjects as criminals. By capturing information and classifying it, Bertillon transformed photography into an archival instrument by which to know and thereby control the criminal body, both individually and in the aggregate. As Tagg writes, "What we have in this standardised image is more than a picture of a supposed criminal. It is a portrait of the product of the disciplinary method: the body made object; divided and studied; enclosed in a cellular structure of space whose architecture is the file-index; made docile and forced to yield up its truth; separated and individuated; subjected and made subject. When accumulated, such images amount to a new representation of society."[94] Yet, while Tagg focuses on the discursive power of the camera, for Sekula photography is only one component of a larger archival system that aimed to produce the criminal body. "The central artifact of this system is not the camera, but the filing cabinet," Sekula writes.[95] In Sekula's view, "photography was to be both an *object* and *means* of bibliographic rationalization," which "rel[ied] heavily on the archival model for its legitimacy."[96] In other words, the "vast taxonomic ordering of images of the body" made possible by Bertillon was not just a photographic promise but "an archival promise," as Sekula writes.[97] Such "archival rationalization," enabled in part by mug shots, reveals the fundamentally transformative nature of record creation in that it turns people and objects into documents that can be managed.[98]

This transformation is inherently political. As Tagg writes, "Like the state, the camera is never neutral."[99] Rather, the camera, particularly when it is employed by the institutions of the state, performs the political work of turning individuals into silent objects to be measured and indexed, human beings into types to be classified, and arrestees into criminals to be reformed and/or punished. In short, photography was key to the creation of the political discourse surrounding criminality at the turn of the twentieth century and beyond.

Applying these insights to the Tuol Sleng mug shots, we see that photography at the Khmer Rouge prison was essential in creating the discourse of

The Making of Records

criminality surrounding the prisoners. In the circular logic of the Khmer Rouge, the regime was infallible, and those who were arrested and brought to Tuol Sleng were transformed into criminals by the creation of records (such as mug shots and confession statements) that attested to their criminality. The journalist Nic Dunlop writes, "Once prisoners were captured in the frame, they were no longer in possession of their lives. . . . For the prisoner at S-21, once they were photographed, they could never be anything but guilty—a kind of trial by camera. They had surrendered the last vestige of their individual identities to the Organization."[100] Through the click of Nhem En's camera, the arrestees became criminals, types rather than individuals, objects spoken for rather than human beings with voices. Such is also true for other forms of records at Tuol Sleng. As Cambodia expert Penny Edwards writes about the Tuol Sleng confession statements, "The subject was made to speak so that her or his loudness could be made silent, absorbed on paper, sandwiched between cardboard, stacked on a shelf."[101] By extension, the Tuol Sleng prisoner was made visible by the mug shot only to be rendered invisible through death. In this way, the Tuol Sleng administration was a circular, self-fulfilling bureaucracy that justified its own existence by creating the criminals it sought to condemn. Just as Jorge Daniel Veneciano writes that "torture will always succeed in finding *or* creating that which it seeks," the camera lens of the totalitarian regime will also succeed in finding or creating the criminality it seeks; the camera itself—and the records it produces—are the instruments through which the institution produces that criminality.[102] The camera, as a truth apparatus of the totalitarian Khmer Rouge state, was invested with the power to produce the truth it recorded.[103]

In the context of Tuol Sleng, the camera both recorded and produced criminality, transforming arrestees into criminal types who deviated from the Khmer Rouge ideal in ways that could be measured, indexed, and deemed criminal. This fits within the larger Khmer Rouge goal of promoting the Cambodian peasant ideal. As Edwards writes of Khmer Rouge ideals and the suppression of ethnic minorities under the regime, "It was not enough to *be* a Cambodian, born on the land: one had to speak, act, dress, and perform according to an ideal—that of the Original Khmer."[104] By virtue of being photographed at Tuol Sleng, the prisoners were classified not as "Original Khmers" but as others—criminals, traitors, and enemies of the state. In this way, the process of creating criminals at Tuol Sleng through the creation of records was part of a much larger Khmer Rouge system of classification that divided society along class lines into new people and old (or base) people and along ethnic lines into Chinese, Vietnamese, Khmer Krom, Cham, and "Original Khmers."[105] As Eric D. Weitz reports, Khmer Rouge officials in

some regions further divided their labor force into "bandits" (attempted escapees), "full-strength" workers, and "weak-strength" workers. Weitz further characterizes the Khmer Rouge as having "an unrelenting drive to place every individual in a clearly defined category," such that "categorization was an ideological and political process by which the regime identified its supporters and enemies, real or imagined."[106] The taking of mug shots at Tuol Sleng and the photographs' ability to transform suspects into criminal enemies of the state were part and parcel of this larger Khmer Rouge obsession with classifying the population in an effort to create a purely Cambodian agrarian society.

Hannah Arendt and the Banality of Evil

Elsewhere, I have employed Hannah Arendt's conception of the banality of evil to argue that bureaucratic records that order and document mass murder are what, in part, enabled Khmer Rouge bureaucrats to authorize mass murder by isolating them from the consequences of their actions.[107] While I do not intend to repeat that same argument at length here, I would like to build on it by highlighting the bureaucratic function the mug shots performed within the Tuol Sleng administration as a way to examine their social function within the context of a totalitarian state. In the midst of a radically agrarian, Maoist regime, why such an emphasis on documentation in general and mug shots specifically? As part of the bureaucracy of a total institution like Tuol Sleng, the mug shots (and other forms of obsessive documentation) helped facilitate mass murder by alienating decision makers from the violence of their decisions. In this way, the mug shots functioned bureaucratically in three ways: first, they dehumanized people by reducing them to paper; second, they allowed for specific actions to be routinized and compartmentalized, thus distancing bureaucrats from the larger murderous goal of their discrete tasks; and third, they encouraged a culture of thoughtlessness at the prison. Thus, through recordkeeping, bureaucrats are alienated from the fruit of their labors, both practically (by issuing the orders that designate someone further down the chain of command to torture a prisoner) and socially (orders for murder become nothing more than routine paperwork in a culture of obedience and efficiency).

In its emphasis on secrecy, allegiance, and isolation, Tuol Sleng was a total institution of the type described by both Erving Goffman and Michel Foucault.[108] Within this total institution, mug shots operated as part of a larger administrative reporting system in which people were reduced to paper. Nic Dunlop, the journalist who tracked Duch down for the first time since

the regime's 1979 collapse, has suggested that using reusable batch numbers rather than unique identification numbers further transformed individuals into expendable numbers, adding to a seemingly endless workload for prison staff. "The numbers had replaced their names," he writes.[109] Yet, not only did the batch numbers replace the names of prisoners, but their mug shots replaced their physical bodies, the enduring record outlasting the people depicted in them. Captured as mug shots, prisoners could be shuffled around, discussed by the upper echelons of the Khmer Rouge regime, and their fates determined by administrative order. In a 1999 interview, Duch himself claimed that he ordered the mug shots to be taken in order to keep track of prisoners so that he could reassure his own bosses that no one who was arrested was let go and that any prisoners who did escape would be caught.[110] This confirms Rachel Hughes's assertion that "The meticulous production of the prison portraits was an important element of administrative control . . . reinforc[ing] the total institution" and serving as "emblems of the regime's omnipotence and efficiency."[111]

The creation of the archives, the bureaucratic function that produced and saved records ordering and documenting mass murder, is what, in part, isolated the desk murderers from the "administrative massacres" they ordered (in the words of Arendt).[112] Documents like mug shots allow for specific actions to be compartmentalized, thus distancing bureaucrats from the larger goal of their discrete tasks. Bureaucrats receive written orders to carry out specific compartmentalized tasks, the completion of which they must again document, and administer the next compartmentalized task through written orders to the closest subordinate level of bureaucrat. The larger bureaucratic machine functions through an elaborate system of documentation. Records are the media through which procedures are routinized; records enable repetition, which leads to "the nearly universal ability to make any activity into a routine that deadens the awareness of what is being done."[113] It is for this precise reason that the Khmer Rouge were such meticulous recordkeepers; through obsessive documentation, they were able to transform the everyday, banal practice of recordkeeping into one in which mass murder was normalized. It is the records themselves that enable people to commit atrocious acts they normally would not perpetrate. Thus, through recordkeeping, Khmer Rouge bureaucrats like Son Sen and Duch were alienated from the murderous fruit of their labors in that the orders they issued would designate someone further down the chain of command to torture and kill prisoners.

The culture of obsessive documentation (of which mug shots were a fundamental part) allowed Duch not only to order torture without direct involvement but also to report such torture back to his superiors, garnering

their favor and demonstrating his efficiency. By fulfilling this function, the mug shots (and other documentation) were agents in the elaborate bureaucratic death machine. While historians once debated the degree to which the Khmer Rouge maintained a hierarchical, centralized power structure, documents uncovered by DC-Cam demonstrate the consolidated nature of power under the regime.[114] Under Pol Pot, a clearly delineated hierarchy unfolded in which officials in the upper echelons were known not only by their revolutionary names but also by numbered monikers, such as Brother Number 2. While Duch was not high ranking enough to serve on Pol Pot's National Security Committee, he did receive orders from and reported back to the Committee in a strict chain of command. As Duch himself has said, "The decisions to kill were made not by one man, not just Pol Pot, but the entire central committee. . . . Pol Pot knew about S-21, but did not direct it personally. He left that job to Nuon Chea as No. 2 in the party and to Son Sen as head of the army and police."[115] Khmer Rouge security documents corroborate this chain of command, revealing, in the words of Craig Etcheson, "a centralized execution system operated at high efficiency over the entire course of the . . . regime."[116] In this consolidated hierarchy in which every cadre knew his place, the order to kill was separated from the act of murder by several chains of command.

As Arendt's commentary on the Eichmann case demonstrates, strict record-keeping in a centralized bureaucracy enables midlevel managers to delegate gruesome acts so that their direct involvement in torture or murder is minimal. Curiously, Duch testified in the early weeks of his trial that the only time he stepped inside Tuol Sleng was during a recent visit he had made to the Genocide Museum (housed in the former Tuol Sleng complex) during the investigative phase of the trial.[117] Later, Duch testified that, "while he was not directly involved in the daily operation of S-21, he did receive daily updates," revealing how documents such as daily torture summaries enabled Duch to run the facility efficiently without getting blood on his hands. Furthermore, "Duch confirmed that 'noxious odors' dominated S-21 but that he himself did not go inside the facility."[118] Again, Duch was physically distant from the realities of torture, thanks to written reports from his inferiors. Later, Duch denied having participated in any interrogations, with two exceptions. As the *KRT Trial Monitor* reported, "The accused persistently dissociated himself from both the decisionmaking and the actual implementation of the execution process. He steadfastly maintained that the upper echelon had already decided that the people sent to S-21 were to be smashed. He claimed that the only thing he could do was turn a blind-eye to the torture and killing at S-21, and refrain from participating in its daily operations. Duch maintained that he only

witnessed killings when specifically ordered to do so."[119] Repeatedly, Duch asserted that he had never killed anyone himself. Kok Sros, a former guard at S-21, also testified that he never witnessed Duch interrogate, torture, or execute detainees and that Duch merely walked past detention cells and watched from the outside.[120] What enabled Duch to "watch from the outside" was the culture of documentation at S-21, ensuring that no important detail would escape the daily reports he received from his inferiors. For example, daily "execution logs," signed by both Duch's deputy director and the chief guard at S-21, reported the names of prisoners executed that day, while "torture logs" reported the names of prisoners tortured that day, the techniques used, and their duration, as well as confession statements obtained as a result of this torture.[121] Such documents allowed Duch to efficiently monitor the daily operations of Tuol Sleng, while distancing and ultimately alienating him from the gruesome acts he ordered.

In turn, such exact and detailed documentation allowed Duch to report up the chain of command to his superiors. Duch testified, for example, that photographs of disemboweled prisoners were "requested by the upper echelons in order to confirm the execution" and that other photographs of dead prisoners were taken "in anticipation of superiors' inquiries."[122] Similarly, during the trial, "Duch confirmed that the purpose of the interrogation was to obtain confessions about traitorous acts," which were then "used to both justify the arrest as well as apprehend others who were implicated."[123] Thus, by documenting confessions (obtained through torture), Duch and his staff at S-21 were able to prove to the upper echelons that their own top-level decisions regarding arrests were prudent, thereby reaffirming the omniscience of the highest-ranking Khmer Rouge leaders; while the use of the records was to document killings, the purpose was to flatter the upper echelon. In this twisted tautology, when a high-ranking Khmer Rouge leader suspected someone of being a traitor, that person had to be tortured so that he would confess, so that his confession would serve as written proof confirming the original suspicion. The truth of such confessions was irrelevant; what ultimately mattered was the existence of the document, not its underlying truth or fallacy. As Duch testified, he believed "only 50% of the confessions were true . . . that only 20% of their implications were accurate . . . [and that] even the upper echelon at one time did not believe in the truthfulness of the confessions."[124] In this way, documentation surpassed truth, replacing lived reality with a dangerous and steadfast belief in the infallibility of records.

Documentation like the mug shots also encouraged a culture of thoughtlessness in which administrators did not question the morality of their actions. Here, Arendt's analysis of the banality of evil continues to provide insight into

the minds of seemingly ordinary individuals who commit murder on an incomprehensible scale. Arendt, deeply troubled by her efforts to reconcile the frail and inane Eichmann on trial with the calculating and murderous Eichmann who organized the Holocaust, shifted her own prior conceptions of radical evil to explain how a new category of thoughtless bureaucrats became capable of committing mass murder. She wrote, "The trouble with Eichmann was precisely that so many were like him, and that the many were neither perverted nor sadistic, that they were, and still are, terribly and terrifyingly normal. From the viewpoint of our legal institutions and of our moral standards of judgment, this normality was much more terrifying than all the atrocities put together, for it implied . . . that this new type of criminal . . . commits his crimes under circumstances that make it well-nigh impossible to know or to feel that he is doing wrong."[125] In this new view, the opposite of evil is not good but thought. It is thoughtfulness, not goodness per se, that allows human beings to question the ethical motivations of the larger society and to resist orders that run contrary to personal morality. The thinking individual, according to Arendt, maintains moral judgment and an ethical basis for action even when society's values are skewed enough to endorse mass murder. Arendt constructs the banal, bureaucratic murderer, as epitomized by Eichmann, as a uniquely modern form of criminal, alienated from the impact of his murderous efforts in the same way modern men and women are alienated both from the fruits of their labor and from the rigid goals of the bureaucratic system by which they are imprisoned. What separates the new "enemies of the human race" from the old, in Arendt's estimation, is a deliberate and willful lack of awareness of the consequences of their actions, engendered by modern technologies and documentary practices.

Within this centralized execution system, Duch, a former math teacher, prided himself on unquestioning obedience to his superiors. In fact, after joining the Khmer Rouge, he gave himself the name Duch after an obedient schoolboy character in a Cambodian children's book. Testifying in the tribunal, he explained, "I wanted to be a well-disciplined boy who respected the teachers and did good deeds. . . . In my entire life, if I do something, I'll do it properly."[126] Duch was far from Pol Pot's inner circle and was under the strict supervision of his superiors. While he admitted some guilt and responsibility for the deaths at S-21, he repeatedly fell back on the claim that he was only following orders. Duch himself drew on the cog analogy made famous by Eichmann, claiming on the final day of his trial, "I ended up serving a criminal organization. I could not withdraw from it. I was like a cog in a machine."[127] He also testified, "everyone obeyed orders, and if you disobey orders, you run the risk of losing your life."[128] This culture of thoughtlessness in which bureaucrats

simply do not question the orders they have been given is made possible, in part, by the reduction of people to paper and by the compartmentalization of tasks, as previously addressed.

However, in the case of Duch, the records themselves, while distancing Duch from the actual act of murder, did not create a situation in which it was "well-nigh impossible" for Duch to know the consequences of his actions. On the contrary, such gruesome photographs and reports, arriving on Duch's desk on a daily basis, made it "well-nigh impossible" for him *not* to have full knowledge of the murderous consequences of his orders. However, to draw on Arendt, the essential distinction is not between knowing and not knowing but between knowing and thinking. While Duch clearly knew the murderous inner workings of S-21, he willfully refused to think about them.

As I have argued elsewhere, both the culture of documentation and the culture created *by* documentation are at issue here. For example, the records of totalitarian regimes not only serve the specific functions they directly address (such as documenting the arrival of a prisoner or ordering a prisoner to be tortured in a specific way) but also enable a culture of alienation and irresponsibility that divorces the functions of the records from their end results. Ciaran Trace has called on archivists to expand the traditional view of records as merely "by-products of activity" and to acknowledge that "the record has, as one of its functions, a strong element of social control."[129] While Trace examines records put to less sinister aims than the Khmer Rouge mug shots discussed here, her distinction between the "use" of records (whereby records carry out "a purpose or action of an organization") and the "purpose" of records (which "encompasses the social factors that impinge upon record creation and record keeping") is helpful in understanding the culture of documentation at Tuol Sleng.[130] While the use of such records was to document prisoners and to administer specific acts of violence, the purpose of such records was to transform arrestees into criminal subjects and to further alienate bureaucrats from knowledge of and responsibility for mass murder. In this view, the mug shots are not just "the detritus of bureaucracy" but also the mode through which bureaucracy functions practically and socially.[131]

Focusing on the context of the creation of the records, and not just their content allows us to see how the Tuol Sleng mug shots not only functioned to record prisoners, but served a social role as well. If we accept, as Trace suggests, a "framework [that] allows for an understanding of records as social entities, where records are produced, maintained, and used in socially organized ways," then we can begin to see how the Tuol Sleng mug shots not only served the specific bureaucratic functions of extracting confessions and eliminating enemies of the state, but also how the Tuol Sleng record-keeping practices

served a *social* function; they both turned those arrested into enemies of the state and created a culture whereby bureaucrats were recognized, promoted, and rewarded on the basis of both their efficiency in advancing records through the system and their ability to separate the creation of records from their ultimate use.[132]

Furthermore, the social function of the creation of these records calls into question the archival notion of impartiality, as Trace has suggested in other settings. From the traditional archival view, records are impartial "by-products of activity rather than . . . conscious players in the activity itself."[133] As we have seen in this exploration, the creation of these mug shots serves an active social purpose, not only recording events but constituting events themselves. They are not impartial to the activities to which they attest, but are active discursive elements in the transformation both of Tuol Sleng arrestees into enemies of the state and of mindless bureaucrats into mass murderers.

Silences, Power, and the Community of Records

Returning to Trouillot, the creation of these mug shots is rife with silences—both the silences of those not depicted and the silences of those depicted—and these silences are deeply linked to issues of power. The silences embedded in these photographs are not just the natural by-product of the photographic medium itself (in the sense that all photographs are silent) but, rather, an active attempt by the Khmer Rouge to silence the people depicted. Yet, despite the Khmer Rouge's attempts to silence these victims, we, the contemporary viewers of these mug shots, still attempt to uncover their whispers in these photographs. These silences and whispers have important implications for the archival conceptions of provenance and co-creatorship, as well as for the writing of history.

While Tuol Sleng may have been at the apex of the regime's interrogation system, the Khmer Rouge did not create records documenting the deaths of the vast majority of its victims. Trouillot writes, "Silences are inherent in history because any single event enters history with some of its constituting parts missing. Something is always left out while something else is recorded."[134] For most victims, the constitutive parts of the Khmer Rouge archive are missing. Their lasting traces take three main forms: the bones they left behind, any records, such as family photographs, that predate 1975 and managed to survive the regime, and the stories about them told by their friends and family. For the Cambodians whose loved ones were not captured in the Tuol Sleng mug

shots, their missing family members remain a void that cannot be filled, a question that may never be answered. For these Cambodians, the Tuol Sleng mug shots provide only the uncertainty of absence.

Yet, even for the victims whose Tuol Sleng mug shots we do have, the photographs are marked by silences. As we have seen, through these photographs the victims were spoken about, transformed into enemies of the state, and ultimately denied both their humanity and their lives. These are records of absence that deeply implicate the power of the Khmer Rouge not only to kill but to silence its victims. In this way, the silence of these victims is not an unintended consequence of some larger bureaucratic aim but rather, was the direct aim of the Khmer Rouge recordkeeping apparatus; the Khmer Rouge actively silenced these victims through the creation of these photographs.

In light of this active silencing and our attempts to the contrary, it is virtually impossible to uncover the whispers of the victims in these photos. This argument responds to recent calls by archival theorists, most notably Jeannette Bastian, that archivists should read against the grain to find the voices of the powerless in records created by the powerful.[135] In reading against the grain, we look for ways of interpreting records that were not intended by their creators, searching for evidence of resistance, contention, and voice in the face of oppressive power. In reading the Tuol Sleng mug shots against the grain, we empathize and align ourselves with the victims they depict, but we are left with a deafening silence. While we see the photographs not as evidence of the criminality of the prisoners (as the Khmer Rouge intended them) but, rather, as evidence of the criminality of the regime that took them, we strain to hear the victims' voices. The photographs were taken within a total institution within a totalitarian state, leaving little room in the records for prisoners to voice resistance; we can only project our own voices on these silent witnesses. Here, we must tread carefully for fear of conferring a false sense of agency on the part of the victims; the subjects of these mug shots did not choose to be photographed, they did not have any ownership over the way they were depicted, they were acted upon against their will. In these circumstances, the idea of co-creatorship is a fallacy that grants too much agency to the subjects of these photos. The people in these mug shots were transformed into enemies of the state by the act of records creation; to reinterpret the records to grant these victims creatorship is to deny the discursive power of the creation of records in a total institution.[136]

In our attempts at listening closely for the whispers of the Tuol Sleng victims, we are reminded of W. J. T. Mitchell's question: "What do pictures want?"[137] We can imagine that the people captured in these mug shots want to be exonerated, to be released, to survive. Yet, as we read them after the fact

as traces of the past, we project on them the desire to be remembered. Here, the Tuol Sleng mug shots are materialized contradictions: they are silent photographs that speak, insentient objects with desires, lifeless things with a social life, the embodied presence of absence. In the wake of the loss created by genocide, the mug shots are inanimate surrogates for the dead with which we imbue human desires; given the legacy left by the Khmer Rouge, the images are perversely imbued with a social life that the people they portray were denied.

2

The Making of
Archives

A lot of people think the death of Pol Pot is the end of the Khmer Rouge. . . . That's not true. . . . [Many other Khmer Rouge leaders are] still at large. We should not let them escape justice. I have 150,000 pages of high-level correspondence and I can get them to any lawyer in the world by e-mail within fifteen minutes.

Youk Chhang, as quoted in Seth Mydans, "Death of Pol Pot: The Analysis"

You stupid idiot, why didn't you burn all those archives?

Nuon Chea to Duch, as paraphrased in Ben Kiernan's lecture
at the Global Resources Network Conference and Forum

We now turn to the archivization of the records, or the process by which the mug shots were collected, preserved, and presented as archives. For Trouillot, archives are institutions of immense social power in that they both "organize facts and sources" and "condition the possibility of existence of historical statements."[1] In Trouillot's view, there is no significant distinction between the Foucauldian definition of the archive as "the first law of what can be said, the system that governs the appearance of statements as unique events," and the physical (and now digital) collection of material traces of the past; rather, the existence and assembly of physical materials in archives dictate which statements about the past historians can render true and which are deemed false.[2] Trouillot writes: "Archives assemble. Their assembly work is not limited to a more or less passive act of collecting. Rather, it is an active act of production that prepares facts for historical intelligibility. Archives . . . are the institutionalized sites of mediation

between the sociohistorical process and the narrative about that process. They enforce the constraints on 'debatability' . . . they convey authority and set the rules for credibility and interdependence; they help select the stories that matter."[3] Archives are thus "the institutionalized sites of mediation between the sociohistorical process and the narrative about that process," and, in this specific case, the assembly of the Tuol Sleng mug shots into archives is an ongoing and often contested process influenced by a variety of social, political, and historical factors. Trouillot's claims that the inclusion of records in archives is intertwined with the power to determine historic facts is made manifest by the processes by which Khmer Rouge mug shots became (physical and digital) archival collections. From their initial inclusion and exhibition in the Vietnamese-run Tuol Sleng Genocide Museum, to their microfilming, preservation, publication, and exhibition by human rights activists, Cornell University, the Photo Archive Group, and Yale University, to their digitization by DC-Cam, the Tuol Sleng mug shots have been figured and reconfigured as archival collections by a host of governments, individuals, and organizations. Each of these moments in the archivization of the mug shots is pregnant with power—the power to determine which sources constitute legitimate historical evidence, the power to claim physical and intellectual custody of the records, and the power of the political will to deem them objects of national and international attention.

In light of the political and historical factors that shaped the archivization of the Tuol Sleng mug shots, we can see how the creation of archives is inextricably linked to both the assembly of facts and the formation of political power. The various institutions and individuals that assembled and reassembled the Tuol Sleng mug shots as archival collections did so in order to advance particular (often politically motivated) truth claims about the Khmer Rouge. From 1979 to 1989, the ruling Vietnamese forces in Cambodia exhibited the photographs at the Tuol Sleng Genocide Museum in order to justify their own overthrow of the Khmer Rouge and subsequent decade-long occupation of the country.[4] Next, from 1989 to 1997, American individuals, institutions, and organizations such as Cornell University and the Photo Archive Group conducted large-scale preservation, microfilming, and exhibition efforts aimed primarily at increasing international awareness of and scholarship about Khmer Rouge atrocities. Finally, from 1994 to the present, DC-Cam, first as a field office at Yale and later as an independent Cambodian-run nongovernmental organization, classified, preserved, and digitized the mug shots in support of efforts to hold the Khmer Rouge legally accountable in an international court of law. In each of these reconfigurations, Cambodians have used the mug shots to match the faces with the names of dead loved ones, creating new facts where silences previously prevailed.

This chapter's discussion of the mug shots as museum displays builds on the foundational work of Judy Ledgerwood and Rachel Hughes.[5] In her 1997 article, "The Cambodian Tuol Sleng Museum of Genocidal Crimes: National Narrative," Ledgerwood, an anthropologist, skillfully uncovers the political motivations behind the Tuol Sleng exhibitions, placing them within the context of Vietnamese control. Following the next stages in the social life of the photos, Hughes traces their conservation and display in American art museums and argues that Western viewers depoliticize such images by viewing them as aesthetic objects first and foremost. Both of these authors skillfully interrogate the politics of exhibition and reception, laying the groundwork for much of the work presented in this chapter.

Vietnamese Involvement: The Formation of the Tuol Sleng Genocide Museum

The Vietnamese Army invaded Phnom Penh and overthrew the Khmer Rouge in January 1979. For the next ten years, Cambodia would be run by a Vietnamese-backed coalition of Cambodian Khmer Rouge defectors. Vietnamese power and influence were pervasive. The Vietnamese army (and later the Vietnamese-backed Cambodian government) transformed Tuol Sleng into a Genocide Museum and exhibited the Tuol Sleng mug shots as a way to publicize Khmer Rouge atrocities, thereby justifying Vietnamese military intervention.[6] The archivization and display of the mug shots was crucial for this justification.

Before the Vietnamese army invaded Phnom Penh, it gave one day's warning. Pol Pot, the Khmer Rouge dictator, issued immediate orders to officials to destroy as many documents as possible in that time period. At Tuol Sleng, the murderous impulses of Duch ironically led to the preservation of records that would one day incriminate him; ignoring Pol Pot's orders to destroy records, Duch spent his final time at Tuol Sleng killing the remaining prisoners, leaving behind more than one hundred thousand documents, including thousands of photographs.[7] (Fleeing Tuol Sleng, Duch changed his name and spent several years living in anonymity. It was not until the British photojournalist Nic Dunlop tracked him down in 1999 that his identity was widely revealed.[8])

On January 8, 1979, a day after the Vietnamese army marched into Phnom Penh, two Vietnamese photojournalists noticed the awful stench of decaying bodies coming from the Tuol Sleng compound. Entering the complex, they found fourteen recently murdered bodies, five orphaned children, and rooms

full of torture equipment.[9] The photojournalists photographed the rooms as they discovered them and alerted the Vietnamese army. In the following days, the Vietnamese uncovered troves of documents, printed photographs, contact sheets, and undeveloped negatives that Duch and the guards under his command left behind in nearby buildings.[10]

The preservation of photographs and other records at Tuol Sleng began almost immediately after the fall of the Khmer Rouge and was linked to international politics from the start. The Vietnamese army recognized the importance of the Tuol Sleng records in efforts to hold the Khmer Rouge accountable. In August 1979, the Vietnamese staged a weeklong trial—the People's Revolutionary Tribunal—in which documentary evidence from Tuol Sleng and other offices was used to convict the Khmer Rouge leaders Pol Pot and Ieng Sary in absentia. This trial is generally deemed to be a show trial to support the Vietnamese invasion.[11] Khmer Rouge records—referred to as "captured documents"—admitted as evidence in the trial include party directives, the personal notebooks of Khmer Rouge officials, reports to high-ranking officers, minutes from high-level meetings, and lists of people arrested by the regime. Records used in and created by that trial are now housed at the National Archives of Cambodia, where access to them is restricted to those with special permission from the Council of Ministers; however, English translations of the trial documents were published by the University of Pennsylvania Press in 2000, and are thus widely available to foreign scholars.[12] However, despite this early Vietnamese interest in documentation from Tuol Sleng, many records were pillaged for use as scrap paper; Nic Dunlop writes that in 1979 paper could be found in the street near Tuol Sleng, and he interviewed a survivor who bought a pile of bananas wrapped in his friend's Tuol Sleng confession.[13] There is no way to know how much was lost.

In addition to their use in early efforts to hold the regime legally accountable, Khmer Rouge mug shots were used in attempts to shape collective memory of the regime through museum displays. The Vietnamese converted Tuol Sleng prison into a "Museum of Genocidal Crimes" with the help of East German funding and opened the doors for foreign tours as early as 1979.[14] The museum and archives were directed by Mai Lam, a Vietnamese colonel well known for creating the Museum of American War Crimes in Ho Chi Minh City. Lam arranged the records left behind and printed copies of thousands of mug shots for display at the museum. The mug shot exhibition attracted throngs of people (despite the lingering stench), many of who were hoping to identify pictured friends and relatives. Visitors who recognized people in these unidentified mug shots wrote the victims' names directly on the photographic prints on display.[15] As Judy Ledgerwood describes, a

staggering 320,000 people (309,000 Cambodians and 11,000 foreigners) visited the Tuol Sleng Genocide Museum from July to October 1980.[16] Throughout the 1980s, Cambodians continued to visit Tuol Sleng, searching for the fate of missing loved ones in the mug shot display. For example, in a 1989 *New York Times* article, the photojournalist Dith Pran (who was the subject of the film *The Killing Fields*) recounts visiting Tuol Sleng with a Cambodian American refugee who "suddenly" discovered her father's mug shot on display and started "to cry uncontrollably." He writes, "Her parents were killed by the Khmer Rouge but, until this moment, she didn't know where they were killed or when."[17] This scenario played out thousands of times in front of mug shots at Tuol Sleng in the first decade the museum was open and still plays out (though less frequently) today.

Ledgerwood asserts the museum's displays and their popularity helped construct a national narrative of suffering under the Khmer Rouge, while simultaneously reinforcing the "master narrative" advanced by the Vietnamese-backed government, namely that "a glorious revolution [was] stolen and perverted by a handful of sadistic, genocidal traitors who deliberately exterminated three million of their countrymen."[18] In other words, the museum blamed the few top leaders in the "Pol Pot clique" rather than broader Cambodian society or Communist ideology for the violence at Tuol Sleng.[19] Similarly, David Chandler writes that "Mai Lam wanted to arrange Cambodia's recent past to fit the requirements of the PRK [the new Cambodian government] and its Vietnamese mentors" and that "the history that he constructed in the exhibits at S-21 denied the leaders of the CPK [the Khmer Rouge] any socialist credentials and encouraged viewers to make connections between . . . Tuol Sleng [and] . . . Auschwitz."[20] Chandler also reports that a Tuol Sleng survivor, Ung Pech, was named director of the Tuol Sleng Museum in 1980 and traveled extensively with Mai Lam to Holocaust memorial sites in Europe as part of a conscious attempt to mold Tuol Sleng in that vein. According to Chandler, Lam worked at Tuol Sleng until 1988 but often hid his role there in order to "creat[e] the impression that the initiatives for the museum and its design had come from the Cambodian victims rather than from the Vietnamese."[21] Indeed, Mai Lam's early involvement and the heavy-handed pro-Vietnamese rhetoric of the museum may have contributed to false rumors that Tuol Sleng was a Vietnamese hoax.[22] Here we see one of the first in a long line of examples that illustrate the complex interplay among politics, the assembly of facts, and the construction of narrative through the use of these archival documents.

Under the direction of Ung Pech and Mai Lam, the museum hired several former prisoners as guides. Vann Nath, a Tuol Sleng survivor who has since

died, was hired in 1979 to paint scenes from his imprisonment. In his account of his imprisonment, Nath wrote, "The idea of returning to [that] horrifying place filled me with dread but it was my decision to return. . . . On my first day back I tried to distance myself from my feelings so that I wouldn't be overcome with sadness. . . . As I entered the prison compound I had an indescribable feeling. The place was very quiet, but full of rubbish everywhere because no one was living there. Prisoner records were scattered all the way from the entrance to the office. . . . My friends and I walked around and quietly picked up the documents, putting them into one pile."[23] Nath described running into another former prisoner, whom he identifies as Uncle Kong, at the museum, who told him, "We have come with the duty to organize this place into a museum. I believe the spirits of the dead would be very glad about this."[24] Nath also recounted how visitors to the museum screamed and cried when they recognized their family members in the photographs on display. He wrote, "I believe that the spirits of the people who died must have applauded our work. Contributing to the establishment of this Genocide Museum was the most meaningful thing I have ever done."[25]

In 1981, another Tuol Sleng survivor, Bou Meng, was identified and asked by Pech to join the museum staff. He found survivors Vann Nath, Im Chan, and Ruy Neakong already working there. Meng writes, "I'd never thought of returning to that bitter place again; however, I saw that it was my opportunity to tell the Cambodian people and the world about the tragedy that I had suffered under the Khmer Rouge."[26] Like Nath, Meng believes that the Tuol Sleng victims spoke to him through their displayed photographs at the museum. He describes his experience: "Sometimes, I examined the photos of the prisoners. . . . Many prisoners' eyes showed their cries, pain, and fear, and seemed to be telling me that they had been harshly killed although they were innocent. Moreover, those eyes seemed to be telling me to share their suffering with the rest of the world to avoid a repeat of the brutal crimes against humanity that the Khmer Rouge had committed. Like me, they also needed justice."[27] Here, the photographic records are seen as conduits for ghosts. Through both Nath's and Meng's biographies, the importance of Tuol Sleng survivors to the establishment of the Tuol Sleng Genocide Museum is made apparent. These survivors served as living witnesses, supplementing the artifacts on display and adding legitimacy to the museum.

Yet, while the museum on the first floor of the Tuol Sleng complex was popular, the archives on the second floor remained uncataloged, exposed to the elements, and largely unused in the 1980s. The collection included the mug shot negatives; logbooks of arrests; forced confession statements; daily lists of prisoners; and, most chilling, page after page of dated name lists, labeled

The Making of Archives

"the names of prisoners crushed to bits."[28] As the scholars Chanthou Boua, Ben Kiernan, and Anthony Barnett described in 1980, "In the Tuol Sleng offices, papers are piled on open desks, [and] old cupboards are stacked unsystematically." Boua, Kiernan, and Barnett also reported that important documents were missing, including a forced confession statement that was borrowed to be used as evidence in the People's Revolutionary Tribunal and never returned, as well as other documents that were allegedly "stolen by staff who have defected and sold them, apparently to Pol Pot supporters," and lamented that "An invaluable record is being lost."[29] Similarly, Tom Fawthrop and Helen Jarvis report that in 1979, Min Khin "recalls sending instructions out through the governmental apparatus to village level, asking the people not to touch the remaining physical or documentary evidence of the crimes committed. While this was indeed done in some places, on others the local population tore down prisons both to vent their anger and also to salvage building materials."[30] In light of the chaos after the Vietnamese invasion, it is impossible to tell just how many Khmer Rouge records were destroyed and how many survived but are still not in the custody of archives or museums; clearly, many were dispersed from their original locations, leaving their chain of custody untraceable.

The Start of American Involvement in the Archives

While the Vietnamese-backed government maintained the mug shot exhibition at Tuol Sleng, American individuals and organizations launched efforts to preserve and microfilm the mug shots and related Khmer Rouge records so that they could be used as historical sources and legal evidence. From collection attempts by American human rights activists to Cornell University's microfilming project and the Photo Archive Group's cleaning, exhibition, and publication programs, the motives for these efforts were varied, but in general they sought to increase international attention to and scholarship about Khmer Rouge atrocities.

Human Rights Collecting

Adding to the initial Vietnamese-driven collection efforts, the first decade after the fall of the Khmer Rouge saw some initial attempts by American activists to collect documentation in support of an international legal tribunal against the regime. In the early 1980s, David Hawk and Gregory Stanton, two American human rights activists who had led humanitarian

relief and human rights projects in Cambodia, began to gather evidence and to garner support for an international tribunal against Khmer Rouge officials. In 1982, Stanton founded a US-based nonprofit organization called the Cambodian Genocide Project (CGP). Stanton, who became a law professor at Washington and Lee University, enlisted the help of the Cambodia historian Ben Kiernan in the project. The organization initially tried to get the Australian government to support a Khmer Rouge tribunal, but it was unable to find the necessary political backing.[31] Hawk soon distanced himself from the Cambodian Genocide Project and formed another group, the Cambodian Documentation Commission, "to document and analyze the Khmer Rouge genocide, advocate remedy and redress, and prevent those responsible from returning to power."[32] Hawk spent the next several years working towards this threefold mission of historical accountability, legal accountability, and political action through the collection of documentation. Writing in 2002, Hawk noted that none of the contemporary strategies to monitor, collect evidence, and respond to large-scale human rights violations existed during the late 1970s.[33] He made it his mission to collect and create such documentation. Hawk traveled repeatedly to Cambodia to photograph recently unearthed mass graves and to conduct archival research and make photocopies of documents at Tuol Sleng. Working with a translator, Hawk encountered extraordinarily cooperative staff at the Tuol Sleng archives, who handed over pile after pile of Khmer Rouge records. "You're kidding me. This stuff is written down?" Hawk recalled thinking when he first encountered the detailed records.[34] Hawk writes that "the next step was to get this rare archival material from Phnom Penh to the West so it could be analyzed and circulated globally."[35] Although a nongovernmental organization donated a photocopy machine for use at Tuol Sleng, the electricity proved unreliable, making attempts at photocopying erratic.

Yet Hawk's replication of the Tuol Sleng mug shots would have a significant impact on public opinion and future documentation efforts. He had initially taken photos of the mug shots on display at Tuol Sleng but reports that after he returned home from Cambodia, "out of the blue, hundreds of rolls of negatives arrived in my mailbox in New York. The staff at Tuol Sleng, no doubt delighted that someone in the outside world valued their work, had sent me a complete duplicate set of photographic negatives of the prisoners executed at S-21."[36] Nine of the mug shots Hawk photographed on display at Tuol Sleng were reproduced in a 1982 article he authored in *The New Republic*; twenty-one of the mug shots in Hawk's possession were later reproduced in a 1986 article he authored in the British publication *Index on Censorship*.[37] These publications were among the first times the West was exposed to the Tuol Sleng mug shots. Additionally, Hawk reprinted twenty of the mug shots (as well as images of

mass gravesites and dozens of photographs the Khmer Rouge took to document dead prisoners) to accompany his article "The Photographic Record," which appeared in the 1989 volume *Cambodia 1975–1978: Rendezvous with Death*.[38] Other copies of Hawk's negatives were displayed in an exhibition called *Cambodia Witness* that was sponsored by Amnesty International and mounted at the US House of Representatives, among other places in the United States and in Europe. Later, Hawk donated his copies of the Tuol Sleng negatives to the Cornell University Library. In 2000, he donated the remaining materials he had collected to DC-Cam. Although these efforts by human rights activists did not directly lead to the creation of a tribunal as intended, they were successful in raising awareness against US policy, which at that point still supported the Khmer Rouge.

Cornell University's Microfilming Project

Cornell University has long-standing research ties to Southeast Asia. Eva Mysliwiec, a Cornell graduate, was one of only a few Americans living in Cambodia in the early 1980s and spent several years trying to negotiate with the Cambodian government to allow Cornell to establish a preservation program there.[39] In 1988, with Mysliwiec's help, Judy Ledgerwood, then a Cornell doctoral student, along with a librarian, John Badgley, flew to Cambodia and successfully negotiated permission from the Cambodian government to start a limited microfilming project of palm leaf manuscripts concerning Buddhist and literary topics. The goals of the project were twofold: to acquire microfilm copies for the benefit of Cornell faculty and students who could not travel to Cambodia and to help Cambodian institutions preserve materials that had suffered during the decades of civil war.[40] One copy of the microfilm would be deposited at Cornell; another copy would be given to the Cambodian National Library. The Cambodian government granted initial permission for Cornell staff to microfilm these palm leaf manuscripts at the Cambodian National Library, the Cambodian National Museum, and the Royal Palace, but denied repeated requests to microfilm any Khmer Rouge records at Tuol Sleng.[41]

In 1989, Cornell sent a team of preservation librarians to Cambodia. The Cornell team undertook a major rehousing project on this trip, created preservation guidelines for the National Library collection that had been dismantled during the Khmer Rouge takeover, trained National Library staff in how to house archival documents in storage boxes, and restored some palm leaf manuscripts that had been rescued by Cambodians after the Khmer Rouge threw them away.[42] While Cornell library staff took short trips to Cambodia, Ledgerwood remained in Cambodia and oversaw the microfilming process.[43]

While the palm leaf manuscripts were being microfilmed, the Cornell team determined "that the filming of the Tuol Sleng archives should be accomplished as a matter of urgency" because of preservation and security threats.[44] However, it took a shift in political power before Ledgerwood was granted permission to microfilm records at Tuol Sleng. The United States strongly discouraged Americans from visiting Cambodia while it was under Vietnamese-backed rule, and many Cambodians viewed Americans with suspicion. Most foreigners in Cambodia were Vietnamese or Russian. Ledgerwood describes the political situation at the time: "When I first got there, there were still weekly self-criticism sessions where people would denounce whatever hegemonic thing. This quickly changed when the Vietnamese government left in 1989."[45] In September 1989, after the Vietnamese withdrawal from Cambodia, government permission for Cornell staff to microfilm at Tuol Sleng was granted through "an informal, oral agreement."[46] From 1989 to April 1993, Cornell, under the auspices of its John M. Echols Collection on Southeast Asia, entered into a partnership agreement with the Tuol Sleng Museum to make preservation microfilm copies of four hundred thousand pages of handwritten prisoner confession statements and internal prison documents. (Copies of the mug shots, which had previously been made by David Hawk, were soon donated to Cornell for inclusion in the collection.) Ledgerwood set up a database on a Macintosh computer and did data entry for each document (including Hawk's mug shots), while a Cornell preservation expert, John F. Dean, trained Tuol Sleng staff in how to make boxes to house documents, moved the documents into an enclosed room, and purchased an air conditioner and backup electrical generator for Tuol Sleng.

The biggest challenge to the microfilming project was political. Ledgerwood's status as an American still made her suspect under the eyes of the Cambodian government. She said, "The Ministry of Interior had people following me around, making sure I wouldn't leave Phnom Penh."[47] In addition, there was "a constant interruption of the work by various government officials and a consequent defection by Khmer project staff."[48] Ledgerwood managed to train two Cambodian staff members in how to microfilm despite these interruptions.

Processing the film was also difficult, as no developing facilities existed in Cambodia and there were very few reliable delivery options. Film was sent via a delivery service contracted by foreign NGOs on a weekly flight to Bangkok, flown to Ithaca, and developed and inspected by Cornell staff; requests for corrections were then faxed back to Bangkok for delivery in Phnom Penh.[49] Additionally, Cambodia's tropical environment and unreliable electrical supply

posed significant challenges to storing the film. Ledgerwood recalls that the only constant and reliable refrigeration was available at a veterinarian's office a few miles away from Tuol Sleng; Ledgerwood negotiated to store the film among veterinary medication in the walk-in refrigerator and motorbiked to and from the office each time she needed a new roll of film.[50] Despite these challenges, these early microfilming efforts prevailed, resulting in the filming of a significant portion of the Tuol Sleng collection and providing a framework for future efforts to microfilm Khmer Rouge records.[51]

During the time of the Cornell project, most visitors to Tuol Sleng were Cambodians. "People were still trying to figure out what happened to their loved ones and went there hoping to find their photos," Ledgerwood reported. However, while the mug shots were on display in the museum's public exhibition spaces, the rest of the archives remained virtually closed. "People had to ask permission to use the archives. It was not an everyday thing," said Ledgerwood.[52]

Photo Archive Group

In 1993, two American photojournalists, Christopher Riley and Douglas Niven, decided to help restore negatives found in a rusty file cabinet in a back office at the Tuol Sleng Genocide Museum. The negatives included mug shots, photos taken during and after torture sessions, and some propaganda photographs from a model Khmer Rouge community. As Niven described it in a 1998 British Broadcasting Corporation (BBC) documentary: "We were invited upstairs [at Tuol Sleng] and up inside was this gray rusting metal cabinet. And we opened the drawers and inside those drawers were thousands of negatives, victims of dust, mildew, fungus, bugs—in the worst conditions negatives could be kept. We pulled out some of the negatives and held them up to the light. In that initial moment, we knew that we had to print them."[53] Similarly, Riley detailed the deteriorating state of the negatives and the need to conserve them: "It was sort of incredible finding this . . . photographic archive just sort of in this cabinet covered in rat droppings. Some of them had been nibbled away, actually eaten on by hungry rats. Literally some of the negatives were rotting away. . . . As photographers, finding this material and recognizing we could do something [with them] with our training, there was never a question of why. It was like this has to be done. And more people need to see these."[54] Riley and Niven established the independent nonprofit organization Photo Archive Group. They set up a darkroom, gained permission from the Cambodian Ministry of Culture to clean and catalogue the negatives, recruited volunteers, made contact sheets and organized them in binders to

help survivors identify victims, and selected images for publication and exhibition.[55] They also raised $25,000 from private sources in the United States to fund the project.[56]

While Riley and Niven were clearly working in close contact with Tuol Sleng Museum staff, they also questioned the staff's competence and motives. In the 1998 BBC documentary *Secrets of S-21: Legacy of a Cambodian Prison*, Niven said, "I wish that the archive was a little more accessible to the average Cambodian. Like most official bureaucracies, anyone who wants to see the archive has to pay the proper bribe to get into the rooms."[57] (This allegation was not confirmed by other sources.) Riley and Niven were particularly puzzled by the discrepancy between the 12,000 to 20,000 prisoners scholars estimated to have been incarcerated at Tuol Sleng and the 5,190 mug shots they found. This discrepancy was particularly haunting, given that they surmised that some Tuol Sleng images shown in two East German documentaries from 1979 were no longer available at the Tuol Sleng archives.[58] They became convinced that additional negatives were locked away in a back room at Tuol Sleng, effectively rendered inaccessible by museum staff. Riley said:

> It would be nice to . . . complete what is known about S-21 through the photographic material [and] complete this process that we began, but at this point it is daunting to face the obstacles we have to overcome. Unfortunately, in Cambodia . . . particularly with the museum because there are so many mysteries associated with it, it is extremely difficult and . . . as we have gone on it seems there are more and more strings that we find and pulling those strings will just lead to more strings. . . . I think there's a good chance that there may still be negatives at the museum that we haven't found. We know that recently a room we wanted to get into was opened and there was a large amount of very interesting material in that room. We had talked to various people at the museum about going into these locked rooms and got various responses that added up to no. Given that there's a possibility I think it's worth the effort to try to get into those rooms.[59]

The documentary then reveals Riley and Niven asking Chey Sophera, then the Tuol Sleng museum director, for permission to gain access to the building's locked back rooms. Remarkably, Sophera responds, "There is nothing there but old stuff and photos. But yes, you can."[60] Riley and Niven then cut the locks to a back room, finding a wasp-infested file cabinet overflowing with Khmer Rouge documents, as well as the chair outfitted with the Bertillon-inspired measuring device on which prisoners sat while some of the mug shots were taken. Despite these remarkable finds, Riley and Niven did not uncover any additional mug shot negatives in these rooms.

Riley and Niven then went on a hunt beyond Tuol Sleng to find the missing negatives, traveling to rural areas to interview former prison staff. After tracking down a former Tuol Sleng guard, Him Huy, Niven asked Huy if he knew where the negatives might be, but Huy responded that all he knew is that the Tuol Sleng couriers and photographers all fled to Thailand after the 1979 invasion of Phnom Penh. They then interviewed Suos Thy, a former Tuol Sleng clerk in charge of the prisoners' lists, but he responded, "I'm not the one to ask. I am not sure who would have been assigned to remove that stuff."[61] Eventually, Niven speculated, "I don't think the negatives are at S-21 anymore. I think there's a chance that a good chunk of them were taken to Vietnam and may be sitting in some military archives there. It's very frustrating for us."[62] While there are reports that a Khmer Rouge photographer was selling some photos from the regime on the black market, Niven's speculation that additional mug shots might be in Vietnam remains unconfirmed.[63] In a 1994 interview with former Tuol Sleng museum director Mai Lam, then retired in Saigon, Riley and his friend Peter Maguire were told rather mysteriously that a "third person knows about pictures, negatives, [and] prisoners," but they were unable to find out any further details.[64] Maguire later investigated the possibility that an East German film crew failed to return some Tuol Sleng negatives it had borrowed for a documentary in 1979, but he was told by the film's director that "we did not keep a single piece" of material evidence.[65]

As Riley and Niven cleaned and printed the existing negatives, they made significant contributions to the historical understanding of Tuol Sleng. While many of the mug shots on display at the museum had been cropped, the negatives restored by Riley and Niven revealed a more complete picture. Riley said, "One of the most important things we have been able to contribute is a better understanding of what happened here by printing the whole negative. It is a very simple photographic thing, but it's vital because the pictures on the museum walls now have been heavily cropped. And, curiously, in some of the pictures, when we open it up to the full frame, mothers were photographed with their children, individuals were photographed in a cell, surrounded by other people. So by printing the full frame we were able to get more . . . narrative information about the prison."[66] There is a direct link between archival preservation and the construction of facts about the regime; had the negatives been destroyed, scholars and the public would have been left with fewer traces of the child prisoners or of the crowded and deplorable conditions of the prison cells. In this way, Riley and Niven's work represents a significant contribution to the archival record or to the moment of fact assembly, as Trouillot would term it.

However, while Riley and Niven's restoration efforts were clearly successful, their subsequent attempts to exhibit the mug shots in art galleries and museums around the world rightly met much criticism. In 1997, they helped organize a controversial exhibition of twenty-two of the mug shots at the Museum of Modern Art (MoMA) in New York. The mug shots were displayed as art works, evaluated for their aesthetic value alone, and divorced from their gruesome creations.[67] In a scathing review of the exhibition in *The Village Voice*, the cultural critic Guy Trebay wrote, "The Cambodian dead are held up for consideration in the cool light of formalist concerns," displaying at best an insensitivity and at worst blatant racism, given that such display would be inconceivable if the photos were of Holocaust victims.[68]

At the MoMA exhibit, curators provided little background information to contextualize the images. Labels accompanying the images merely read: "Photographer unknown. *Untitled*. 1975–79. Gelatin-silver print. 14x11."[69] Furthermore, none of the people depicted in the mug shots were identified by name. As one museum visitor wrote, the photographs "were transcending their original time, place and function, and becoming, to our western eyes and consciousness, significant works of art."[70] Without any context, viewers were left to extrapolate historical details. As one reviewer of the MoMA exhibition claimed, "These mug shots cannot document history. The visitor must fill in the gaps by becoming the imaginative history maker."[71] Such "imaginative" history does a real disservice to the victims, particularly when scholars and archivists at DC-Cam were hard at work at that same time preserving and providing access to the historical context of these very mug shots.[72] Trebay wrote, "That this audience [at MoMA] might also include those Cambodians still attempting to find their loves ones seems not to have occurred to the museum's curators."[73] Trebay then quoted Dinah PoKempner, deputy general counsel at Human Rights Watch, as saying: "*Everyone* in Cambodia is still looking for relatives. . . . Simply print [the pictures] up in books and make them accessible to people in the country. That's what's needed. Not a show in an American art museum."[74] Furthermore, without adequate contextual information, American viewers were able to disconnect Cambodian atrocities from their own government's role in bringing about political chaos in Southeast Asia. "Showing the images in this way can also encourage us to forget what governments do in our name," wrote Nic Dunlop.[75]

Critics noted that framing these images as primarily aesthetic objects calls their evidentiary value into question. As the art critic Stephanie Benzaquen writes, "The particular context offered by art settings for looking at such images makes it compelling to ask to which extent aestheticization affects the evidential

status of these images. . . . One cannot but acknowledge that the evidential status of the mug shots has already been seriously undermined as their reception in widening geographic and cultural circles charged them with new meanings."[76] Here, the tension between the mug shots as images and as records is apparent; without adequate contextualization, the mug shots were simply images, (temporarily) devoid of their evidential values, to the detriment to the memory of those portrayed in them. Trebay asks, "Is it ignorance, though, or moral attrition that makes possible the exhibition of pictures from a genocide with only the flimsiest framework of context? Who are the people in the Tuol Sleng photographs? Who are their families? What is the role of our own amnesiac culture in the atrocities that took place . . . ? Where, a viewer might ask, are the bones?"[77] By displaying the mug shots as artworks first and evidence second, the MoMA exhibition undermined attempts by others to frame them as historical and legal records.

The photos were transformed not only into aesthetic objects but also into commodities. Riley and Niven claimed copyright ownership of a select group of one hundred of the mug shots and sold several of the images to the Los Angeles County Museum, MoMA, and the San Francisco Museum of Modern Art, despite significant outcry. According to Youk Chhang, they even tried to sell copies of the images to DC-Cam.[78] *wrong?*

Adding to the questionable ethics of the photographs' museum display and purchase in the United States was the publication of seventy-eight of the photographs in an accompanying catalog, *The Killing Fields*.[79] Retailing for $200, the volume was published by Twin Palms Publishers, an art press that describes itself as the producer of "some of the most beautiful photography and art books available."[80] Twin Palms has published work by famous art photographers, including Robert Mapplethorpe and Herb Ritts. But, despite this impressive roster of artists, even more than fifteen years after the publication of the catalog, Twin Palms still considers *The Killing Fields* one of its crowning achievements; the home page of the publisher's website highlights both *The Killing Fields* and another documentary photography book of questionable ethics, *Without Sanctuary: Lynching Photography in America*, as its two "most controversial and thought provoking books."[81]

The mug shots are impeccably reproduced as art photographs in the catalog, appearing without caption. The catalog provides no contextual information until page 94; the first ninety-three pages consist of page-sized unlabeled mug shots, some alternating with page-size black boxes.[82] Finally, on page 94, the book provides some basic information on Tuol Sleng, as well as a translation of the account by the Tuol Sleng survivor Vann Nath of his imprisonment

and escape, followed by an historical essay titled, "The Pathology of Terror on Pol Pot's Cambodia," by David Chandler. Thus, though this context is not denied, it recedes into the background; readers are led to interpret the photographs primarily as works of art and secondarily as evidential artifacts from a particular historical context.

This publication clearly frames the photographs as art. Dunlop astutely writes, "To view them in this way one feels almost predatory. . . . There is a danger of it becoming a self-defeating exercise in highbrow voyeurism."[83] And indeed, one cannot help feeling voyeuristic viewing the mug shots as stylized black-and-white portraits, "reproduced," as the catalog boasts, "using the sheet-fed gravure method on Japanese paper."[84] It is particularly cruel to view them as one would an art book, from the comfort of one's home or office, entirely divorced from the daily realities of the legacy of the Khmer Rouge in Cambodia. Context is key to the reception of these photographs, as this Twin Palms Press publication inadvertently makes clear.

Adding to this decontextualization, the catalog includes this claim: "The photographs are copyright Chris Riley and Douglas Niven."[85] It is unclear whether Riley and Niven made any money from the sales of the book; indeed, Maguire asserts that Riley and Niven were "deeply in debt" from the Photo Archive Group's work and that income generated from the exhibitions and catalog were not enough to eliminate this debt. "Nobody got rich in the process," Maguire writes.[86] While three thousand copies of the first edition were printed, it is unknown how many sold; the first edition of the book was still available for purchase via the publisher's website in 2013.[87] Faced with accusations of commodification, Maguire asserts, there was "little interest" among publishers in the Tuol Sleng photos, and the format and design of the book were left up to the publishers; they were out of Niven and Riley's control.[88]

Riley and Niven's work raises significant questions about the politics of preservation, reception, and ownership. On the one hand, their conservation efforts constitute a timely intervention that rescued important archival material from imminent destruction, increasing historical understanding of Tuol Sleng prison and allowing victims' family members greater access to the last traces of their dead loved ones. On the other hand, the cooption of the mug shots by Americans with commercial interests (regardless of their success) is distasteful at best. As Trebay poignantly asked, "The pictures from Tuol Sleng are the sole remaining evidence of 6,000 human lives. Can anyone truly own them?"[89] While it is debatable whether these images rightfully *do* belong to someone (such as the current government of Cambodia as a successor state to the Khmer Rouge or to the victims' families), clearly the American photographers who restored them are not high on the list of contenders.

Here, an archival studies perspective provides guidance. At issue is the conflict between the mug shots as records (that is, as evidence of human activity, in this case abuse) and as images (aesthetic objects). When we see them as records first and foremost, we rightfully keep the act of creation and, by extension, the victims and their descendants (and not aesthetic merit or commercial gain) as our primary concern. Archival concepts like provenance and creatorship help center and contextualize our reception of the mug shots, foregrounding the ethics of looking in ways that other frameworks fail to provide. Indeed, archival institutions have preserved, published, and digitized the mug shots to significantly better ends, as this chapter now investigates.[90]

Documentation Center of Cambodia: Archives for Accountability

In 1994, the collection and preservation of Khmer Rouge records entered a new phase. With the founding of DC-Cam, first as a field office at Yale and later as an independent Cambodian-run nongovernmental organization, Tuol Sleng records were microfilmed and digitized with the explicit purpose of supporting a legal case against surviving Khmer Rouge officials in an international tribunal. As the political motivations behind DC-Cam's founding and the political challenges to its ongoing success show, the archivization and digitization of archival materials are inherently discursive and political acts.

Archives Formation and the Pursuit of Legal Accountability

Despite the success of these initial Vietnamese and American collection, exhibition, and preservation efforts, it would take a large-scale shift in international politics to ensure the continued preservation of the mug shots and to bolster calls for accountability. Given the evidential value of the mug shots, their fate is inextricably linked to efforts to hold the Khmer Rouge legally responsible for mass murder. Yet such efforts took a circuitous route, meeting much opposition from the international community. From 1979 to 1990, the United States and the United Nations continued to recognize the Khmer Rouge as the legitimate government of Cambodia. This was largely a result of the politics of the Cold War and the aftermath of the Vietnam War; any enemy of Vietnam (in this case the Khmer Rouge), was an ally of the United States.[91] As a result, the United States and its supporters in the United Nations condemned Vietnam for violating Cambodia's sovereignty under the

Khmer Rouge and refused to recognize the legitimacy of the Vietnamese-backed People's Republic of Kampuchea (PRK) government. A US-backed international economic embargo on the PRK government and a UN ban on development aid had disastrous consequences for the people of Cambodia (particularly on poor women and children), resulting in stalled reconstruction efforts.[92]

By 1990, however, there was renewed international interest in Cambodia's reconstruction, and efforts to halt combat among still-warring factions and to hold fair elections began. However, the potential inclusion of the Khmer Rouge in any reconstruction efforts engendered much controversy. In January 1990, a group of human rights activists founded the Campaign to Oppose the Return of the Khmer Rouge (CORKR). They were soon joined by Ben Kiernan and several Cambodian refugees. The organization's goal was to prevent the Khmer Rouge from becoming part of an official peace settlement in Cambodia.[93] This goal was unsuccessful, however, as the Khmer Rouge, together with three additional rival factions from within Cambodia and eighteen foreign nations, signed the Paris Peace Accords in 1991, guaranteeing elections under the supervision of the United Nations Transitional Authority in Cambodia (UNTAC). In order to placate member nations that supported the Khmer Rouge, the Accords glossed over the regime's atrocities. There is no mention of mass murder, genocide, execution, or forced labor in the agreement; instead, such atrocities are referred to euphemistically as "the policies and practices of the past [which] shall never be allowed to return."[94] Here we see a willful evasion of Khmer Rouge atrocities in the name of peace.

Yet, even while UN-mandated elections were being organized, many activists in Cambodia and abroad would not let Khmer Rouge atrocities be forgotten. After losing the fight over the inclusion of the Khmer Rouge in the Paris Peace Accords, CORKR channeled its energies into demanding an international Khmer Rouge tribunal.[95] In 1990 and 1991, Ben Kiernan, who served as co-chair of CORKR's Justice Committee, met several times with congressional aides working on Cambodia through the Aspen Institute's Indochina Program and discussed drafting legislation calling for a tribunal, which Senator Charles Robb of Virginia supported.[96] In consultation with Kiernan, congressional aide Peter Cleveland drafted a bill, which, after revision, passed the US Congress in 1994.[97] The Cambodia Genocide Justice Act was a radical departure from the pro-Khmer Rouge stance the US government had taken prior to the United Nations period in Cambodia, signaling the end of old Cold War hostilities toward Vietnam. The act also represented a major shift in American policy toward the Khmer Rouge, from supporting the regime in the 1980s, to glossing over atrocities leading up to the Paris Peace Accords, to demanding formal accountability.

This shift in US policy toward Cambodia met with criticism from the left and the right. The act was denounced as "hypocritical" by those on the left who perceived it as too little too late, as well as blind to both the United States' own role in setting the stage for the Khmer Rouge through its sustained and devastating bombing campaign and the ongoing US support that had propped up the regime subsequent to the Vietnamese invasion.[98] By limiting the dates of the crimes to be investigated to the years 1975 to 1979, the act ruled out the possibility of indicting Henry Kissinger, President Richard Nixon's national security adviser and later secretary of state, who expanded the US bombing of Cambodia in alleged violation of international law, much to the chagrin of antiwar activists. Furthermore, many critics denounced what they saw as the political motivations behind the genocide label. Calling genocide a "political commodity," Serge Thion wrote, "Genocide is nothing more than a political label aimed at the excluding a political leader or party from the bonds of mankind [sic]. Accusing others of genocide leads us to believe we are good, that we have nothing to do with these monsters. This is entirely mis-leading. Pol Pot was produced by our political world, is part of it, is using it, and is growing strong from it. Before saying he is dirty—which, without a doubt, he is—we should first clean our own house."[99] This view has been echoed by leftist scholars and activists like Noam Chomsky, Edward S. Herman, and David Peterson, who argue that genocide is a label the West uses to condemn the rest of the world in order to justify publicly the politics of foreign aid and invasion.[100]

The act also had its critics on the right. As Fawthrop and Jarvis report, "many U.S. government officials were far from enthusiastic about the new mandate, fearing that it might also turn up incriminating evidence concerning U.S. bombings and other acts of warfare against the countries of Indochina."[101] Furthermore, many conservatives sought to uphold the United States' Cold War alliances, which actively supported the Khmer Rouge against Cambodia's Vietnamese-aligned government.

The act definitively linked efforts to collect and preserve documents with calls to hold the Khmer Rouge accountable through the establishment of the Office of Cambodian Genocide Investigations in the US State Department. Reproduced in its entirety on the "About" page of DC-Cam's website, the Cambodian Genocide Justice Act states:

> The purpose of the Office shall be to support, through organizations and individuals with whom the Secretary of State may contract to carry out the operations of the Office, as appropriate, efforts to bring to justice members of the Khmer Rouge for their crimes against humanity committed in Cambodia between April 17, 1975, and January 7, 1979, including:

1. to investigate crimes against humanity committed by national Khmer Rouge leaders during that period;
2. to provide the people of Cambodia with access to documents, records, and other evidence held by the Office as a result of such investigation;
3. to submit relevant data to a national or international penal tribunal that may be convened to formally hear and judge the genocidal acts committed by the Khmer Rouge; and
4. to develop the United States proposal for the establishment of an international criminal tribunal for the prosecution of those accused of genocide in Cambodia.[102]

The new bill tied the collection of and access to documents to efforts to hold the Khmer Rouge legally accountable. The Cambodian Genocide Program at Yale, which Kiernan had founded in 1994, seemed like the ideal choice to carry out the work. Kiernan, together with Craig Etcheson and Helen Jarvis, applied for the State Department funds under the auspices of the CGP.[103] The newly created Office of Cambodian Genocide Investigations voted unanimously to award $499,000 in grant funds to the CGP to conduct research, training, and documentation of the Khmer Rouge.[104] In the next two years, the governments of Australia and the Netherlands and the Henry Luce Foundation awarded CGP additional funding, and in 1997 the US State Department's Bureau of Democracy, Human Rights, and Labor contributed another $1 million in funding.[105]

In January 1995, Kiernan established DC-Cam as the Phnom Penh field office of CGP. Kiernan added significant legitimacy to the project. He was one of only a handful of foreign scholars studying the Khmer Rouge period at that time. His field research in a village on the Thai-Cambodian border began in 1979, before the fall of the Khmer Rouge, and he was one of the first foreigners to view the Choeung Ek mass gravesite as it was first being excavated in 1980.[106] He worked tirelessly both as an academic and as an activist within Cambodia and, as a result, possessed the ideal contacts, Khmer language skills, and cultural agility to collect Khmer Rouge documents that had been dispersed throughout the country.

Kiernan hired Youk Chhang, a Cambodian American refugee and a survivor of torture under the Khmer Rouge, as director of the field office. After witnessing the Khmer Rouge murder his sister and being imprisoned for stealing food for another pregnant sister, Chhang escaped Cambodia at the age of seventeen, eventually resettling in Texas. In the United States, he increasingly became involved in activist efforts to hold the Khmer Rouge accountable and began volunteering for the CGP. He moved back to Cambodia to start the field office in 1995, even before the State Department funds came through.

Chhang recalls, "My research budget was twenty-five dollars a month. . . . The day I left America to go back to Cambodia, there was no money for the air ticket so Ben Kiernan used his American Express card to buy a ticket for me. He said, 'Go. You survived the Khmer Rouge. You can eat [fish paste] there, you can survive, so don't worry.' I had no money, I had nothing. I went there with empty hands, with nothing but my heart. The grant [from the State Department] got approved, but it wasn't available until one year later, and 75 percent of it had to be spent at Yale. So [when I arrived in Phnom Penh], I had twenty-five dollars in my pocket to do research to put Khmer Rouge leaders on trial."[107] Thus, with twenty-five dollars, a credit card, and the promise of State Department funds, the archival repository that now houses the world's largest collection of Khmer Rouge materials was founded.

Helen Jarvis, then a faculty member at the School of Library and Archive Studies at the University of New South Wales, in Sydney, lent her documentation expertise to the project. Along with her colleague Nereida Cross, Jarvis designed DC-Cam's databases, selected appropriate software, trained staff, and implemented storage and access protocols and platforms.[108] She also worked closely with the School of Geomatic Engineering at the University of New South Wales to conceive and implement DC-Cam's GIS mapping of mass gravesites, a project that was cutting edge for its time.

When DC-Cam started, its intent was to index all existing Khmer Rouge materials in Cambodia, a goal that appeared to be "relatively manageable" at first.[109] As Craig Etcheson, who then served as a program manager at CGP, writes, "What the leaders of the Cambodian Genocide Program did not immediately understand, however, was that an enormous quantity of previously unknown primary material lay hidden in various caches around Cambodia and that an extraordinary range of additional types of evidentiary materials also existed and was in dire need of preservation, cataloging, and analysis."[110] Kiernan expressed similar surprise at the amount of materials the group uncovered. He recalled, "We really didn't expect to find all that much. Our major anticipated focus was to catalogue and assemble an archive of what had already been found. . . . Luckily, there was a huge collection of archives, which had remained undetected from 1979 until we located them in 1996."[111] Thus, an indexing project quickly turned into an archival collecting project.

Word began to spread around Cambodia that an organization was collecting Khmer Rouge records. DC-Cam soon acquired not only the Santebal secret police files but thousands of records found by disparate sources that were deteriorating in several warehouses, abandoned Khmer Rouge offices, and homes throughout the country.[112] DC-Cam staff negotiated an agreement with the highest levels of the Cambodian government and the ruling party

that authorized the organization to go anywhere in Cambodia, including government offices, and to seize any item it deemed relevant to its investigation.[113] This agreement had a profound effect on DC-Cam's growing collection. Etcheson recalled, "When we first got this agreement [from the government], I assumed that it would be of some use but wouldn't get us into that many places, but over the subsequent years I have just been amazed at how much that agreement has been honored in all but a couple of very specific instances."[114] Materials DC-Cam soon acquired through this agreement include documents from another Khmer Rouge prison (Krang Ta Chan in Takeo Province); records produced by the Lon Nol regime relating to its treatment of Khmer Rouge prisoners of war and intelligence reports; the personal notebooks of Tuol Sleng prison guards; and the Renakse petition, through which Cambodians demanded that the United Nations stop recognizing the Khmer Rouge as the official government of Cambodia.[115] At this time, DC-Cam staff decided not to ask to remove the Tuol Sleng mug shots from their location at the Tuol Sleng Genocide Museum but to make microfilm and digital copies instead, as I soon describe.

In these early years of DC-Cam, Chhang named three significant challenges to the organization. First, there was the international and domestic political challenge. Given that the Khmer Rouge still controlled strongholds in the jungle from which it was fighting the Cambodian government, political allies were scarce, and few foreign governments supported DC-Cam's work. Next, Chhang said that the growing number of human rights organizations in Cambodia posed a major, if unexpected, challenge. Surprisingly, the human rights community was concerned only with ongoing human rights abuses, not with the deaths of nearly 1.7 million people that had happened in the recent past. "Everywhere I went, people asked me, 'Why do you want to poke at old wounds?' I felt like I was crazy. . . . No one wanted to support me," said Chhang. And, finally, security was a major threat. Chhang received death threats daily, some publicly, from Khmer Rouge leaders who wanted to put a halt to DC-Cam's work. Chhang recalls telling Yale's CGP staff, "I put my life in the hands of God. That is my insurance policy. It is free. Don't worry about me." All of these challenges, Chhang said, "made our project stronger because we wanted to push forward."[116]

Like Chhang, Kiernan has commented about political threats to the establishment of DC-Cam. According to Kiernan, Khmer Rouge leaders, apologists for the regime, American Republicans, and the *Wall Street Journal* all attacked DC-Cam. Kiernan calls this opposition an odd "anti-Soviet alliance between the United States and China during the later stages of the Cold War, an alliance which often brought together conservative anti-communists and Maoist

radicals."[117] As Kiernan details, the *Wall Street Journal* launched a particularly vicious attack on him, denouncing him as a Communist and calling on the State Department to reverse its decision to fund the CGP and DC-Cam. Prominent Republicans subsequently accused CGP of fiscal mismanagement— allegations that were soon disproved.[118] At the same time, the Khmer Rouge called Kiernan an "arch-war criminal." Later, a faction of the regime created its own "Research and Documentation Center" to mount evidence in its defense.[119]

DC-Cam's growing collection provided evidence to counter what Kiernan has characterized as "two forms of denial of the Cambodian genocide and one of suppression" regarding scholarship and political engagement about the Khmer Rouge period.[120] In Kiernan's estimation, the first form of denial consists of early reports from scholars who grossly underestimated the damage caused by the Khmer Rouge.[121] While not specifically mentioned by Kiernan, Noam Chomsky and Edward S. Herman's work seems to represent this view; in 1979 Chomsky and Herman claimed that the Western media's reports of mass killings in Cambodia were exaggerated and based solely on biased refugee accounts and that they constituted nothing more than propaganda aimed at shifting the blame away from the United States' disastrous devastation in Southeast Asia.[122] The second form of denial in Kiernan's view is the insistence by scholars like David Chandler that, while millions died during the regime, these mass killings do not necessarily fit within a narrow legal definition of genocide. Kiernan calls this view "incorrect" but "legitimate" with a "defensible intellectual basis."[123] Finally, Kiernan contends that concerted efforts to block DC-Cam's investigations through personal attacks on himself and unfounded allegations of fiscal mismanagement constituted an attempt "simply to suppress the facts of the case."[124]

DC-Cam was the only organization (international or domestic) with the interest and funding to collect dispersed Khmer Rouge materials in the 1990s. The National Archives of Cambodia, itself straining to recuperate after decades of civil war that left its collection partially dismantled and many of its senior staff dead, did not have the resources, expertise, or political directive to undertake new collections.[125] Much has improved since then, but the National Archives of Cambodia remains underfunded, with only one computer shared among the staff and researchers. Few Khmer Rouge records are in the National Archives, with the exception of those of the regime's Commerce Ministry, which have also been cataloged and included in DC-Cam's databases and are not accessible at the National Archives without government permission.[126] Additionally, DC-Cam staff possessed the political savvy and professional legitimacy to attract American and Western European funding. Certainly, its

connection to Yale University and its endorsement by well-established historians like Kiernan added to the project's legitimacy, while Chhang's personal story of torture under the regime, his unwavering dedication to holding the perpetrators accountable, and his talent for navigating both the Cambodian political system and the world of international funders lent an unprecedented drive to the organization.

DC-Cam's Preservation and Digitization Efforts

The Yale program sparked renewed international funding and interest in archival work in Cambodia. Adding to the work Cornell University had accomplished earlier, the Yale project placed microfilm safety copies of records newly uncovered by DC-Cam in repositories in the United States and Australia in case the originals were destroyed by political opponents in Cambodia. Digitization efforts aimed to make Khmer Rouge records accessible to Cambodian refugees and human rights workers around the world.

As DC-Cam's collection grew, it became increasingly clear that the organization could be targeted for violence. Security was such a major threat that initially the location of the DC-Cam repository was not made public. DC-Cam staff "feared that ex-Khmer Rouge cadres might discover the secret Documentation Center location and attempt to destroy the archives to prevent future criminal investigations."[127] In 1999, a journalist described DC-Cam's offices: "Housed in a building behind a black metal gate, the documentation center does not broadcast its presence, for many in this country are afraid that they might be found complicit in war crimes, or else will be asked to testify against someone who will kill them."[128] As Paul Conway, then head of the Preservation Department at Yale University Library, described the situation, "We were concerned about this nightmare scenario of that house in Phnom Penh [where DC-Cam was located] going up in flames."[129]

In light of such security threats, it was crucial for DC-Cam to create safety copies of its collection and place them in secure locations outside the country. Conway suggested that DC-Cam first microfilm, rather than digitize, the collection because microfilming was considered to be more stable for preservation. The project aimed to create microfilm use copies of the Santebal records for DC-Cam and two preservation copies for safekeeping in the United States, to be stored at Yale and at the Center for Research Libraries (where they could be accessed at other universities via interlibrary loan). Despite significant challenges posed by unreliable electricity, heat, and the nonexistence of development facilities in Cambodia, the microfilm project prevailed, and all of the Santebal records were microfilmed.[130]

With preservation microfilm projects successfully under way, DC-Cam once again turned its attention to digitization, including digitizing the mug shots and making them available online. Etcheson notes that the creation of a database of digitized documents initially served internal purposes, but database creation and digitization soon turned into a much larger and more significant project supported by the technical expertise of Helen Jarvis and Nereida Cross. The digitization project expanded to include information on records that were not in the physical custody of DC-Cam, such as the Tuol Sleng mug shots. As a result of this project, four databases were created and made accessible online: a biographic database of information on more than thirty thousand victims and perpetrators; a bibliographic database of information on more than three thousand records; a geographic database mapping mass gravesites; and a photographic database consisting of 5,190 digitized mug shots found at Tuol Sleng (figures 12 and 13). While the other databases contain information on documents that are not digitized and that can be accessed only in person at DC-Cam, the photographic database consists of digitized mug shots. The photographic database was created as the result of a 1995 agreement in which DC-Cam gained permission from the Tuol Sleng Genocide Museum to digitize its mug shot collection.

The online databases were visionary for their time. As Jarvis explained, "We always had in mind making information available widely inside and outside of Cambodia and were aware of the (only then emerging) power of computers and the internet."[131] The photographic database was an effort, in part, to reunite the mug shots with the names of the unidentified victims (those taken before 1978) and, subsequently, their interrogation files. As stated on the Yale site, "The purpose of the CGDB [Cambodian Genocide Data Bases] Photographic Database is to bring together in one place the most complete collection ever assembled of images pertaining to gross violations of human rights under the Democratic Kampuchea regime."[132] By circulating digital copies of these images, the project aimed to link Cambodian knowledge—the names of victims—with the mug shots. As CGP's website states, "The photographs are presented here in the hope that these Khmer Rouge victims—most of whom remain unidentified—might be recognized by friends or family members, and thus they will no longer be forced to linger in the status of 'unknown victim.'"[133] Similarly, an April 21, 1997, *New York Times* story about the website states that the Cambodian Genocide Program's website "will allow people to put names to the photos."[134]

The project represents an early attempt at the digital reunification of disparate information from archival and other sources online. Conway said, "The vision that Ben Kiernan and the Yale staff had was that they would use

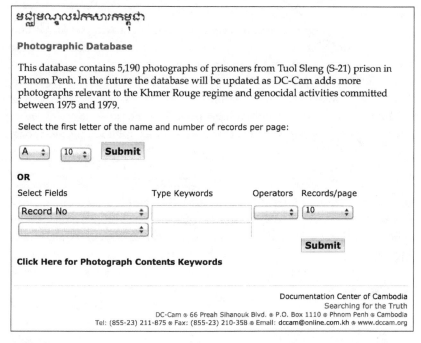

Figure 12 Photographic Database, Documentation Center of Cambodia.

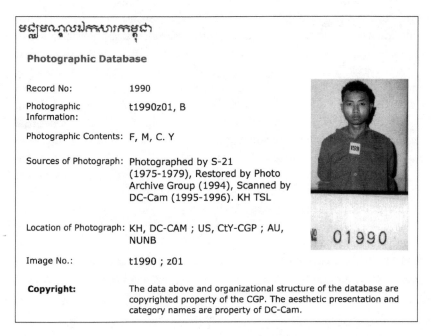

Figure 13 "Mug Shot 01990," name unidentified, from Photographic Database, Documentation Center of Cambodia.

digitization to marry chaotically arranged testimonies with separated and equally chaotically arranged photographs of victims. They thought they could use the web as a way of having survivors unite these files so that people could look at that and say 'I recognize this person' or 'I know whose testimony this was.' It was a decade ahead of its time." These newly reunited digital files would then serve as "an open testimony to the horrors of the Khmer Rouge," as Conway put it. Conway posits that the databases prefigure the social networking concept that archives are only now starting to employ for participatory archival description.[135]

This plan presents an important chapter in the social life of the mug shots. On one hand, digitizing materials separates objects from the information they contain, so that users no longer need to be in the presence of the material artifact of the mug shots to view the images. The act of viewing a digital image online is a wholly different experience from viewing it in person, one that presents a significant challenge for archivists in terms of providing context and ensuring authenticity and reliability. As Stephanie Benzaquen has written, "These are well-known photographs. Yet it is one thing to see them on the computer screen . . . and it is another thing to see them in their original context."[136] On the other hand, the vision for this digitization project was to unite disparate sources of information in a sort of virtual reunification of facts, if not of the actual archival records.

Mug shots, a turn-of-the-twentieth-century technology, were being transformed and reinterpreted through new technology at the turn of the twenty-first century. Geoffrey Bowker and Susan Leigh Star's work on memory, time, and information infrastructure sheds light on this situation. Bowker argues that the technical labor of digitization has profound political and ethical consequences and that information infrastructures should be analyzed as material artifacts.[137] In this light, the database of digitized mug shots aimed to induce survivors to remember tragic events, with important personal, ethical, and political consequences. By migrating the mug shots from a paper to a digital format, archivists were both performing a "conscious act in the present" and changing the nature of the record so that it can be "read in new ways" in the future. The digitization process is inherently one that crosses temporal boundaries, preserving records of the past for future users but also changing them irrevocably. Bowker writes, "Each new medium imprints its own special flavor to the memories of that epoch."[138] By digitizing these records, the project aimed to unite disparate information online, allowing people to reinterpret documents and events, thereby shaping memory of them. At the cusp of the twenty-first century, digitization was the most prevalent technology

through which the world could remember Khmer Rouge victims, and this digitization altered the uses and meaning of the mug shots, simultaneously decontextualizing them and enabling them to serve as conduits for new types of information.

A key aspect in this envisioned digital reunification was the identification by name of previously unidentified victims. The DC-Cam database (and the newsletter, which is discussed later) is, like the names visitors to Tuol Sleng wrote on the displayed photographs in the 1980s, an attempt to restore the individuality—and thus the humanity—of the victims. The act of naming counters Susan Sontag's impressions of the photos, presumably gathered primarily from the MoMA exhibition. She wrote, "These Cambodian women and men of all ages, including many children, photographed from a few feet away, usually in half figure, are . . . forever looking at death, forever about to be murdered, forever wronged. . . . The prison photographer's name is known—Nhen Ein [sic]—and can be cited. Those he photographed, with their stunned faces, their emaciated torsos, the number tags pinned to the top of their shirts, remain an aggregate: anonymous victims."[139] Linking the photos with the names of the people portrayed is a form of memorial, of remembering victims as the individuals they were and not as the aggregate nameless mass of "traitors" into which they were transformed by the Khmer Rouge.

However, the limits of the technology in 1995, when the photos were being scanned, coupled with budgetary constraints, prevented the widespread use of these digitized mug shots for this intended reason. Furthermore, global digital divides still prevent the majority of Cambodians from accessing the photographs online, since fewer than 5 percent of Cambodians had Internet access in 2012, a significant increase from the fewer than half of 1 percent who had access in 2010.[140] Etcheson wrote in 2005, "Only a small trickle of suggested identities has been forwarded to the Cambodian Genocide Program, but it is hoped that with time, identities can be restored to at least some of these anonymous victims of the Cambodian genocide."[141] Yet, even with that caveat, the digitized mug shots—now accessible via two separate databases, one at Yale and one at DC-Cam—have played a major role in raising awareness of the crimes of the Khmer Rouge among scholars and the international legal community. Furthermore, Cambodian refugee communities around the world use the database to look up their loved ones and to find out more information about the Khmer Rouge period.[142] As is discussed in further detail later, DC-Cam's newsletter is now largely filling the database's intended function of victim identification within Cambodia.

DC-Cam as Cambodian NGO

In 1997, DC-Cam's contract with Yale expired and it became its own independent, nonprofit, nongovernmental organization under the direction of Chhang. Its mission is to both "record and preserve the history of the Khmer Rouge regime for future generations . . . [and] to compile and organize information that can serve as potential evidence in a legal accounting for the crimes of the Khmer Rouge."[143] Since then, Chhang has consistently, relentlessly, and successfully ensured that media attention and government action both within Cambodia and abroad over the past fifteen years have addressed the growing demands of Khmer Rouge victims to hold the regime accountable through the tribunal. Chhang's efforts, together with those of his staff, were essential in sparking and later reviving United Nations interest in a tribunal and in assuring international legal experts that there would be enough evidence for convictions. Indeed, a 145-page memorandum from DC-Cam staff to the United Nations detailing all of the evidence compiled against five specific individuals for specific crimes is what convinced the UN Group of Experts to pursue the tribunal.[144] As explained on the "About" page of DC-Cam's website:

> Based principally on their examination of DC-Cam holdings, in February 1999 the UN Group of Experts found a prima facie case against certain former Khmer Rouge leaders for war crimes, genocide and other crimes against humanity. . . . A memorandum from the United Nations, A/59/432 of 12 October 2004 stated: "It is expected that the Chambers will rely heavily on documentary evidence. Some 200,000 pages of documentary evidence are expected to be examined. The bulk of that documentation is held by the Documentation Centre of Cambodia, an NGO dedicated to research and preservation of documentation on crimes perpetrated during the period of Democratic Kampuchea."[145]

Thus, rather than being an apolitical or neutral repository as many archives have historically claimed to be, DC-Cam has taken an active role in bringing about the tribunal. As Jarvis explained, "Unquestionably our documentation work provided not only great support for the arguments for the tribunal, but much of the evidence that was examined by the U.N. Group of Experts in 1998, whose mandate included assessing whether there was sufficient evidence to pursue the case, and of course much of the evidence [DC-Cam collected] has been placed subsequently in the case files at the ECCC [Tribunal] and presented in court."[146]

As the trial has begun, it has become virtually impossible to overestimate the scope of Chhang's and DC-Cam's impact. Through countless media interviews, educational outreach programs, publications, digitization efforts, and training programs for DC-Cam staff with international archival and legal experts, Chhang has become a prominent voice for accountability in Cambodia, epitomizing the "archivist activist" model that has been popularized in recent archival studies literature.[147] In 2007, Chhang was named one of *Time* magazine's 100 Most Influential People. His profile, written by Senator John Kerry, called Chhang "a hero confronting the past's villains."[148] Similarly, there is a striking overlap between the founding staff of DC-Cam and ECCC staff; Jarvis retired in 2010 after three years as the ECCC's Head of the Victims Support Section, and Etcheson served as Lead Investigator for the Office of the Co-Prosecutors.

At the time of writing, DC-Cam employs an all-Cambodian forty-five-member staff under the direction of Chhang, houses more than six hundred thousand documents, six thousand photographs, and four thousand oral histories, and is the main source of documentary evidence being used by the tribunal. DC-Cam receives funding from the governments of the United States, Norway, Australia, the United Kingdom, Canada, and the Netherlands, as well as from private foundations such as the MacArthur Foundation and the Open Society Institute.[149] Its programs include a Public Information Room in Phnom Penh whereby members of the public can access primary and secondary sources on the Khmer Rouge; a genocide education and teacher training program that trains teachers throughout Cambodia in how to address the Khmer Rouge period; a robust publication program, including the publication and free distribution of both the first Cambodian high school history textbook to address the Khmer Rouge period and a monthly Khmer language newsletter, *Searching for the Truth* (which is translated into English on a quarterly basis); a Living Documents project that brings Khmer Rouge survivors from rural areas to Phnom Penh to witness the tribunal so that they can go back and inform their neighbors about it; an extensive oral history project in which staff interview both Khmer Rouge victims and perpetrators alike throughout Cambodia; a forensic program that maps mass graves and memorials; and ongoing archival collection, preservation, microfilming, digitization, and cataloguing of materials.

DC-Cam is a much better-funded, better-staffed, and better-organized organization than the Tuol Sleng Genocide Museum, which is government run. The contrast is striking. The museum is in a total state of decay; visitors can easily make a wrong turn in a hallway and wind up in a dusty room full of construction debris and old toilets, as I did in January 2012 (figure 14).

The Making of Archives

Figure 14 Debris at Tuol Sleng, January 2012. (Photo by author)

Backrooms are covered in graffiti (in Khmer, English, and other languages), and there are no security or educational staff stationed in the buildings. While foreigners are charged a two-dollar admission fee, these funds are distributed among underpaid museum staff rather than reinvested in the institution.[150] There are donation boxes near all of the bathrooms in order to pay for upkeep.

Many foreign visitors pay an additional five dollars to get a private tour of the museum from Cambodian guides, who are free agents (not museum staff), some of whom had family members who were imprisoned there. If it were not for DC-Cam-produced exhibitions, there would be virtually no explanatory information at the museum; DC-Cam's exhibitions remain up at Tuol Sleng long past their official runs, despite significant fading and the defacement of photographs of Khmer Rouge leaders. The Tuol Sleng mug shots on display are in a state of disrepair, many showing signs of mildew; the largest image on display, that of Chan Kim Srun's mug shot, has been torn and taped together multiple times. The atmosphere is one of abandonment, decrepitude, and neglect, despite the tour buses that line up in front; perhaps the tourists think the decay and mismanagement add authenticity to the site. Many of the resources at the museum have been donated; DC-Cam has donated the AV system used at Tuol Sleng for its twice-daily screenings of the documentary *Bophana*, and tour companies have donated the benches on which visitors can sit in the courtyard and in the film screening room.

Despite repeated attempts to gain entry, I was denied access to the Tuol Sleng Archives. When I asked to be directed to the archives during a 2011 visit, I was told to go to DC-Cam. When I asked again during a 2012 visit, I was told that the archives do not keep regular hours. Subsequent attempts proved equally fruitless.[151] Neither the museum nor the archives has a functioning official website. The e-mail address listed on the pamphlet given out to visitors does not work. The message here is clear; the current government does not deem the preservation of Tuol Sleng history—even history that justifies the regime's own political agenda—important enough to allocate significant resources to it.

By contrast, DC-Cam is a bustling modern office in the heart of Phnom Penh, across from the city's landmark Independence Monument. Housed in three adjacent buildings, DC-Cam is virtually unmarked due to security concerns, but the public is welcome to use the resources in its public information room during set business hours.[152] The office teems with life; dozens of young Cambodian staffers mill about working on various projects. Its website is frequently updated with information, and director Chhang responds promptly to e-mail requests and keeps an international database of contacts to whom he sends out biweekly updates. DC-Cam recently announced plans to build a permanent educational facility, named the Sleuk Rith Institute after the leaves on which ancient Cambodian manuscripts are inscribed, that will house a museum, archives, a policy research center, and a degree-granting school.[153] After visiting both institutions, one cannot help feeling relieved that DC-Cam has copies of the Tuol Sleng mug shots.

In July 2011, DC-Cam entered into a formal agreement with the Ministry of Culture and Fine Arts to preserve and develop the Tuol Sleng Genocide Museum.[154] Under the agreement, DC-Cam transformed unused space at Tuol Sleng into a classroom in order to run genocide prevention and education programs. DC-Cam staff will also provide management training to the Tuol Sleng Genocide Museum staff and mount photography exhibitions at the museum. While this agreement in no way constitutes a formal takeover of the archival records in Tuol Sleng's collections (including the mug shots) by DC-Cam, it reveals the development of a much closer working relationship between the organizations and is a possible harbinger of DC-Cam's further involvement with the reuse of the Tuol Sleng mug shots in the future.

Political Power, Silences, and the Making of Archives

As the Tuol Sleng mug shots (and other records) were transformed from active bureaucratic records to material and digital archival collections over the course of the past three decades, they were imbued with the power to establish historical and legal facts about the Khmer Rouge's human rights abuses. This power to establish fact is wholly intertwined with politics, as each successive archival collection effort was enabled by and steeped in the political context from which it emerged. The flipside of the establishment of fact—the absences resulting from the silences of the records—is also apparent in this history of the archivization of the mug shots.

Trouillot posits that power is imbricated in each moment of the creation of archives, a process he defines as "the moment of fact assembly." He writes, "In short, the making of archives involves a number of selective operations: selection of producers, selection of evidence, selection of themes, selection of procedures—which means, at best the differential ranking and, at worst, the exclusion of some producers, some evidence, some themes, some procedures. Power enters here both obviously and surreptitiously."[155] While Trouillot lacks the vocabulary of archival administration, his delineation of the various types of "selection" can be accurately mapped to the archival functions of appraisal, description, preservation, and access, as in each case archivists are "selecting" records to be included in archives, to be described in archival ways, to be preserved by archival standards, and to be made accessible through print, digital, and material archives. In terms of the transformation of Tuol Sleng mug shots into archival collections, each archival function belies a relationship of power; only certain actors (the Khmer Rouge's Vietnamese-backed

successors, Western human rights activists and librarians, the US State Department, and, finally, the Cambodian-run DC-Cam) had the power to archivize these photographs, to determine that they were worthy of collection, sustained preservation attention, exhibition, publication, and digitization. Trouillot writes that "archival power at its strongest, [is] the power to define what is and what is not a serious object of research, and therefore, of mention."[156] Clearly, throughout the course of their transformation into archival collection, the Tuol Sleng mug shots were deemed objects of serious research, worthy of attention from historians, lawyers, lawmakers, Khmer Rouge survivors, and tourist visitors to the museum.

Taking Trouillot's claims a step further, through the examination of the Tuol Sleng mug shot collection we see how such archival decisions are based not on just any type of power but on *political* power in particular. Writing about his work at DC-Cam, Etcheson asserts that archival collecting is "inherently submerged in a political context, and thus any organization involved with such matters will also find itself swimming in a turbulent political sea. Given the origins of the Cambodian Genocide Program in an explicitly political advocacy effort, the officers of the [CGP] were fully aware of the political character infusing their otherwise largely scientific undertaking."[157] Note the distinction Etcheson makes between the political and the scientific aspects of archival collection; this distinction is rendered meaningless upon closer examination, both in the sense that archives are always political and in the sense that politics and science are never a hard and fast binary. Yet, while Kiernan similarly asserts that "political pressure is the greatest threat to honest inquiry," the creation of archives, rather than being a neutral antidote to political discourse, is in and of itself a political act; preserving the mug shots, assembling them into archives, and digitizing them required immense political support and has ongoing profound political implications.[158] In contrast to Etcheson and Kiernan, Chhang readily admits the political implications of archival work. "Documentation is a political act," he has said, "and therefore it alarms politicians who don't want to see truth revealed."[159] Here, the work of the South African archivist Verne Harris is particularly useful. Shunning critiques that suggest that political power interferes with archival duties, Harris asserts, "The archive is the very possibility of politics."[160] He writes, "Firstly, the very structure of recordmaking both invites politics in and generates a politics of its own. Ultimately, there is no understanding of the record, or of the archive, without understanding of politics. Secondly, and this argument flows directly from the first, political pressure never only comes from 'outside.' It is always also at work from 'inside'; from within the process of recordmaking. Recordmakers, including archivists, are, from the beginning and always, political

players. Thirdly, not only is recordmaking ('the archive') woven through by the political; politics is woven through by the archival. . . . This is to go beyond a claim that the archive is political. It is to assert that the archive *is* politics."[161] In light of Harris's assertions, the three decades of competing international claims to the Tuol Sleng mug shots are not a political *intrusion* on the archives but are central to the very fabric of the archival endeavor. There are no archives without politics; the process of transforming the Tuol Sleng mug shots into archives is inherently and inescapably political. Similarly, the archival scholar David Wallace writes, "Struggles for social justice are battlegrounds over values, priorities, resources, dignity, and survival. To claim that such initiatives politicize archives misses the point that *archives are already political* and always manifested and shaped at the coalface of power, privilege, and resourcing. These are realities we cannot escape. . . . [T]he work of archives is politics by other means. Wishing this away will not evaporate politics."[162] While the history of the Tuol Sleng mug shots provides a particularly extreme example of the ways in which politics infuses the work of archives, such political power is always present to some extent, both "obviously and surreptitiously" in the words of Trouillot.

Yet, while archival collecting is an affirmative act of political power (the power to determine something worthy of archiving), it is also always an act of silencing those voices not worthy or not capable of being included in the archives. Compounding the unbearably heavy silences of those voiceless victims depicted in the mug shots, as well as the silence of the Khmer Rouge victims who left no trace, the archivization of the Tuol Sleng mug shots belies two crucial silences: the silence of the missing mug shot negatives and the silence of the missing names of the unidentified victims depicted.

The missing negatives create a silence in our facts about Tuol Sleng, causing the omission in our collective memory of those thousands of Tuol Sleng victims not depicted in the mug shot images that currently form the archives. Given the varied estimates for the number of people killed at Tuol Sleng, the missing negatives represent an unknown number of victims whose faces the world does not now know. For Cambodians searching for missing loved ones, this silence of omission is deafening, leaving unanswered questions and unresolved grief. These silences add to those inherent in any archival collection, as Harris describes:

> In any circumstances, in any country, the documentary record provides just a sliver of a window into the event. Even if archivists in a particular country were to preserve every record generated throughout the land, they would still have only a sliver of a window into that country's experience.

But, of course, in practice, this record universum is substantially reduced through deliberate and inadvertent destruction by records creators and managers, leaving a sliver of a sliver from which archivists select what they will preserve. And they do not preserve much. Moreover, no record, no matter how well protected and cared for by archivists, enjoys an unlimited life span. Preservation strategies can, at best, aim to save versions of most archival records. So archives offer researchers a sliver of a sliver of a sliver.[163]

For Cambodians still looking for answers about dead relatives, a sliver of a sliver of a sliver is simply not enough.

Yet archivists have tried to counter another type of silence embedded in the Tuol Sleng collection—the silence of the names of those depicted. Through exhibition, digitization, and publication, staff at the Tuol Sleng Museum and DC-Cam have helped Cambodians identify the previously anonymous victims in the photos (that is, those whose photos were taken before 1978), collected these names, and added them to the archival record (via finding aids, databases, and publication of the now-captioned photos). Using Trouillot's language, archivists have countered the silences embedded in the moment of fact creation (the taking of the mug shots) by adding voice in the moment of fact assembly (the archivization of the mug shots). While this act of matching names to photographs in the process of archivization is seemingly small and simple, it has had an overwhelming impact on countering larger societal silences about the Khmer Rouge, as the next chapter explores.

In this stage of their social life, the mug shots were transformed from records into archival collections. As we have seen throughout, the formation of archives is a contested, political act, imbued with moments of empowerment and, conversely, silencing. As Trouillot posited, the assembly of these photographs into archives constitutes an attempt to establish facts about the Khmer Rouge, facts that can then be used to create narratives that honor the dead, shape history, and hold those responsible legally accountable, as the next chapter addresses.

3

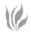

The Making of
Narratives

The people pictured here are important and unique, their photographs
heartbreaking cries for recognition. Frozen by the lens, the prisoners stare
out at their captors. Nearly twenty years later, they are also regarding us.
Their expressions ask their captors: "Who are you? Why am I here?"—
and ask us: "Why did this happen? Why have we been killed?"

David Chandler, "The Pathology of Terror in Pol Pot's Cambodia"

But a truth about all photographic portraits, including the Cambodian
pictures, is that they are mute. We can never be sure what their expressions
mean.

Michael Kimmelman, "Hypnotized by Mug Shots That Stare Back:
Are They Windows or Mirrors?"

Until very recently, it was taboo in Cambodia to discuss the
Khmer Rouge. The regime was conspicuously absent
from classrooms, and parents rarely discussed their experiences with their
children. In the past decade, foreign tourists have been the primary visitors to
the Tuol Sleng Genocide Museum. Until 2009, when DC-Cam commissioned
a staff member, Khamboly Dy, to write a new history textbook and distributed
it free of charge to hundreds of thousands of high school students, young
Cambodians were formally taught very little about the regime. The ninth-grade
history textbook prepared by the Royal Government of Cambodia in 2000
contained only the following information on the Khmer Rouge, reproduced

here in its entirety, as quoted on the "Genocide Education" page of the DC-Cam website: "From April 25 to April 27, 1975, the Khmer Rouge leaders held an extraordinary Congress in order to form a new Constitution, and re-named the country 'Democratic Kampuchea.' A new government of the DK, led by Pol Pot, came into existence after which Cambodian people were massacred."[1] By 2002, even this passage was omitted, as a political dispute over coverage of the United Nations–sponsored elections in 1993 caused the entire modern-history section to be removed. A whole generation of Cambo-dians, too young to have firsthand memory of the Khmer Rouge, was being raised with literally no formal information about the regime. A 2009 survey conducted by the University of California, Berkeley's Human Rights Center found that, out of the 68 percent of Cambodians age twenty-nine or younger (who therefore did not live under the Khmer Rouge), 81 percent of respondents described their knowledge of that time period as either poor or very poor.[2] Anecdotally, a guide at the Tuol Sleng Genocide Museum told me in 2005 that even her own children did not believe her stories about forced labor, starvation, and execution under the Khmer Rouge. In this information vacuum, the Berkeley survey found that 77 percent of all respondents and 85 percent of respondents too young to have lived during the 1970s reported that they wanted to learn more about what happened during the Khmer Rouge's rule.[3] Both DC-Cam and the tribunal have emerged against the backdrop of this prior national amnesia and have made significant strides in getting Cambo-dians to talk about the country's bloody past.

But, despite this earlier reluctance to discuss the Khmer Rouge, the Tuol Sleng mug shots are now inspiring survivors and victims' family members to tell narratives about the regime and its victims.[4] These narratives take three forms: legal testimonies, interviews conducted by documentary filmmakers, and articles published by DC-Cam.[5] These narratives are also occasioned by new visual records that document survivors and victims' family members looking at the mug shots. Across many formats, mug shots are used as a touch-stone for people to remember and, more important, to tell stories to others about the regime.[6] These stories then become records themselves, adding a layer of meaning and context to the ever-expanding archive of the Cambo-dian genocide. As these stories draw the listeners and viewers into the act of witnessing trauma, they answer the paradoxical questions of how to speak about the unspeakable, how to witness (in the words of the Holocaust scholars Shoshana Felman and Dori Laub) "an event eliminating its own witness."[7] Engendering narratives about the regime, the mug shots become active agents in the performance of human rights in Cambodia as they are reused by survivors and recaptured into new records.[8]

These stories represent the moment of fact retrieval or the creation of narratives, which is also the third moment of silencing for Trouillot. In acts of storytelling, Trouillot posits, "retrieval and recollection [of facts] proceed unequally."[9] Any storyteller is selective, including some facts while excluding others, emphasizing some events at the expense of others. The silences encoded in the first two phases of historical production (the creation of sources and archives) are compounded in the creation of narratives; in Trouillot's words, "Historical narratives are premised on previous understandings, which are themselves premised on the distribution of archival power."[10] In this framework, narratives about the Khmer Rouge are built on records created by the Khmer Rouge and archives created by survivors and foreign scholars.

Yet, while the Tuol Sleng mug shots are being used to spark narratives that counter the previous collective silence about the regime, they also belie another series of silences—the silences of those stories not told, those records not archived, and those victims not documented. Despite these deafening silences, a community of survivors, victims' family members, and archivists is using records to assert the voices of victims and the agency of survivors where previously silences once prevailed. In this way, archives are inscribing and creating memory by providing a space where the voices of survivors can be heard, the names and photos of victims can be recorded, the tribunal can be publicized, and the younger generation of Cambodians can be educated. In the process, the mug shots are being incorporated into new records that document the act of witnessing, revealing both how photographs specifically are an active part of the performance of human rights in Cambodia and how records in general are dynamic performative entities whose meaning and context change as they travel through space and time with reuse.

Legal Testimonies

In 2010, the Extraordinary Chambers in the Courts of Cambodia (ECCC) convicted Duch, former head of Tuol Sleng prison, of crimes against humanity and other violations of international and domestic law.[11] Thirty years in the making, the ECCC was the result of much diplomatic wrangling, intense internal political negotiations, and relentless advocacy by organizations representing victims and their families, including DC-Cam. In this discussion of the first trial heard in the tribunal, we see that mug shots were used by attorneys for the prosecution as legal evidence, by civil party witnesses as catalysts for telling narratives about Tuol Sleng victims, and by the accused himself as final arbiters of truth.

Mug shots were a key component of evidence compiled in Duch's trial, composing some of the sixteen thousand documents in his case file.[12] During the proceedings, several witnesses, including the prison photographer, Nhem En, and Duch, testified that prisoners at Tuol Sleng were photographed by the photography unit in Building E as part of their registration process. Lawyers for the prosecution projected mug shots on overhead screens during these testimonies so that judges, lawyers, and trial observers could see them (figure 15).[13] Throughout the trial, attorneys used mug shots to corroborate witness testimony and to communicate the sense of loss experienced by victims and family members. For example, one witness at the trial clutched a mug shot of his wife taken at Tuol Sleng; his attorney said, "To this day, all he has left of her is a copy of her S-21 photograph."[14] In this way, the mug shots were used as physical evidence that embodied the absence of the dead, serving as powerful symbols of remembering. Yet, most important, the mug shots inspired narrative testimony about Tuol Sleng victims from their family members. In the interest of space, this section addresses the use of mug shots in legal testimony about three victims: Ouk Ket, as told by his wife, Martine Lefeuvre, and his daughter, Ouk Neary; Ma Yoeun, as told by her husband, Bou Meng; and the mother of Norng Chan Phal as told by Norng Chan Phal.[15] These three cases are primary examples of how mug shots were used to tell stories about the dead, evoke the presence of their absence, and transform the family members into witnesses who are compelled to speak on behalf of the dead.

On August 17, 2009, the ECCC heard the testimony of two civil party witnesses regarding Ouk Ket, a Tuol Sleng victim. First, Ouk Ket's wife, Martine Lefeuvre, told the court Ket's story. She first met Ket, a Cambodian national, in Paris, where he was studying engineering. After Ket graduated, in 1970, he was given a diplomatic position at the Cambodian Embassy in Senegal. Ket and Lefeuvre married in 1971, moved to Senegal, and had two children. In 1977, Ket received orders from the Foreign Ministry in Cambodia to return to Phnom Penh. Lefeuvre and the children moved back to France, and Ket, unaware of the dire situation in Cambodia, flew back there on June 7, 1977, sending two postcards to his family during the journey. They never heard from him again. Lefeuvre spent years searching for him, unsuccessfully trying to enlist diplomatic help and traveling to refugee camps on the Thai-Cambodian border in 1979 to look for him. Eventually, a family friend told Lefeuvre that he had seen Ket's name in a file at the Tuol Sleng archives. In 1991, Lefeuvre and her children traveled to Cambodia, where they found Ket's name on a list of people to be sent from Tuol Sleng to the killing fields for extermination. Not until 2009, with the help of DC-Cam staff, did they find Ket's Tuol Sleng mug shot. Lefeuvre's testimony directly references this photograph:

The Making of Narratives

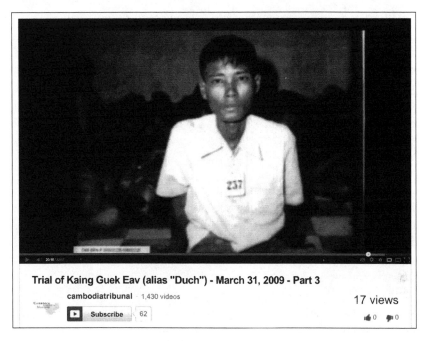

Figure 15 Mug shots in trial footage. (From Cambodia Tribunal Monitor, "Trial of Kaing Guek Eav [alias 'Duch']")

On the 15th of June [1977] he was kidnapped with his hands tied behind his back, blindfolded and brought in a truck, beaten in the face—as we can see in his photograph that we finally found. When he arrived at Tuol Sleng he was therefore tied up like a slave to a metal bar, chained up in a filthy cell. He was deprived of his most elementary rights, arbitrarily detained because he was of course not entitled to a lawyer and he doesn't know why he has to go to this hell. He was deprived of his most fundamental needs—no food, no care, no medical care, no hygiene, psychological solitude, torture with Nazi methods; six months of this and I am sure that Ket was able to face it and that he did everything in his power to be able to resist this and to be able to return back to us one day. . . . So now I understand his physical and psychological degradation. I can picture it. He died a slow death at S-21 in the most complete secrecy, in solitude, and on the 9th of December 1977 murderers broke his skull at Choeung Ek and then cut his throat while throwing him into a pit. This is an absolutely inexcusable murder. And for the past 32 years Ket's absence is something that we cannot bear. It is a permanent absence. My children grew up without the presence of their father; a presence that was comforting, a presence that

would protect them; without his affection, without a fatherly figure. That is to say everything that organizes the life of a child. Ket's suffering was and is still our suffering and it does not go away with time, and I can tell you that the suffering in fact is more and more intense. It is like a gigantic screen that would be too close to our eyes. Until today we still haven't found the body. We do not have any kind of restitution. . . . So therefore I came before this Chamber in order to ask for justice to be done—justice to be done for this barbaric crime so that we can finally take into consideration Ket's suffering and the suffering of all of the other Cambodians, whether they were in S-21 or anywhere else in the country, and so that they can also take into consideration the suffering of the survivors.[16]

Having never directly experienced Tuol Sleng firsthand as a prisoner, Lefeuvre testifies as a secondary witness who experienced Tuol Sleng through its images. She seems to experience her pain through the lens of visual images, describing the suffering as "a gigantic screen" that is "too close" for her eyes to take in. After viewing the photographs at Tuol Sleng, she "can picture it," it becomes more real than it was when she had written evidence alone. Furthermore, in Lefeuvre's testimony, the presence of Ket's absence is made palpable through his image. The photograph stands in for Ket, breaking the silence left by his absence by providing key information about his arrest and torture, and yet is not enough to fill the void left by his disappearance.

Yet it is not until the conclusion of Lefeuvre's testimony and the beginning of her daughter Ouk Neary's testimony that the mug shot itself is displayed at the trial. Before Neary begins, her lawyer requests on her behalf that the court view two sets of photographs, which are then projected overhead: the first, a series of images of Ket in happier times, posing with his family, at parties, and shaking the hands of Senegalese government officials; the second, Ket's Tuol Sleng photograph, in which he appears in solitude, wearing all black and barefoot.[17] The cataloging number assigned to the photograph by DC-Cam staff is also visible. The photographs stand in stark contrast to each other, the first set showing all that was made possible by Ket's life, the second showing all that was lost in his death. The court is left to view these images for a few minutes before Neary begins her testimony. After describing her experiences growing up without a father, she directly discusses the Tuol Sleng mug shots, telling the court that, on her first visit to Tuol Sleng in 1991, she was fascinated by them:

and on the wall we could see black and white photographs—and I'd like to say black and white photographs of a rare violence because could you imagine how violent these pictures would have been if they had been

coloured pictures? . . . I remembered how much I was traumatized by these photographs but it was very much soothing for me to see them. . . . With my brother we continued with the visit and in the next room, going through that door which plunged us into an unreal world, and in the second room there were ID pictures that covered all of the walls and we were drawn to these faces which stared at us, one after the other, drawing them to each one of these faces. And I wondered if the horror was to see these emaciated faces of children, men, women, babies sometimes, or if it was to think that there are others whose pictures aren't even there. So I continued to walk through this room and saw another one of these doors taking us to a third room with just as many pictures on the walls and just as many people staring back at me. And I told my brother, "We have to start all over again and look at each one of them because perhaps my father is there. And if he is amongst them, we can't afford to miss him." . . . The reason why I'm describing S-21 to you at such length, it's because that day that is the day when a drop of poison came to me, and I have never since that day stopped trying to find out what happened."[18]

Despite this thorough search, Neary did not discover her father's Tuol Sleng photograph on display during that first visit. Again, the presence of his absence is made palpable through the missing mug shot. She is both comforted and traumatized by the mug shots she sees at Tuol Sleng and even more disturbed by the absence of those whose photographs aren't on display. The photos mercifully lack color, their black-and-white status somehow removing them from a more intense realism. Later, she testifies about finally finding her father's Tuol Sleng photograph, eighteen years after her initial visit to Tuol Sleng: "I went to DC-Cam in February [2009] where I managed, thanks to Youk Chhang, whom I wish to thank in passing even though I didn't understand at first his hesitations and reluctance. I managed to recover the picture of my father in S-21 which this time represented for me the confirmation that he had been through that venue and that he was no longer alive."[19] For Neary, the photograph provides the ultimate confirmation, despite other types of documentary evidence found at Tuol Sleng. She concludes her testimony by saying that the "walls [of Tuol Sleng] are shouting," that the "whole world is looking at Cambodia," and that "the only way to relieve things is to testify."[20] In Neary's testimony, we learn not only about Ket's life and the suffering his death has caused his family but also about the ways in which family members process the mug shots as visual evidence that represents the Tuol Sleng experience as a whole, filling the void left by the missing family member with visual details. Through the mug shots, the walls of Tuol Sleng shout at the world, compelling Neary and other family members to tell the stories of the dead,

transforming those who testify from silent victims into witnesses. After Neary's testimony, the judge then asked Duch to respond. Faced with Ket's mug shot, Duch accepted responsibility for his death and apologized to Lefeuvre and Neary.

On July 1, 2009, a Tuol Sleng survivor, Bou Meng, took the witness stand in the Duch trial on behalf of his dead wife, Ma Yoeun. Meng had been separated from Yoeun at Tuol Sleng and tortured but was saved from death because of his skills as a painter; he was made to paint portraits of Pol Pot.[21] Haunted by his dead wife's ghost, Meng claims that her spirit, in the form of her Tuol Sleng mug shot, appears to him often, encouraging him to participate in the trial by telling him, "Only you, Bou Meng, can find justice for us."[22] He still carries a tattered copy of her Tuol Sleng mug shot in his wallet, an image of which was projected overhead in the courtroom during his testimony. Meng was visibly shaken throughout his testimony, in many instances crying too hard to speak in detail about his own experiences and unable to follow the judge's orders to "recompose." Asked by the judge whether there was anything Meng would like to ask Duch, Meng turned to Duch and asked, "Where was my wife killed? Was my wife killed in Phnom Penh, at Choeung Ek or elsewhere? When I get the answer, I will go there to get the remains in order to pray for her soul."[23] Duch, for whom Ma Yoeun was only one of tens of thousands he was responsible for killing, was unable to provide Meng any solid answers. "Please accept my highest regards and respect towards the soul of your wife. Emotionally, I am responsible for all these crimes," Duch responded, breaking down into tears. Through Bou Meng's testimony, we see not only how the Tuol Sleng mug shots embody the memory of the victims but also how they have inspired efforts to hold the regime legally accountable for its actions. For Meng, it is his wife's photograph itself that seems to be possessed, reaching back from the dead to demand justice. In this case, the mug shot induces Meng to testify.

However, these two cases also reveal a problematic relationship between the mug shots and the construction of truth. While Duch admitted guilt for the deaths of those victims for whom there is an existing mug shot such as Ouk Ket and Ma Yoeun, he denied any responsibility for those victims whose photographs were missing from the case file. This is made apparent by the case of Norng Chan Phal. Phal testified to being arrested with his mother and brother and being held as a child prisoner at Tuol Sleng. His father had already been arrested. Phal told the court, "We were sent into an office and there was a room with white walls and a camera. My mother was made to sit down and her photo taken. She was given a number to hold. They pushed her and threatened her. She had never been photographed before and it was very

unsettling for her. They then pushed her backwards and forwards. I was terrified."[24] Phal broke into tears as he recounts the taking of his mother's mug shot. He was separated from his mother the next day and never saw her again. However, unlike the two cases previously described, in this case Phal's mother's mug shot is missing; it is the experience of having witnessed the taking of the mug shot and not the mug shot as an existing material object that inspires his testimony. Because prosecutors were unable to project the image in the courtroom, Phal's testimony is marked by the absence of this photograph. In this absence, Duch denied the allegations on the basis of the lack of documentary evidence. Holding up a copy of Phal's father's Tuol Sleng file, Duch admitted that Phal's father was killed at Tuol Sleng, but also stated that he would acknowledge that Phal's mother was killed and that Phal was held at the prison only "if some evidence was shown to him to support this claim." Duch continued, "Regarding Norng Chan Phal and his mother, where did they suffer? I am uncertain in this matter. Is there another letter that proves she and her children were in S-21?"[25] Phal was clearly distraught at Duch's questioning.

Subsequently, an article in the *Phnom Penh Post* reports that researchers at DC-Cam uncovered Nong Chan Phal's mother's Tuol Sleng biography and submitted it to the court. Having seen the newly submitted document, Duch is quoted as saying, "So through this court I would like to seek forgiveness from Mr. Norng Chan Phal. Now I would accept it [his testimony] entirely."[26] Similarly, one witness, Nam Man, testified in Duch's trial that she was a medic at Tuol Sleng and that she witnessed Duch beat two of her uncles to death. Denying the allegations, Duch said Man's testimony could not possibly be true since there were no mug shots of or confession statements signed by her uncles. Man was later quoted in the *New York Times* as saying, "Now I have to find the records to prove I am telling the truth."[27] However, clearly Man herself knows the truth of her claims regardless of their confirmation in the archives; she knows that her uncles died at S-21, even if there are no mug shots to prove it. Here we see how participants in the tribunal referenced records as the embodiment of veracity, revealing little understanding of the incomplete nature of any archive.[28] Duch in particular conceived of the archive as the complete and final arbiter of truth, reflecting both an arrogance about the infallibility of his own recordkeeping system and the widespread misconception that the records reflect the truth.

As archives are never complete and always mediated through archivists, granting them the sole capacity to establish the forensic truth is highly problematic. Addressing the recordkeeping practices of oppressive regimes, the archivist Eric Ketelaar has written that "the corollary of the assertion: 'if it

does not appear in our records, it does not exist,' is 'it appears in the records, therefore it exists.'"[29] In Duch's trial, both Duch and victims drew repeatedly on this tautological argument, despite overwhelming information that thousands of Tuol Sleng mug shots are missing and that no recordkeeping system, however detailed, is ever absolutely complete. The use of mug shots in legal testimony reveals a complicated and problematic relationship between narrative and archival record in which the presence of mug shots can inspire narratives about the regime, while their absence can undermine the veracity of other narratives, effectively silencing them.

Through their use in the trial, the mug shots have taken on a new life as tools for the creation of narratives that expose the criminality of those who orchestrated them. They also gain another life as they are incorporated into new records that document the tribunal. These photographs, now embedded in footage of the trial, were shown in the weekly television show *Duch on Trial: Time for Justice*, which was broadcast throughout Cambodia, watched by a staggering 20 percent of the Cambodian population, and posted via the online video platform Vimeo.[30] Digital footage of the tribunal has also been posted online via Vimeo by Cambodia Tribunal Monitor, a website jointly operated by DC-Cam and Northwestern University.[31] Through digital footage, the mug shots have an ever-increasing audience, as not only tribunal participants but Cambodians, Cambodian emigrants around the world, and the international community view them in the context of footage of the tribunal.[32] They become, in the words of Catherine M. Cole (addressing television broadcasts of the South African Truth and Reconciliation Commission), "moving," in the sense that they are not only emotionally expressive but "spatially mobile . . . across geographic distances," and, I would add, temporally mobile, as well, as I watched them online almost two years after they appeared in the trial.[33] In this way, the mug shots also have been subsumed into new digital records that document not only the Khmer Rouge's abuses but efforts by survivors and victims' family members to bring Khmer Rouge leaders to justice. Incorporated into tribunal footage, they become part of the performance of justice as media event in Cambodia. Placed in these new contexts, the mug shots *as legal evidence* in the Duch trial subsume and supersede all previous uses of them, transforming them from records of oppression to records of accountability.

Documentary Films

While the tribunal tasks mug shots with establishing a singular definitive legal truth, documentary filmmakers—including those on staff at

DC-Cam—are using these photos to create an extrajudicial space for survivors to tell their stories. Over the past fifteen years, many documentary films have used mug shots as powerful visual tools that induce Tuol Sleng survivors and guards to recount their horrific memories and inspire victims' family members to tell stories that memorialize the dead. These documentaries, directed by Cambodians and foreigners alike, reflect a wide range of motives, backgrounds, and agendas. For brevity, this discussion is limited to five such films: *The Secrets of S-21*; *The Conscience of Nhem En*; *Samsara: A Film about Survival and Recovery in Cambodia*; *S21: The Khmer Rouge Killing Machine*; and *Preparing for Justice*.[34] Although the first three films were directed by Westerners and the second two films were made by Cambodian Khmer Rouge survivors, Tuol Sleng mug shots are used in strikingly similar ways in all of them.

The Secrets of S-21: Legacy of a Cambodian Prison is a thirty-minute BBC production dating from 1996. The film is primarily concerned with documenting the efforts of Doug Riley and Chris Niven in restoring the Tuol Sleng photographs (as described in chapter 2) and follows them on their fruitless search for missing negatives. With its focus on the allegedly heroic efforts of these two American photographers, the film is clearly aimed at a Western audience. Yet, while Riley and Niven occupy most of the screen time, the film contains glimpses of the ways in which victims and the family members of victims interact with the mug shots Riley and Niven restored. One memorable scene depicts an interview with Jun Chhoun Srien, a widow whose husband was imprisoned at Tuol Sleng. Srien is looking through a well-ordered book of photographic prints of the mug shots, presumably a book created by Riley and Niven for that purpose. Pointing to her husband's mug shot, Srien says, "I feel very sorrowful when I see my husband like this. It isn't right that he should have died in this way, being beaten and badly tortured. I'm now in a pitiful state. There was just me, my husband, and the two boys. After my husband, they also killed my boys. Now I'm all alone. When I see my husband's photograph, I am in agony. My heart wants to stop and I can't speak."[35] The camera then focuses on Srien shaking and obsessively picking at her eyebrow in utter despair. As Srien tells the camera, her husband's mug shot induces this mental anguish. She is both rendered silent by the mug shot ("I can't speak") and compelled to tell her husband's story. This paradox of being simultaneously without words and compelled to speak echoes the work of Felman and Laub, who have described how mass acts of violence leave victims speechless, without adequate words to convey the horror they have experienced.[36] Slowly and with time, victims can form narratives about (previously) unspeakable trauma, regaining words where silence once prevailed. In the footage of Srien, we see a survivor caught in the middle of this paradox, trying to speak but not yet able to fully testify.

The documentary also includes footage of two Tuol Sleng survivors, Vann Nath (now deceased) and Im Chhan, speaking about their experiences and (almost impossibly) looking at their own mug shots. Vann Nath, a painter, was kept alive at Tuol Sleng in order to paint propaganda. The film shows Nath at Tuol Sleng, walking through a display of his more recent paintings depicting some of the graphic scenes he witnessed there.[37] He tells his story: "Prisoners were tortured in many ways. The screams and other noises could be heard at all hours. It was terrifying. When they brought me out of my cell, I was in no shape to paint. But I knew a lot of artists who hadn't made the grade had been killed. Fortunately they liked my work so they allowed me to live. I never imagined I would be standing here today looking at these images because back then my time was up. I was lucky to escape that peril."[38] The camera focuses on Nath holding up his own mug shot and then turns to another survivor, Im Chhan, a sculptor who was kept alive to create busts of Pol Pot. As the camera shows Chhan walking through Tuol Sleng and viewing the sculptures he created under duress, he tells his story: "We were questioned about our background. They tested our skills. Those who did poorly were killed. Those who did well were spared. We all thought we were going to die. No matter how hard one tried to sculpt, one couldn't get a perfect likeness. Sometimes I feel angry and think that they [the sculptures] should be destroyed. But if they were, we'd lose something. It's better to preserve them, to show them to our people and to the world."[39] Chhan then holds up his own mug shot to the camera. These are two improbable instances when the people in the mug shots literally *can* speak to us. By simultaneously telling their stories and showing their mug shots, these survivors defy their former captors and force us, the viewers, to bear witness to the trauma they have experienced firsthand.

Another example of how survivors interact with the records on film is provided by the Academy Award–nominated documentary *The Conscience of Nhem En*, a twenty-six-minute 2008 HBO production. Directed by Steven Okazaki, the film traces three Tuol Sleng survivors (Bou Meng, Chum Mey, and Chim Math) as they return to the prison, grapple with survivor guilt, and confront Nhem En, the Tuol Sleng photographer. Raising complicated issues of culpability and complicity, the film portrays Nhem En as a remorseless perpetrator concerned only with his own ongoing survival and financial wellbeing.

The documentary follows survivor Bou Meng (whose legal testimony was already addressed in this chapter) as he points at mug shots on display at the Tuol Sleng genocide museum. Meng says, "When I see these photos, I think about my wife. I wonder how much she suffered before she died. . . . Both of

us were detained here, but I lived and she died. After the first day, I never saw her again."[40] Later, Meng encounters a group of schoolgirls looking at the mug shot display at the museum. He begins crying as he recounts his story to them, and some of them awkwardly smile and/or turn away from him and the photographs. Meng implores them, "It is important you know about this. This is your history. Your grandparents lost their lives. No one is teaching our young people about the Khmer Rouge."[41] Here, the mug shots not only inspire personal narrative about dead family members but also underscore the drive for collective narrative about the Khmer Rouge.

In that same film, survivor Chim Math points to her own mug shot on display in the museum. She says, "I arrived, sat down, and answered some questions. They took the picture quickly. All I thought was, 'I am going to die.'" Math was tortured for two weeks and inexplicably released. Her survivor guilt is palpable; she has no idea why she was spared. The experience, embodied by her photo, has haunted her despite her attempts to move on. Reflecting the cultural taboo about discussing the regime, she confesses, "I've tried to forget. I never told my husband and children. But I remember what they did like it happened yesterday."[42] Here, Math's mug shot and her filmed interaction with it are a powerful tool for breaking this silence; in the film she is telling not only her husband and children but also the world about her experience.

Yet another striking scene in the film reveals how the mug shots serve as powerful memory texts for the family members of victims. Speaking outside the ECCC Tribunal building, an unnamed man holds up a print of his wife's mug shot. He says, "I must speak for my wife. She was completely innocent. That's why I am here, to demand justice from the tribunal. The wounds inside still haven't healed. The pain continues. The hurt won't stop until there is justice."[43] This interview is revealing for two reasons. First, like Bou Meng, it seems as if the husband is channeling his wife's voice through the mug shot ("I must speak for my wife"). Second, it reveals an intimate connection between the voices heard through the mug shots and the demands of victims' families for legal accountability; this man will continue to speak for his wife until those responsible are found guilty. In this way, the mug shots are being used to craft narratives of redemption in which the records of the perpetrators are tools for enacting justice for the victims.

Samsara: A Film about Survival and Recovery in Cambodia is another short documentary directed by a Westerner. Filmed in 1989, it is the oldest of the films discussed and is meant as an educational film to be shown in the Western classroom.[44] Without an overarching narrative structure, the film follows Cambodians in their daily lives as they attempt to recover after decades of war. Yet the opening scene, which was shot at Tuol Sleng, illustrates the profound

tension between presence and absence, silence and agency, in the ways the family members of victims use the mug shots. The film focuses on several individual mug shots as a male voice says:

> People killed by cruel punishment and torture cannot die with their eyes closed. If we look into the faces of those who died here we can see they suffered great pain. They were tortured and then killed. They suffered pain beyond human measure. [The camera pans to a young man standing in front of the mug shots display at Tuol Sleng. It is his voice we have been hearing. He continues speaking.] I heard that if my relatives were missing I should look for their photos here at Tuol Sleng Execution Center. Pol Pot might have sent them here. But I haven't found them yet. I haven't found their photos. For those we know to have died, we the survivors already made the offerings to send their spirits out of this world. But if we feel in our hearts that our relatives are still alive we are afraid to make the offerings to release their spirits. So we continue to search. As for us, the survivors, we must salvage what is left from this destruction. We have been through such hardship and danger together. Now, we must love one another . . . even more than before Pol Pot time. Because before Pol Pot we thought only of ourselves. . . . Now if we want the spirits of those who died to rest in peace, those of us who are left must change our ways. We must stop being selfish, stop thinking only of ourselves, or we will betray the spirits of those who died here.[45]

The camera zooms in on the eyes of one of the mug shots before continuing to the next scene in which a woman is performing Buddhist rites in honor of her siblings who were killed by the Khmer Rouge. The viewers are set up to make a connection between the visitor to Tuol Sleng searching for his relatives' mug shots, and the performance of religious rituals honoring the dead. Indeed, as the man interviewed in *Samsara* suggests, there is a profound religious crisis that ensues from not knowing with certainty whether a relative is dead or alive and, if dead, on which date the death occurred; it is improper to perform death rituals for someone who might still be alive but equally as consequential not to perform the rituals for someone who is in fact dead, as a dead spirit not properly honored is said to haunt the living as an angry ghost.[46] For those Cambodians who recognize faces at Tuol Sleng, the mug shots provide that certainty, while those who do not find their relatives are condemned to keep searching while their relative's spirit is in limbo. In this clip from *Samsara*, the mug shots are imbued with an immense religious and cultural significance that is also tied into a moral message for the country's future. For the young man in the film, Cambodians can honor the spirits through the performance of religious rites but also by changing their behavior in the present. In this

way, the young man depicted in this scene is tying his personal search for a relative's mug shot to a collective message of action for all Cambodians.

This use of mug shots to connect personal with collective memory about the regime is also apparent in films directed by Cambodians. Rithy Panh is the best-known Cambodian documentary film director. Panh's parents and siblings died of malnutrition and exhaustion during the Khmer Rouge period, his uncle was killed at Tuol Sleng, and Panh himself escaped to a refugee camp in Thailand, from which he was resettled to France. One of his short films, *Bophana: A Cambodian Tragedy*, chronicles the life of Hout Bophana, a Tuol Sleng victim, as described in the introduction. While all of Panh's films reveal an interesting relationship with records, reenactment, and performance, this chapter focuses on his 2003 film *S21: The Khmer Rouge Killing Machine*.[47]

In *S21: The Khmer Rouge Killing Machine*, Panh brings together former Tuol Sleng guards and prisoners for an uneasy reunion. As the former prisoners grapple with why they were tortured and who bears responsibility, the former guards slip back into the daily routines of prison life from twenty-five years earlier, reenacting torture, barking orders, and pretending to type up forced confession statements. The film scholar Deirdre Boyle writes, "What Panh does throughout the film is summon traumatic memory by repeatedly exposing both perpetrators and victims to the site of trauma. By placing them in the empty rooms of S-21 and amid its artifacts, he propels them to live beyond reenactment to 're-live' the past."[48] Boyle posits that it is trauma itself that engenders this reenactment, leaving both victims and perpetrators speechless, so that they can recall events only through bodily memory. Traumatic memory sits at the disjuncture between that which is "virtually inaccessible through language" and that which *must be* told.[49]

The film repeatedly uses Tuol Sleng records as ways to invoke memory.[50] In one scene, two Tuol Sleng survivors, Vann Nath and Chum Mey, brush layers of dust off mug shots at the Tuol Sleng Genocide Museum as they search for familiar faces. Nath recognizes someone he knows and, pointing at the mug shot, names the person depicted and begins to recount a story: "Seak Thap. He was arrested with me. He was from Ksoy. We arrived the same day on the same truck, but our feet weren't shackled together. He was with his brother. I don't know his name, but they were together."[51] "Were there many of you?" Mey asks. "The day I arrived, thirty-two," Nath responds. "Was it at night?" Mey asks. "Three in the morning. We had left at noon," Nath responds. Here, the mug shots are prompts to get survivors to both speak about their own experiences and remember those who were killed. Nath then says that he is looking for a mug shot of his cousin, who was also arrested on the same night at the same cooperative and brought on the same motorbike and truck

to Tuol Sleng. Nath says, "If I find it, I'll make a copy for his mother. . . . She cries when she sees me."[52] Again, we see the profound tension between presence and absence, silence and agency. As we noted when the survivor clutched his wife's mug shot during the Duch trial, Nath's intention to give a copy of his cousin's mug shot to his aunt reveals that mug shots are powerful tools for memory and mourning. Nath survived and is visible and audible in the film, while his cousin, arrested under similar circumstances, is inexplicably dead, his photo is missing, his voice is silent. The cousin serves as Nath's dead doppelganger, the absent counterpart to Nath's presence. His mug shot is never found. For those victims not captured in the surviving collection of mug shots (or in other Khmer Rouge records), the documents, facts, and narratives remain conspicuously silent, histories remain markedly incomplete.

Nath and Mey discuss the possibility of reconciliation. Nath asks, "Until now, has anyone said this past action was wrong, that two million dead among the Khmer people was wrong? Has anyone begged forgiveness? Have you heard that from the lips of any leaders or underlings? Have you? Neither have I. So how can we help the families of victims and survivors find peace again? How do we know it was wrong? Why ask for forgiveness if they did nothing wrong? . . . But to tell us to forget, because it belongs to the past . . . it's not like you step over a puddle and get your pants wet. They dry and you forget. This is something painful, really painful and even if it has been twenty years it's not so far back. It hasn't 'dried.'" Tearfully, Mey responds, "To my dying day it won't, Nath. So long as I live, nothing will be erased."[53] Like the mug shots Mey just looked at, his memory remains vivid, despite the dust that accumulated over time. As these men speak, they are haunted by their memories, unable to forget despite the tragic toll remembering has had on their lives. By telling their stories, these survivors seek acknowledgment from both their former torturers and the world at large.

The film's depiction of Nath's search for meaning at Tuol Sleng is devastating. Throughout, Nath calmly confronts his former captors with documentary evidence, asking them to take responsibility for their actions and to explain why they forced their captives to pose for photographs and to sign elaborate confession statements that they knew weren't true. After Nath reads his own confession statement to Khan, his torturer, the following dialogue ensues:

> NATH: You invented a law that forced people to lie, not to the interrogators like you, Khan, but to lie to ourselves. We denounced people we didn't know, confessed to acts we never did, but we had to so they'd let up a little. . . . So there was nothing human left, was there?

KHAN: We had to have a story, words and phrases.

NATH: You crushed all humanity. Document in hand, you left us in the cell without food, a living corpse, neither man nor animal. And when the time came, you took them away. When you killed them, they were no longer human.

KHAN: At that time, any person who worked here, whether he liked it or not, owed absolute obedience to Angkar.

NATH: I don't want to hear that, "obedience to Angkar." If everyone only thinks Angkar, discipline, obeying orders, "carry out orders or be killed," it's the end of our world, of justice. There are no more human ideals, no more human conscience. We distinguish man from animals. Men are different from animals, they're two distinct things, man and animal. If men turn human beings into animals, or worse than animals, then . . . that's not right. . . . Look, all this is left [points to mug shots and confession statements]. All this evidence is left, all these testimonies. It's lying there, but you pay no attention.[54]

Nath is grappling with both the function of records creation in the Tuol Sleng bureaucracy and his desire to get his former captors to own up to their actions by confronting them with the same records. When Nath confronts another former guard, the guard says that thinking about his actions at Tuol Sleng gives him a headache. Nath responds, "We are not here to tell pleasant stories. We only talk about this unbearable past, which we cannot escape. I can't anyway. I'm trying to understand what happened, to make sense of it. I want to understand it."[55] Nath is compelled to tell his unbearable story and that of the other victims as part of a sense-making quest, and yet, despite his efforts, the violence remains senseless.

In the same film, some of the former guards are also induced into remembering by the mug shots, but their stories are reluctantly told and their memories are strikingly different from those of Nath and Mey. As the guards scan the mug shots on display, they are first silent and then slowly recall how they tortured those prisoners depicted in them. One former guard looks at the mug shot of Nay Nan, a young female "doctor," and describes beating her but getting no response.[56] After consulting Duch, the head of Tuol Sleng, the guard decided to use "strong-arm tactics." Pointing at her photograph and her forced confession statement, he remembers, "I took their advice. I insulted her, intimidated her, pounded on the table, I broke off a tree branch and beat her. When I hit her, she pissed herself. Then she asked to make her confession: Nay Nan's confession. I made her write it in four or five days. I got a page of it. Reading it, I didn't know what network was involved, what party. It contained nothing. So I explained and suggested she write it using my method. She

should describe a network, a party, an activity of sabotage, a network leader. In the end, we managed to write up this document."[57] He is shown with her confession statement. As he tells this story, the guard seems cold, showing no sign of emotion or remorse. And yet, confronted with the documentary evidence, he is still induced to speak about the victims, even while ultimately denying responsibility.

Another Cambodian-directed documentary explicitly connects how family members use mug shots to remember Tuol Sleng victims to efforts to hold the perpetrators legally accountable. *Preparing for Justice* is a sixteen-minute film produced and directed by DC-Cam staff in 2007 and made available via DC-Cam's YouTube channel.[58] The film explains basic information about the establishment of the ECCC and was shown by DC-Cam staff in rural villages as part of the organization's efforts to educate the public about the tribunal. The project documents DC-Cam's outreach programs in which groups of rural Cambodians of all ages and religious backgrounds are brought on day trips to Phnom Penh to visit the Tuol Sleng Genocide Museum, the killing fields at Choeung Ek, and the ECCC building, with the explicit goals of getting them to talk about the regime and to participate in the tribunal. The participants in and the audience for the film are rural residents who might not otherwise know about DC-Cam, the Tuol Sleng Genocide Museum, and the ECCC.[59]

As the visitors make their first stop at Tuol Sleng, one man recalls that he visited the site in 1983. "Today it's different," he says, followed by, "The blood-stains are gone, but the agony remains." While looking at the mug shots and the shackles on display, one man says, "When we see new clothes, it makes us sad because our dead relatives cannot wear them like we can. What can we do? We are all old. We cannot cry. We are too reserved."[60] Another woman is in tears as she looks at the mug shots. She says, "I never came here before. I feel pity for the Khmer people. It makes me very sad. My relatives, your relatives, I miss all of them. Why did Khmers mistreat Khmers? I can't hold back my tears. I lost six to seven family members. My father was killed and so was my uncle and brothers. I had never visited Tuol Sleng before. I feel anger and horror now that I have seen with my own eyes the crime of Pol Pot."[61] Her grief is both personal ("*my* relatives") and collective ("*your* relatives"). Even though she did not find her own relatives' photos at Tuol Sleng, she grieves for the entire nation.

In the next scene, an unnamed man (who, to judge from his age, must have been a young child during the Khmer Rouge period) points at a mug shot on display. Recognizing the face in the photograph, he says, "I know it's him because he's my brother. I recognized him by his hair and lips. When I

look at this photo, I can see his misery. In 1974, he was a soldier in the 110th unit. His rank was Deputy Commander for the Special Sector which protected Phnom Penh. Until 1975, he still came but in 1975 he disappeared. I was very worried and could only hope that he went abroad. I don't feel hopeless, but I'm sad because I know him only through his photo."[62] His comments underscore the ability of the mug shots both to spark stories about the victims of the regime and to embody the memory of those depicted. Again, the family members are confronted with the presence of the victim in the photo and the person's absence in life; a photograph is no substitute for a living brother. The mug shots are simultaneously unwelcome because they confirm death, abruptly halting any hopes of alternative possibilities ("I could only hope that he went abroad") and welcome in that they provide some knowledge of and connection to the dead. If this surviving brother knows his dead brother only through the photo, without it the dead brother would remain unknown.

In the following scene, an elderly woman speaks about discovering her husband's mug shot at Tuol Sleng. She begins by telling her husband's story: "The Khmer Rouge deceived my husband into telling them about his work in the previous regime. He admitted that he was a soldier serving the royal family. They took him to Phnom Penh. A man, who was arrested with him managed to escape and said my husband was hung at Tuol Sleng. I came here to see for myself. I only saw his photograph. I have no hope. They took him forever because he told them the truth. It's too painful to even talk about. Now I am all alone. I lost all my brothers and sisters."[63] The experience of viewing her husband's mug shot simultaneously provides evidence of his fate ("I came here to see for myself") and is utterly inadequate ("I *only* saw his photograph") (emphasis mine). Paradoxically, viewing the mug shot serves as a catalyst for the construction of a narrative about the dead but at the same makes survivors feel that they are rendered speechless ("It's too painful to even talk about"). Words are inadequate in the face of such images, yet survivors are compelled to speak.

The film then follows the participants to the killing fields at Choeung Ek and to the ECCC building, which the narrator claims is "the most important stop on the tour." Participants are told that when they get involved with the tribunal, "you can determine for yourself whether the court can bring justice." In subsequent interviews, participants remark how "satisfied" they are after seeing the ECCC, how the court "will give perpetrators the chance to reveal the truth," "give people a great sense of relief," and "bring justice to the dead and relieve their spirits of anger." Only one woman seems unconvinced by the ECCC's potential merits: "they should be punished with torture and death, the same way they treated us," she says. However, the underlying message of

the film is clearly summarized by one man's final comments: "I am glad to participate in this tour because there will be no more bloodshed in our country if the establishment of the court is successful." The film explicitly links the past injustices as documented at Tuol Sleng to the possibility of future redemption through the rule of law. The footage captures a unique moment after the establishment of the court but before the verdict of the first trial; after Duch's sentencing to a thirty-year prison term in 2010 and repeated allegations of court corruption and mismanagement, such optimism about its importance has clearly diminished in the eyes of the Cambodian public.[64] Yet, as *Preparing for Justice* reveals, the families of Tuol Sleng victims clearly make a connection between the mug shots (and other Tuol Sleng records) as personal evidence that inspires their own stories about the dead and legal evidence that they hoped will inspire collective memory and justice.

Despite their differing agendas, directors, and styles, these five films are united in their use of Tuol Sleng mug shots as catalysts to spur survivors and victims' family members to talk about the Khmer Rouge. In these films, it is the survivors themselves who use the mug shots as a way to talk about what happened to them. Yet, for the most part, we are still confined to secondary testimony. With the exception of the handful of Tuol Sleng survivors and guards we hear and see in these films, the torture at Tuol Sleng and the subsequent mass murder at the killing fields is an event with few surviving direct witnesses. We are left with the mug shots themselves as silent witnesses, brought back to life (figuratively) by the telling of stories by their family members. As Eric Ketelaar writes about records in a different context, "Some records . . . had, as it were, to be 'performed.' Records do not speak for themselves: to make them alive requires a rhetorical act."[65] In these documentaries, family members use the mug shots to perform remembrance, making them "alive" through the act of narrative creation. Through this performance of memory in the trial and on film, victims' family members are also performing human rights, linking memory to legal and historical accountability and asserting the right to remember in the face of a regime that encourages forgetting.

DC-Cam's Newsletter: *Searching for the Truth*

Adding to the use of the mug shots in the tribunal and in documentary films is their use in DC-Cam's magazine, *Searching for the Truth*. DC-Cam began publishing *Searching for the Truth* in January 2000. The publication comes out monthly in Khmer and quarterly in English. It is

distributed free of charge in Khmer throughout Cambodia and for a small fee in English in Cambodia's two major cities (Phnom Penh and Siem Reap); it is also available for download in both languages free of charge via DC-Cam's website.[66] Bound copies compiling English editions are also available for a steep fee at foreigner-oriented bookstores in Phnom Penh and are periodically sent by DC-Cam staff free of charge to select research libraries in the United States.[67] The magazine has changed through time but currently contains several regular features: a letter from DC-Cam director Youk Chhang; a Documentation section, which reproduces images and/or translations of Khmer Rouge records in DC-Cam's collection; a History section, which has reprinted scholarly articles written by scholars of the Khmer Rouge from around the world; a Public Debate section, in which Cambodians write in with their stories about the Khmer Rouge period and opinions on accountability efforts; a Legal section, which explains the intricacies of the tribunal; and a Family Tracing section, in which Cambodians write in soliciting information from both DC-Cam staff and the Cambodian public about loved ones missing since the Khmer Rouge period.[68] Any information in response to such requests is gathered through archival research and then printed in subsequent editions of the magazine. As Chhang introduced the column in *Searching for the Truth*'s first issue, "While it will be a column of horrific and tragic pain, it is a column that will help eliminate doubt and bring an eternal happiness. The column will help honestly disseminate information to the public, and it will describe new lives after the Khmer Rouge time."[69] As I have written elsewhere, the Family Tracing section often uses pre-1975 family photographs to show the disappeared in happier times and provides a space in which personal memory becomes collective memory.[70]

While *Searching for the Truth* reprints many types of photographs, its frequent use of Tuol Sleng mug shots is striking. Every issue has at least one Tuol Sleng mug shot; several issues have featured dozens of them. Some mug shots accompany related articles, some are devoid of context, some are reproduced over entire back covers, and many appear on the contents page; some depict named victims, some depict unknown victims with the hope that readers will be able to identify them.[71] In fact, identification is one of the main reasons DC-Cam publishes the mug shots. As one unattributed article states: "Some of the photographs published in the magazine are associated with biographies, while others, especially those of victims, bear no identification and are unrelated to any specific article. We will appreciate any relevant information, such as age, place of birth, and whereabouts of the individuals whose photographs appear in our pages, so that we may further improve our data regarding the Democratic Kampuchea [Khmer Rouge] regime. The Documentation Center

of Cambodia would like to thank you in advance for any additional informa-
tion the reader may be able to provide relating to unidentified photos. Our
sincere thanks."[72] This chapter's discussion is limited to five key instances that
illustrate the ability of these photographs to evoke detailed narratives through
their reuse on the pages of the magazine. These instances are the stories of one
Tuol Sleng survivor, Bou Meng (who was also discussed earlier in this chapter),
and four Tuol Sleng victims, Chan Kim Srun, Poeung Kim Sea, Yuk Chantha,
and Norng Kim Gech, as told by their surviving family members.

In the October 2001 issue of the magazine, Sorya Sim, a DC-Cam staffer,
profiled Tuol Sleng survivor Chum Mey. Mey openly acknowledged in the
article that he was still afraid that speaking about his experiences might lead
Khmer Rouge officials to target him but said that he would tell his story any-
way, because he wanted to "document the history and tell the leaders about
what happened, so that they won't repeat the same tragedy."[73] The article
then details Mey's graphic story of being arrested, tortured, and forced to sign
a confession statement at Tuol Sleng.[74] Mey explains how he was briefly re-
united with his wife and child after the Vietnamese invasion, only to witness
them both being killed by retreating Khmer Rouge soldiers. The article is
accompanied by a 1979 photograph of the seven then-known surviving Tuol
Sleng prisoners, as well as an enlarged image from that same photograph of a
prisoner named Bou Meng, who the article states has since passed away. How-
ever, a subsequent article in the April 2003 edition of the newsletter corrects
this error. The article reveals how Bou Meng, alive and well and living in a
rural area of Cambodia, came forward to tell DC-Cam his story after seeing
his own photograph in the article about Mey.[75] He received a copy of the
newsletter from the head of the Buddhist pagoda in his province. Meng is
quoted as saying, "I am not dead. I am one of the victims of this prison. I want
to see former KR leaders prosecuted and I'll be a witness."[76] Meng then gave a
forty-page statement to Sim, a much shorter version of which was published
in the magazine; he also spoke at public events at DC-Cam, agreed to tell his
story for the DC-Cam documentary *Behind the Walls of S-21: Oral Histories
from Tuol Sleng Prison*, and later testified against Duch in the tribunal.[77] In
the article, Meng recounts how, like Vann Nath, he was spared from being
killed because of his skills as an artist; the Tuol Sleng administration marked
"keep a while" on his prison record and used him to paint portraits of Pol
Pot. Meng's narrative, inspired by the publication of Mey's narrative and the
accompanying photographs, is now part of the historic record and an integral
component of the burgeoning collective narrative that DC-Cam is helping to
shape about the regime. Seeing his own photograph in *Searching for the Truth*,
Meng was compelled to step forward with his story of surviving Tuol Sleng.

Furthermore, Meng's narrative has the explicit end goal of legal accountability in that he wants his story to be heard, not just by the readers of *Searching for the Truth* but also by a court.

In several cases, victims' families were reunited with their dead loved one's mug shots after the photos were published in *Searching for the Truth*, leading not only to identification of the victim in the photo but also to further details of the victim's life. For example, the July 2000 issue of the magazine included several unidentified mug shots. The following year, a 2001 article titled, "Want to Know the Truth," published in the Family Tracing section, recounts how Van Sar saw the mug shot of his cousin Yuk Chantha reprinted in the July 2000 issue of the magazine.[78] Sar then wrote to DC-Cam identifying his cousin in the photo and asking for any further information on Chantha. Having connected the name with the photograph, DC-Cam staff were then able to find Chantha's Tuol Sleng file, which had been separated from the mug shot. The article recounts the details of Chantha's life culled from this file, including his position in the government before the Khmer Rouge takeover, his date of arrest, his wife's name, and the number of children he had. It also includes the accusation, taken from his Tuol Sleng file, that he was a Soviet spy and lists his date of death as July 18, 1978. After being presented with this information about his cousin, Van Sar is then quoted as saying, "I want to seek real justice." The article ends with an explanation of the purpose of the Family Tracing section: "to heal the mental wounds of the victims' families by providing knowledge about their relatives' fates, including the place, time, and reasons for execution."[79] While Chantha's mug shot is not reprinted in the 2001 issue, three unidentified Tuol Sleng mug shots appear beside the article, presumably awaiting identification by another reader who, like Sar, "wants to know the truth" about a missing family member. Again, in this case reprinted mug shots led not only to narratives about the dead but also to demands for justice in the form of a tribunal.

Another published letter in the Family Tracing section, "The Confession of My Father," reveals how the mug shots allow family members to both request further information from DC-Cam's records about the deceased and publicly tell their own stories about the lives cut short.[80] In the letter, Sea Kosal writes, "Reading such material [in *Searching for the Truth*] reminds me of the considerable suffering of my parents experienced [*sic*], as well as all Cambodian citizens who lost their lives due to the barbarous, disgusting reign of the leaders of Democratic Kampuchea." Kosal then describes finding the then-unidentified mug shot of his father, Proeung Kim Sea, in a CD-ROM produced by DC-Cam. He describes his father as a former medical doctor "who was tortured to death by the Khmer Rouge monsters." His letter requests that DC-Cam staff look

up his father's case file and provide additional information. Kosal concludes by wishing DC-Cam "continued success in the research and documentation of genocidal perpetrators to be brought to justice very soon."[81] The letter appears next to a full-page reproduction of the father's Tuol Sleng mug shot, which is identified by name and includes the caption: "Before 17 April 1975, he was a chief of Health Office in Battambang province and he ran the state-owned Provincial Hospital of Battambang. He graduated from a University in Paris, France."[82] In these letters, the family members make public their personal memories about the dead, and yet their own stories are never enough; they request more information from the archives as external proof of their loved one's life and death. The end goal of this drive for more information and to tell stories about the dead is not just remembrance but also justice; individual memory, collective memory, and legal accountability are intimately connected in these narratives.

Another article provides some clues about the importance of these mug shot reunions and their ensuring narratives in the cultural and religious context of Cambodian Buddhism. A July 2002 *Searching for the Truth* article titled "From the Border to S-21" tells the story of Chan Lim, whose wife, Norng Kim Gech, and son, Chauv Kea, were imprisoned at Tuol Sleng in 1978. The article is accompanied by both of their mug shots and recounts the story of where the family lived, what business they were in before the Khmer Rouge takeover, and their escape to a Vietnamese border town that was eventually taken over by the Khmer Rouge. Lim recalls how the Khmer Rouge arrested his wife and son while he was away and adds that he never heard from them again. The article goes on:

> [Lim's] brother-in-law Hong Chea visited the Tuol Sleng Genocide Museum in Phnom Penh. There, he came across portraits of Lim's wife and son. Hong told Cham Lim about this when he returned home. Cham Lim was stunned and afraid to go and see the photographs. So Hong brought Lim's children to see them and take photographs of the portraits. . . . The family still uses the photographs for ceremonies. Cham Lim cannot forget his family's suffering during the regime, even though more than 20 years have passed. He is still preoccupied with the image of his wife and son. During the Hungry Ghost Festival, Cham Lim always pays homage to the pictures. He never dares to burn incense before the portraits; he cannot bear the suffering. Instead, he asks his children to do this.[83]

In this example, the victims have already been identified through the photo exhibition at Tuol Sleng, yet photos of their mug shots on display at Tuol

Sleng serve important cultural and religious functions. In this narrative, the grief of the living is palpable. The mug shots, once used as instruments to streamline mass murder, have now come to embody the dead and serve as tools to honor them for the living. In this way, the archive is complexly layered and ever expanding, encompassing all of these attempts to make meaning through the use of records. Once again, this story concludes with demands for a tribunal. It ends: "Cham Lim supports an independent tribunal to prosecute Khmer Rouge leaders and obtain justice for his wife and son as well as the other innocent people of Cambodia who perished under the Khmer Rouge regime. The longer he waits, the less hope he has that justice will be done."[84] In this way, the mug shots are political tools as well as personal memory texts.

Perhaps the most striking example of the circular construction of narrative enabled by these printed mug shots is the story of Chan Kim Srun. Chan Kim Srun was the wife of Sek Sath, a high-ranking Khmer Rouge officer (Secretary of Region 25 Southwest) who was accused of treason in 1978. Srun, her husband, and their one year-old son were all brought to Tuol Sleng and executed. Srun's mug shot is one of the mostly widely known iconic images from Tuol Sleng; in it, she holds her sleeping son (figure 16). Exhibited at MoMA and reprinted in the accompanying catalog, her face has become an international emblem of maternal grief.[85] Srun's mug shot has also been reprinted dozens of times in *Searching for the Truth* and was the full-page cover of the fourth issue in 2003 (figure 17) as well as one of nine mug shots (some identified, some not) on the cover of the first issue of 2011.[86]

In 2008, the magazine ran a story entitled "30 Years Later," which describes how Chan Kim Srun's surviving daughter, Sek Say, was separated from her remaining family in 1979 at age twelve.[87] Say's cousin, Sek Saron, had been searching for her ever since and in 2003 had broadcast several announcements looking for her on both television and radio, to no avail. In 2007, Saron wrote an article in *Searching for the Truth* asking for any information on her cousin Sek Say's whereabouts.[88] As a result of this article, Saron and Say were reunited. A 2008 article in *Searching for the Truth* describes this reunion: "Say was so happy the first time she reached her hometown. . . . Say smiles as she remembers the reactions of her family when they saw her for the first time in nearly 30 years. . . . However, Say's happiness soon turned to sadness. The reunion was joyous for only a moment because Say realized that nothing could equal the feeling of seeing her parents again. . . . She could only see a photo of her mother with her baby brother."[89] It was the first time Say had seen her mother's Tuol Sleng mug shot. The article continues by recounting details of Say's memories of her parents, how her mother was strict, what her father wore each day. It describes how Say asked for a copy of her mother's mug shot

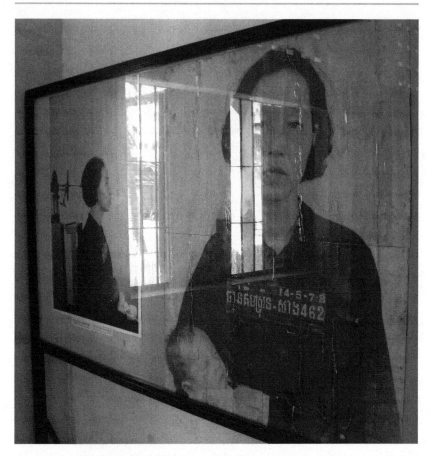

Figure 16 Chan Kim Srun's mug shot at Tuol Sleng Genocide Museum. (Photo by author)

and, when she received confirmation from DC-Cam staff about her parents' death dates, donated money in their honor to the local pagoda. It concludes with Say's demands for justice: "her desire is to directly participate in the trials as a witness but she worries that she may not be able to speak well because she does not have a higher education."[90] The article is accompanied by a photograph of Say, holding both her own child and the framed mug shot of her dead mother and brother (figure 18). In this case, the mug shot did not reunite Say with her cousin (indeed, the written word did), but the mug shot linked Say with evidence of her dead parents and brother. The mug shot serves as both visual proof of their imprisonment at Tuol Sleng and a prompt for Say to tell both their stories and her own during the regime. The mug shots are evidence of both a larger narrative of mass torture at Tuol Sleng and very

The Making of Narratives

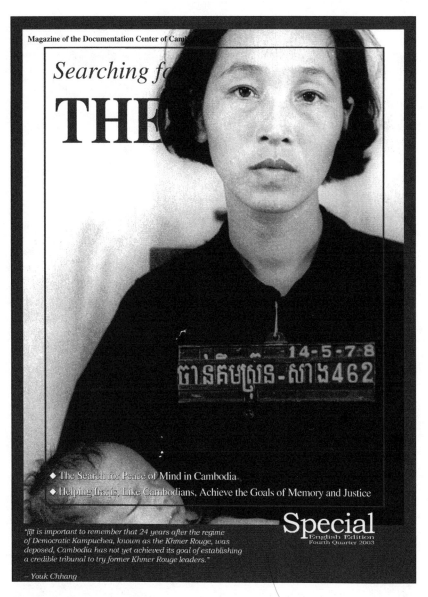

Figure 17 Chan Kim Srun on cover of *Searching for the Truth*. (Courtesy of Documentation Center of Cambodia Archive)

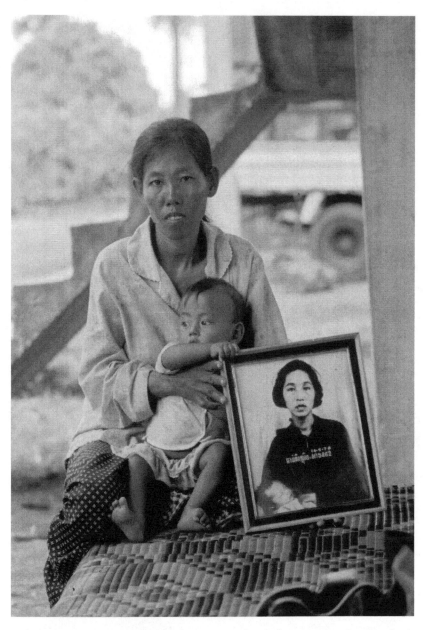

Figure 18 Sek Say with Chan Kim Srun's mug shot. (Originally appeared in *Searching for the Truth* 1 [2008]: 7; courtesy of Documentation Center of Cambodia Archive)

personal reminders of the dead. In the hands of DC-Cam staff writers, they also become calls to action, linking memory to the tribunal.

As these five cases have illustrated, by printing mug shots in various forms, DC-Cam is providing a space in which private memories become public memory, personal narrative becomes collective narrative. Through the pages of the Family Tracing and Documentary Photographs columns, survivors' missing family members become all of Cambodia's missing family members; survivors' grief becomes Cambodian collective grief over all of the victims of the Khmer Rouge.[91] By using the mug shots as a tool for both information gathering and narrative generation, DC-Cam is providing a space for individual trauma and memory to become collective trauma and memory through the construction of collective narratives about the dead. The seemingly simple act of reprinting the mug shots and, when possible, the corresponding letters from victims' families transforms these documents into powerful testimony in which we are all implicated as witnesses to the crimes of the Khmer Rouge and are compelled to negotiate a collective narrative about the regime.

And yet, for DC-Cam's writers and the victims' family members, the narratives are not only about the lives of the dead but also ultimately about justice for the living. In all five of the featured stories, the final goal of the remembering engendered by the mug shots is legal justice. DC-Cam is mobilizing these mug shots for an explicitly political aim: the conviction of a few top-ranking Khmer Rouge leaders. This narrative—that archival evidence will lead to the legal conviction of those who bear the most responsibility for the genocide—is made explicit throughout DC-Cam publications. The readers of *Searching for the Truth* are to look at the mug shots as overwhelming evidence for the guilt of the regime and be compelled into action in support of a tribunal by them.

While DC-Cam's newsletter gave voice to the majority of Cambodians who supported the ECCC's efforts at legal accountability (at least at the start of the tribunal), it downplayed the voices of Cambodians who think the tribunal is a waste of resources. Indeed, while the 2009 University of California, Berkeley survey showed that nine out of ten Cambodians support efforts to hold the regime legally accountable, very few Cambodians (only 2 percent) mentioned justice for the victims of the Khmer Rouge as a top priority. Instead, the overwhelming majority of Cambodians surveyed prioritized job creation, economic opportunity and poverty alleviation (83 percent), basic services like health care (20 percent), and access to food (17 percent). Furthermore, 76 percent of respondents said that the government should prioritize current problems rather than past atrocities, and 53 percent of respondents said the government should spend resources earmarked for ECCC toward projects other than the ECCC.[92] Viewed in the context of these statistics, the DC-Cam stories reveal

a gap between a conception of human rights as the legal adjudication of the Khmer Rouge past and a conception of human rights as seen through more immediate struggles over labor, land, health care, and corruption. While these two differing conceptions of human rights are not necessarily conflicting or mutually exclusive, they do represent competing priorities in terms of international funding, political agendas, and media attention.

Images of People Looking

In each of the featured formats—video footage of the tribunal, documentary films, and print publication—there is also another layer of looking. In each of the three examples—legal testimony, interviews in documentary films, and still images in the DC-Cam newsletter—mug shots are reproduced as the focal point of new images of people looking at them. Video footage from the tribunal shows judges, lawyers, witnesses, and observers looking at the mug shots projected on a screen as legal evidence. Documentary film footage shows Tuol Sleng survivors and the family members of victims looking at the mug shots either at the Tuol Sleng archives or on display at the Tuol Sleng Genocide Museum. *Searching for the Truth* routinely features photographs of Cambodians looking at the mug shots, particularly the family members of victims and rural villagers and students on DC-Cam–sponsored trips to the Tuol Sleng Genocide Museum as part of the organization's outreach efforts on behalf of the ECCC.[93]

The printed reuses of Chan Kim Srun's mug shot in photos of people looking at them provide a particularly rich example. Adding to the photograph of Srun's daughter, Say, holding her mother's mug shot previously described (figure 18) are additional images of Srun's surviving family members looking at her mug shot. In 2010, *Searching for the Truth* ran another image of Say holding a photograph; this time the photograph was not just of her mother's mug shot but of Hillary Clinton and Youk Chhang looking at her mother's mug shot during a visit Clinton made to the Tuol Sleng Genocide Museum as part of a trip to bolster international support of the tribunal (figures 19 and 20). A more recent image used by DC-Cam documents the next generation of Srun's family witnessing her mug shot; the cover of a 2011 monograph published by DC-Cam, *Cambodia's Hidden Scars: Trauma Psychology in the Wake of the Khmer Rouge*, shows Chan Kim Srun's nine-year-old granddaughter, Phan Srey Leab, holding her grandmother's mug shot (figure 21).[94] In these images, the witnesses looking at Srun's mug shot stand in for larger constituencies; Clinton is a symbol of the international community, Leab, a direct descendant of a

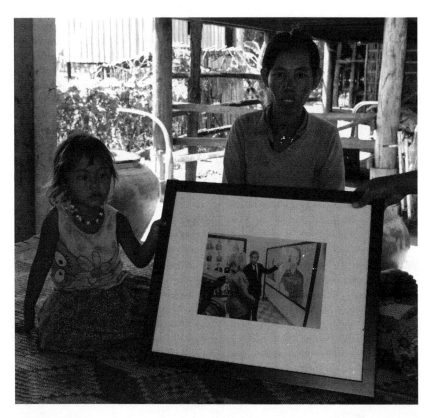

Figure 19 Sek Say with photo of Hillary Clinton looking at Chan Kim Srun's mug shot. (Originally appeared in *Searching for the Truth* 4 [2010]: 2; courtesy of Documentation Center of Cambodia Archive)

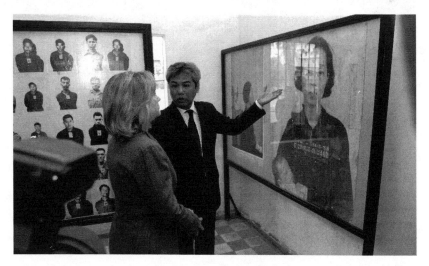

Figure 20 Hillary Clinton and Youk Chhang in front of Chan Kim Srun's mug shot at Tuol Sleng Genocide Museum, November 2010. (Photo by US Embassy, Public Affairs Office; courtesy of Documentation Center of Cambodia Archive)

Figure 21 Phan Srey Leab with Chan Kim Srun's mug shot on the cover of *Cambodia's Hidden Scars*, edited by Beth Van Schaack, Daryn Reicherter, and Youk Chhang. (Courtesy of Documentation Center of Cambodia Archive)

Khmer Rouge victim, a symbol of the next generation of Cambodians. In the case of Sey's photo, a survivor of the Khmer Rouge is witnessing the international community witness her mother's murder. In the case of Leab's photo, the next generation of Cambodians is witnessing the murder of its ancestors. In both cases, witnessing the mug shots is an antidote to forgetting.

These complexly layered images reflect the creation of new records that document the act of looking at the mug shots and provide an opportunity for us, the viewers of these images, to enable another layer of looking. In this way, the mug shots are performing human rights by becoming a vehicle through which people can document bearing witness to the crimes of the Khmer Rouge and garner international attention for the assertion that such crimes should not be repeated.[95] As they gain another life in reprints of images (digital and paper, video and still) of people looking at them, the mug shots are transformed from records of oppression to records of justice, the narrative transformed from one of the helplessness of victims in the face of genocide to one of the agency of survivors in the act of witnessing.

These photographs of people looking at the photographs attempt to forge a narrative of agency where a narrative of grief once prevailed. It's as if to say to the victims, "You had no choice to be photographed, but I have a choice to look at those photographs, and I want the world to know that I am looking."[96] By documenting the viewing of these images, DC-Cam staff and other creators of records are inserting agency—through both the viewing and the documentation of the viewing. These photos document the very act of memory. Taken together, they form an archive of the act of archiving, again implicating us, the viewers, as bearing witness to the testimony of the victims.

This exploration of the creation of narratives of bearing witness builds on the work of the psychiatrist Dori Laub and the film studies scholars Frances Guerin and Roger Hallas. Dori Laub, an expert on treating posttraumatic stress disorder in Holocaust survivors, addresses the importance of the presence of the listener when taking oral histories about traumatic events. She writes, "Bearing witness to a trauma is, in fact, a process that includes the listener. For the testimonial process to take place, there needs to be a bonding, the intimate and total presence of an *other*—in the position of one who hears. Testimonies are not monologues; they cannot take place in solitude. The witnesses are talking to somebody; to somebody they have been waiting for for a long time."[97] Following Laub's cue, Guerin and Hallas define witnessing as a mutually constitutive and performative act. They write: "The encounter with an other is central to any conception of bearing witness. For a witness to perform an act of bearing witness, she must address an other, a listener who consequently functions as a witness to the original witness. The act of bearing

witness thus constitutes a specific form of address to an other. It occurs only in the framework of relationality, in which the testimonial act is itself witnessed by an other. This relationality between the survivor-witness and the listener-witness frames the act of bearing witness as a performative speech act . . . [which] affirms the reality of the event witnessed."[98] For Laub, the testimony is verbal, the witness a listener. As media studies scholars, Guerin and Hallas expand Laub's conception of testimony and the witness to apply to visual materials, specifically addressing the viewers of images that document trauma. They use the term "secondary or retrospective witnessing" to describe the act of looking at photos of genocide.[99] In this reworking of Laub's ideas, the viewers of such images become retrospective witnesses, not present in the original documentary act but essential to the performance of witnessing through subsequent viewing.

In this vein, we, the viewers of these images of Cambodians viewing the mug shots, are implicated in the process of witnessing; it is a mutually constitutive act between the witness *in* the photograph and the witness *to* the photograph. Our looking at these images enables the subjects in them to become witnesses and us, the viewers, to become retrospective witnesses. Transformed into witnesses, the Cambodians pictured in these images are asserting a sense of agency in the creation of new documents. These new documents then become part of the archives, serving as springboards for new narratives to be crafted. In this way, a narrative of victimhood in which 1.7 million people were murdered by the Khmer Rouge is transformed into a narrative of witnessing, in which countless people are remembering genocide and even more are witnessing this remembering through the circulation of digital and print photographs that document the act of looking.

In this secondary layer of witnessing, the viewers of these images and the listeners of these narratives are burdened with almost unbearable knowledge. As Laub posits about Holocaust testimony, the listeners to testimony of traumatic events become an integral component of the process, "co-owners" of the trauma, who are forever changed by the experience.[100] As secondary witnesses to the violence of Tuol Sleng, we are to become transformed into advocates for justice, as legal accountability is the explicit agenda of many of the narratives explored in this chapter. Here, archivists become (in the words of Ricardo Punzalan) not just "co-witnesses" to the event but accomplices to witnessing and, as such, political actors.[101]

Adding to this argument, the occasion of taking these photos of survivors and victims' family members looking at the mug shots constitutes a political act marking the performance of human rights in Cambodia. In this view, the creation of new records of witnessing constitutes a performative deployment

of the archive for political activism. This analysis draws on work by Andrea Noble on the uses of photographs of the disappeared in Latin America and by Susan Slyomovics on the various ways human rights are performed by the family members of political prisoners in Morocco. Here, as Noble claims, photographs are not merely props but also "centrally important element[s] in the material culture of protest and struggles for justice."[102] Arguing that staged photos of family members holding photos of the disappeared in Argentina constitute "a mode of photographic performance" that taps into an "established iconography of human rights activism," Noble contends that "the photograph within the photograph has become a poignant symbol of forced disappearance." Furthermore, as Noble claims, these photos of photos constitute political performances, as "the physical deployment of images, particularly identity photographs, is central to the representation of absent bodies of the missing," performed in direct opposition to regimes that promote forgetting, destroy evidence, and actively encourage silence.[103]

If we apply Noble's insightful analysis to a different context, the images of Cambodians looking at the mug shots become a photographic genre, establishing a repetitive pattern that becomes instantly recognizable as part of the performance of human rights in Cambodia.[104] In Cambodia as in Argentina, the staging of the photo itself is an act of political protest that extends beyond local and national borders by creating a spectacle that moves through space and time as it is published and reproduced in various media and formats. Through their strategic deployment in such media spectacles, the photographs become active agents in the human rights struggle in that they perform the act of bearing witness.[105] And here in the Cambodian context, the photos within the photos shift our focus not just to the presence of the absence of the victim but also to the absent perpetrator at whom (in the Cambodian case) the victim is literally staring in the mug shots, with us as witnesses.

Yet these photographs advance a very particular construction of human rights as experienced in the context of the Khmer Rouge past. In this construction, human rights are defined vis-à-vis the absence and adjudication of their most egregious violation, that is, systematic mass murder, rather than in the more immediate context of ongoing Cambodian struggles against labor exploitation, land grabbing, and corruption. However, despite this point of tension between two different conceptions of human rights, these images of witnessing still speak to contemporary Cambodian politics in the sense that the Khmer Rouge past is still very present in virtually every aspect of society. In this sense, these images of witnessing are in direct conversation with the current regime's strategic deployment of the Khmer Rouge past and are staged against the backdrop of ongoing demands for economic and social justice.

Undergirding this assertion that images of witnessing perform a particular notion of human rights is the theoretical and methodological framework of the social life of records. Through the lens of Appadurai, Tuol Sleng mug shots are material objects given various meanings and values as they circulate through time and space. For Mitchell, the Tuol Sleng images would be "complex assemblages" of meaning incarnated in objects, made tangible through media, behaving as agents that shape human behavior and "want to be heard."[106] The Tuol Sleng mug shots perform this desire to be heard for us, but, as Mitchell asserts, this desire is an impossibility; the images remain silent regardless of the voices we impose on them. And yet, while the victims pictured in the images remain silent, their surviving family members are compelled to speak by the images, breaking the silence of the images with the voices of those left behind to witness.

In light of Trouillot's four moments of silence (silences encoded at the creation of documents, archives, narratives, and histories), the witnessing engendered by these photographs reintroduces an active voice into the archive of mug shots, disrupting the silences of the first two moments. Through the deployment of the Khmer Rouge records for the creation of narratives, victims' family members are induced from silence into testimony, transformed from secondary victims into secondary witnesses. We, the listeners to their stories and the viewers of their images, are tertiary witnesses to this struggle. The photos of people looking at the mug shots compel us to bear witness to those who remember. These new records then become incorporated into archives (DC-Cam and other institutions), and are used to create new narratives. In Trouillot's framework, these new records incorporating the Tuol Sleng photos insert the voices of survivors and victims' family members at the moments of archivization and narrative creation where there was a silence embedded in the original moment of document creation.

From a records continuum perspective, the reuses of the mug shots highlight the circular nature of the archive. The record isn't created just once but re-created (as the by-product of the act of witnessing), recaptured (as new records such as tribunal footage, documentary films, and magazine articles), reorganized (in internal institutional systems), and repluralized (as it published and viewed in formation of collective memory) as it is used again and again or "activated" at various points in time and space.[107] While claiming that the Tuol Sleng victims in the mug shots are co-creators of the records gives them a false sense of agency, the witnesses in these photographs of people looking at the mug shots are co-creators of these newly recaptured records. In this way, these new records that reuse the Tuol Sleng images shift the balance from the

The Making of Narratives

Khmer Rouge's power to create records of control to the survivors' power to create records of witnessing. The empowerment expressed in and engendered by the creation of these records imbues them with another layer of agency as they are transformed into agents in the performance of human rights.

Furthermore, the meanings of the mug shots are never fixed in a final instance but rather are in a continual "process of becoming," as they are recontextualized in new records that incorporate them. The mug shots are, in the words of Ketelaar, "membranic" in the way they enable "the infusing and exhaling of values which are embedded in each and every activation," allowing for different meanings to be constructed with each use.[108] Thus, they can simultaneously be tools for legal accountability, witnessing, memorialization, personal and collective memory, and other aims we can not yet anticipate. As Sue McKemmish describes a different set of controversial images, "we see records as dynamic objects, fixed insofar as their original content and structure can be re-presented, but 'constantly evolving, ever-mutating,' . . . as they are linked to other records and ever-broadening layers of contextual metadata that manage their meanings, and enable their accessibility and usability as they move through spacetime."[109] While the content of the Tuol Sleng mug shots does not change, the context is continually shifting to incorporate new uses. Thus, the Tuol Sleng mug shots cannot be adequately viewed on their own but must be viewed in the context of their complex and shifting relationships with people, events, and new records that incorporate and respond to them. Furthermore, these new records that incorporate the mug shots add to what Ketelaar would call the "semantic genealogy" of the records, affecting all future meanings.[110] Once we know the mug shots have been used in legal testimony, in documentary films, and on the pages of *Searching for the Truth*, we can never view them in the same way again; the mug shots themselves have been transformed with each reuse. By extension, the archives are multilayered, dynamic, and in constant motion. This view directly contrasts with more traditional views of archives (as intimated by Trouillot), which see them as static repositories of facts that are merely tapped for the raw materials to begin the more creative process of storytelling. Instead, narrative creation is integral to the archives as the narratives become part of the ever-changing semantic genealogy and provenance of the records. In this way, the legal, video, and print testimonies discussed in this chapter are now part of the mug shots themselves, locating them at specific moments and places of interpretation but also imprinting their future uses.

While survivors and victims' family members craft these narratives, DC-Cam, as a community-based, survivor-led archival institution, plays a

crucial role in the creation of this new sense of agency.[111] In each of the formats addressed—legal testimony, documentary films, and magazine articles— DC-Cam has taken the lead in soliciting, documenting, and disseminating testimony, serving as a hub for a "community of records," composed of survivors, victims' family members, and new generations of Cambodians.[112] For DC-Cam, archival work has an explicit end goal of holding Khmer Rouge leaders legally accountable for their actions. In Cambodia's contentious climate, in which former Khmer Rouge members have infiltrated the highest levels of government, and in the international community, where only certain leaders are ever held responsible for war crimes, this is an inherently political agenda.[113] In this way, DC-Cam is stepping beyond the boundaries of the traditional archival role, engaging archival collecting as a political act that performs the work of human rights in a hostile environment.[114] This political agenda again underscores Verne Harris's claims that archival functions, rather than being apolitical, neutral, or objective, are inherently political and that the archive itself is "the very possibility of politics."[115] By countering the silences with witnessing, DC-Cam is an active agent in the political struggle for remembrance and justice, countering the silences of the victims encoded in the records with the voices of family members who bear witness in new records.

And yet, there are silences embedded here, as well. There is a danger that if we frame Cambodian human rights in the context of the Khmer Rouge's mass murder, more immediate but comparatively less egregious violations of human rights in terms of land and labor will go ignored. There is also a danger that, in the construction of new narratives, the victims of Tuol Sleng have come to stand in as representatives for all of the victims of the Khmer Rouge, despite the unique position of Tuol Sleng at the apex of Khmer Rouge surveillance. Indeed, this focus on Tuol Sleng may hide or distort how most victims of the regime died—from starvation, disease, and exhaustion—rather than from the efficient and systematized incarceration, torture, and murder at Tuol Sleng. As Stephanie Benzaquen writes, "While one focuses on the 17,000 victims of Tuol Sleng one forgets about the other two millions dead who left no trace."[116] While the Tuol Sleng mug shots gain new life as they are recaptured in new documents that perform human rights, the vast majority of the dead remain silent, leaving no material trace, except, perhaps, for their bones resurfacing at Cambodia's many mass graves. Furthermore, the disproportionate rate with which certain Tuol Sleng mug shots—Chan Kim Srun's is a prime example— get reproduced on book covers, in publications, and on DVDs, misrepresents Khmer Rouge victims as women and children and as elites, silencing the other victims of Tuol Sleng and the Khmer Rouge. Even the narrative of the empowerment and agency of witnessing—created in part by DC-Cam—is

bounded by the limits of record creation. As Trouillot writes, "the production of traces is always the creation of silences. Some occurrences are noted from the start; others are not. Some are engraved in individual or collective bodies; others are not. Some leave physical markers; others do not."[117] For those victims not captured in the Tuol Sleng mug shots (or in other Khmer Rouge records) or whose photographs have not become iconic, our documents, facts, and narratives remain conspicuously silent, our histories remains markedly incomplete.

4

The Making of
Commodities

Many who visit Tuol Sleng do so because they desire to be haunted.

Rachel Hughes, "Dutiful Tourism: Encountering the Cambodian Genocide"

During visits to the Tuol Sleng Genocide Museum in December 2011 and January 2012, I was stunned to see both Bou Meng and Chum Mey—the two known surviving adult Tuol Sleng prisoners—in the courtyard of the museum selling DC-Cam publications that document their stories to foreign tourists and posing for tourist photographs (figures 22 and 23). Bou Meng was set up in front of the very structure where his mug shot was taken, sitting in front of a sign with a reproduction of his dead wife's mug shot on it, selling copies of his biography, *Bou Meng: A Survivor from Khmer Rouge Prison S-21*, for ten dollars.[1] Chum Mey was sitting closer to a concession stand, selling copies of the issue of *Searching for Truth* in which he is featured on the cover for five dollars. Like almost everything else in Cambodia, the suffering of the Tuol Sleng survivors has a price.

As virtually none of the tourists would have recognized Bou Meng and Chum Mey without being told who they were, the survivors had signs in English indicating their connection to Tuol Sleng, as well as companions who informed passers-by of their identities. Neither of the survivors speaks English and almost none of the foreign tourists speak Khmer, so communication was strained and awkward, enabled by the help of the survivors' English-speaking companions, the tourists' English-speaking tour guides, and body language. I watched as dozens of tourists walked idly by the survivors to get to their departing tour buses, while others stopped to awkwardly ask questions through

Figure 22 Tuol Sleng survivor Bou Meng at the Tuol Sleng Genocide Museum, December 2011. (Photo by author)

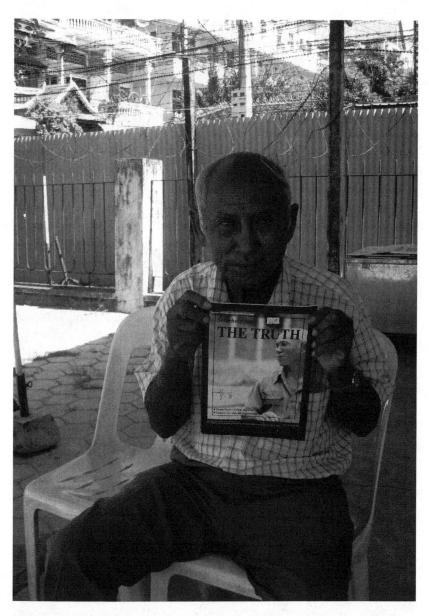

Figure 23 Tuol Sleng survivor Chum Mey at the Tuol Sleng Genocide Museum, December 2011. (Photo by author)

the interpreters and to buy books. For those who stopped to buy books, the same scenario was repeated: the publication and cash were exchanged, the survivor motioned toward the tourist's camera, the interpreter asked if the tourist wanted to pose for a photo with the survivor, the tourist consented and was directed to sit on a chair next to the survivor, both tourist and survivor leaned in, held up the publication, and smiled as the photo was taken by the survivor's companion or the tour guide, and the survivor pressed his hands together in a sign of gratitude, sometimes even kissing the tourist's hands or placing the tourist's hand on his head.[2] In all cases that I witnessed, it was the survivor, his companion, or the tour guide who initiated the photograph, not the tourist.

The sight of the survivors at Tuol Sleng is profoundly disarming. It is always oddly thrilling to see someone in person for the first time after watching that person on television or online (in my case, watching hours of individual testimonies in tribunal footage online), but seeing them so unexpectedly in situ was shocking. It was as though Bou Meng and Chum Mey were stuck in crevices of the space-time continuum, unable to leave the place of their torture more than thirty years after their release, inexplicably forced to serve as living museum artifacts. At that instant, asked to buy books from and take photos with Bou Meng and Chum Mey in the courtyard of the Tuol Sleng Genocide Museum, I was caught off guard, feeling simultaneously that my actions might paradoxically constitute both a crass second murder (as Susan Sontag might see it) and a deliberate act of co-witnessing between the survivors and myself. Walking within the unease of these ethical contradictions, I ultimately erred on the side of the survivors' expressed wishes, paying Bou Meng ten dollars and Chum Mey five dollars to buy their publications and take pictures of them. Like many tourists at Tuol Sleng, I took the survivors' photographs because they asked me to, because it is doubly disorienting to be at a site commemorating torture and to be unexpectedly confronted with survivors of that torture, because I wanted some external proof that I was witnessing a double impossibility—the impossibility of two men surviving Tuol Sleng and the impossibility of two Tuol Sleng survivors earning their living by selling their book to foreign tourists. Look at this impossibility, my photographs say, I was there.

Like so many other Tuol Sleng tourists, I ultimately decided that photographing the survivors in exchange for money was within the boundaries of ethical action given the context of contemporary Cambodia. Storytellers deserve to be paid for their stories, and survivors of horrific torture deserve to live with some measure of financial security; I cannot quickly or easily change the global economic and domestic political systems that dictate the conditions under

which the survivors must sell their stories and their images to scrape by, but I can help ensure their immediate well-being. Of course, by taking the photographs and reproducing them in this book, I am a part of the phenomenon I am observing.

As confirmed by a plethora of travel blogs, my experience of being asked to pose for pictures with the survivors at Tuol Sleng has become quite common. What do we make of their presence at the site and of the tourist snapshots they initiate? What function is served by the creation of these new photographic records posed with Bou Meng and Chum Mey? How are they circulated and why? In short, what do these records do? Like the photographs taken by DC-Cam staff and others discussed in the previous chapter, these snapshots transform tourists into witnesses, performing human rights. Yet, the conception of human rights being performed here is very different. While the photographs of people looking at the mug shots conceptualize human rights in relation to mass murder, these tourist snapshots directly address the subtle degradation of human rights through ongoing economic injustice. Although the Khmer Rouge's mass atrocities are crucial background information for interpreting the tourist snapshots, these photographic records are more immediately concerned with the ongoing needs of the survivors. In this context, the tourists in these photos are transformed not just into secondary witnesses to the past human rights violations at Tuol Sleng but into primary witnesses to the current poverty of the survivors. In this way, the tourist photographs document not just Bou Meng and Chum Mey's survival but also the economic and political climate in which the survivors must sell their stories to tourists to survive. In so doing, these snapshots simultaneously perform human rights and injustice. The records constitute a double reversal in which the survivors reverse the gazes of both the Khmer Rouge and tourist cameras. Like the photographs of Cambodians looking at the mug shots, these new records rupture the silence of the victims, creating a new narrative of survival that paradoxically embodies both victimhood and agency.

Survivors' Images for Sale

Bou Meng and Chum Mey compete over who can sell the most publications at Tuol Sleng. Bou Meng has earned more than thirteen thousand dollars from selling his book, an enormous improvement from his previous monthly salary of little more than ten dollars earned painting Buddhist murals on pagodas.[3] He is using the money to build a new house. Meng clearly relishes the attention he receives from tourists; he actively markets his story by including

a business card listing four cell phone numbers where he can be reached for interviews and appearances. For Chum Mey's part, he has purchased a new rickshaw to help him travel back and forth from his home to Tuol Sleng and the tribunal.[4] By 2011, he no longer relied on DC-Cam's press to reprint the issue of *Searching for the Truth* that featured him on the cover; instead, he contracted directly with a publishing company to print the copies (which previously had been distributed free of charge in Cambodia by DC-Cam). DC-Cam has since published an extended version of Chum Mey's biography as a monograph, *Survivor: The Triumph of an Ordinary Man in the Khmer Rouge Genocide*, doubtlessly enabling Mey to double the proceeds from his sales.[5] The cover shows Chum Mey inside Tuol Sleng, looking out behind bars, the mug shots behind him, the faces of the victims looking out at us in the background (figure 24).

Previously, both survivors had provoked the ire of museum administration by accosting tourists with aggressive sales pitches; they have since worked out an agreement to pay tour guides a one-dollar commission fee for each tourist who buys a publication.[6] Other stalls in the courtyard sell books and DVDS (many of which carry Chan Kim Srun's iconic mug shot on their covers) but also unrelated trinkets, t-shirts, and soft drinks (figure 25). The bustle of commerce trumps quiet contemplation in the Tuol Sleng courtyard.

The survivors have publicly stated that they feel forced to sell their stories in order to make ends meet. An August 2012 Voice of America story quotes Bou Meng on his daily appearance at Tuol Sleng: "'Whenever I enter this place, I get really tense, but I have to come to earn some money, to feed my family, because I'm inadequately supported by the state,' he said. He continued, 'I sell my book for $10, but some people give me $20 without getting back the change,' he said. 'I thank them and kiss their hands to show that it's their hands that help feed me for my daily survival.'"[7] The accompanying video shows Bou Meng kissing the hands of tourists and placing their hands on top of his head, a sign of supplication in Cambodia. The Voice of America story also specifies that Huy Vannak, the author of Bou Meng's biography, wrote down and translated Bou Meng's story expressly so that Meng could sell copies to improve his financial situation.[8]

The survivors blame the jointly run UN-Royal Government of Cambodia tribunal for their economic situation; the ECCC's verdict in the Duch case could have included some form of material reparations for the survivors instead of the scant "moral and collective reparations" promised by the court.[9] Speaking with a Voice of America reporter, Bou Meng asked, "Why does the court not pity the two remaining survivors who are sitting selling books to feed our stomachs? . . . Why does it pity only the accused so much?"[10] In this

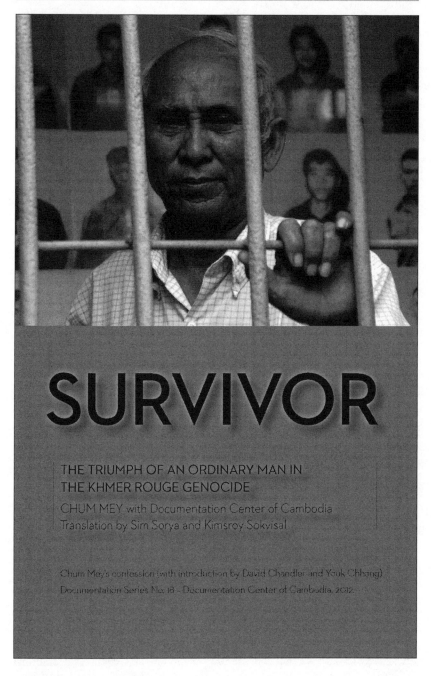

SURVIVOR

THE TRIUMPH OF AN ORDINARY MAN IN
THE KHMER ROUGE GENOCIDE
CHUM MEY with Documentation Center of Cambodia
Translation by Sim Sorya and Kimsroy Sokvisal

Chum Mey's confession (with introduction by David Chandler and Youk Chhang)
Documentation Series No. 16 - Documentation Center of Cambodia, 2012

Figure 24 The cover of *Survivor: The Triumph of an Ordinary Man in the Khmer Rouge Genocide* by Chum Mey. (Courtesy of the Documentation Center of Cambodia Archive)

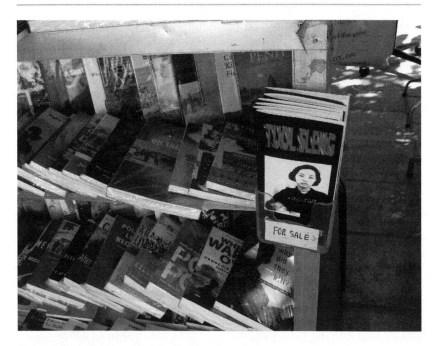

Figure 25 Books for sale at Tuol Sleng. (Photo by author)

view, it is not the survivors' failings but those of the tribunal, the international community, and the Cambodian government that dictate the conditions under which the Tuol Sleng survivors' stories are sold.

The Tuol Sleng victims' call for reparations after the Duch verdict was further underscored by the March 2013 death of Ieng Sary as he was standing trial. The Khmer Rouge's former foreign minister left behind approximately $20 million in a Hong Kong bank account, money he received from the Chinese government in support of Khmer Rouge activities, as well as proceeds from the regime's lucrative involvement in the gemstone and timber industries. This immense wealth notwithstanding, Ieng Sary and his wife, Ieng Thirith (who was also standing trial), were deemed indigent in 2007, and the tribunal paid for their legal costs. Since this bank account has come to light, civil parties have demanded that the $20 million be redistributed as reparations to victims. Youk Chhang has proposed that the money be spent on mental health services for Khmer Rouge victims. He told a reporter from the *South China Morning Post*, "Ieng Sary possessed an extraordinary amount of wealth that could have alleviated the suffering of many Cambodian genocide victims. In practical terms, he possessed enough wealth to build a national mental health centre for the victims. . . . The operating costs to meet the needs of millions of survivors

suffering from trauma would be just under $2 million per year."[11] Despite these demands, Ieng Sary's relatives will most likely inherit the money in the absence of a formal conviction.[12] The tribunal proceeds, even as the defendants die, the victims remain penniless, and justice remains elusive. Although the tribunal's predominant narrative is that without justice for the past Cambodia can't move forward, it is the survivors who quite literally can't move beyond Tuol Sleng without material reparations.

In the decades after the fall of the regime, a third Tuol Sleng survivor, the painter Vann Nath, became famous for painting scenes from Tuol Sleng, but he refused material success, choosing to display his paintings at the Tuol Sleng Genocide Museum, DC-Cam, and the Bophana Audio-Visual Resource Center instead of in commercial galleries or selling them on the international market. However, when Nath fell ill with kidney disease, in 2011, his family and friends tried desperately to raise enough money to treat him, organizing last-minute commercial sales of his work at the Royal University of Fine Arts and the Bophana Center in Phnom Penh. They also started a Facebook page ("Le Cercle des Amis de Vann Nath"), a blog, and a website geared toward an international audience that sold postcards with images of his paintings on them for two euros each. "Profits from these postcard sales will help fund the dialysis treatment that Vann Nath will receive during his stay in France," the website states.[13] The international community could also make credit card donations in support of Nath's treatment via the website, while the local community in Phnom Penh was asked to bring donations to the Bophana Center. The website (which, at the time of writing, has not been updated since Nath's death) stated, "Vann Nath is still in a coma. The family wishes to continue to provide the current medical assistance. The cost averages $300 per day. In this time, the family needs your financial support and solidarity."[14] These efforts were in vain; Nath died on September 5, 2011.[15] Viewed in light of Nath's death, Bou Meng's and Chum Mey's commercial uses of their Tuol Sleng mug shots perform human rights on a local scale in the sense that they allow the two survivors access to meet basic needs such as food and medicine that guarantee their continued survival.

What sense are we to make of this nonsensical situation? Such a comparable scenario is unimaginable in the context of the Holocaust; consider the outcry if Elie Wiesel were forced to eke out his existence by selling *Night* to tourists day after day at Auschwitz. There is enormous potential for retraumatization when these survivors return on a daily basis to the site of their own horrific torture and captivity—as well as the murder of their loved ones—to earn a living. Here, there is a visceral imperative for *less* contextualization in the hope that removing these survivors from the sites of trauma will somehow

alleviate their burdens and that doing so would allow the collective memory of the prison to somehow rise above the contemporary economic and political reality of poverty in Cambodia. Of course, this is only wishful thinking; Tuol Sleng prison—as well as the regime that created it and the forces that have transformed it into a site of memory—is all wrapped up in the fray of power, international geopolitics, economic disparity, and materiality, as this book has detailed. Here, archives are not just the very possibility of politics, as Verne Harris asserts, but of economics, culture, and society as a whole. At Tuol Sleng, as everywhere, memory is of the material world and not above it. Furthermore, virtually anything that puts money directly into the hands of everyday Cambodians (and not into the pockets of international NGO workers and corrupt government officials) can be seen as a positive development.[16]

In the context of contemporary Cambodia, Bou Meng and Chum Mey are actually relieving themselves of trauma by selling their stories rather than reliving it. DC-Cam director Youk Chhang echoed this interpretation. In a 2012 interview, he said, "When [Bou Meng and Chum Mey] are together now, they are no longer survivors. They become authors, booksellers, and competitors. They become free from being traumatized. Like all of us [Cambodians], they compete for success. They are free people now."[17] In their new roles as memory entrepreneurs, Bou Meng and Chum Mey show that life goes on. Like Cambodia as a whole, they are using the resources at their disposal to move beyond the past in the hope of building a prosperous future. Given the country's current economic and social climate, in which virtually everything is for sale, the Tuol Sleng survivors have forged a surprising, yet culturally appropriate response to dealing with trauma. While we should be cautioned against placing too much redemptive potential in capitalism (it is, after all, the global system that dictates ongoing economic inequities in Cambodia), the process by which memories of trauma became marketable in a tourist economy can be read as the ultimate defiance of Khmer Rouge ideology; in selling their stories, Bou Meng and Chum Mey become free agents whose ongoing survival is secured despite the failure of the state and the international community to provide financial reparations to the victims.

Instead of bristling at the commercialization of the Tuol Sleng experience, we should shift the critique from the survivors themselves, who must support themselves within Cambodia's struggling economy, and from DC-Cam, whose publications have given them a means to do so, toward the larger global and domestic climate in which hundreds of millions of dollars are spent on a tribunal while impoverished victims hawk their wares at the site of the murders of their loved ones and their own torture.[18] Certainly, the recent influx of foreign capital into Cambodia, the corruption of high-level Cambodian

government officials, and the ongoing divide between the salaries of foreign NGO workers and Cambodians exacerbate this inequity. The survivors merely operate within this larger economic and social structure they did not create.

"Me and Chum Mey"

While the survivors are compelled to visit Tuol Sleng each day for financial reasons, what compels the tourists? Why pose for photographs with torture survivors? Why then share these photos on travel blogs? Previous scholarship has maligned tourists who visit genocide sites. These "thanatourists," "grief tourists," or "dark tourists," as they are alternately called, are often dismissed as crass and morally bankrupt thrill seekers who travel to "places of pain and shame" in order to seek an authentic (albeit temporary) experience of human suffering and to indulge their neocolonial fantasies of rescue.[19] In their foundational book on this issue, J. John Lennon and Malcolm Foley argue that the phenomenon of "dark tourism" is best understood through the prism of three recent developments: global technologies that erase barriers of space and time and enable interest in and communication about such sites; increasing anxiety about modernity, as caused by and reflected in sites of mass violence and destruction; and the presence of socioeconomic inequalities that open such sites up for commodification and commercialization.[20] While these three factors are all important elements of Tuol Sleng tourism, when viewed in isolation, they oversimplify the desires of Tuol Sleng tourists. Because of Cambodia's association with war and genocide in the minds of foreigners and its unregulated sex and drug industries, the country has indeed attracted a subset of tourists who have come to indulge themselves in "the horror" of what they perceive as the "dark" and uncivilized side of human nature. For these extreme tourists, there are Phnom Penh's numerous nightclubs and brothels, shooting ranges where AK-47s can be tested out on livestock, and "happy" pizza places where marijuana is a standard topping. Although some foreign tourists at the Tuol Sleng Genocide Museum do engage in insensitive and ignorant behavior (the ubiquitous signs imploring visitors not to smile must be there for a reason), the majority I observed behaved with reverence, quiet reflection, an explicit desire to know more about the Khmer Rouge, and bewilderment at the lack of interpretive information found at the site.[21] This behavior is confirmed by Rachel Hughes's extensive ethnographic work interviewing and observing tourists at the site. Hughes's excellent study posits that tourists visit Tuol Sleng out of a sense of duty and leave with a profound sense of the importance of the Cambodian genocide to ongoing efforts to prevent

genocide elsewhere.[22] These "dutiful tourists," as Hughes terms them, arrive with a desire for more knowledge about the Khmer Rouge period (a desire that largely goes unfulfilled because of the lack of interpretive materials at the site) but are instead emotionally and experientially transformed into secondary witnesses to genocide during their visit. As Hughes writes, for tourists at Tuol Sleng, "the experience is no longer epistemological but testimonial, not 'I now know more' but 'I visited.'"[23] Through their experiences at Tuol Sleng, visitors shift from tourists to "humanitarian actors," as Hughes describes.[24]

Building on Hughes's argument and those of the previous chapters, I suggest that the act of posing for photographs with the Tuol Sleng survivors further transforms tourists into witnesses. Visiting Tuol Sleng, the tourists become not just secondary witnesses to the violence of Tuol Sleng (as Hughes argues) but primary witnesses to the ongoing financial struggles of the survivors in the face of the failure of the state and international community to provide for them. As the tourists become witnesses to two different injustices (the past torture at Tuol Sleng, the current financial neglect of the survivors), the photographic records they create perform in two very different ways, simultaneously demonstrating the remembrance of past human rights abuse and acknowledging the ongoing political and economic injustice resulting from that past abuse. At the same time, the survivors express agency by performing victimhood for the cameras, consciously constructing themselves as objects of the tourists' gaze in order to record their precarious financial state.

While the photographs of Cambodians witnessing the mug shots perform a conception of human rights defined by genocide (its legal adjudication, commemoration, and future prevention), the snapshots perform a conception of human rights that is defined by economic injustice (its acknowledgment and alleviation). The tourist photographs expose a point of tension between global human rights rhetoric that defines human rights in terms of the absence and adjudication of genocide and the more local construction of human rights as the ability of the survivors to earn a living and pay for medical care. In so doing, the snapshots reveal a larger disconnect between the tribunal's limited goals of holding a few high-ranking leaders legally responsible and the survivors' expectations for economic reparation. The tribunal offers a narrow legal justice, but the survivors demand a pervasive restorative justice. These demands are unfulfilled, as the tourist snapshots record. In this way, the snapshots are records of injustice even as they perform human rights.

This analysis is based on my own participant observation taking photos of the survivors, as well as an analysis of dozens of photos of the Tuol Sleng survivors on travel blogs. (For a representative image, see figure 26.) While there are a plethora of such images available on travel blogs and social media

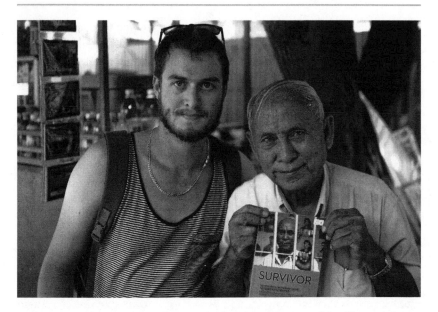

Figure 26 Tourist Sam Hammond poses with Chum Mey. (Courtesy of Sam Hammond)

sites like Facebook, Flickr, Pinterest, and Tumblr, the detailed textual description in this section is limited to two representative blogs found on travelblog .org, a popular site used by tourists.[25] These two blogs are Nancy Kuy's blog post about meeting Chum Mey and Joel and Whitney LaBahn's post about meeting Bou Meng.[26] Throughout this analysis, we see that tourists have complex emotional and intellectual responses to Tuol Sleng in general and to posing for photographs with the survivors in particular.

Nancy Kuy's travel blog, "The World in the Eyes of a Valley Girl," documents her journey in 2012 through nine countries in forty-two days. Kuy was born and raised in the San Fernando Valley and identifies herself as a "Native Angeleno" on her "About" page; she makes only a single passing reference to having Cambodian parents in her Tuol Sleng blog post.[27] Kuy describes an emotional connection to Tuol Sleng. Her visit, she writes, "was so depressing I just wanted to cry. I felt close to this place being that my parents just got out of the country just months before the Khmer Rouge took over."[28] Kuy then summarizes some basic history of the Khmer Rouge period in a paragraph and discusses her experience seeing the Tuol Sleng mug shots. "When you see the horrific images, you wonder how anyone would ever come to that point to do such inhumane acts. So so sad," she writes. She then describes her encounter with Chum Mey: "I met a survivor named Chum Mey from the Tuol Sleng,

who was 1 of the 7 people who survived out of 12,000+ victims who were killed (only 2 remain). He was really sweet and told me his experiences of being tortured, nails pulled, chained, beaten, etc. I bought one of his letters that he wrote and he was so fortunate that I was helping him as the country doesn't have social security. He is 81 now."[29] As this blog post reveals (albeit in an informal and concise manner befitting its genre), Kuy understands the historical events that happened at Tuol Sleng, as well as Chum Mey's impoverishment, the political and economic conditions that produce this impoverishment, and the impact of her own purchase on Chum Mey's fiscal well-being. While brief, her response to meeting Chum Mey at Tuol Sleng is not crass or disrespectful.

Kuy's blog post is accompanied by twenty-two images from her jam-packed day in Phnom Penh, including photographs taken of food and wine in upscale Cambodian restaurants, of art in the National Museum, and of skulls in the ersatz pagoda at the Choeung Ek killing fields site.[30] Her snapshots from Tuol Sleng depict the photographs of victims on display, as well as shackles, torture instruments, and a list of the number of prisons, mass graves, and genocide memorials in the country. The last photograph from Tuol Sleng, titled "Me and Chum Mey," is the only captioned photo in the series. The caption reads, "One of the only 2 left who are alive that survived S-21."[31] With this brief caption, Kuy provides viewers with adequate context to understand the importance of the photograph. In the photo, a smiling Kuy sits close to and leans in toward Chum Mey, who is holding up the issue of *Searching for the Truth* featuring him on the cover. The two sit under the shade of a tree, behind a table of Chum Mey's wares, roughly a dozen books about the Khmer Rouge, including one that reproduces the Tuol Sleng mug shots in its cover. Behind Kuy and Mey is a stall selling postcards, Fanta, Coke, and bottled water. Kuy's smile seems incongruous, but Mey's smile is more of a grimace, perhaps hinting at pain, perhaps revealing the Cambodian cultural practice of easing discomfort with a smile. Mey's face is mirrored by the image of it on the magazine he holds up. This is a photograph of Mey and Kuy holding up a photograph of Mey. Again, we see here records reproduced in secondary records in order to record the act of witnessing.

Similarly, Joel and Whitney LaBahn's travel blog features a photograph of the couple flanking Bou Meng, who is holding up a copy of his biography featuring a picture of him on the cover (figure 27).[32] The LaBahns explain on their blog that they quit their jobs in Seattle and left for a long trip to Southeast Asia, where they hoped to "gain some world experience."[33] Their blog entry from October 30, 2011, describes in detail their visit to Tuol Sleng in ten ample paragraphs that accurately summarize the history of the Khmer Rouge, the function of the prison, and the establishment of the tribunal; they even

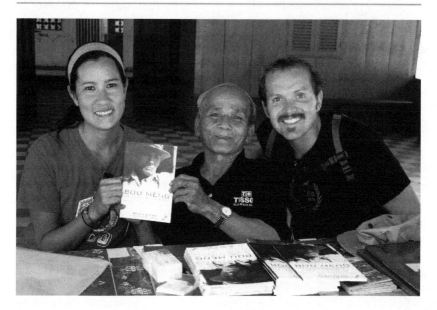

Figure 27 Tourists Joel and Whitney LaBahn pose with Bou Meng. (Courtesy of Joel and Whitney LaBahn)

reproduce the only explanatory plaque at Tuol Sleng in its entirety. For the LaBahns, the message of Tuol Sleng is not just about Cambodian history but also about preventing future genocide; the museum's purpose, they write, is to "remember . . . those that were killed and educat[e] the public about genocide so that it can never happen again."[34] Again, the blog includes what has become the requisite photo of the Tuol Sleng mug shots on display, this time captioned, "The faces of the victims now haunt the visitors as they pass through the rooms."[35] The couple describes their initial encounter with Meng:

> As we left the museum we noticed that a table was set up and covered in books and people were standing in line and taking photos with an elderly man. We soon found out that this was Bou Meng, one of the seven survivors that remained after the Khmer Rouge fell. We bought a copy of his book and shook his hand, we were both in awe to be standing next to someone who survived the atrocities we had just seen where thousands of others had perished. His book goes into detail about the horrors he suffered through but also takes a look at why the Khmer Rouge were able to come to power in the first place . . . now Bou Meng and other advocates are hoping to spread the story of the genocide that happened in Cambodia and educating the younger generations so that it can't happen again.[36]

On the blog, the accompanying photograph is captioned, "Bou Meng, a survivor of the Tuol Sleng prison." In the photo, Bou Meng sits in front of a table with stacks of his books and his business cards. The LaBahns smile; Bou Meng grimaces. Here, as in the case of Kuy's blog, are some key elements: contextual information that identifies the Khmer Rouge regime, Tuol Sleng, and the survivor by name; an explicit link between Tuol Sleng and the prevention of future genocides elsewhere; candid admissions that the tourists initially didn't recognize the survivor and that money was exchanged between the tourist and the survivor before the photograph was taken; and a photograph of a grimacing survivor and smiling tourists displaying the record—both photographic and textual—held up as evidence of Meng's survival.

As Kuy's and the LaBahns' blog posts reveal, many tourists to Tuol Sleng are not vulgar and insensitive thrill seekers but genuinely interested people who wish to learn something about genocide from visiting Tuol Sleng and to share their experiences with others. They take the photographs of Bou Meng and Chum Mey because, like me, they were asked to, because they were disoriented and taking a photograph somehow helps make sense of confusing situations, because, like any tourist photograph, the snapshots with the survivors serve as proof that they were there, "evidence of us," to borrow Sue McKemmish's phrase.[37] But, ultimately, the tourists take the photographs because posing with the survivors provides them with the transformative experience they sought in visiting Tuol Sleng; the creation of the photographic records transforms the tourists into witnesses. To further Hughes's claims about the tourists' transformation, after the photograph is taken, their visit to Tuol Sleng is no longer intellectual but experiential, no longer epistemological but testimonial. The photographs are records of this transformation.

As first a tourist at Tuol Sleng in 2005 and then a researcher at Tuol Sleng in 2010, 2011, and 2012, I have firsthand experience of how visiting the site as a tourist can have a transformative impact. Like many tourists, I documented my experiences at Tuol Sleng in 2005 with photographs and a journal entry, which were published online and viewed by thousands of readers. The journal entry then became the basis for a piece that aired on Chicago Public Radio.[38] For me the transformation during my first visit was not only personal but also professional, changing both my commitment to human rights and the course of my career. Confirming Hughes's observations, my personal history shows how "dark" tourism can have a profound ability to transform tourists into witnesses, even in the face of rampant commercialism, cultural misunderstandings, and economic inequality.

In posing for the photographs, the tourists (and I) become witnesses to two impossibilities—the impossible survival of Bou Meng and Chum Mey as

prisoners at Tuol Sleng during the Khmer Rouge period and the impossible survival of Bou Meng and Chum Mey as hawkers competing for tourist income in the present. They become implicated in the survivors' ongoing struggle for survival. In this way, the tourist photographs simultaneously perform human rights (by transforming tourists into witnesses committed to preventing future violence) and injustice (by recording the survivors' need to sell their stories to tourists). Again, underlying these photographs are two competing conceptions of human rights: that which is defined in opposition to genocide and that which is defined in opposition to economic injustice.

On one level, the tourist photographs perform human rights by documenting both Bou Meng and Chum Mey bearing witness to their own testimonies, as well as tourists (as representatives of the international community) bearing witness to this testimony. These photographs are acts of co-witnessing that transform tourists into "humanitarian actors" as Hughes describes them, dedicated to the prevention of genocide globally.[39] If properly contextualized, these new tourist-generated records have the ability to renew viewers' commitment to human rights in the future, transforming the blog readers into secondary witnesses and creating an ever-expanding circle of human rights performance as such records get pluralized and reused over time. As in all things archival, context is key; viewers' knowledge of who Bou Meng and Chum Mey are is crucial to these records' performance of human rights.

Yet, simultaneously, the tourist photographs also perform injustice by recording how Bou Meng and Chum Mey must sell their publications to tourists to guarantee their financial well-being. These photographs record the injustice of a multi-million dollar tribunal's inability to provide material reparations to the two surviving victims of Tuol Sleng, even as dead Khmer Rouge defendants leave behind millions of dollars. The tourists in these photographs become witnesses to the commodification of the survivor's memory. As Kuy's and the LaBahns' blog posts show, the survivors make it clear that they are dependent on tourist dollars and the tourists readily acknowledge that their photographs were the result of a financial exchange brought on by ongoing economic hardship faced by the survivors. The viewers of these tourist photographs then become secondary witnesses to this injustice; they are transformed into witnesses of the court's failure to provide reparations. Again, context is key; knowing that Bou Meng and Chum Mey are selling their books and photographs at Tuol Sleng is crucial to these records performing injustice. While the tourist snapshots do not always incorporate the Tuol Sleng mug shots, they are always in direct conversation with them.

Archival theory helps to reveal Bou Meng's and Chum Mey's agency in the creation of these new tourist-generated records. By initiating and posing

for these photographs, the survivors are co-creators of the records produced. They have agency in the creation of these records; they are an integral part of the records' provenance. It is their voices and images that are being heard and seen through the subsequent circulation and uses of the records, as long as the photographs are adequately contextualized. In this light, tourist photography becomes a way to help the survivors record both their defiant survival at the site of the initial trauma and their financial hardships that dictate the terms of the creation of such photographs. It is the survivor, not the tourist, who is initiating the transformation of the tourists into witnesses of current injustice through the staging of the photographs. Bou Meng and Chum Mey carefully construct the content of the photographs to meet the watchful gaze of the tourists' lens. In this way, the survivors perform victimhood for the cameras and, in so doing, express a sense of agency in and control over the creation of Tuol Sleng's new photographic records despite their marginalized economic and political status. In this way, they gain the very sense of creatorship and self-representation they were denied more than thirty years ago when their mug shots were taken as they were registered as prisoners at Tuol Sleng. They are, in effect, re-creating their own Tuol Sleng photographic records of their own accord. In dictating the terms under which their images are taken at Tuol Sleng, they are reversing the Khmer Rouge's gaze.

This argument builds on the seminal work of John Urry, who convincingly describes how what tourists see and what they photograph is "socially organized and systematized," forming a "tourist gaze" that is "structured by culturally specific notions of what is extraordinary and what is worth viewing."[40] In the Tuol Sleng courtyard, the survivors themselves carefully construct the object of the tourist gaze, repeatedly staging near-identical scenarios (except for the face of the interchangeable tourist) again and again for the cameras. They are not passive recipients of the tourists' gaze; they are active constructors of it. The survivors demand to be viewed.[41] At the same time they are being photographed, they reverse the gaze of the tourists' camera, peering back at a world that has sequentially traumatized them, ignored them, and left them to fend for themselves financially.[42]

The English-speaking tour guides and the survivors' companions notify the tourists of the identity of the survivors, pointing out the spectacle that is worthy of photographing. *Here*, they point out, *this is something extraordinary. Take a picture*. In this way, the photograph is the by-product of a three-way relationship: the tourist, the survivor, and the tour guide or handler who actually takes the photograph. A fourth player, the viewer, comes into the picture when the photographs are posted online. If the photographs are not adequately contextualized, the viewers, seeking evidence of the authentic,

interpret the photographs as slivers of the real—natural depictions of the real survivors in situ—rather than the carefully rehearsed, socially constructed, politically strategized records that they are. By contrast, once viewers are given information about how the photographs were taken as the result of a financial exchange initiated by the survivors, their staged and strategized nature comes to light.

By staging the photographs, the survivors express a sense of agency. Chum Mey and Bou Meng not only stage the "authenticity" that tourists seek (as Dean MacCannell describes) but also perform victimhood, staging their bodies to be read as victims for public consumption.[43] The staging of these photographs is a form of protest in which the survivors make their poverty visible to the world.

As Urry adeptly argues, the objects of the tourist gaze serve as symbols.[44] Through the creation of the photographs, the survivors are transformed from symbols of past injustice into symbols of contemporary injustice. The survivors stage these scenarios of co-witnessing for tourists in order to construct themselves as symbols; they stand in for the failure of the ECCC to provide material reparations, they stand in for the ongoing injustice of social, economic, and political inequity in Cambodia and globally, and they stand in for the paralysis of the international community, which does nothing but witness this injustice. The survivors construct themselves as metaphors for the neglect of Cambodia. In contrast, for the tourists, the survivors stand in for Cambodia as an impoverished, horrific, genocidal place. The tourists' gaze doesn't just capture Bou Meng or Chum Mey as individuals; it captures them as symbols of Cambodia, as Urry would argue.[45] For foreign tourists, Cambodia specializes in images of death and poverty, offering up a slice of the extreme for consumption.

And yet, at the same time, the survivors as they are depicted in the photographs are also symbols of renewed agency. These are victims restaging their own mug shots on their own terms to serve their own personal, political, and economic agendas. They are victims rewriting their own history, creating new narratives of the Khmer Rouge period.

I am advocating for a more nuanced reading of these photographs than recent research on tourism and in visual studies might suggest. Much work has been done that stresses how those othered (by race, gender, sexuality, poverty, or histories of colonization) are subjectified, victimized, oppressed, and exploited by photography, particularly (but not limited to) tourist photography.[46] While that is certainly true in many cases, an examination of the Tuol Sleng tourist photographs calls for a more complicated understanding of the agency of the survivors. While they have been made victims twice over (first by the Khmer Rouge, second by economic inequality), they are agents in the creation of these records that document that victimhood; it is their narrative

that gets told through the tourist photographs. There is a complex layering here of agency and victimhood, silencing and voice, objectification and empowerment through the creation of records. To see the Tuol Sleng survivors as victimized by tourist cameras oversimplifies the complexities of how these records are constructed and circulated and denies the survivors' agency in creating them.

Power, Complicity, and Tourist Photos as New Records of Agency

Despite the analysis of the survivors' agency in creating the tourist photographs, there are still serious issues to address regarding the complicity of all tourists at Tuol Sleng—myself included—in contributing to and benefiting from the economic and political disparity that created the context of these records. As tourists with enough excess capital and leisure time to visit Cambodia, we have an involvement with Chum Mey's and Bou Meng's poverty that does not begin the moment we snap our cameras but, rather, is always already implicated by our status in the global economy. As foreigners (particularly Americans), we come from countries that created the military, economic, and ethical conditions that led to the Khmer Rouge's initial popularity, and, as such, we bear some responsibility for their takeover. As foreigners, we come from countries that stood idly by as the Khmer Rouge committed mass murder, and, as such, we bear some responsibility for the crimes of Tuol Sleng. And, as foreigners, we come from countries that currently contribute to the conditions that create the impoverishment of Bou Meng and Chum Mey and Cambodians writ large, and, as such, we bear some responsibility for their current presence at Tuol Sleng. Tourists benefit from the same global economic and political superstructure that dictates the conditions of Bou Meng's and Chum Mey's poverty; travel and photography do not absolve us from the responsibility of this power imbalance. At Tuol Sleng, as in many contexts surrounding the shaping of collective memory at difficult heritage sites, tourists negotiate where to place the fine line between pointless voyeurism and respectful remembrance; relationships of power are crucial to interrogating the motivations for this negotiation.

Operating within the confines of the superstructures that have victimized them (the Khmer Rouge, the international community, the ECCC—first communism, now capitalism), the survivors have managed to express an extraordinary sense of agency through the staging of tourist photographs that record their impoverished state and transform tourists into witnesses to their poverty. These new photographic records, co-created by the survivors and the

tourists, function within a contradiction, simultaneously performing two different conceptions of human rights, the global and the local, one focused on remembering and preventing mass atrocity and one demanding acknowledgment for more subtle forms of economic injustice. In so doing, they both transform tourists into witnesses with a strengthened commitment to preventing genocide globally and record the impoverishment and neglect of the survivors. In this second function, they occasion a sense of discomfort on the part of tourists in the face of their own subtle complicity in global systems of inequality.

As an archival perspective demands, the tourist photographs as records are "persistent representations of activity," representing not just the activity of taking the photo but also the activity of the survivors selling their photos in order to earn a living.[47] They are evidence of injustice. The crucial context for reading these records is the neglect of the survivors by the tribunal and, in turn, the Cambodian government and the UN.

Yet the survivors are not just victims but also agents. In stark contrast to the Tuol Sleng mug shots that they were forced to endure, in the tourist photographs, the survivors control their image. The gaze is always linked to power, as Foucault proposed, but the flow of power here is multidirectional; the survivors demand to be photographed, and the photographs record their neglect as a form of staged protest. These new records constitute a double reversal in which the survivors restructure the gazes of both the Khmer Rouge and the tourists' cameras. By staging the photographs, the survivors are taking control of the Tuol Sleng narrative within the limited confines of the power allotted to them by the court, the Cambodian government, and the international community. With the click of the tourist cameras, Bou Meng and Chum Mey insert their voices into an ongoing drama previously marked by their conspicuous silence.

Like the Tuol Sleng mug shots, the tourist photographs perform in service of political, economic, and social goals, as well as two differing conceptions of human rights, as they are staged, created, contextualized, shared, and received. They too are performative agents with a distinct social life, but they are mirrors to the Tuol Sleng mug shots, documenting survival instead of death, staged by victims rather than perpetrators. As such, the tourist photographs respond to both the mug shots and the photographs of people witnessing the mug shots, breaking the silences of the original records and adding a narrative of protest to the mug shots' infinitely layered archive. By viewing the mug shots in relation to the tourist photographs, we see how the records of Tuol Sleng are never finalized, their meaning never resolved; they are always in the process of becoming.

Conclusion

The Archival Performance of Human Rights and the Ethics of Looking

> Remembering *is* an ethical act, has ethical value in and of itself. Memory is, achingly, the only relation we can have with the dead.
>
> Susan Sontag, *Regarding the Pain of Others*

Tracing the social life of Khmer Rouge mug shots uncovers moments of silence and acts of silencing as the photographs were created, transformed into archives, and activated by survivors and by victims' family members as they craft narratives about the regime. Through these various activations, the mug shots enable Cambodians and the international community to bear witness to the Khmer Rouge's crimes and make powerful visual testaments that they will not stand idly by as such violence is perpetuated.

Any investigation of the social life of records must begin with the context of their creation. The origins of the Tuol Sleng mug shots rest in French colonial policing strategies that employed photography to discursively transform suspects into criminal bodies. The colonial impulse to classify foreign bodies was turned inward in the creation and adoption of the Bertillon system in France and then turned outward once again in the adaptation of the Bertillon system in French colonies throughout the world, including Cambodia. Khmer Rouge bureaucrats then adopted and adapted the format of their colonial

predecessors by implementing the use of standardized photography at Tuol Sleng with the hope of creating a modern and efficient bureaucracy at the prison. The mug shots, together with other Tuol Sleng records, allowed officials to compartmentalize labor, alienated bureaucrats from the violent consequences of their actions, and encouraged a culture of thoughtlessness at the prison. The Tuol Sleng mug shots not only documented the oppression of prisoners but served a key social function within that oppression. The records were not neutral by-products of activity (as classical Western archival theory would posit) but an integral part of that activity; they made the incarceration, torture, and murder possible. Although archival theorists have recently tried both to uncover the voices of the oppressed in the records of the oppressor and to re-frame the subjects of photographs as co-creators, these claims deny both the absolute totalitarian environment of Tuol Sleng, where resistance was impossible, and the discursive power of records creation to transform those arrested into enemies of the state.

Because of both the transformative power of the creation of these mug shots and the complete oppressiveness of Tuol Sleng as a total institution within a totalitarian state, there are no whispers of the victims in these records; the photographs, like the dead they depict, remain frustratingly silent. While postcolonial theorists debate whether the subaltern can speak, most of us agree that the dead cannot. While we project our own voices onto these photographs (in the vein of W. J. T. Mitchell) in the face of this silence, we must admit that it conveys a false sense of agency to deem the Tuol Sleng victims co-creators of the records used to murder them.

Instead of redeeming the archival conception of creatorship through its expansion, we should complicate creatorship's direct ties to provenance. For, while the Tuol Sleng victims are not co-creators of their mug shots, they are certainly part of their provenance, as are the descendants of the victims, the archivists and museum professionals who displayed, digitized, and preserved them, and the Cambodians who look at them, tell stories about them, and create new records incorporating them. These stakeholders form the "community of records" surrounding the mug shots, whose voices are our only viable alternative to the impossible whispers of the dead.

In the next stage in the social life of these records, competing political claims were made manifest in the transformation of the Tuol Sleng mug shots into archival collections, museum displays, and online databases. The mug shots became the focal point of the Vietnamese-led Tuol Sleng Museum of Genocide, whose displays were used by Cambodians to identify the dead in the aftermath of the regime's overthrow. Individual American human rights workers then attempted to deploy the mug shots to attract international

attention to the crimes of the Khmer Rouge in the face of Western indifference and, in some cases, outright hostility to efforts to hold the regime accountable. American efforts to preserve the Tuol Sleng mug shots led to the creation of DC-Cam as a Phnom Penh field office funded by a grant from the US State Department and to an early effort to digitize the mug shots and publish them online in order to identify the victims. As DC-Cam became its own independent nonprofit organization, the deployment of the mug shots as archival records shifted in support of Cambodian-led efforts to create an international criminal tribunal amid significant resistance both at home and abroad. The creation of archives documenting violence in a transitional society is intimately linked to human rights activism and is inherently an expression of political power.

More recently, Tuol Sleng survivors and the families of victims are using the mug shots to tell narratives about the dead through legal testimonies, interviews in documentary films, and articles published by DC-Cam. DC-Cam staff, survivors, and victims' family members are incorporating the mug shots into new records that document the act of looking. These new images not only bear witness to the crimes of the regime but bring the viewers into the circle of witnessing. By asserting that the violence happened, that it will be remembered, and that it should not be repeated, these records of witnessing perform human rights in the face of a local and international political climate that favors forgetting. As we have seen throughout this examination, the records are agents that actively influence human lives, society, and politics in spite of their silences.

More recently, the two known living adult survivors of Tuol Sleng have staged photographs for tourists that record their views of the inadequacies of the tribunal, which has not awarded them reparations, and Cambodia's current impoverishment, which dictates their economic status. These photographic records are co-created by the survivors and the tourists and are digitally circulated on travel blogs and photo-sharing websites. An analysis of the tourist photographs reveals how the survivors stage their victimhood for the camera and, in so doing, exercise a sense of agency that was absent in the creation of the mug shots. These new visual records of Tuol Sleng paradoxically perform human rights and injustice by transforming tourists into witnesses of both the violence at Tuol Sleng and the economic need of the survivors.

In the view from the continuum, all of these activations—past, present, and future—form the never-ending provenance of these records, each adding a new layer of meaning to a constantly evolving collection of records that opens out into the future. By giving contexts to these texts, archivists have an unparalleled capacity to shape the future uses of these records, contributing to

their social significance and, ultimately, their agency as they support identification, adjudication, and memorialization. While we may never be able to hear the voices of the Tuol Sleng victims, DC-Cam's work has ensured that we hear the voices of the survivors and the victims' descendants, who repurpose these records of death into legal evidence, touchstones for shaping collective memory, and, above all, raw material for new records of witnessing.

While the creation of archives and narratives can be seen as positive developments on the path to justice and reconciliation in Cambodia, each of these moments in the historical production of the Khmer Rouge period is rife with silences. During the creation of the mug shots, the silence of those mute prisoners they depict is overwhelming, despite the many attempts of survivors, scholars, and other viewers to posthumously assign a voice to the faces. Also at this moment of the making of sources, the silence of the vast majority of Khmer Rouge victims who were not photographed and who left few material traces is audible. Next, in the moment when archives are created, we have seen how thousands of Tuol Sleng victims whose mug shots did not survive the chaos of the Vietnamese invasion and its aftermath are silenced by their omission from the archives; they are notably absent from the walls of Tuol Sleng Genocide Museum and from DC-Cam's databases. These silences are compounded in the making of narratives about the regime; the stories told about the Khmer Rouge are overwhelmingly shaped by the extant mug shots, and those stories are strategically deployed by DC-Cam in favor of the conviction of Khmer Rouge leaders in a hotly contested international tribunal.

And yet, Cambodians are breaking through these layers of silence by creating new photographs that document bearing witness to the Tuol Sleng mug shots, effectively inserting the voices of survivors and victims' family members into this complex continuum of records. Here, redemption lies not in imposing a voice on the mute Tuol Sleng victims or in reinterpreting these victims as co-creators but in the creation of new records that repurpose the old, transforming them from objects of mass murder to agents of witnessing. In this transformation, the Tuol Sleng mug shots become agents that perform human rights, revealing how Cambodians are defiantly witnessing Khmer Rouge abuses even as they negotiate the meaning and legacy of the regime. Furthermore, we, the viewers of these new records that incorporate records, are brought into this circle of bearing witness and, as such, are transformed into agents of social change. After viewing these performative records, our commitment to human rights is renewed; we are no longer passive bystanders but engaged witnesses. There is thus a direct connection between the performative qualities of records and their ability to inspire social and political change. We have an ongoing duty to honor the silences of the victims by respectfully

activating and contextualizing the mug shots in the present and properly stewarding them into the future.

In this formulation, we also see fissures of incompatibility between Trouillot's framework and archival science's continuum model. First, while Trouillot's moments proceed in a linear fashion, through the lens of the continuum we see how records are never finished, how archives are never finalized, how narratives shift to suit contemporary needs, and how history is never written in the final instance as Trouillot posits. Records, archives, narratives, and history are all always in the process of becoming, always existing in the realm of the possible, always waiting to be deployed for new records, for new uses, for new attempts at meaning making. Records are not the static raw material for historical struggle as Trouillot sees them but key players in that struggle. Archives are not sites where neutral or objective archivists assemble facts but always already sites of intense mediation. And, finally, narratives are not just the retrieval of facts latent in the archives but the shaping of those facts and, often, the media through which the very definition of fact is construed.

The photographs of Cambodians witnessing the mug shots and tourists witnessing the survivors are not the end result of a linear process but brief snapshots of a complexly layered, ever-expanding, multidimensional web that includes multiple instances of creation, capture, organization, and pluralization, though not in any particular order. Here, the records continuum provides a more accurate model than Trouillot's linear framework for envisioning the many contemporary and future reuses of the mug shots, reuses that incorporate not only the original images but earlier incarnations of reuses as well. These new uses spark new epicenters for new continua, creating a layered, multidimensional overlapping of continua as records are reused, reincorporated, and re-created over and over again at different instances in time and space. The image here is not a singular bull's-eye (as the records continuum has been depicted) but a volley of fireworks, not a lone drop with a rippling effect in a pond but a rain shower on an ocean, each drop inducing an infinitely expanding ripple of creation, capture, and pluralization as it spreads out across space and into the future.

At the same time, the continuum model is not without its limits. What is missing is Trouillot's attention to power, silencing, and marginalization. Not every act results in record creation, not every created record gets captured in a system, not every captured record in a system gets pluralized, to superimpose Trouillot's moments on the continuum. Power drives important gaps of silence that disturb the layers of the continuum, contorting the concentric circles with the warps and ruptures of the marginalized voices that are not recorded, archived, and narrativized.

The Ethics of Looking

In researching and writing this book, I grappled considerably with the ethics of looking at and showing others these photographs. What is my ethical obligation to these victims? What is my own culpability, as an American (and as the daughter of a Vietnam War–era veteran), in producing the conditions that made such inhumanity possible? What responsibility do I have to the Tuol Sleng victims when I introduce these images to other spectators? Does my research contribute to the commodification of these images, as well as perpetuate their iconic status at the expense of all of the other unphotographed victims of the Khmer Rouge? How do I not perpetuate the silences encoded in these mug shots? How can we ensure that looking at these images is a political act of witnessing and not an exploitative act of voyeurism? Here, I turn to my home field, archival studies, for guidance. When we view these mug shots as records, that is, as evidence of human activity, we see them within their proper context. Viewing the mug shots as records first and foremost forces us to connect them to the violation of human rights that occurred in their creation and the performance of human rights that occurs in their use. To view them as records situates them in their ongoing provenance.

Through this discussion, I would like to put an archival studies lens on a raging debate in visual studies and memory studies over the utility (and/or futility) of looking at photographs that document "the pain of others," to use Susan Sontag's phrase.[1] At the extreme end of this continuum, critics like Sontag decry photography as an act of violence and argue that viewing images of violence like the Tuol Sleng mug shots further exploits the victims they portray. Our inundation with so many violent images, these critics argue, creates a sense of atrocity fatigue among viewers, who are no longer mobilized into action by such images and, in the extreme, can no longer even empathize with the subjects in these photographs. Writing about Holocaust photographs, the historian Susan A. Crane posits that, since such images were taken without the consent of their subjects, they should be "rendered inadmissible," barred from classroom use, and not republished in academic books. "While I am not advocating the wholesale destruction of Holocaust photographs, I will suggest that removing them from view or 'repatriating' them might serve Holocaust memory better than their reduction to atrocious objects of banal attention," she writes.[2] Crane argues that, like culturally sensitive Native American materials repatriated under the Native American Graves Protection and Repatriation Act (NAGPRA), Holocaust photographs should be removed from circulation and entrusted to appropriately reverential Jewish institutions. In looking at the Tuol Sleng images, Sontag and Crane would argue, we are

reenacting Nhem En's voyeuristic gaze, further objectifying these dead prisoners, and disrespectfully turning their pain into kitsch. In this vein, our scholarship about these images only worsens their ill effect; as David Chandler writes, "Anything we say or write about S-21, or about the Holocaust, has the effect of softening and cleaning what went on."[3] In researching atrocity, these scholars posit, we attempt to make sense of the nonsensical, and, in so doing, we fail miserably.

On the other hand, some critics assert that we have an ethical imperative *to* look at violent images, as long as we do so in an appropriate context. The journalism scholar Susie Linfield makes a convincing argument in favor of looking at atrocity images. She notes the ways in which images of violence have mobilized the public into political action and upholds our ability to read these images empathetically, from the points of view of the victims, not the perpetrators. Photographs taken by Nazis or Khmer Rouge members, she astutely writes, "sabotage their own intent" by making the viewer aware of the senseless cruelty of the photographer.[4] And yet she cautions against any and all acts of looking, positing that we enter a complex and shaky ethical terrain when we begin to look. Writing about the Tuol Sleng images specifically, she argues:

> Looking at these doomed people is not a form of exploitation; forgetting them is not a form of respect. But it would be good to eschew a knowledge that is easy, an identification that is glib, and a resolution that is cheap. Neither humanism nor history will bridge the chasm between we viewers and Number 5: we cannot become him, switch places with him, or reach back into history to protect him. We are simply too late.[5]

And herein lies the contradiction of looking at these Tuol Sleng images: we are both compelled to act and "too late," compelled to speak but rendered speechless. "Words fail us," as Chandler writes, in the midst of his word-filled book on Tuol Sleng.[6]

Building on my argument that witnessing Tuol Sleng images constitutes the performance of human rights and that archivists are "co-witnesses" to this process, I suggest that we have an ethical imperative *to* look at these photographs, as long as such looking is properly contextualized. Too often, American scholars and critics have seen the Tuol Sleng prisoners in these photos as faceless masses—or, even worse, seen the photos as decontextualized art pieces—ignoring DC-Cam's important and often-successful efforts to identify the victims.[7] As archivists are in the business of context, archival work is central to the ethical viewing of these images. As Linfield aptly argues (and many of the relatives of the dead would concur), forgetting the Tuol Sleng victims and their images does not honor them. Instead, preserving their photographs,

publishing and digitizing them so that the victims might be identified, and deploying them as legal evidence to hold the perpetrators accountable are the highest forms of respect, and all are actions DC-Cam has undertaken. This last point, the use of the Tuol Sleng mug shots as legal evidence, is key; for the survivors of Tuol Sleng and many of the families of victims, the antonym to forgetting is not remembering but justice, as Yosef Hayim Yerushalmi famously wrote.[8] By extension, archival interventions into these photographs are not just about remembering but also about justice and the performance of human rights. As viewers of these images, we have an ethical obligation to act in support of a politics of justice. This obligation extends to the work not only of remembering past and preventing future mass murders but also of acknowledging more subtle and ongoing economic, social, and political injustice.

My insistence on the mug shots as records builds on Ricardo Punzalan's notion of archivist as co-witness and his archival adaptation of Ruth Behar's concept of the vulnerable observer. In embarking on this kind of research, I have attempted to bring "the most profound ethnographic empathy possible," as Behar describes.[9] My initial shock at seeing the survivors selling their stories and posing for tourist photographs at Tuol Sleng was just one in a series of jarring moments during my time spent in Cambodia, moments in which this research broke my heart, to use Behar's apt phrase. I am not an objective, neutral scientist but a "vulnerable archivist" (to use Punzalan's term), at once a co-witness to and an actor in the drama surrounding the Tuol Sleng photographs.[10] This book is now part of the provenance of these records. Its readers are now brought into the web of witnessing that these images engender. As such, this research contributes in some small ways, I hope, to the performance of human rights in Cambodia and around the world.

And yet, despite this ethical obligation *to* look, we should be cautioned by the ways in which these images have been decontextualized. The MoMA exhibition and its accompanying catalog, as discussed in chapter 2, is a particular cause for alarm, as is the potential for decontextualization as the photographs are posted to photo sharing websites. As scholars, we must acknowledge the work of archivists and honor the victims by doing our homework and providing proper context for these photographs. Insisting on viewing them as records, which this book has attempted, partially solves this ethical dilemma by embedding their viewing inextricably in the context of their creation.

Throughout this book, we have seen how mug shots as records act as agents, accommodating ever-new and previously unforeseen uses—from legal accountability, to identification, to commercialization—including their use in this book. While the future uses of these records are unknown, we can be certain that their active social life will continue as long as we continue to try to make

sense of the crimes of the Khmer Rouge. This is not history in the final instance as Trouillot would have it, but an ongoing and contested battle for meaning, of which this book is a small part.

In conclusion, let us return to Tuol Sleng victim Hout Bophana's story, told in the introduction. On the website for the Bophana Audiovisual Resource Center, Rithy Panh and the other founders reveal why they named the Center after her. "By choosing the name of Bophana, the Center hopes to bear witness to the message of dignity and courage exemplified by this young woman during her S21 Center detention."[11] Here, Bophana, embodied by her Tuol Sleng mug shot, stands as a symbol for all of the victims of the Khmer Rouge, her mug shot a visceral and visual embodiment of all those whose lives were lost. While this equation of Bophana with all Khmer Rouge victims silences both those who were not imprisoned at Tuol Sleng and those whose Tuol Sleng photographs did not get archived, her mug shot continues to inspire Cambodians to tell their own varied stories and to preserve and provide access to collective Cambodian narratives about the past. By focusing on one image of one person as a symbol (despite the silences encoded in this image), Cambodians can begin to acknowledge a multiplicity of stories and struggles and together begin the work of shaping narratives about the past. As the founders of the Bophana Center detail, "Our objective has been to gather, image after image, snatches of life and a volley of voices. In order to try to understand, to try to give a name, a soul, a face and a voice to those whose had been deprived of them. To return to the victims of a murderous history their destiny and their memory. To recover freedom of speech by integrating reflection about the past with the construction of the present in order to escape tragedy and to begin to invent the future."[12] Bophana's photograph and others like it are now being used to memorialize the dead, hold those responsible legally accountable, and bear witness to genocide. Through their proliferation, these records perform human rights in the present, and ensure, in the words of Chum Mey, that "nothing will be erased." As scholars, as archivists, as humans, it is our responsibility to respectfully activate these records in the present, acknowledge the silences encoded within them, and bring them forth from the past into the future, ensuring that they will not be erased.

Notes

Introduction

1. Cambodian naming conventions are the reverse of what they are in the West, so that, for example, Hout is a family name and Bophana is a given name. I have followed the Western convention throughout for the sake of consistency.

2. For a more detailed account of Hout Bophana's life story, see Elizabeth Becker, *Bophana* (Phnom Penh: Cambodia Daily Press, 2010). The description of Bophana's story found in this chapter relies on Becker's painstaking reconstruction.

3. I contend that "mug shot" is the most appropriate term for the Tuol Sleng identification photographs because it links them to the long history of criminal identification photography and the Bertillon system, as chapter 1 details.

4. This echoes Elizabeth Becker's claim that Bophana herself has "taken on a life of her own." I am referring specifically here to her mug shot. Elizabeth Becker, "Minor Characters," *New York Times*, August 28, 2005, G27.

5. David Hawk, "Confronting Genocide in Cambodia," in *Pioneers of Genocide Studies*, ed. Samuel Totten and Steven Leonard Jacobs (New Brunswick, NJ: Transaction, 2002), 521–544.

6. Elizabeth Becker, *When the War Was Over* (New York: Public Affairs, 1986).

7. In August 2012, an additional 1,200 mug shots were discovered in a house in Cambodia and donated to DC-Cam. This discovery will doubtlessly yield more narratives.

8. Becker, "Minor Characters," G27.

9. This book employs Sue McKemmish and Frank Upward's view of records as "inclusive of records of continuing value (archives), which stresses their uses for transactional, evidentiary and memory purposes, and which unifies approaches to archiving/recordkeeping whether records are kept for a split second or millennium." Frank Upward, "Structuring the Records Continuum Part I," *Archives and Manuscripts* 24:2 (1996): 275–276. To use Eric Ketelaar's characterization, records are "authentic evidence of human activity and experience" that travel through space and time, often with the

help of archivists. Eric Ketelaar, "Time Future Contained in Time Past: Archival Science in the 21st Century," *Journal of the Japan Society for Archival Science* 1 (2004): 20–35, http://cf.hum.uva.nl/bai/home/eketelaar/timefuture.doc.

10. Geoffrey Yeo, "Concepts of Record (1): Evidence, Information, and Persistent Representation," *American Archivist* 70 (2007): 334. Yeo echoes Ketelaar's characterization as cited earlier.

11. The phrase "community of records" was first proposed by Jeannette Bastian to denote the various stakeholders that coalesce around archival collections. Jeannette Bastian, *Owning Memory: How a Caribbean Community Lost Its Archives and Found Its History* (Westport, CT: Libraries Unlimited, 2003).

12. The phrase "the performance of human rights" is borrowed from anthropologists and scholars of visual culture. See Susan Slyomovics, *The Performance of Human Rights in Morocco* (Philadelphia: University of Pennsylvania Press, 2005), and Andrea Noble, "Traveling Theories of Family Photography and the Material Culture of Human Rights in Latin America," *Journal of Romance Studies* 8:1 (2008): 43–59.

13. Taylor Owen and Ben Kiernan, "Bombs over Cambodia," *The Walrus* (October 2006): 67. Owen and Kiernan's study was based on recently released archival sources and corrects previous findings that the US bombing of Cambodia began under President Richard Nixon; in fact, it began under President Lyndon B. Johnson and escalated under Nixon.

14. David Chandler, *The Tragedy of Cambodian History* (New Haven, CT: Yale University Press, 1991).

15. Pol Pot's sister had been a concubine of King Sisowath Monivong.

16. Documentation Center of Cambodia, *Factsheet: Pol Pot and His Prisoners at Secret Prison S-21* (Phnom Penh: Documentation Center of Cambodia, 2011).

17. Ibid. Scholars estimate that between 12,000 and 20,000 prisoners were processed at Tuol Sleng. It is unclear whether all prisoners were photographed or whether thousands of mug shots were destroyed in the chaos preceding the Vietnamese invasion.

18. While early reports listed the number of Tuol Sleng survivors at seven or eight, a recent DC-Cam publication clarifies that 179 prisoners were released and 23 survived the Vietnamese invasion. See ibid.

19. Youk Chhang admits to consciously hiring Cambodians too young to have personally experienced the regime in an attempt to shape a staff with some measure of emotional distance from the materials they collect. Youk Chhang, "Connecting the Broken Pieces after the Cambodian Genocide: Legacy as Memory of a Nation," UC Berkeley-UCLA Distinguished Visitor from Southeast Asia Series, 2010, http://webcast.berkeley.edu/event_details.php?seriesid=dce46db2-c561-e73-e92-e3dab794ec1b.

20. While the Vietnamese-sponsored Cambodian regime tried Khmer Rouge leaders in absentia in 1979, that trial is commonly dismissed as not complying with the standards of international law.

21. Michel-Rolph Trouillot, *Silencing the Past: Power and the Production of History* (Boston: Beacon Press, 1995), 26. Postmodern archival theorists may bristle at

Trouillot's emphasis on facts, instead asserting that archives are repositories of evidence, rather than free-floating facts.

22. The power of archives and archivists to silence has been explored by Rodney G. S. Carter. Rodney G. S. Carter, "Of Things Said and Unsaid: Power, Archival Silences, and Power in Silence," *Archivaria* 61 (2006): 215–233.

23. Indeed, they underestimate the importance of the oral tradition, performance, three-dimensional objects, and other memory texts not commonly found in mainstream Western archives.

24. Trouillot, *Silencing the Past*, 27.

25. This figure does not include the mug shots discovered in 2012.

26. DC-Cam has estimated that there were twenty thousand prisoners at Tuol Sleng, while the ECCC has estimated that there were twelve thousand, but no one knows the exact number.

27. Laura Millar, "Touchstones: Considering the Relationship between Memory and Archives," *Archivaria* 61 (Spring 2006): 105–126.

28. Bastian, *Owning Memory*.

29. As Wendy Duff and Verne Harris argue, for example, archival description "is always storytelling—intertwining facts with narratives, observation with interpretation." Wendy Duff and Verne Harris, "Stories and Names: Archival Description as Narrating Records and Constructing Meanings," *Archival Science* 2 (2002): 276.

30. The continuum model represents a radical shift from the previously predominant records life-cycle model, which sees archival deposit as the final resting place for inactive records.

31. Frank Upward, "Modelling the Continuum as Paradigm Shift in Recordkeeping and Archiving Processes and Beyond," *Records Management Journal* (December 2000): n.p.

32. Sue McKemmish, "Placing Records Continuum Theory and Practice," *Archival Science* 1 (2001): 336.

33. Ibid., 335.

34. This conceptualization relies on that described in both ibid., 352, and in Frank Upward and Sue McKemmish, "Teaching Recordkeeping and Archiving Continuum Style," *Archival Science* 6 (2006): 223. The records do not move through the continuum in a linear, stage-like fashion but rather coexist in multiple spaces and times within the continuum.

35. By contrast, the records life-cycle model commonly used in records management posits distinct stages through which a record moves from creation to use to storage to disposition. In this view, these records are in a state of final disposition once their original function is fulfilled and they are deposited in an archival institution, a position against which this books argues.

36. Arjun Appadurai, ed., *The Social Life of Things: Commodities in Cultural Perspective* (Cambridge: Cambridge University Press, 1986). Other work has since stressed the co-modification and exchange value of material objects as they move through

this trajectory. See Nicholas Thomas, *Entangled Objects: Exchange, Material Culture, and Colonialism in the Pacific* (Cambridge, MA: Harvard University Press, 1991).

37. Appadurai, *Social Life of Things*, 5. See also Igor Kopytoff, "The Cultural Biography of Things: Commoditization as a Process," in *The Social Life of Things: Commodities in Cultural Perspective*, ed. Arjun Appadurai (Cambridge: Cambridge University Press, 1986), 66–67.

38. John Seely Brown and Paul Duguid, "The Social Life of Documents," *First Monday* 1:1 (1996), http://firstmonday.org/htbin/cgiwrap/bin/ojs/index.php/fm/article/view/466/387.

39. This exploration is absent from the first and third editions of this book. Gillian Rose, *Visual Methodologies: An Introduction to the Interpretation of Visual Materials*, 2nd ed. (London: Sage, 2006), 216.

40. Ibid., 217. Another example of Appadurai's social-life-of-images approach as applied to photographs is detailed in Christopher Pinney, *Camera Indica: The Social Life of Indian Photographs* (London: Reaktion Books, 1997).

41. Rose, *Visual Methodologies*, 219–220.

42. Elizabeth Edwards, *Raw Histories: Photographs, Anthropology, Museums* (Oxford: Berg, 2001), 5.

43. Ibid., 17.

44. W. J. T. Mitchell, *What Do Pictures Want? The Lives and Loves of Images* (Chicago: University of Chicago Press, 2005), 8.

45. Ibid., xiii.

46. Ibid., xv.

47. Ibid., 11.

48. Ibid., 45.

49. Ibid., 27. Another related trajectory of this approach from science and technology studies is Bruno Latour's actor network theory. Bruno Latour, *Reassembling the Social: An Introduction to Actor-Network-Theory* (Oxford: Oxford University Press, 2005).

50. Despite sharing the word "life," the social life of objects approach, when placed within the framework of existing archival theory, is not necessarily bound to the records life-cycle model but can be used to describe records within the continuum as well.

51. Eric Ketelaar, "Tacit Narratives: The Meaning of Archives," *Archival Science* 1:2 (2001): 138.

52. Ibid., 137.

53. Ibid., 141.

54. Geoffrey C. Bowker, *Memory Practices in the Sciences* (Cambridge, MA: MIT Press, 2005), 123. See also Geoffrey C. Bowker and Susan Leigh Star, *Sorting Things Out: Classification and Its Consequences* (Cambridge, MA: MIT Press, 1999).

55. Jennifer Douglas, "Origins: Evolving Ideas about the Principle of Provenance," in *Currents of Archival Thinking*, ed. Terry Eastwood and Heather MacNeil (Santa Barbara, CA: Libraries Unlimited, 2010), 23–43.

56. Society of American Archivists, "Provenance," *A Glossary of Archival and Records Terminology*, http://www.archivists.org/glossary/term_details.asp?Definition Key=196.

57. The archival principle of inalienability posits that records generated by state or governmental institutions rightfully should be placed in the custody of state-operated or governmental archives.

58. Douglas, "Origins," 24.

59. Tom Nesmith, "Still Fuzzy but More Accurate: Some Thoughts on the 'Ghosts' of Archival Theory," *Archivaria* 47 (1999): 146.

60. Laura Millar, "The Death of the Fonds and the Resurrection of Provenance: Archival Context in Space and Time," *Archivaria* 53 (2002): 12–13.

61. Joel Wurl, "Ethnicity as Provenance: In Search of Values and Principles Documenting the Immigrant Experience," *Archival Issues* 29:1 (2005).

62. Bastian, *Owning Memory*.

63. Jeannette Bastian, "Reading Colonial Records through an Archival Lens: The Provenance of Place, Space, and Creation," *Archival Science* 6 (2006): 269.

64. Hurley defines parallel provenance as "the coterminous generation of the same thing in the same way at the same time." However, I would add that in many contentious examples, particularly those involving disputes over the physical custody of records, the provenance is not parallel but on a collision course. Chris Hurley, "Parallel Provenance," http://www.infotech.monash.edu.au/research/groups/rcrg /publications/parallel-provenance-combined.pdf, 10. See also Chris Hurley, "Parallel Provenance: What if Anything Is Archival Description?" *Archives and Manuscripts* 33:1 (2005): 110–145.

65. Livia Iacovino, "Rethinking Archival, Ethical and Legal Frameworks for Records of Indigenous Australian Communities: A Participant Relationship Model of Rights and Responsibilities," *Archival Science* 10 (2010): 353–372.

66. Jeannette Bastian, "Whispers in the Archives: Finding the Voices of the Colonized in the Records of the Colonizer," in *Political Pressure and the Archival Record*, ed. Margaret Procter et al. (Chicago: Society of American Archivists, 2005), 41.

67. Gayatri Chakravorty Spivak, "Can the Subaltern Speak?," reprinted in *The Post-Colonial Studies Reader*, ed. Bill Ashcroft et al. (New York: Routledge, 1995), 28–37.

68. Archival scholars (including myself) have referred to this as the "archival multiverse." Pluralizing the Archival Curriculum Group, "Educating for the Archival Multiverse," *American Archivist* 74:1 (2011): 69–101. By opening archival theory to include Cambodian ways of using archival records, this book heeds the call of Anne Gilliland et al. to make the archival paradigm "more inclusive and less in danger of becoming a hegemonic or even neocolonial force." Anne Gilliland, Sue McKemmish, Kelvin White, Yang Lu, and Andrew J. Lau, "Pluralizing the Archival Paradigm: Can Archival Education in Pacific Rim Communities Address the Challenge?" *American Archivist* 71:1 (2008): 87.

69. Verne Harris, "The Archival Sliver: Power, Memory, and Archives in South Africa," *Archival Science* 2:1–2 (2002): 64.

70. Jacques Derrida, *Archive Fever: A Freudian Impression* (Chicago: University of Chicago Press, 1996).

71. Slyomovics, *The Performance of Human Rights in Morocco*, and Noble, "Traveling Theories of Family Photography and the Material Culture of Human Rights in Latin America."

Chapter 1. The Making of Records

1. David Hawk, "Tuol Sleng Extermination Centre," *Index on Censorship* 15:1 (January 1986): 25.

2. Documentation Center of Cambodia, *Factsheet: Pol Pot and His Prisoners at Secret Prison S-21* (Phnom Penh: Documentation Center of Cambodia, 2011), n.p.

3. David Chandler, "The Pathology of Terror in Pol Pot's Cambodia," in *The Killing Fields*, ed. Doug Niven and Chris Riley (Santa Fe: Twin Palms, 1996), 104.

4. Vann Nath, *A Cambodian Prison Portrait* (Bangkok: White Lotus Press, 1998), 83.

5. Chandler, "The Pathology of Terror in Pol Pot's Cambodia," 104.

6. David Chandler, *Voices from S-21: Terror and History in Pol Pot's Secret Prison* (Chiang Mai, Thailand: Silkworm Books, 2000), 16.

7. Documentation Center of Cambodia, *Factsheet*. Bou Meng and Chum Mey are the only two known adult survivors of Tuol Sleng who regularly speak about their experiences. A few of the child survivors have also come forward.

8. Ibid.

9. Chandler, "The Pathology of Terror in Pol Pot's Cambodia," 103.

10. Some of the surviving documentation from Tuol Sleng is communication between Son Sen and Duch.

11. George Chigas, "The Trial of the Khmer Rouge: The Role of the Tuol Sleng and Santebal Archives," *Harvard Asia Quarterly* (Winter 2000): 45.

12. Chanthou Boua and Ben Kiernan with Anthony Barnett, "Bureaucracy of Death," *New Statesman* (May 2, 1980): 671.

13. Documentation Center of Cambodia, *Factsheet*.

14. Ibid.

15. Chandler, *Voices from S-21*, 17.

16. Ibid., 27. Chandler also reports that at least ten members of the Documentation Unit themselves were accused of treason and became prisoners at Tuol Sleng.

17. Interestingly, at the tribunal, Duch testified that he estimated only 50 percent of the confession statements extracted at Tuol Sleng were true and that only 20 percent of the named accomplices were actually guilty. Seth Mydans, "Legal Strategy Fails to Hide Torturer's Pride," *New York Times*, June 21, 2009. I have addressed the social function of these textual records in other articles and am limiting the focus of this investigation to photographic records. For more information on Duch's role and the

social function of textual records, see Michelle Caswell, "Hannah Arendt's World: Bureaucracy, Documentation and Banal Evil," *Archivaria* 70 (Fall 2010): 1–25, and Michelle Caswell, "Khmer Rouge Archives: Accountability, Truth, and Memory in Cambodia," *Archival Science* 10:1–2 (January 2010): 25–44.

18. For a more exhaustive list, see Hawk, "Tuol Sleng Extermination Centre," 25.

19. Chandler, *Voices from S-21*, 27.

20. Ibid.

21. Youk Chhang, interview with author, December 9, 2011, Phnom Penh. Indeed, En, now a council member of a small town in Cambodia, has made a cottage industry of being interviewed by reporters and participating in documentary films for a steep fee, garnering the distrust of many authors. For example, Peter Maguire reports that En was a "smooth operator" who asked for money and for an introduction to the US ambassador. Peter Maguire, *Facing Death in Cambodia* (New York: Columbia University Press, 2005), 4. En, who remained a Khmer Rouge member until 1995, has also been accused of trying to profit from the sale of records that many claim belong to the Cambodian public. In 2007, En announced plans to open a museum of other photographs in his possession and to charge admission, and in 2009 he unsuccessfully tried to auction off two cameras and a pair of sandals he claimed once belonged to Pol Pot for $500,000.

22. Maguire, *Facing Death in Cambodia*, 113.

23. Ibid., 120.

24. Youk Chhang, interview with author, December 9, 2011, Phnom Penh.

25. Nic Dunlop describes this chair as an "old colonial-era photographer's chair used in the past primarily for identification photographs." More on this chair to come. Nic Dunlop, *The Lost Executioner* (London: Bloomsbury, 2005), 149. The earlier Tuol Sleng mug shots did not use this chair.

26. It is unclear why measurements and profile pictures were inconsistently taken.

27. Youk Chhang, interview with author, December 9, 2011, Phnom Penh.

28. Seth Mydans, "Out from behind a Camera at a Khmer Torture Center," *New York Times*, October 27, 2007, 3A.

29. The grey zone is a concept first introduced by Primo Levi, a Holocaust survivor, to describe the moral ambiguity of lower-ranked accomplices to mass murder, such as prison guards. Chandler, *Voices from S-21*, 28.

30. Maguire, *Facing Death in Cambodia*, 122.

31. "Ex-Khmer Rouge Photographer Plans to Set Up Museum in Anlong Veng," *Japan Economic Newswire* (January 25, 2007).

32. Chandler, "The Pathology of Terror in Pol Pot's Cambodia," 103.

33. Maguire, *Facing Death in Cambodia*, 120.

34. Norng Chanphal, interview with Vanthan Peou Dara and Chy Terith, February 13, 2009, Documentation Center of Cambodia, Phnom Penh, Cambodia, unpaginated. The name is also listed as Nong Chan Phal in other publications.

35. Chum Mey, interview with Sim Soraya, March 23, 2006, Documentation Center of Cambodia, Phnom Penh, Cambodia, unpaginated.

36. Huy Vannak, *Bou Meng: A Survivor from Khmer Rouge Prison S-21* (Phnom Penh: Documentation Center of Cambodia, 2010), 35.

37. Nath, *A Cambodian Prison Portrait*, 40.

38. Youk Chhang, interview with author, December 9, 2011, Phnom Penh.

39. For a more thorough exploration of the French colonial period in Cambodia, see John Tully, *France on the Mekong* (Lanham, MD: University Press of America, 2002).

40. Ibid., 121.

41. Peter Zinoman, *The Colonial Bastille: A History of Imprisonment in Vietnam, 1862–1940* (Berkeley: University of California Press, 2001).

42. Tully, *France on the Mekong*, 122.

43. While Zinoman's history of prisons in French colonial Vietnam is comprehensive, many of his findings remain specific to Vietnam and cannot be extrapolated to the Cambodian context given the different degrees to which the French administered each colony. Zinoman, *The Colonial Bastille*, 14.

44. Tully, *France on the Mekong*, 34.

45. Ibid., 142. This shift from public execution to imprisonment in France is detailed by Michel Foucault in *Discipline and Punish: The Birth of the Prison* (New York: Random House, 1977).

46. Tully, *France on the Mekong*, 142. As Tully writes elsewhere, "The ideals of 1789 were not for export. The model was a colonial police state, not a democratic society." John Tully, *Cambodia under the Tricolour* (Clayton, Australia: Monash University, 1996), xi.

47. Tully, *France on the Mekong*, 288, 293. For details on just how dismal Cambodian prison conditions were, see chapter 15 of Tully's book.

48. Tully, *Cambodia under the Tricolour*, vii.

49. Tully, *France on the Mekong*, 365. These figures contrast sharply with those for neighboring French colonial Vietnam, where, as Peter Zinoman writes, more than ninety thousand people—half of 1 percent of the total population—were imprisoned in 1936. Zinoman, *The Colonial Bastille*, 63. While Pol Pot and many of his colleagues grew up in a Cambodia occupied by the Vichy French colonial power and although Pol Pot himself studied in France after the Second World War, there is no evidence as far as I know to suggest that the Khmer Rouge directly studied Nazi techniques. I am not suggesting that Khmer Rouge leaders had knowledge of and/or modeled their own organizational structure after Nazi bureaucracy. For more information on the possible influence of Vichy France on Pol Pot, see Ben Kiernan, *Blood and Soil* (New Haven, CT: Yale University Press, 2007), 540–48.

50. Tully, *France on the Mekong*, 417.

51. Zinoman, *The Colonial Bastille*, 17. Zinoman also notes that, due to complicated historical factors, prisons in each of the different territories within French colonial Indochina "functioned within their own distinct legal, bureaucratic, and financial frameworks," including totally "different kinds of institutions." In other words, there was no uniform French colonial penal system in Indochina but rather discrete,

decentralized, and fractured systems in each territory. Zinoman, *The Colonial Bastille*, 38.

52. Foucault, *Discipline and Punish*.

53. Simon A. Cole, "Fingerprint Identification and the Criminal Justice System: Historical Lessons for the DNA Debate," http://www.hks.harvard.edu/dnabook /Simon%20Cole%20II.doc, 3. Early attempts at the classification of criminals included alphabetized registers (ineffective for suspects lying about their names) and branding, which was outlawed in France in 1832. Simon A. Cole, *Suspect Identities: A History of Fingerprinting and Criminal Identification* (Cambridge, MA: Harvard University Press, 2001), 16.

54. Joe Nickell reports that Belgian police departments introduced the daguerreotype in 1843, and France and the United States followed suit in the 1850s. By the 1870s in the United States, mug shots were quite common and used, most famously, by Allan Pinkerton's detective agency. Joe Nickell, *Camera Clues: A Handbook for Photographic Investigation* (Lexington: University of Kentucky Press, 1994). Also see Cole, *Suspect Identities*.

55. In the introduction to the 1896 American edition of his handbook, Bertillon writes, "During the last ten years the Parisian police have collected over 100,000 photographs. Do you suppose it possible to compare successively each of these 100,000 photographs with each of the 100 individuals arrested daily in Paris? . . . The search would take more than a week of application." Alphonse Bertillon, *Signaletic Instructions including the Theory and Practice of Anthropometrical Identification* (Chicago: Werner, 1896), 12.

56. Bertillon's father was Louis-Adolphe Bertillon, a demographer and anthropologist. At that time, many anthropological projects were under way that included the systematic measurement of members of racial groups; no doubt these influenced Bertillon's thinking. Bertillon's system was at first rejected by management, but Bertillon remained persistent until it was adopted in 1883. Alphonse Bertillon, "Letter to Joseph Nicholson," published in Joseph Nicholson, "The Identification of Criminals," Congress of the National Prison Association at Pittsburgh, October 10–15, 1891.

57. Bertillon, *Signaletic Instructions including the Theory and Practice of Anthropometrical Identification*.

58. Cole, *Suspect Identities*, 45.

59. Cole, "Fingerprint Identification and the Criminal Justice System."

60. Bertillon, *Signaletic Instructions including the Theory and Practice of Anthropometrical Identification*, Plate 7.

61. Bertillon, "Letter to Joseph Nicholson."

62. Martine Kaluszynski, "Republican Identity: Bertillonage as Government Technique," in *Documenting Individual Identity*, ed. Jane Caplan and John Torpey (Princeton: Princeton University Press, 2001), 127. For further discussion of this classification, see Cole, *Suspect Identities*, chapter 2.

63. Many other scholars have documented the role played by early photography and its exhibition in the creation of anthropological "truth" that justified imperialism

in the Middle East, Africa, the Americas, Australia, and Asia. See Keri A. Berg, "The Imperialist Lens: Du Camp, Salzmann and Early French Photography," *Early Popular Visual Culture* 6:1 (2008): 1–18; Anne Maxwell, *Colonial Photography and Exhibitions* (London: Leicester University Press, 1999); Eleanor M. Hight and Gary D. Sampson, eds., *Colonialist Photography: Imag(in)ing Race and Place* (New York: Routledge, 2002); Deborah Poole, *Vision, Race, and Modernity: A Visual Economy of the Andean Image World* (Princeton: Princeton University Press, 1997). Furthermore, it is no coincidence that the 1889 Paris Exposition featured an exhibition of the Bertillon system in the Palais de Justice, a series of lectures by the Société d'Anthropologie, and a display of people from the French colonies. As one enthusiastic American visitor wrote, attendees could see "twelve types of Africans, besides Javanese, Tonkinese, Chinese, Japanese, and other oriental peoples, living in native houses, wearing native costumes, eating native food, practicing native arts and rites on the Esplanade des Invalides side by side with the latest inventions and with the whole civilized world as spectators." Otis T. Mason, "Anthropology in Paris during the Exposition of 1889," *American Anthropologist* 3:1 (January 1890): 31.

64. Bertillon, *Signaletic Instructions including the Theory and Practice of Anthropometrical Identification*, 12.

65. Alphonse Bertillon, *Ethnographie Moderne: Les Races Sauvages* (Paris: Librairie de L'Académie de Médecine, 1883). This type of anthropometric image of colonized people did not originate with Bertillon. In 1869, Thomas Henry Huxley, the British biologist and follower of Darwin, undertook a project to photograph and measure all of the races found within the British Empire. The resulting photographs of naked subjects in front and profile views next to rulers are strikingly similar to the images produced in Bertillon's book. Elizabeth Edwards, *Raw Histories: Photographs, Anthropology and Museums* (Oxford: Berg, 2001), chapter 6.

66. Simon A. Cole reports that it was adopted in the United States and Canada in 1887, in Argentina in 1891, in colonial Bengal in 1893, in Great Britain in 1894, and in Germany, Belgium, the Netherlands, Spain, Italy, Russia, Sweden, Norway, Turkey, Monaco, Luxembourg, Romania, Tunisia, and much of South America by 1899. Cole, *Suspect Identities*, 51–52.

67. In response to Nicholson, Bertillon wrote that he hoped that Chicago would be wise enough to adopt the system for its upcoming World's Columbian Exposition. Indeed, Bertillon exhibited his new system at the 1893 World's Columbia Exposition in Chicago. Joseph Nicholson, "The Identification of Criminals," Congress of the National Prison Association at Pittsburgh, October 10–15, 1891.

68. The Publishers, "Preface of American Publishers," *Signaletic Instructions including the Theory and Practice of Anthropometrical Identification* (Chicago: Werner, 1896), vii.

69. Raymond B. Fosdick, "The Passing of the Bertillon System of Identification," *Journal of the American Institute of Criminal Law and Criminology* 6:3 (1915): 364.

70. Cole, *Suspect Identities*, 52–53.

71. A 1903 controversy in which the identities of two suspected criminals, Will West and William West, were conflated in the Bertillon system contributed to the system's demise. Joe Nickell, *Camera Clues: A Handbook for Photographic Investigation* (Lexington: The University of Kentucky Press, 1994).

72. Indeed, as Simon A. Cole asserts, "It is because of Bertillon's belief in the identifying potential of the ear that today's mug shots include the profile." Cole, *Suspect Identities*, 43. According to the *Oxford English Dictionary*, the slang use of "mug" to mean face is "perhaps in allusion to the drinking mugs made to represent a grotesque human face which were common in the 18th century." Jennifer Green-Lewis has suggested that the contemporary use of the term implies that the "the subject is being 'mugged,' or assaulted, by the camera." Jennifer Green-Lewis, *Framing the Victorians* (Ithaca, NY: Cornell University Press, 1996), 200. Many vestiges of the Bertillon system remain in archives scattered throughout the United States, as detailed in Paige "B" Gridack, "Bringing Bertillon Back: The Preservation and Research Application of Bertillon Materials in Museums, Archives and Historical Societies," *Journal of Archival Organization* (February 2010): 188–213.

73. Allan Sekula, "The Body and the Archive," *October* 39 (Winter 1986): 62.

74. Other evidence may exist in archives in France.

75. "Dealing with the Yellow Peril in Indo-China," *Public Opinion* (September 23, 1905): 401.

76. Margaret Slocomb, *Colons and Coolies: The Development of Cambodia's Rubber Plantations* (Bangkok: White Lotus, 2007), back cover.

77. Earlier records may have been sent to France rather than deposited at the National Archives of Cambodia or may have been destroyed during the Cambodian civil war.

78. Request from Résident de Kompong Cham to Résident Supérieur Phnom Penh for "Fourniture des photos d'identité des chinois residant dans la province de Kompong Cham," November 12, 1936, file number 31386, and Request from Résident de Kampot to Résident Supérieur Phnom Penh for "Fourniture de photographie d'identité pour les chinois résident a Kampot," May 13, 1937, file number 31378, National Archives of Cambodia.

79. Bertillon Cards, 1939–1940, National Archives of Cambodia, Folder PA1.

80. No longer attached with glue, the Bertillon cards and their accompanying arrest record are now housed together in plastic folders at the National Archives of Cambodia.

81. However, there is no evidence to show that Bertillon's detailed indexing system was used at Tuol Sleng; it is unclear if the indexing component of Bertillon's system was ever adopted in colonial Cambodia.

82. Chandler, *Voices from S-21*, 88. However, while Chandler posits that Duch and his colleagues at Tuol Sleng implemented such colonial vestiges as mug shots in an attempt to create a modern and efficient prison bureaucracy, their adaptation was not "a straight-forward extension of prerevolutionary police procedures." Rather, the administration of Tuol Sleng reveals a mixture of the influence of French colonial

policing techniques, the Communist obsession with confession and self-criticism, and a uniquely Cambodian manifestation of totalitarianism. Chandler writes, "S-21, therefore, like DK [the Khmer Rouge regime] itself, was a Cambodian, Communist, imported, twentieth-century phenomenon." Chandler, *Voices from S-21*, 152.

83. Ibid., 50.

84. Alexander Laban Hinton, *Why Did They Kill? Cambodia in the Shadow of Genocide* (Berkeley: University of California Press, 2005), 45.

85. Foucault, *Discipline and Punish*.

86. Foucault's phrase "docile bodies" is particularly apt here. Ibid.

87. Gillian Rose has two chapters on the Foucauldian discourse analysis of visual images that are particularly helpful in decoding Foucault. Rose, *Visual Methodologies: An Introduction to the Interpretation of Visual Materials*, 2nd ed. (London: Sage, 2006), 141–195.

88. John Tagg, *The Burden of Representation* (Amherst: University of Massachusetts Press, 1988), 62.

89. In fact, Bertillon's indexing and measurement system evolved out of his initial interest in standardizing police photography; his 1890 handbook on police photography, *La Photographie Judiciaire* (Paris: Gauthier-Villars et Fils), predates the adoption and publication of his indexing system.

90. Allan Sekula, "The Traffic in Photographs," in *Only Skin Deep: Changing Visions of the American Self*, ed. Coco Fusco and Brian Wallis (New York: International Center for Photography, 2003), 81–82.

91. Brian Wallis, "Black Bodies, White Science: Louis Agassiz's Slave Daguerreotypes," in *Only Skin Deep: Changing Visions of the American Self*, ed. Coco Fusco and Brian Wallis (New York: International Center for Photography, 2003), 177. Similarly, Shawn Michelle Smith has noted the simultaneous growth in popularity in the United States of the criminal mug shot and the middle-class portrait at the end of the nineteenth century. Shawn Michelle Smith, *American Archives: Gender, Race, and Class in Visual Culture* (Princeton: Princeton University Press, 1999). Sekula describes these two genres—mug shots and portraits—as mirror images or shadow archives; he writes, "every proper portrait has its lurking, objectifying inverse in the files of the police." Allan Sekula, "The Body and the Archive," *October* 39 (Winter 1986): 7.

92. A similar argument could be made of many of the Tuol Sleng mug shots, despite the absolute authoritarian nature of the Tuol Sleng administration. Peter Doyle, "Public Eye, Private Eye: Sydney Police Mug Shots, 1912–1930," *Scan Journal* 1:1 (January 2004): 1–30.

93. Tagg, *The Burden of Representation*, 59.

94. Ibid., 76.

95. Sekula, "The Body and the Archive," 16.

96. Ibid., 57.

97. Ibid., 16.

98. In the words of Craig Robertson, "To locate archives within a larger process makes it apparent that archives do not neutrally store documents, but rather in capturing

them, archives transform objects into knowledge." Craig Robertson, "The Archive, Disciplinarity, and Governing: Cultural Studies and the Writing of History," *Critical Studies, Critical Methodologies* 4:4 (2004): 453.

99. Tagg, *The Burden of Representation*, 63.

100. Dunlop, *The Lost Executioner*, 148.

101. Penny Edwards, *Cambodge: The Cultivation of a Nation, 1860–1945* (Honolulu: University of Hawaii Press, 2007), 4.

102. Jorge Daniel Veneciano, "Tuol Sleng, Abu Ghraib, and the Discourse of Torture," in *Night of the Khmer Rouge: Genocide and Justice in Cambodia*, ed. Jorge Daniel Veneciano and Alexander Hinton (Newark, NJ: Rutgers University Press, 2007), 56.

103. Penny Edwards makes a similar argument. Edwards, *Cambodge: The Cultivation of a Nation*, 4.

104. Ibid., 1.

105. Elsewhere, I have detailed the Khmer Rouge's ethnic classifications and its ramifications for genocide charges. Michelle Caswell, "Using Classification to Convict the Khmer Rouge," *Journal of Documentation* 68:2 (2012): 162–184.

106. Eric D. Weitz, *A Century of Genocide: Utopias of Race and Nation* (Princeton: Princeton University Press, 2003), 160–161.

107. Michelle Caswell, "Hannah Arendt's World: Bureaucracy, Documentation, and Banal Evil," *Archivaria* 70 (Fall 2010): 1–25.

108. Erving Goffman, *Asylums: Essays on the Social Situations of Patients and Other Inmates* (Piscataway, NJ: Aldine Transaction, 2007), and Foucault, *Discipline and Punish*.

109. Dunlop, *The Lost Executioner*, 149.

110. Duch's exact words were: "When a new detainee arrived at S-21, he was immediately photographed. This was to protect myself, and also, if the prisoner escaped, with the photograph, it would be easier to catch him back." Christophe Peschoux, interview with Kaing Guek Eav, also known as Duch, Chairman of S-21, April–May 1999, 22, David Chandler Cambodia Collection, Monash University Library, http://arrow.monash.edu.au/vital/access/manager/Collection/monash:64226.

111. Rachel Hughes, "The Abject Artefacts of Memory: Photographs from Cambodia's Genocide," *Media Culture Society* 25:23 (2003): 25.

112. Hannah Arendt, *Eichmann in Jerusalem: A Report on the Banality of Evil* (New York: Penguin, 2006), 294.

113. George Kateb, *Hannah Arendt: Politics, Conscience, Evil* (Totowa, NJ: Rowman & Allanheld, 1983), 73.

114. Craig Etcheson, *After the Killing Fields: Lessons from the Cambodian Genocide* (Lubbock: Texas Tech University Press, 2005), 54.

115. Kaing Guek Eav ("Duch"), quoted in ibid., 83.

116. Ibid., 78–79.

117. Asian Justice Initiative, *The KRT Trial Monitor*, Report Issue No. 4 (April 26, 2009): 2.

118. Asian Justice Initiative, *The KRT Trial Monitor*, Report Issue No. 9 (June 21, 2009): 3.

119. Ibid., 7.

120. Asian Justice Initiative, *The KRT Trial Monitor*, Report Issue No. 15 (August 2, 2009): 3.

121. Craig Etcheson describes a particularly gruesome execution log from July 23, 1977, which lists the names of eighteen prisoners killed that day, as well as a handwritten note from the chief guard at the bottom of the log that reads, "Also killed 160 children today for a total of 178 enemies killed." Etcheson, *After the Killing Fields*, 83.

122. Asian Justice Initiative, *The KRT Trial Monitor*, Report Issue No. 9 (June 21, 2009): 6.

123. Ibid., 4.

124. Ibid.

125. Arendt, *Eichmann in Jerusalem*, 276.

126. As quoted in Mydans, "Legal Strategy Fails to Hide Torturer's Pride."

127. Seth Mydans, "Khmer Rouge Figure Is Found Guilty of War Crimes," *New York Times*, July 26, 2010.

128. Asian Justice Initiative, *The KRT Trial Monitor*, Report Issue No. 3 (April 12, 2009): 3.

129. Ciaran B. Trace, "What Is Recorded Is Never Simply 'What Happened': Record Keeping in Modern Organizational Culture," *Archival Science* 2 (2002): 139, 143.

130. Ibid., 153.

131. Michael Thad Allen, "The Banality of Evil Reconsidered: SS Mid-Level Managers of Extermination through Work," *Central European History* 30:2 (1997): 255.

132. Trace, "What Is Recorded Is Never Simply 'What Happened,'" 152.

133. Ibid., 139.

134. Trouillot, *Silencing the Past*, 49.

135. Jeannette Bastian, "Whispers in the Archives: Finding the Voices of the Colonized in the Records of the Colonizer," in *Political Pressure and the Archival Record*, ed. Margaret Proctor et al. (Chicago: Society of American Archivists, 2005), 25–43.

136. However, as chapter 3 addresses, the creation of new records that incorporate the mug shots by survivors and victims' family members adds another layer of agency to this situation; while the Tuol Sleng prisoners are not co-creators of their mug shots, their surviving relatives are creators of records that bear witness to the mug shots.

137. W. J. T. Mitchell, *What Do Pictures Want? The Lives and Loves of Images* (Chicago: University of Chicago Press, 2005).

Chapter 2. The Making of Archives

1. Michel-Rolph Trouillot, *Silencing the Past: Power and the Production of History* (Boston: Beacon Press, 1995), 52.

2. Michel Foucault, *Archeology of Knowledge* (New York: Pantheon Books, 1972), 129.

3. Trouillot, *Silencing the Past*, 52.

4. This political motivation was first posited by Judy Ledgerwood. Judy Ledgerwood, "The Cambodian Tuol Sleng Museum of Genocidal Crimes: National Narrative," *Museum Anthropology* 21:1 (1997): 82–98.

5. Ibid. See also Rachel Hughes, "The Abject Artefacts of Memory: Photographs from Cambodia's Genocide," *Media Culture Society* 25:23 (2003): 23–44.

6. Ledgerwood, "The Cambodian Tuol Sleng Museum of Genocidal Crimes."

7. Ben Kiernan, untitled lecture, Global Resources Network Conference and Forum, Yale University Center for International and Area Studies, March 24, 2005, http://www.library.yale.edu/mssa/globalrecord/new_web/kiernan_richie.html#text.

8. Nic Dunlop, *The Lost Executioner* (London: Bloomsbury, 2005).

9. David Chandler estimates that the number of bodies found at Tuol Sleng was fifty. David Chandler, *Voices from S-21: Terror and History in Pol Pot's Secret Prison* (Chiang Mai, Thailand: Silkworm Books, 2000).

10. Ibid.

11. For a more detailed discussion of the use of the term "show trial" and its accuracy in describing the People's Revolutionary Tribunal, see Howard J. De Nike, "Reflections of a Legal Anthropologist on the Trial of Pol Pot and Ieng Sary," in Howard J. De Nike, John Quigley, and Kenneth J. Robinson, eds., with the assistance of Helen Jarvis and Nereida Cross, *Genocide in Cambodia: Documents from the Trial of Pol Pot and Ieng Sary* (Philadelphia: University of Pennsylvania Press, 2000), 19–28. John Quigley, a foreign lawyer who participated in the trial, complicates the "show trial" moniker, but writes that the trial is "widely viewed as an event staged by Vietnam to justify its military intervention" and that, "in holding the trial, the new government of Cambodia sought to discredit the Khmer Rouge and to challenge the international community over its recognition policy on Cambodia." John Quigley, "Introduction," in Howard J. De Nike, John Quigley, and Kenneth J. Robinson, eds., with the assistance of Helen Jarvis and Nereida Cross, *Genocide in Cambodia: Documents from the Trial of Pol Pot and Ieng Sary* (Philadelphia: University of Pennsylvania Press, 2000), 8.

12. De Nike et al., *Genocide in Cambodia*. For the National Archives of Cambodia's statement on these access restrictions, see http://nac.gov.kh/english/index.php?option=com_content&view=article&id=55&Itemid=67. Documents used in and related to the People's Revolutionary Tribunal are also listed in DC-Cam's Bibliographic Database.

13. Dunlop, *The Lost Executioner*, 182.

14. Ledgerwood, "The Cambodian Tuol Sleng Museum of Genocidal Crimes."

15. Cambodian Genocide Program, Yale University, "Documentation of the Photographic Database," http://www.yale.edu/cgp/cimgdoc.html.

16. Ledgerwood, "The Cambodian Tuol Sleng Museum of Genocidal Crimes."

17. Dith Pran, "Return to the Killing Fields," *New York Times*, September 24, 1989, SM30.

18. Ledgerwood, "The Cambodian Tuol Sleng Museum of Genocidal Crimes," 82.

19. This view is still advanced by the museum in what little English wall text there is. A pamphlet picked up at the museum in January 2012 blames "Pol Pot's clique" for the evacuation of Phnom Penh, as if there were only a handful of high-level perpetrators. "Tuol Sleng Genocide Museum," pamphlet (Phnom Penh: Tuol Sleng Genocide Museum), undated.

20. Chandler, *Voices from S-21*, 5.

21. Ibid., 6.

22. David Chandler, "Tuol Sleng and Choeung Ek," *Searching for the Truth* (First Quarter 2008): 34. These rumors persist, despite overwhelming evidence to the contrary, and tap into deep anti-Vietnamese sentiment in Cambodia.

23. Vann Nath, *A Cambodian Prison Portrait* (Bangkok: White Lotus Press, 1998), 100.

24. Ibid., 101.

25. Ibid., 108.

26. Huy Vannak, *Bou Meng: A Survivor from Khmer Rouge Prison S-21* (Phnom Penh: Documentation Center of Cambodia, 2010), 55.

27. Ibid., 57. The ability of these photographs to "speak" is explored in further detail in chapter 3.

28. Chanthou Boua and Ben Kiernan, with Anthony Barnett, "Bureaucracy of Death," *New Statesman* (May 2, 1980): 671.

29. Ibid.

30. Tom Fawthrop and Helen Jarvis, *Getting Away with Genocide?* (Ann Arbor, MI: Pluto, 2004), 41.

31. For a more detailed account of this organization, see Gregory H. Stanton, "The Call," in *Pioneers of Genocide Studies*, ed. Samuel Totten and Steven Leonard Jacobs (New Brunswick, NJ: Transaction, 2002), 401–425.

32. David Hawk, "Confronting Genocide in Cambodia," in *Pioneers of Genocide Studies*, ed. Samuel Totten and Steven Leonard Jacobs (New Brunswick, NJ: Transaction, 2002), 521.

33. Ibid., 529.

34. David Hawk, quoted in Seth Mydans, "Word for Word / Torturers' Archive: Cambodia's Bureaucracy of Death: Reams of Evidence in Search of a Trial," *New York Times*, July 20, 1997, section 4, page 7.

35. Hawk, "Confronting Genocide in Cambodia," 531.

36. Ibid.

37. David Hawk, "The Killing of Cambodia," *The New Republic*, November 15, 1982, 17–21; David Hawk, "Tuol Sleng Extermination Centre," *Index on Censorship* 15 (January 1986): 25–31.

38. David Hawk, "The Photographic Record," in *Cambodia 1975–1978: Rendezvous with Death*, ed. Karl D. Jackson (Princeton: Princeton University Press, 1989), 209–214 and unpaginated photo insert.

39. John F. Dean, "The Preservation of Books and Manuscripts in Cambodia," *American Archivist* 53 (Spring 1990): 282–297.

40. Judy Ledgerwood, phone interview with author, July 21, 2011.

41. Ibid.

42. John F. Dean, "The Preservation and Conservation Needs of the Upper Regions of Southeast Asia," *Libri* 47 (1997): 129.

43. Judy Ledgerwood, phone interview with author, July 21, 2011.

44. Dean, "The Preservation and Conservation Needs of the Upper Regions of Southeast Asia," 129.

45. Judy Ledgerwood, phone interview with author, July 21, 2011.

46. Dean, "The Preservation and Conservation Needs of the Upper Regions of Southeast Asia," 130.

47. Judy Ledgerwood, phone interview with author, July 21, 2011.

48. Dean, "The Preservation and Conservation Needs of the Upper Regions of Southeast Asia," 130.

49. Ibid.

50. Judy Ledgerwood, phone interview with author, July 21, 2011.

51. Ibid.

52. Ibid.

53. Douglas Niven, quoted in British Broadcasting Corporation, *Secrets of S-21: Legacy of a Cambodian Prison*, VHS, Films for the Humanities and Sciences, 1998. As previously stated, it is unclear what changes at the Tuol Sleng Museum led to this change in the preservation of the negatives from being well kept in 1982, when David Hawk received a copy of them, to deteriorating in 1993, when Christopher Riley and Douglas Niven encountered them.

54. Chris Riley, quoted in British Broadcasting Corporation, *Secrets of S-21: Legacy of a Cambodian Prison*.

55. Dawne Adam, "The Tuol Sleng Archives and the Cambodian Genocide," *Archivaria* 45 (1998): 21.

56. Guy Trebay, "Killing Fields of Vision," *The Village Voice*, June 3, 1997, 34.

57. Douglas Niven, quoted in British Broadcasting Corporation, *Secrets of S-21: Legacy of a Cambodian Prison*.

58. Peter Maguire, upon viewing the East German footage, writes, "I had not seen many of these images. . . . The unfamiliar photos were definitely not among the 5,000 in the Tuol Sleng archive and were lost, probably forever." Peter Maguire, *Facing Death in Cambodia* (New York: Columbia University Press, 2005), 96.

59. Chris Riley, quoted in British Broadcasting Corporation, *Secrets of S-21: Legacy of a Cambodian Prison*.

60. Chey Sophera, quoted in British Broadcasting Corporation, *Secrets of S-21: Legacy of a Cambodian Prison*.

61. Suos Thy, quoted in British Broadcasting Corporation, *Secrets of S-21: Legacy of a Cambodian Prison*.

62. Douglas Niven, quoted in British Broadcasting Corporation, *Secrets of S-21: Legacy of a Cambodian Prison*.

63. Craig Etcheson, Skype interview with author, May 30, 2011.

64. Maguire, *Facing Death in Cambodia*, 90.

65. Ibid., 96–97.

66. Chris Riley, quoted in British Broadcasting Corporation, *Secrets of S-21: Legacy of a Cambodian Prison.*

67. Much criticism has been written about this exhibition, which I only summarize here. See Rachel Hughes, "The Abject Artefacts of Memory," and Paul Williams, "The Atrocity Exhibition: Touring Cambodian Genocide Memorials," in *On Display: New Essays in Cultural Studies,* ed. Anna Smith and Lydia Weaver (Wellington, New Zealand: Victoria University Press, 2004).

68. Trebay, "Killing Fields of Vision."

69. Williams, "The Atrocity Exhibition," 210. When asked by Nic Dunlop how museumgoers should view these photos, Nhem En said, "Firstly, they should thank me. . . . When they see that the pictures are nice and clear, they'd admire the photographer's skill." Dunlop, *The Lost Executioner,* 168.

70. William Dunlap and Linda Burgess, "Facing the Past: Cambodia Then and Now," The Works of William Dunlap Website (2003), http://www.williamdunlap .com/writing/cambodia.html.

71. Williams, "The Atrocity Exhibition," 211.

72. This decontextualization is quite common for Western scholars. Another example can be found in Susie Linfield's otherwise nuanced treatment of atrocity images. She writes that the Tuol Sleng victims depicted in the mug shots are unidentified ("There are no names") and refers to the prisoners by the numbers in the photographs, seemingly unaware that those are processing batch numbers and not unique identification numbers. This oversight is highlighted by the fact that Linfield places a Tuol Sleng mug shot on the cover of her book and identifies the person portrayed as an "unidentified child prisoner. . . . Date and photographer unknown." It is unclear whether DC-Cam has in fact tracked down the name of the victim and the date of the photograph. She also mislabels the Tuol Sleng victims as "weather-beaten peasants" when we know that some elite were imprisoned at Tuol Sleng. Susie Linfield, *The Cruel Radiance: Photography and Political Violence* (Chicago: University of Chicago Press, 2010), 56; inside back cover; 56.

73. Trebay, "Killing Fields of Vision."

74. Dinah PoKempner, quoted in ibid.

75. Dunlop, *The Lost Executioner,* 167.

76. Stephanie Benzaquen, "Remediating Genocidal Images into Artworks: The Case of the Tuol Sleng Mug Shots," *Rebus* 5 (Summer 2010): 4–5.

77. Trebay, "Killing Fields of Vision."

78. Youk Chhang, interview with author, January 9, 2012, Phnom Penh.

79. Chris Riley and Doug Niven, *The Killing Fields* (Santa Fe, NM: Twin Palms, 1996).

80. Twin Palms Press, http://www.twinpalms.com.

81. Ibid.

82. Riley and Niven, *The Killing Fields.*

83. Dunlop, *The Lost Executioner,* 166.

84. Riley and Niven, *The Killing Fields*, 112.

85. Ibid. Other than the Twin Palms Press catalog, I have seen only one publication that acknowledges Riley and Niven's claims to copyright; Peter Maguire, a friend of Riley, credits both the Tuol Sleng Museum and the Photo Archive Group in the reproduction of several of the Tuol Sleng mug shots in his book. Peter Maguire, *Facing Death in Cambodia*.

86. Maguire, *Facing Death in Cambodia*, 151.

87. Riley and Niven, *The Killing Fields*, 112. Twin Palms Press, http://www.twin palms.com.

88. Maguire, *Facing Death in Cambodia*, 150–151.

89. Trebay, "Killing Fields of Vision."

90. A comparison between the Twin Palms volume *The Killing Fields* and DC-Cam's publication *Stilled Lives: Photos from the Cambodian Genocide* is particularly revealing. *Stilled Lives* produces biographies of fifty-one Khmer Rouge victims alongside both prewar family snapshots and official Khmer Rouge photographs. The result is a highly contextualized, nuanced, and respectful portrait of victims as seen by their surviving family members. While the Twin Palms book takes an aesthetic perspective, the DC-Cam publication takes an archival perspective by focusing on context, provenance, and the interrelationship of records. The results are two very different viewing experiences with different ethical agendas. Wynne Cougill, with Pivione Pang, Chhayran Ra, and Sopheak Sim, *Stilled Lives: Photographs from the Cambodian Genocide* (Phnom Penh: Documentation Center of Cambodia, 2004).

91. Fawthrop and Jarvis, *Getting Away with Genocide?*

92. Chanthou Boua, "Development Aid and Democracy in Cambodia," in *Genocide and Democracy in Cambodia*, ed. Ben Kiernan (New Haven, CT: Yale University Southeast Asia Studies, 1993), 273–283.

93. Ben Kiernan, email interview with author, April 19, 2011.

94. "Agreement on a Comprehensive Political Settlement of the Cambodian Conflict," reprinted in *Propaganda, Politics, and Violence in Cambodia*, ed. Steve Heder and Judy Ledgerwood (Armonk, NY: M. E. Sharpe, 1996), 247. As Penny Edwards points out in an essay in that same volume, the refusal to utter "genocide" in the agreement did not mean that genocide was ignored by the subsequent elections; indeed, the major political parties readily accused each other of genocide. Penny Edwards, "Imaging the Other in Cambodian Nationalist Discourse before and during the UNTAC Period," in *Propaganda, Politics, and Violence in Cambodia*, ed. Steve Heder and Judy Ledgerwood (Armonk, NY: M. E. Sharpe, 1996), 50–72.

95. Craig Etcheson, Skype interview with author, May 30, 2011.

96. Ben Kiernan, email interview with author, April 19, 2011.

97. Ibid. Craig Etcheson, *After the Killing Fields: Lessons from the Cambodian Genocide* (Lubbock: Texas Tech University Press, 2005), 43.

98. Fawthrop and Jarvis, *Getting Away with Genocide?*, 109.

99. Thion also makes it clear that, despite his distaste for the genocide label, he was in favor of holding Pol Pot (and his American, Thai, and Chinese associates)

legally accountable through a trial under Cambodian law. Serge Thion, "Genocide as Political Commodity," in *Genocide and Democracy in Cambodia*, ed. Ben Kiernan (New Haven, CT: Yale University Press, 1993), 187. For a more detailed account of the political implications of the use of the term genocide, see Michelle Caswell, "Using Classification to Convict the Khmer Rouge," *Journal of Documentation* 68:2 (2012), 162–184.

100. Edward S. Herman and David Peterson, *The Politics of Genocide* (New York: Monthly Review Press, 2010), "Foreword" by Noam Chomsky.

101. Fawthrop and Jarvis, *Getting Away with Genocide?*, 110.

102. "About," Documentation Center of Cambodia, http://www.dccam.org /Abouts/History/Histories.htm.

103. Craig Etcheson, Skype interview with author, May 30, 2011.

104. Gregory H. Stanton, "The International Campaign to End Genocide: A Review of Its First Five Years," Genocide Watch (undated), http://www.genocidewatch .org/reviewoffirstfiveyrs.html.

105. Cambodian Genocide Program, "Introduction," http://www.yale.edu/cgp /cgpintro.html.

106. Ben Kiernan, email interview with author, April 19, 2011.

107. Youk Chhang, "Connecting the Broken Pieces after the Cambodian Genocide: Legacy as Memory of a Nation," UC Berkeley-UCLA Distinguished Visitor from Southeast Asia Series, 2010, http://www.youtube.com/watch?v=vZuD4Fo-ZOc.

108. Helen Jarvis, email interview with author, July 24, 2011.

109. Craig Etcheson, *After the Killing Fields*, 55.

110. Ibid., 55–56.

111. Kiernan, untitled lecture, Global Resources Network Conference and Forum, March 24, 2005.

112. Today, DC-Cam still routinely acquires new materials through word of mouth. Indeed, during my May 2010 visit to DC-Cam, Chhang showed me an envelope full of Khmer Rouge records that DC-Cam had recently acquired from a villager. The villager had heard of DC-Cam and gave the envelope to a friend who was going to Phnom Penh; the friend gave the envelope to a friend who knew where the DC-Cam offices were located.

113. Craig Etcheson, Skype interview with author, May 30, 2011. This agreement may surprise followers of current Cambodian politics, who note Prime Minister Hun Sen's public opposition to expanding the scope of the tribunal. However, at the point this agreement was reached, Hun Sen, then co-prime minister of Cambodia, publicly supported the creation of the tribunal. Hun Sen later alternated between opposing and supporting the tribunal as long as he controlled several key aspects of the court's setup.

114. Ibid.

115. By 2005, these materials were all microfilmed for preservation reasons, with copies deposited at the Center for Research Libraries. See Richard Richie, "Preserving Khmer Rouge Archives," *Focus on Global Resources*, http://www.crl.edu/focus/article /493.

116. Chhang, "Connecting the Broken Pieces after the Cambodian Genocide."

117. Ben Kiernan, "Bringing the Khmer Rouge to Justice," *Human Rights Review* (April–June 2000): 103.

118. For a more detailed account of the allegations and their refutation, see "State Department Clears Yale's Cambodia Program of Wrongdoing," *Chronicle of Higher Education* (November 27, 1998): A9.

119. Kiernan, "Bringing the Khmer Rouge to Justice," 101.

120. Ibid., 94.

121. Kiernan himself initially underestimated the number of deaths caused by the Khmer Rouge but quickly revised these estimates as further evidence was gathered.

122. Noam Chomsky and Edwards S. Herman, *After the Cataclysm* (Boston: South End Press, 1979).

123. Kiernan, "Bringing the Khmer Rouge to Justice," 97. The debate over whether Cambodians experienced a genocide according to legal definitions is a fascinating one. See Caswell, "Using Classification to Convict the Khmer Rouge."

124. Kiernan, "Bringing the Khmer Rouge to Justice," 97.

125. Until 1986, the National Archives and National Library were part of the same department. It has been reported that thirty-five of the forty-one employees of the National Library were killed during the Khmer Rouge period; only two returned to their jobs. See De Nike et al., *Genocide in Cambodia*, 358, and Helen Jarvis, "The Cambodian National Library: Surviving after Seventy Years," *Libraries & Culture* 30:4 (1995): 391–408.

126. National Archives of Cambodia, "Introduction to the Collection of the National Archives of Cambodia," http://www.camnet.com.kh/archives.cambodia/English/naccoll.htm Most researchers consult the National Archives for its strong French colonial-era collections, not for its small and restricted Khmer Rouge collection.

127. Rich Richie, untitled lecture, Global Resources Network Conference and Forum, Yale University Center for International and Area Studies, March 24, 2005, http://www.library.yale.edu/mssa/globalrecord/new_web/kiernan_richie.html#text.

128. David Wheeler, "Documenting Genocide in Cambodia, One Face after Another," *Chronicle of Higher Education* 45:38 (May 28, 1999): B2.

129. Paul Conway, phone interview with author, October 21, 2010.

130. Yale's copies are available for loan through the Center for Research Libraries. For a complete list of microfilm made during this project that is available via ILL from the Center for Research Libraries, see Richie, "Preserving Khmer Rouge Archives."

131. Helen Jarvis, email interview with author, July 24, 2011.

132. Yale's Cambodian Genocide Program, "Documentation of the Photographic Database," http://www.yale.edu/cgp/cimgdoc.html.

133. Ibid.

134. Tina Rosenberg, "Cambodia's Blinding Genocide: A Web Site Exhumes the Faces of Death," *New York Times*, April 21, 1997, A14.

135. Paul Conway, phone interview with author, October 21, 2010.

136. Stephanie Benzaquen, "Postcolonial Aesthetic Experiences: Thinking Aesthetic Categories in the Face of Catastrophe at the Beginning of the Twenty-First Century," paper presented at the European Congress of Aesthetics, Madrid, November 10–12, 2010, 2. This issue will be discussed in more detail in chapter 4.

137. Geoffrey C. Bowker, *Memory Practices in the Sciences* (Cambridge, MA: MIT Press, 2005), 123.

138. Ibid., 26.

139. Susan Sontag, *Regarding the Pain of Others* (New York: Picador, 2003), 61.

140. Internet World Stats, "Internet Usage in Asia 2012 Q2," http://www.internet worldstats.com/stats3.htm. The numbers may be significantly higher for Cambodians with Internet access via cell phone, but the databases were not designed with mobile devices in mind.

141. Etcheson, *After the Killing Fields*, 61.

142. Ben Kiernan, email interview with author, April 19, 2011.

143. "About," Documentation Center of Cambodia, http://www.d.dccam.org /Abouts/History/Histories.htm.

144. Interestingly, this memorandum admits that DC-Cam falls short of having sufficient evidence to convict Khmer Rouge officials of genocide against the Khmer population, but it specifically makes the case for charges of genocide against ethnic minorities by providing both a case study of how the Cham Muslim population was targeted and a list of Vietnamese prisoners who were killed at Tuol Sleng. Elizabeth Moorthy, Youk Chhang, Putheara Lay, Dara Peuv Vanthan, and Beth Van Schaack, "Memorandum: A Preliminary Evaluation of Evidence Held by the Documentation Center of Cambodia," November 1998, Phnom Penh, Cambodia, David Chandler Cambodia Collection at Monash University Library, http://arrow.monash.edu.au /vital/access/manager/Collection/monash:64226.

145. "About," Documentation Center of Cambodia, http://www.d.dccam.org /Abouts/History/Histories.htm.

146. Helen Jarvis, email interview with author, July 24, 2011.

147. Randall Jimerson, "Archives for All: Professional Responsibility and Social Justice," *American Archivist* 70 (2007): 252–281. Indeed, such activism has recently led to DC-Cam's coming under fire for political bias; Chhang was even summoned to testify about DC-Cam's political bias at the ECCC in February 2012.

148. Ibid. John Kerry, "Heroes and Pioneers," *Time*, May 8, 2007, reprinted at http://ki-media.blogspot.com/2007/05/youk-chhang-time-magazine-2007-most .html.

149. For a complete list of funders, see http://www.d.dccam.org/Abouts/Finance /Finances.htm.

150. Youk Chhang, interview with author, January 9, 2012, Phnom Penh.

151. Other scholars have been granted access after multiple requests from the Ministry of Culture and Fine Arts or after UNESCO intervened on their behalf. UNESCO's recent involvement with Tuol Sleng may signal a reinvestment in this site.

152. Access to archival materials is more restricted, again due to security concerns; requests for access are made directly to Chhang. The sign outside the building merely reads "Public Information Room."

153. Sleuk Rith Institute, http://www.cambodiasri.org/.

154. Youk Chhang, email to author, July 1, 2011.

155. Trouillot, *Silencing the Past*, 53.

156. Ibid., 99.

157. Etcheson, *After the Killing Fields*, 72.

158. Kiernan, "Bringing the Khmer Rouge to Justice," 103.

159. Youk Chhang, interview with author, January 9, 2012, Phnom Penh.

160. Verne Harris, *Archives and Justice* (Chicago: Society of American Archivists, 2007), 245.

161. Ibid., 254.

162. David A. Wallace, "Locating Agency: Interdisciplinary Perspectives on Professional Ethics and Archival Morality," *Journal of Information Ethics* 19:1 (Spring 2010): 184.

163. Verne Harris, "The Archival Sliver: Power, Memory, and Archives in South Africa," *Archival Science* 2:1–2 (2002): 64–65.

Chapter 3. The Making of Narratives

1. Documentation Center of Cambodia, "Genocide Education," http://www.d .dccam.org/Projects/Genocide_Education.htm.

2. Phuong Pham, Patrick Vinck, Mychelle Balthazard, Sokhom Hean, and Eric Stover, *So We Will Never Forget: A Population-Based Survey on Attitudes about Social Reconstruction and the Extraordinary Chambers in the Courts of Cambodia* (Berkeley: Human Rights Center, University of California, Berkeley, 2009), 2, http://hrc.berkeley .edu/pdfs/So-We-Will-Never-Forget.pdf.

3. Ibid.

4. The use of family photographs to memorialize the dead provides a striking counterpoint to this chapter's discussion of mug shots and is a topic for future research. Some examples of family photographs used in this way can be seen throughout *Searching for the Truth* and other DC-Cam publications such as Wynne Cougill, Pivione Pang, Chhayran Ra, and Sopheak Sim, *Stilled Lives: Photographs from the Cambodian Genocide* (Phnom Penh: Documentation Center of Cambodia, 2004). I also touch briefly on the use of family photos for collective memory in Michelle Caswell, "Khmer Rouge Archives: Accountability, Truth, and Memory in Cambodia," *Archival Science* 10 (2010): 25–42.

5. The mug shots have also inspired many other forms of records that are not addressed directly in this chapter, including biographies of Tuol Sleng prisoners; dance performances such as Em Theay, "The Continuum: Beyond the Killing Fields," Sydney 2009; and drama such as DC-Cam's many productions of the play *Breaking the Silence*. For examples of Tuol Sleng prisoner biographies, see Vann Nath, *A Cambodian Prison*

Portrait (Bangkok: White Lotus Press, 1998); Huy Vannak, *Bou Meng: A Survivor from Khmer Rouge Prison S-21* (Phnom Penh: Documentation Center of Cambodia, 2010); Ysa Osman, *Oukoubah: Justice for the Cham Muslims under the Democratic Kampuchea Regime* (Phnom Penh: Documentation Center of Cambodia, 2002); and Elizabeth Becker, *Bophana*. These biographies and the ways in which they rely on and interact with Tuol Sleng mug shots are the subject of future research.

6. This use of the word "touchstone" to discuss a material object that triggers a memory is taken from Laura Millar, "Touchstones: Considering the Relationship between Memory and Archives," *Archivaria* 61 (Spring 2006): 105–126. Yet, I argue that what is most important is not the individual memory triggered by material objects like the mug shots but the stories—and the performative act of telling them to others—that the objects trigger. These stories then form the basis of collective memory. This formulation complicates the simplistic equation of archives with collective memory found in some archival studies literature.

7. Shoshana Felman and Dori Laub, *Testimony: Crises of Witnessing in Literature, Psychoanalysis, and History* (New York: Routledge, 1991), xvii. Felman and Laub are writing about the Holocaust, but the term applies equally well here.

8. This phrase—the performance of human rights—is borrowed from the work of Andrea Noble and Susan Slyomovics, as is discussed later. Andrea Noble, "Traveling Theories of Family Photography and the Material Culture of Human Rights in Latin America," *Journal of Romance Studies* 8:1 (2008): 43–59; Susan Slyomovics, *The Performance of Human Rights in Morocco* (Philadelphia: University of Pennsylvania Press, 2005).

9. Michel-Rolph Trouillot, *Silencing the Past: Power and the Production of History* (Boston: Beacon Press, 1995), 53.

10. Ibid., 55.

11. The ECCC is a unique hybrid tribunal jointly operated by the government of Cambodia and the United Nations.

12. This estimate is included in KRT Trial Monitor Report but cannot be confirmed because Duch's case file is closed to the public. Asian Justice Initiative, *The KRT Trial Monitor*, Report Issue No. 4 (April 26, 2009): 6.

13. Two examples of mug shots being used in the tribunal can be seen in these digital video-clip footage of the tribunal. For an example of a lawyer for the prosecution discussing the mug shots taken at S-21, see Cambodia Tribunal Monitor, "Trial of Kaing Guek Eav (Alias 'Duch') March 31, 2009—Part 3," from 2:45 on at http://video.google.com/videoplay?docid=6252322569882809042#. For an example of a mug shot being used as evidence in Duch's trial, see that same clip from 20:00.

14. Ibid. Also available from Extraordinary Chambers in the Courts of Cambodia, "Transcripts of Proceedings," March 31, 2009, 28, http://www.eccc.gov.kh/sites/default/files/documents/courtdoc/E1_6.1_TR001_20090331_Final_EN_Pub.pdf.

15. Norng Chan Phal's mother's name remains curiously absent from the testimony. Phal's name is transliterated as Nong Chanphal in other publications.

16. Extraordinary Chambers in the Courts of Cambodia, "Transcript of Trial Proceedings," August 17, 2009, http://www.eccc.gov.kh/sites/default/files/documents /courtdoc/E1_63.1_TR001_20090817_Final_EN_Pub.pdf.

17. The photos are displayed at Cambodia Tribunal Monitor, "Trial of Kaing Guek Eav (Alias 'Duch')," August 17, 2009—Part 2," http://vimeo.com/22355984, 46:00 to 48:00.

18. Extraordinary Chambers in the Courts of Cambodia, "Transcript of Trial Proceedings," August 17, 2009, 54–55.

19. Ibid., 65.

20. Ibid., 70.

21. Bou Meng's story is discussed in further detail later in this chapter.

22. Bou Meng recounts this story of being haunted by his wife in Seth Mydans's foreword to Huy Vannak's biography of Bou Meng. Seth Mydans, "Foreword," in Huy Vannak, *Bou Meng: A Survivor from Khmer Rouge Prison S-21*, 3. There are also many other accounts of Tuol Sleng being haunted by the victims in the mug shots. One Tuol Sleng archivist claims that during the afternoon, "the images around here almost seem to come to life." See Seth Mydans, "Coming Khmer Rouge Trial Rouses Jail's Ghosts," *New York Times*, June 30, 1999, A4. Similarly, Peter Maguire reports that Sophearla Chey, the director of the Tuol Sleng Genocide Museum, claims that "All of us [museum staff] have been haunted by ghosts, even myself." Peter Maguire, *Facing Death in Cambodia* (New York: Columbia University Press, 2005), 22. Further-more, in the introduction to his comprehensive book *Voices from S-21*, the historian David Chandler connects the Tuol Sleng mug shots, the ghosts of the dead, and the compulsion to speak. He writes, "Moving through the museum, absorbing its archive . . . , we can still hear many of these ghostly voices. They control the narrative that follows." David Chandler, *Voices from S-21: Terror and History in Pol Pot's Secret Prison* (Chiang Mai, Thailand: Silkworm Books, 2000), 13.

23. In Cambodian Buddhism, the dead must be honored at the place and on the date of their death or else they will haunt the living as angry ghosts. Footage from this month of the trial is curiously missing from the Cambodia Tribunal Monitor site. In order to reconstruct Meng's testimony, I have relied on reports of it from Huy Vannak's biography of Meng, cited above, and edited tribunal footage broadcast via East-West Center, "Duch on Trial," episode 10, June 29–July 2, 2009, http://vimeo .com/5467572.

24. East-West Center, "Duch on Trial."

25. Ibid.

26. Robbie Corey-Boulet, "Challenges to Civil Parties," *Phnom Penh Post*, July 9, 2009. Phal's name is transliterated both as Nong and Norng depending on the source.

27. Seth Mydans, "Torture and Death Recounted at Cambodian Trial," *New York Times*, July 15, 2009.

28. For more examples, see Caswell, "Khmer Rouge Archives," 25–44.

29. Eric Ketelaar, "Archival Temples, Archival Prisons: Modes of Power and Protection," *Archival Science* 2 (2002): 231.

30. A 20 percent viewing rate is especially high given that approximately only 20 percent of Cambodians have electricity. The figure is quoted in *Asia in View: Facing Khmer Rouge Atrocities*, Japan Broadcasting Corporation/Ortis Japan, 2011. Viewed at Bophana Audiovisual Resource Center, Phnom Penh.

31. Cambodia Tribunal Monitor, "Trial Footage," http://www.cambodiatribunal .org/. The website also includes transcripts of the tribunal. Abridged video footage of the tribunal was also shown in a weekly television show broadcast in Cambodia called "Duch on Trial," as cited above.

32. The Duch trial, echoing what Eyal Sivan wrote about the Eichmann trial fifty years after that hearing, "was conceived as a show" in the sense that "millions of people around the world could follow it on television." Eyal Sivan, "Archive Images: Truth or Memory? The Case of Adolf Eichmann's Trial," in *Experiments with Truth: Transitional Justice and the Processes of Truth and Reconciliation*, ed. Okwui Enwezor et al. (Ostfildern, Germany: Hatje Cantz, 2002), 278–279.

33. Catherine M. Cole, "Mediating Testimony: Broadcasting South Africa's Truth and Reconciliation Commission," in *Documentary Testimonies: Global Archives of Suffering*, ed. Bhaskar Sarkar and Janet Walker (New York: Routledge, 2010), 211.

34. Many more documentaries that use the Tuol Sleng mug shots are available at the Bophana Audiovisual Resource Center in Phnom Penh. The five films discussed here were selected for their relevance and their ease of access.

35. British Broadcasting Corporation, *Secrets of S-21: Legacy of a Cambodian Prison*, VHS, Films for the Humanities and Sciences, 1998.

36. Felman and Laub posit that through testimony, survivors of trauma achieve "a retrieval of the possibility of speaking and to a recovery and a return of the voice." Felman and Laub, *Testimony: Crises of Witnessing in Literature, Psychoanalysis, and History*, xix.

37. Nath's paintings depicting torture at Tuol Sleng have been exhibited at the Tuol Sleng Genocide Museum, DC-Cam, and the Bophana Film Archives and constitute a new archive documenting the abuse there.

38. British Broadcasting Corporation, *Secrets of S-21: Legacy of a Cambodian Prison*.

39. Ibid.

40. Steven Okazaki, Director, *The Conscience of Nhem En*, DVD, HBO Documentary Films, 2008. Meng gives a more lengthy oral history in Documentation Center of Cambodia, *Behind the Walls of S-21: Oral Histories from Tuol Sleng Prison*, 2007, http:// www.youtube.com/watch?v=g2xmOq_dj8k.

41. Okazaki, *The Conscience of Nhem En*.

42. Ibid.

43. Ibid.

44. The film won a Golden Apple Award at the National Educational Film Festival, and its promotional website highlights a review calling it "a natural" for classrooms from high school through college: http://www.brunofilms.com/samsara.html.

45. Ellen Bruno, Director, *Samsara: A Film about Survival and Recovery in Cambodia*, DVD, Bruno Films, 1989. Clip available at http://www.brunofilms.com/samsara_movie.html.

46. For fifteen days each year during the Pchum Ben festival, Cambodian Buddhists believe that the boundary between Earth and the afterworld is opened up and the spirits of dead ancestors return home. During this time, Cambodians return to their home-towns and make food offerings to their ancestors; it is said that if the spirits are not properly fed, they will haunt their descendants.

47. Rithy Panh, Director, *S21: The Khmer Rouge Killing Machine*, DVD, Human Rights Watch, 2003. Another film produced by Rithy Panh warrants mention here, although there is not enough space to explore it at length. *About My Father* documents Phung-Guth Sunthary's search for information about her father, Phung Ton, a Tuol Sleng victim who was a dean at a Cambodian university prior to the Khmer Rouge takeover. Phung-Guth Sunthary reports returning to Phnom Penh in 1979 and trading some rice for some palm sugar; astonishingly, the sugar was wrapped in her father's newspaper obituary, which showed his Tuol Sleng mug shot; she almost didn't recognize him because of how gaunt he had become. The photo was her first confirmation that he had been killed there. Rithy Panh, *About My Father* (Phnom Penh: Bophana Center, 2009). The documentary also shows that a framed copy of Vann Nath's mug shot was hung on the wall of his apartment.

48. Deirdre Boyle, "Trauma, Memory, Documentary: Reenactment in Two Films by Rithy Panh (Cambodia) and Garin Nugroho (Indonesia)," in *Documentary Testimonies: Global Archives of Suffering*, ed. Bhaskar Sakar and Janet Walker (New York: Routledge, 2010), 158.

49. Ibid., 160.

50. Forced confession statements, log books, and written orders also play a major role in this film.

51. Rithy Panh, *S21: The Khmer Rouge Killing Machine*.

52. Ibid.

53. Ibid.

54. Ibid.

55. Ibid.

56. The regime killed nearly all trained medical professionals and then enlisted teenagers into "medical" courses in which they were taught rudimentary and often detrimental medical procedures.

57. Rithy Panh, *S21: The Khmer Rouge Killing Machine*.

58. DC-Cam, *Preparing for Justice* (2007), online video, http://www.youtube.com/watch?v=TOngbCZQ1BA&feature=related.

59. DC-Cam's outreach efforts have been criticized by the American journalist Joel Brinkley, who has accused DC-Cam of "re-traumatizing" Khmer Rouge victims by encouraging them to speak about their experiences and then providing little or no psychological support to deal with the effects of PTSD. While much psychological research has shown that speaking about past trauma has no clear immediate positive

impact on those who suffer from PTSD, Brinkley's critique has been refuted by DC-Cam staff, who point out that from 2003 to 2009 DC-Cam closely collaborated with the organization Transcultural Psychological Organization (TPO) to provide counseling to victims through its Victims of Torture Project. Furthermore, as Brinkley himself cites, there are only twenty-six licensed psychiatrists in all of Cambodia; providing psychiatric support in the Western sense to participants in DC-Cam projects is simply not feasible. As DC-Cam staff point out, Cambodians have many culturally rooted practices for dealing with trauma, including religious rituals and other communal activities. For more detailed information on this debate, see Joel Brinkley, *Cambodia's Curse: The Modern History of a Troubled Land* (New York: Perseus, 2011), 326–330, and Sayana Ser, Savina Sirik, Farina So, Dacil Keo, and Sarah Jones Dickens, "A Response to Brinkley's Writing about the DC-Cam Outreach Activities," email from Sarah Jones Dickens to author, May 5, 2011. Given that Brinkley's book rests on the Orientalist premise that Cambodia is virtually unchanged by modernity (its "customs and practices set in stone a millennium ago") and that the book asserts an irrational central premise that Cambodia is somehow predestined or "cursed" to suffer misfortune, it does not merit further attention.

60. New clothes have symbolic significance in Cambodia, as they are often given as gifts and worn during religious holidays.

61. Documentation Center of Cambodia, *Preparing for Justice*.

62. Ibid.

63. Ibid.

64. Youk Chhang's many published editorials addressing the corruption of the tribunal reveal how many survivors quickly became disillusioned with the court after a decade of advocating for its establishment. Duch's sentence has since been changed to life in prison.

65. Eric Ketelaar, "Records Out and Archives In: Early Modern Cities as Creators of Records and as Communities of Archives," *Archival Science* 10 (2010): 207.

66. Documentation Center of Cambodia, *Searching for the Truth*, http://www.d.dccam.org/Projects/Magazines/Magazine_Searching.htm. For the first two years of publication, each issue of the magazine was translated into English, resulting in monthly English editions. In 2003, DC-Cam began selecting articles from the monthly Khmer issues to translate into quarterly English editions. This book relies on the English language translations.

67. This includes the University of Wisconsin–Madison. Conversation with Larry Ashmun, Bibliographer for Southeast Asia, University of Wisconsin–Madison, September 1, 2011.

68. Another way that Cambodians are finding missing relatives is through the popular television show *It's Not a Dream*, in which television crews scour the country to reunite separated families.

69. Youk Chhang, "About the Magazine," *Searching for the Truth* 1 (2000): 4.

70. Caswell, "Khmer Rouge Archives," 2010.

71. The mug shots are also reprinted in the magazine in images of people looking at them; these are discussed later in this chapter.

72. Unattributed, "About the Photographs," *Searching for the Truth* 5 (2000): 49.

73. Chum Mey's name is transliterated as Chum Manh in this publication. Sorya Sim, "Chum Manh: An S-21 Survivor," *Searching for Truth* 22 (October 2001): 13.

74. Mey gives a more lengthy oral history in DC-Cam, *Behind the Walls of S-21.*

75. Meng later became one of Tuol Sleng's most famous survivors and is profiled in the 2008 documentary *The Conscience of Nhem En.* Vannak Huy, *Bou Meng: Survivor of S-21,* 23–24.

76. Ibid., 23.

77. Documentation Center of Cambodia. *Behind the Walls of S-21.*

78. Dara P. Vanthan, "Want to Know the Truth," *Searching for the Truth* 14 (2001): 48.

79. Ibid.

80. Sea Kosal, "The Confession of My Father," *Searching for the Truth* 32 (2002): 48.

81. Ibid.

82. Ibid., 49.

83. Dany Long, "From the Border to S-21," *Searching for the Truth* 31 (2002): 24–25.

84. Ibid.

85. Srun's photograph appears in Doug Niven and Chris Riley, eds., *The Killing Fields* (Santa Fe, NM: Twin Palms, 1996), no page number provided. As an example of how iconic Srun's image has become, the journalist Nic Dunlop writes, "Looking at Chan Kim Srun and her baby, it is easy to believe she is imploring you to help. It is the illusion of intimacy that is so troubling." Nic Dunlop, *The Lost Executioner* (London: Bloomsbury, 2005), 164.

86. DC-Cam, *Searching for the Truth* 4 (2003): cover; DC-Cam, *Searching for the Truth* 1 (2011): cover.

87. Sophal Ly, "30 Years Later," *Searching for the Truth* 1 (2008): 7.

88. This article appeared in the Khmer language edition, as described in ibid.

89. Ibid., 10.

90. Ibid., 7.

91. For another example of the creation of collective memory through DC-Cam's publications, see Caswell, "Khmer Rouge Archives."

92. Phuong Pham et al., *So We Will Never Forget.*

93. Examples of photographs of people looking at the mug shots include photos captioned: "Survivors visiting Tuol Sleng on February 25, 2006," *Searching for the Truth* 2 (2006): 6–7; "Villager looking at the photo of the prisoners at S-21," *Searching for the Truth* 2 (2007): 15; "Villagers looking at the photo of the prisoners at S-21," *Searching for the Truth* 3 (2007): 49; and "College students and Muslim youths tour to Tuol Sleng, Choeung Ek and ECCC on September 25, 2008," *Searching for the Truth* 3 (2008): 28–29.

94. Beth Van Schaack, Daryn Reicherter, and Youk Chhang, eds., *Cambodia's Hidden Scars: Trauma Psychology in the Wake of the Khmer Rouge* (Phnom Penh: Documentation Center of Cambodia, 2011).

95. My argument here is in contrast to Janina Struk's claims that people take atrocity photographs either to distance themselves from the atrocity or without thinking, as taking photographs is just what tourists do. Here, she outrageously compares tourists taking pictures of memorial sites to Nazi soldiers taking pictures of Holocaust victims. Janina Struk, *Photographing the Holocaust* (London: I. B. Tauris, 2004), 190.

96. This formulation is, again, a direct response to Janina Struk's assertion that Holocaust photographs should be removed from circulation—a rather curious assertion given that her book reproduces fifty-six such images. About the Holocaust victims who are depicted in these photos, she writes, "They had no choice but be photographed. Now they have no choice but to be viewed by posterity. Didn't they suffer enough the first time around?" Ibid., 216. I posit that images of people looking at atrocity images do not further victimize the victims but rather perform the work of human rights in the present. For a thoughtful counterargument to Struk, see Susie Linfield, *The Cruel Radiance: Photography and Political Violence* (Chicago: University of Chicago Press, 2010).

97. Dori Laub, "Bearing Witness, or the Vicissitudes of Listening," in *Testimony: Crises of Witnessing in Literature, Psychoanalysis, and History*, ed. Shoshana Felman and Dori Laub (New York: Routledge, 1991), 70–71.

98. Frances Guerin and Roger Hallas, *The Image and the Witness: Trauma, Memory and Visual Culture* (London: Wallflower Press, 2007), 10.

99. Ibid., 12.

100. Laub, "Bearing Witness," 57.

101. Ricardo Punzalan, "All the Things We Cannot Articulate: Colonial Leprosy Archives and Community Commemoration," in *Community Archives: The Shaping of Memory*, ed. Jeanette Bastian and Ben Alexander (London: Facet, 2009), 197–219.

102. Noble, "Traveling Theories of Family Photography and the Material Culture of Human Rights in Latin America," 44. Noble is primarily concerned with family portraits rather than mug shots, but the similarities are evident.

103. Ibid., 47.

104. Susan Slyomovics discusses the importance of repetition and pattern in the performance of human rights in Morocco. Slyomovics, *The Performance of Human Rights in Morocco.*

105. Here, I am echoing Guerin and Hallas's assertion that Holocaust testimony undergirds the "ultimate agency of the image in the performative act of bearing witness to historical trauma." Guerin and Hallas, "Introduction," in *The Image and the Witness*, 11.

106. W. J. T. Mitchell, *What Do Pictures Want? The Lives and Loves of Images* (Chicago: University of Chicago Press, 2005), 45.

107. While this book has focused on records in tangible forms such as digital footage, VHS tapes, and paper materials, I also recognize that orality itself is a form of record, in line with Sue McKemmish's assertion that "records in oral forms including the words spoken, heard, remembered, recalled, and witnessed" form part of the stories told around and about images. See Sue McKemmish, "Traces: Document, Record,

Archive, Archives," in *Archives: Recordkeeping in Society*, ed. Sue McKemmish et al. (Wagga Wagga, Australia: Center for Information Studies, 2005), 14. "Activation" is a term frequently used by Eric Ketelaar to describe the uses and reuses of records.

108. Eric Ketelaar, "Recordkeeping and Societal Power," in *Archives: Recordkeeping in Society*, ed. Sue McKemmish et al. (Wagga Wagga, Australia: Center for Information Studies, 2005), 295.

109. McKemmish, "Traces," 14.

110. Eric Ketelaar, "Tacit Narratives: The Meaning of Archives," *Archival Science* 1:2 (2001): 138.

111. As chapter 2 detailed, DC-Cam did not start out as a community-based organization, but it can now be defined as such given that its director, paid staff, and board members are composed entirely of Cambodians.

112. While DC-Cam staff directed only one of the five documentary films addressed in this chapter, DC-Cam provided records and research support for all of them.

113. Chapter 2 describes how many critics argue that international law is selectively enforced to serve the needs of dominant countries.

114. In the positivist Western conception of archives, archivists are said to be impartial custodians of records.

115. Verne Harris, "Archives, Politics, and Justice," in *Political Pressure and the Archival Record*, ed. Margaret Procter et al. (Chicago: Society of American Archivists, 2005), 175.

116. Stephanie Benzaquen, "Postcolonial Aesthetic Experiences: Thinking Aesthetic Categories in the Face of Catastrophe at the Beginning of the Twenty-First Century," paper presented at the European Congress of Aesthetics, Madrid, November 10–12, 2010.

117. Trouillot, *Silencing the Past*, 29.

Chapter 4. The Making of Commodities

1. Huy Vannak, *Bou Meng: A Survivor from Khmer Rouge Prison S-21* (Phnom Penh: DC-Cam, 2010). The tourist economy in Cambodia operates on US dollars.

2. These are signs of supplication.

3. Youk Chhang, interview with author, January 9, 2012, Phnom Penh.

4. Chhang told me that Mey caused a ruckus at Tuol Sleng by driving his new tuk tuk right through the museum compound's doors. When a guard told Mey not to park his tuk tuk inside the courtyard, Mey responded that he was a survivor and could do whatever he wanted, to which the guard responded that he himself had lost nine family members. Mey moved the tuk tuk. Youk Chhang, interview with author, January 9, 2012, Phnom Penh.

5. Chum Mey with Documentation Center of Cambodia, *Survivor: The Triumph of an Ordinary Man in the Khmer Rouge Genocide*, tr. Sim Sorya and Kimsroy Sokvisal (Phnom Penh: Documentation Center of Cambodia, 2012).

6. Youk Chhang, interview with author, January 9, 2012, Phnom Penh.

7. Say Mony, "Survivors Sell Books at Prison That Once Held Them," Voice of America, August 3, 2012, http://www.voacambodia.com/content/survivors-sell-books-at-prison-that-once-held-them-138139178/1359237.html.

8. Ibid.

9. Such moral and collective reparations may take the form of memorials and/or books listing the names of victims.

10. Mony, "Survivors Sell Books at Prison That Once Held Them."

11. Tom Fawthrop, "Khmer Rouge Leader Ieng Sary Has US $20m in Hong Kong Account," *South China Morning Post*, March 31, 2013.

12. Phorn Bopha and Simon Lewis, "Victims Call for Ieng Sary's Assets to Be Seized," *Cambodia Daily* 54:51 (March 20, 2013): 102.

13. Friends of Vann Nath Association, "Appeal for Funds: Postcards," http://www.vannnath.com/appeal-funds/postcards/.

14. Ibid.

15. Unattributed, "Vann Nath," *The Economist*, September 17, 2011, http://www.economist.com/node/21529005. Some Western academics also attempted to take up a collection to pay for Nath's medical care, but it was too late.

16. Cambodia's thriving sex trade is an important exception.

17. Youk Chhang, interview with author, January 9, 2012, Phnom Penh.

18. Final figures for the cost of the ECCC are not yet known, but from 2006 to 2009 $78.4 million were spent; the budget for 2010 was $45.5 million, and that for 2011 was $46.8 million. Public Affairs Section of the Extraordinary Chambers in the Courts of Cambodia, "An Introduction of the Khmer Rouge Trials" (Phnom Penh, undated): 21.

19. For examples of this characterization, see William Logan and Keir Reeves, eds., *Places of Pain and Shame: Dealing with "Difficult" Heritage* (New York: Routledge, 2009), and J. John Lennon and Malcolm Foley, *Dark Tourism: The Attraction of Death and Disaster* (London: Continuum, 2000).

20. Lennon and Foley, *Dark Tourism*, 11.

21. Paul Williams has written about how the lack of interpretive information and mediation at the Tuol Sleng site invokes a particularly strong anxiety among tourists. Paul Williams, "Witnessing Genocide: Vigilance and Remembrance at Tuol Sleng and Choeung Ek," *Holocaust and Genocide Studies* 18:2 (Fall 2004): 234–255.

22. Rachel Hughes, "Dutiful Tourism: Encountering the Cambodian Genocide," *Asia Pacific Viewpoint* 49:3 (December 2008): 318–330.

23. Ibid., 326.

24. Ibid., 327.

25. A quick search for "Tuol Sleng" or "S-21" on these social media sites yields thousands of images, dozens of which are photographs of tourists posing with Bou Meng or Chum Mey. I highlight blog posts over other social media sites because, unlike the blog posts, which allow space for caption and contextualization, the digital recirculation of the photographs on Flickr, Tumblr, and Pinterest runs the risk of

decontextualizing the mug shots, divorcing them from their function as records documenting violence and victimhood, and ultimately calls into question their ability to perform human rights. Viewed without accompanying metadata, the tourist photographs are decontextualized, divorced from their histories, and viewed primarily as aesthetic objects; they become images and not records.

26. Nancy Kuy, Untitled, http://www.travelblog.org/Asia/Cambodia/South/Phnom-Penh/blog-711575.html. The photo is available at Nancy Kuy, "Me and Chum Mey," http://www.travelblog.org/Photos/6884077. Joel and Whitney LaBahn, "Bou Meng," http://www.travelblog.org/Photos/6564027.

27. Nancy Kuy, "The World in the Eyes of a Valley Girl," http://www.travelblog.org/Bloggers/The-World-In-The-Eyes-Of-A-Valley-Girl/.

28. Nancy Kuy, Untitled, http://www.travelblog.org/Asia/Cambodia/South/Phnom-Penh/blog-711575.html.

29. Ibid.

30. Ibid.

31. Nancy Kuy, "Me and Chum Mey," http://www.travelblog.org/Photos/6884077.

32. Joel and Whitney LaBahn, "Bou Meng," http://www.travelblog.org/Photos/6564027.

33. Joel and Whitney LaBahn, "LaBahn," http://www.travelblog.org/Bloggers/LaBahn/.

34. Joel and Whitney LaBahn, Untitled, http://www.travelblog.org/Asia/Cambodia/North/Siem-Reap/blog-661691.html. Of course genocide on a smaller scale has happened since and is currently happening in other parts of the world.

35. Ibid.

36. Ibid.

37. Sue McKemmish, "Evidence of Me," *Archives and Manuscripts* 24:1 (May 1996): 28–45.

38. Michelle Caswell, "A Bad Day in Cambodia," IntheFray.org. March 28, 2007, http://inthefray.org/joomla/index2.php?option=com_content&do_pdf=1&id=2133. An audio version of the piece also aired on Chicago Public Radio in 2007.

39. Hughes, "Dutiful Tourism: Encountering the Cambodian Genocide."

40. John Urry, *The Tourist Gaze* (London: Sage, 1990), 1, 66.

41. This notion of demand is borrowed from Gunther Kress and Theo van Leeuwen, *The Grammar of Visual Design* (New York: Routledge, 1996).

42. I take the terminology of the reverse gaze from Alex Gillespie, who describes how the objects of tourist photography look back at tourists. Alex Gillespie, "Tourist Photography and the Reverse Gaze," *Ethos* 34:3 (2006): 343–366.

43. Dean MacCannell, *The Tourist: A New Theory of the Leisure Class* (New York: Schocken, 1976). I rely here on Jane C. Desmond's work on staging bodies for tourist consumption, but I attribute a more complex sense of agency to the Tuol Sleng survivors than Desmond does to the Hawaiian and animal bodies on display in her case studies. Jane C. Desmond, *Staging Tourism* (Chicago: University of Chicago Press, 1990).

44. Urry, *The Tourist Gaze*, 128–129.

45. "Different countries . . . come to specialize in particular kinds of objects to be gazed upon," Urry argues. Ibid., 48.

46. Examples include Jane C. Desmond, *Staging Tourism*; Mike Robinson and David Picard, eds., *The Framed World: Tourism, Tourists and Photography* (Burlington, VT: Ashgate, 2009); Laura Wexler, *Tender Violence* (Chapel Hill: University of North Caroline Press, 2000); James R. Ryan, *Picturing Empire: Photography and the Visualization of the British Empire* (Chicago: University of Chicago Press, 1998).

47. Geoffrey Yeo, "Concepts of Record (1): Evidence, Information, and Persistent Representation," *American Archivist* 70 (2007): 334.

Conclusion

1. Susan Sontag, *Regarding the Pain of Others* (New York: Picador, 1997).

2. Susan A. Crane, "Choosing Not to Look: Representation, Repatriation, and Holocaust Atrocity Photography," *History and Theory* 47 (October 2008): 309.

3. David Chandler, *Voices from S-21: Terror and History in Pol Pot's Secret Prison* (Chiang Mai, Thailand: Silkworm Books, 2000), 144.

4. Susie Linfield, *The Cruel Radiance: Photography and Political Violence* (Chicago: University of Chicago Press, 2010), 52.

5. Ibid., 59.

6. Chandler, *Voices from S-21*, 144.

7. Both Susan Sontag and Susie Linfield fall victim to the trope of the nameless Cambodian, showing that both sides of the atrocity image debate omit important contextual information.

8. Yosef Hayim Yerushalmi, *Zakhor: Jewish History and Jewish Memory* (Seattle: University of Washington Press, 2005), 117.

9. Ruth Behar, *The Vulnerable Observer: Anthropology That Breaks Your Heart* (Boston: Beacon, 1996), 167.

10. Ricardo Punzalan, "All the Things We Cannot Articulate: Colonial Leprosy Archives and Community Commemoration," in *Community Archives: The Shaping of Memory*, ed. Jeannette Bastian and Ben Alexander (London: Facet, 2009), 210.

11. Rithy Panh et al., Bophana Audiovisual Resource Center, http://www.bophana.org/site/index.php?option=com_content&task=view&id=13&Itemid=57.

12. Ibid.

 Bibliography

"About the Photographs." *Searching for the Truth* 5 (2000): 49.

Adam, Dawne. "The Tuol Sleng Archives and the Cambodian Genocide." *Archivaria* 45 (1998): 5–26.

Allen, Michael Thad. "The Banality of Evil Reconsidered: SS Mid-Level Managers of Extermination through Work." *Central European History* 30:2 (1997): 253–294.

Appadurai, Arjun, ed. *The Social Life of Things: Commodities in Cultural Perspective.* Cambridge: Cambridge University Press, 1986.

Arendt, Hannah. *Eichmann in Jerusalem: A Report on the Banality of Evil.* New York: Penguin, 2006.

Asian Justice Initiative. *The KRT Trial Monitor.* Report Issue No. 3 (April 12, 2009), http://krttrialmonitor.files.wordpress.com/2012/07/aiji_eccc_case1_n03_12april09_en.pdf.

Asian Justice Initiative. *The KRT Trial Monitor.* Report Issue No. 4 (April 26, 2009), http://krttrialmonitor.files.wordpress.com/2012/07/aiji_eccc_case1_n04_26april09_en.pdf.

Asian Justice Initiative. *The KRT Trial Monitor.* Report Issue No. 9 (June 21, 2009), http://krttrialmonitor.files.wordpress.com/2012/07/aiji_eccc_case1_n09_21june09_en.pdf.

Asian Justice Initiative. *The KRT Trial Monitor.* Report Issue No. 12 (July 9, 2009), http://krttrialmonitor.files.wordpress.com/2012/07/aiji_eccc_case1_n012_09july09_en.pdf.

Asian Justice Initiative. *The KRT Trial Monitor.* Report Issue No. 15 (August 2, 2009), http://krttrialmonitor.files.wordpress.com/2012/07/aiji_eccc_case1_n015_02aug09_en.pdf.

Bastian, Jeannette. *Owning Memory: How a Caribbean Community Lost Its Archives and Found Its History.* Westport, CT: Libraries Unlimited, 2003.

Bastian, Jeannette. "Whispers in the Archives: Finding the Voices of the Colonized in the Records of the Colonizer." In *Political Pressure and the Archival Record*, edited by Margaret Procter et al., 25–43. Chicago: Society of American Archivists, 2005.

Bastian, Jeannette. "Reading Colonial Records through an Archival Lens: The Provenance of Place, Space, and Creation." *Archival Science* 6 (2006): 267–284.

Becker, Elizabeth. *When the War Was Over.* New York: Public Affairs, 1986.

Becker, Elizabeth. "Minor Characters." *New York Times,* August 28, 2005, G27.

Becker, Elizabeth. *Bophana.* Phnom Penh: Cambodia Daily Press, 2010.

Behar, Ruth. *The Vulnerable Observer: Anthropology That Breaks Your Heart.* Boston: Beacon, 1996.

Benzaquen, Stephanie. "Remediating Genocidal Images into Artworks: The Case of the Tuol Sleng Mug Shots." *Rebus* 5 (Summer 2010): 4–5.

Benzaquen, Stephanie. "Postcolonial Aesthetic Experiences: Thinking Aesthetic Categories in the Face of Catastrophe at the Beginning of the Twenty-First Century." Paper presented at the European Congress of Aesthetics, Madrid, November 10–12, 2010.

Berg, Keri A. "The Imperialist Lens: Du Camp, Salzmann and Early French Photography." *Early Popular Visual Culture* 6:1 (2008): 1–18.

Bertillon, Alphonse. *Ethnographie Moderne: Les Races Sauvages.* Paris: Libraire de L'Academie de Medecine, 1883.

Bertillon, Alphonse. *La Photographie Judiciaire.* Paris: Gauthier-Villars et Fils, 1890.

Bertillon, Alphonse. "Letter to Joseph Nicholson." In Joseph Nicholson, "The Identification of Criminals." Congress of the National Prison Association at Pittsburgh, October 10–15, 1891.

Bertillon, Alphonse. *Signaletic Instructions including the Theory and Practice of Anthropometrical Identification.* Chicago: Werner, 1896.

Bopha, Phorn, and Simon Lewis. "Victims Call for Ieng Sary's Assets to Be Seized." *Cambodia Daily* 54:51 (March 20, 2013): 102.

Boua, Chanthou. "Development Aid and Democracy in Cambodia." In *Genocide and Democracy in Cambodia,* edited by Ben Kiernan, 273–283. New Haven, CT: Yale University Southeast Asia Studies, 1993.

Boua, Chanthou, and Ben Kiernan, with Anthony Barnett. "Bureaucracy of Death." *New Statesman* (May 2, 1980): 671.

Bowker, Geoffrey C. *Memory Practices in the Sciences.* Cambridge, MA: MIT Press, 2005.

Bowker, Geoffrey C., and Susan Leigh Star. *Sorting Things Out: Classification and Its Consequences.* Cambridge, MA: MIT Press, 1999.

Boyle, Deirdre. "Trauma, Memory, Documentary: Reenactment in Two Films by Rithy Panh (Cambodia) and Garin Nugroho (Indonesia)." In *Documentary Testimonies: Global Archives of Suffering,* edited by Bhaskar Sarkar and Janet Walker, 155–172. New York: Routledge, 2010.

Brinkley, Joel. *Cambodia's Curse: The Modern History of a Troubled Land.* New York: Perseus, 2011.

British Broadcasting Corporation. *Secrets of S-21: Legacy of a Cambodian Prison.* VHS. Films for the Humanities and Sciences, 1998.

Brown, John Seely, and Paul Duguid. "The Social Life of Documents." *First Monday*

1:1 (1996). http://firstmonday.org/htbin/cgiwrap/bin/ojs/index.php/fm/article/view/466/387.

Bruno, Ellen. *Samsara: A Film about Survival and Recovery in Cambodia*. DVD. Bruno Films, 1989.

Cambodia Tribunal Monitor. "Trial Footage." http://www.cambodiatribunal.org/.

Cambodia Tribunal Monitor. "Trial of Kaing Guek Eav (Alias 'Duch')." March 31, 2009. http://video.google.com/videoplay?docid=6252322569882809042#.

Cambodia Tribunal Monitor. "Trial of Kaing Guek Eav (Alias 'Duch')." August 17, 2009. http://vimeo.com/22355984.

Cambodian Genocide Program, Yale University. "Documentation of the Photographic Database." http://www.yale.edu/cgp/cimgdoc.html.

Cambodian Genocide Program, Yale University. "Introduction." http://www.yale.edu/cgp/cgpintro.html.

Carter, Rodney G. S. "Of Things Said and Unsaid: Power, Archival Silences, and Power in Silence." *Archivaria* 61 (2006): 215–233.

Caswell, Michelle. "A Bad Day in Cambodia." IntheFray.org. March 28, 2007. http://inthefray.org/joomla/index2.php?option=com_content&do_pdf=1&id=2133.

Caswell, Michelle. "Hannah Arendt's World: Bureaucracy, Documentation and Banal Evil." *Archivaria* 70 (2010): 1–25.

Caswell, Michelle. "Khmer Rouge Archives: Accountability, Truth, and Memory in Cambodia." *Archival Science* 10:1–2 (January 2010): 25–44.

Caswell, Michelle. "Using Classification to Convict the Khmer Rouge." *Journal of Documentation* 68:2 (2012): 162–184.

Chandler, David. *The Tragedy of Cambodian History*. New Haven, CT: Yale University Press, 1991.

Chandler, David. "The Pathology of Terror in Pol Pot's Cambodia." In *The Killing Fields*, edited by Doug Niven and Chris Riley, 102–109. Santa Fe: Twin Palms, 1996.

Chandler, David. *Voices from S-21: Terror and History in Pol Pot's Secret Prison*. Chiang Mai, Thailand: Silkworm Books, 2000.

Chandler, David. "Tuol Sleng and Choeung Ek." *Searching for the Truth* (First Quarter 2008): 34.

Chanphal, Norng. Interview with Vanthan Peou Dara and Chy Terith. February 13, 2009, Documentation Center of Cambodia, Phnom Penh, Cambodia.

Chhang, Youk. "About the Magazine." *Searching for the Truth* 1 (2000): 4.

Chhang, Youk. "Connecting the Broken Pieces after the Cambodian Genocide: Legacy as Memory of a Nation." UC Berkeley-UCLA Distinguished Visitor from Southeast Asia Series, 2010. http://www.youtube.com/watch?v=vZuD4Fo-ZOc.

Chhang, Youk. *The Duch Verdict: Khmer Rouge Tribunal Case 001*. Phnom Penh: Documentation Center of Cambodia, 2010.

Chigas, George. "The Trial of the Khmer Rouge: The Role of the Tuol Sleng and Santebal Archives." *Harvard Asia Quarterly* (Winter 2000): 45.

Chomsky, Noam, and Edwards S. Herman. *After the Cataclysm*. Boston: South End Press, 1979.

Cohen, David William. *The Combing of History.* Chicago: University of Chicago Press, 1994.

Cole, Catherine M. "Mediating Testimony: Broadcasting South Africa's Truth and Reconciliation Commission." In *Documentary Testimonies: Global Archives of Suffering,* edited by Bhaskar Sarkar and Janet Walker, 196–214. New York: Routledge, 2010.

Cole, Simon A. "Fingerprint Identification and the Criminal Justice System: Historical Lessons for the DNA Debate." http://www.hks.harvard.edu/dnabook/Simon%20 Cole%20II.doc.

Cole, Simon A. *Suspect Identities: A History of Fingerprinting and Criminal Identification.* Cambridge, MA: Harvard University Press, 2001.

Corey-Boulet, Robbie. "Challenges to Civil Parties." *Phnom Penh Post,* July 9, 2009.

Cougill, Wynne, with Pivione Pang, Chhayran Ra, and Sopheak Sim. *Stilled Lives: Photographs from the Cambodian Genocide.* Phnom Penh: Documentation Center of Cambodia, 2004.

Crane, Susan A. "Choosing Not to Look: Representation, Repatriation, and Holocaust Atrocity Photography." *History and Theory* 47 (October 2008): 309–330.

"Dealing with the Yellow Peril in Indo-China." *Public Opinion* 39:13 (September 23, 1905): 401.

Dean, John F. "The Preservation of Books and Manuscripts in Cambodia." *American Archivist* 53 (Spring 1990): 282–297.

Dean, John F. "The Preservation and Conservation Needs of the Upper Regions of Southeast Asia." *Libri* 47 (1997): 124–128.

De Nike, Howard J., John Quigley, and Kenneth J. Robinson, eds., with the assistance of Helen Jarvis and Nereida Cross. *Genocide in Cambodia: Documents from the Trial of Pol Pot and Ieng Sary.* Philadelphia: University of Pennsylvania Press, 2000.

Derrida, Jacques. *Archive Fever: A Freudian Impression.* Chicago: University of Chicago Press, 1996.

Desmond, Jane C. *Staging Tourism.* Chicago: University of Chicago Press, 1990.

Documentation Center of Cambodia. "About." http://www.d.dccam.org/Abouts /History/Histories.htm.

Documentation Center of Cambodia. "Genocide Education." http://www.d.dccam .org/Projects/Genocide_Education.htm.

Documentation Center of Cambodia. "Photographic Database." http://www.d.dccam .org/Database/Photographic/Cts.php.

Documentation Center of Cambodia. *Behind the Walls of S-21: Oral Histories from Tuol Sleng Prison.* 2007. http://www.youtube.com/watch?v=g2xmOq_dj8k.

Documentation Center of Cambodia. *Preparing for Justice.* 2007. http://www .youtube.com/watch?v=TOngbCZQ1BA&feature=related.

Documentation Center of Cambodia. *Factsheet: Pol Pot and His Prisoners at Secret Prison S-21.* Phnom Penh: Documentation Center of Cambodia, 2011.

Douglas, Jennifer. "Origins: Evolving Ideas about the Principle of Provenance." In

Currents of Archival Thinking, edited by Terry Eastwood and Heather MacNeil, 23–43. Santa Barbara, CA: Libraries Unlimited, 2010.

Doyle, Peter. "Public Eye, Private Eye: Sydney Police Mug Shots, 1912–1930." *Scan Journal* 1:1 (January 2004): 1–30.

Duff, Wendy, and Verne Harris. "Stories and Names: Archival Description as Narrating Records and Constructing Meanings." *Archival Science* 2 (2002): 263–285.

Dunlap, William, and Linda Burgess. "Facing the Past: Cambodia Then and Now." The Works of William Dunlap website. 2003. http://www.williamdunlap.com /writing/cambodia.html.

Dunlop, Nic. *The Lost Executioner.* London: Bloomsbury, 2005.

Dy, Khamboly. *A History of Democratic Kampuchea (1975–1979).* Phnom Penh: Documentation Center of Cambodia, 2007.

East-West Center. "Duch on Trial." Episode 10, June 29–July 2, 2009. http://vimeo .com/5467572.

Edwards, Elizabeth. *Raw Histories: Photographs, Anthropology, Museums.* Oxford: Berg, 2001.

Edwards, Penny. "Imaging the Other in Cambodian Nationalist Discourse before and during the UNTAC Period." In *Propaganda, Politics, and Violence in Cambodia*, edited by Steve Heder and Judy Ledgerwood, 50–72. Armonk, NY: M. E. Sharpe, 1996.

Edwards, Penny. *Cambodge: The Cultivation of a Nation, 1860–1945.* Honolulu: University of Hawaii Press, 2007.

Etcheson, Craig. *After the Killing Fields: Lessons from the Cambodian Genocide.* Lubbock: Texas Tech University Press, 2005.

"Ex-Khmer Rouge Photographer Plans to Set Up Museum in Anlong Veng." *Japan Economic Newswire*, January 25, 2007.

Extraordinary Chambers in the Courts of Cambodia. "Transcript of Proceedings." March 31, 2009. http://www.eccc.gov.kh/sites/default/files/documents/courtdoc /E1_6.1_TR001_20090331_Final_EN_Pub.pdf.

Extraordinary Chambers in the Courts of Cambodia. "Transcript of Proceedings." August 17, 2009. http://www.eccc.gov.kh/sites/default/files/documents/courtdoc /E1_63.1_TR001_20090817_Final_EN_Pub.pdf.

Faulkhead, Shannon. "Connecting through Records: Narratives of Koorie Victoria." *Archives and Manuscripts* 37:2 (2010): 60–88.

Fawthrop, Tom. "Khmer Rouge Leader Ieng Sary Has US $20m in Hong Kong Account." *South China Morning Post*, March 31, 2013.

Fawthrop, Tom, and Helen Jarvis. *Getting Away with Genocide?* Ann Arbor, MI: Pluto, 2004.

Felman, Shoshana, and Dori Laub. *Testimony: Crises of Witnessing in Literature, Psychoanalysis, and History.* New York: Routledge, 1991.

Fosdick, Raymond B. "The Passing of the Bertillon System of Identification." *Journal of the American Institute of Criminal Law and Criminology* 6:3 (1915): 363–369.

Foucault, Michel. *Archeology of Knowledge*. New York: Pantheon Books, 1972.

Foucault, Michel. *Discipline and Punish: The Birth of the Prison*. New York: Random House, 1977.

Friends of Vann Nath Association, "Appeal for Funds: Postcards." http://www.vannnath .com/appeal-funds/postcards/.

Gillespie, Alex. "Tourist Photography and the Reverse Gaze." *Ethos* 34:3 (2006): 343–366.

Gilliland, Anne, Sue McKemmish, Kelvin White, Yang Lu, and Andrew J. Lau. "Pluralizing the Archival Paradigm: Can Archival Education in Pacific Rim Communities Address the Challenge?" *American Archivist* 71:1 (2008): 87–117.

Goffman, Erving. *Asylums: Essays on the Social Situations of Patients and Other Inmates*. Piscataway, NJ: Aldine Transaction, 2007.

Gourevitch, Philip. "The Abu Ghraib We Cannot See." *New York Times*, May 24, 2009, WK10.

Green-Lewis, Jennifer. *Framing the Victorians*. Ithaca, NY: Cornell University Press, 1996.

Gridack, Paige "B." "Bringing Bertillon Back: The Preservation and Research Application of Bertillon Materials in Museums, Archives and Historical Societies." *Journal of Archival Organization* (February 2010): 188–213.

Guerin, Frances, and Roger Hallas. *The Image and the Witness: Trauma, Memory and Visual Culture*. London: Wallflower Press, 2007.

Harris, Verne. "The Archival Sliver: Power, Memory, and Archives in South Africa." *Archival Science* 2:1–2 (2002): 63–86.

Harris, Verne. "Archives, Politics, and Justice." In *Political Pressure and the Archival Record*, edited by Margaret Procter et al., 173–182. Chicago: Society of American Archivists, 2005.

Harris, Verne. *Archives and Justice*. Chicago: Society of American Archivists, 2007.

Hawk, David. "The Killing of Cambodia." *The New Republic* (November 15, 1982): 17–21.

Hawk, David. "Tuol Sleng Extermination Centre." *Index on Censorship* 15:1 (January 1986): 25–31.

Hawk, David. "The Photographic Record." In *Cambodia 1975–1978: Rendezvous with Death*, edited by Karl D. Jackson, 209–214 and unpaginated photo insert. Princeton: Princeton University Press, 1989.

Hawk, David. "Confronting Genocide in Cambodia." In *Pioneers of Genocide Studies*, edited by Samuel Totten and Steven Leonard Jacobs, 521–544. New Brunswick, NJ: Transaction, 2002.

Heder, Steve, and Judy Ledgerwood, eds. *Propaganda, Politics, and Violence in Cambodia*. Armonk, NY: M. E. Sharpe, 1996.

Herman, Edward S., and David Peterson. *The Politics of Genocide*. New York: Monthly Review Press, 2010.

Hight, Eleanor M., and Gary D. Sampson, eds. *Colonialist Photography: Imag(in)ing Race and Place*. New York: Routledge, 2002.

Hinton, Alexander Laban. *Why Did They Kill? Cambodia in the Shadow of Genocide.* Berkeley: University of California Press, 2005.

Hughes, Rachel. "The Abject Artefacts of Memory: Photographs from Cambodia's Genocide." *Media Culture Society* 25:23 (2003): 23–44.

Hughes, Rachel. "Dutiful Tourism: Encountering the Cambodian Genocide." *Asia Pacific Viewpoint* 49:3 (December 2008): 318–330.

Hurley, Chris. "Parallel Provenance." (2005): 1–23. http://www.infotech.monash.edu .au/research/groups/rcrg/publications/parallel-provenance-combined.pdf.

Hurley, Chris. "Parallel Provenance: What if Anything Is Archival Description?" *Archives and Manuscripts* 33:1 (2005): 110–145.

Iacovino, Livia. "Rethinking Archival, Ethical and Legal Frameworks for Records of Indigenous Australian Communities: A Participant Relationship Model of Rights and Responsibilities." *Archival Science* 10 (2010): 353–372.

Internet World Stats. "Internet Usage in Asia 2012 Q2." http://www.internetworld stats.com/stats3.htm.

Japan Broadcasting Corporation/Ortis Japan. *Asia in View: Facing Khmer Rouge Atrocities,* 2011.

Jarvis, Helen. "The Cambodian National Library: Surviving after 70 Years." *Libraries & Culture* 30:4 (1995): 403.

Jimerson, Randall. "Archives for All: Professional Responsibility and Social Justice." *American Archivist* 70 (2007): 252–281.

Kaluszynski, Martine. "Republican Identity: Bertillonage as Government Technique." In *Documenting Individual Identity,* edited by Jane Caplan and John Torpey, 123–138. Princeton: Princeton University Press, 2001.

Kateb, George. *Hannah Arendt: Politics, Conscience, Evil.* Totowa, NJ: Rowman & Allanheld, 1983.

Kerry, John. "Heroes and Pioneers." *Time* (May 8, 2007), reprinted at http://ki-media .blogspot.com/2007/05/youk-chhang-time-magazine-2007-most.html.

Ketelaar, Eric. "Tacit Narratives: The Meaning of Archives." *Archival Science* 1:2 (2001): 131–141.

Ketelaar, Eric. "Archival Temples, Archival Prisons: Modes of Power and Protection." *Archival Science* 2 (2002): 221–238.

Ketelaar, Eric. "Time Future Contained in Time Past: Archival Science in the 21st Century." *Journal of the Japan Society for Archival Science* 1 (2004): 20–35. http:// cf.hum.uva.nl/bai/home/eketelaar/timefuture.doc.

Ketelaar, Eric. "Recordkeeping and Societal Power." In *Archives: Recordkeeping in Society,* edited by Sue McKemmish et al., 277–298. Wagga Wagga, Australia: Center for Information Studies, 2005.

Ketalaar, Eric. "Records Out and Archives In: Early Modern Cities as Creators of Records and as Communities of Archives." *Archival Science* 10 (2010): 201–210.

Kiernan, Ben. "Bringing the Khmer Rouge to Justice." *Human Rights Review* (April–June 2000): 92–108.

Kiernan, Ben. Untitled lecture, Global Resources Network Conference and Forum,

Yale University Center for International and Area Studies, March 24, 2005, http://www.library.yale.edu/mssa/globalrecord/new_web/kiernan_richie.html#text.

Kiernan, Ben. *Blood and Soil*. New Haven, CT: Yale University Press, 2007.

Kimmelman, Michael. "Hypnotized by Mug Shots That Stare Back: Are They Windows or Mirrors?" *New York Times*, August 27, 1997, C9.

Kopytoff, Igor. "The Cultural Biography of Things: Commoditization as a Process." In *The Social Life of Things: Commodities in Cultural Perspective*, edited by Arjun Appadurai, 211–235. Cambridge: Cambridge University Press, 1986.

Kosal, Sea. "The Confession of My Father." *Searching for the Truth* 32 (2002): 48.

Kress, Gunther, and Theo van Leeuwen. *The Grammar of Visual Design*. New York: Routledge, 1996.

Kuy, Nancy. "Me and Chum Mey." http://www.travelblog.org/Photos/6884077.

Kuy, Nancy. Untitled. http://www.travelblog.org/Asia/Cambodia/South/Phnom-Penh/blog-711575.html.

Kuy, Nancy. "The World in the Eyes of a Valley Girl." http://www.travelblog.org/Bloggers/The-World-In-The-Eyes-Of-A-Valley-Girl/.

LaBahn, Joel, and Whitney LaBahn. "Bou Meng." http://www.travelblog.org/Photos/6564027.

LaBahn, Joel, and Whitney LaBahn. "LaBahn." http://www.travelblog.org/Bloggers/LaBahn/.

LaBahn, Joel, and Whitney LaBahn. Untitled. http://www.travelblog.org/Asia/Cambodia/North/Siem-Reap/blog-661691.html.

Latour, Bruno. *Reassembling the Social: An Introduction to Actor-Network-Theory*. Oxford: Oxford University Press, 2005.

Laub, Dori. "Bearing Witness, or the Vicissitudes of Listening." In *Testimony: Crises of Witnessing in Literature, Psychoanalysis, and History*, edited by Shoshana Felman and Dori Laub, 57–74. New York: Routledge, 1991.

Ledgerwood, Judy. "The Cambodian Tuol Sleng Museum of Genocidal Crimes: National Narrative." *Museum Anthropology* 21:1 (1997): 82–98.

Ledgerwood, Judy. "Seeing Duch on Trial." *Searching for the Truth* 1 (2001).

Lennon, J. John, and Malcolm Foley. *Dark Tourism: The Attraction of Death and Disaster*. London: Continuum, 2000.

Linfield, Susie. *The Cruel Radiance: Photography and Political Violence*. Chicago: University of Chicago Press, 2010.

Logan, William, and Keir Reeves, eds. *Places of Pain and Shame: Dealing with "Difficult" Heritage*. New York: Routledge, 2009.

Long, Colin, and Keir Reeves. "'Dig a Hole and Bury the Past in It?' Reconciliation and the Heritage of Genocide in Cambodia." In *Places of Pain and Shame: Dealing with "Difficult" Heritage*, edited by William Logan and Keir Reeves, 68–81. New York: Routledge, 2009.

Long, Dany. "From the Border to S-21." *Searching for the Truth* 31 (2002): 24–25.

Ly, Sophal. "30 Years Later." *Searching for the Truth* 1 (2008): 7.

Lyotard, Jean-Francois. *The Differend: Phrases in Dispute.* Minneapolis: University of Minnesota Press, 1988.

MacCannell, Dean. *The Tourist: A New Theory of the Leisure Class.* New York: Schocken, 1976.

Maguire, Peter. *Facing Death in Cambodia.* New York: Columbia University Press, 2005.

Mason, Otis T. "Anthropology in Paris during the Exposition of 1889." *American Anthropologist* 3:1 (January 1890): 27–36.

Maxwell, Anne. *Colonial Photography and Exhibitions.* London: Leicester University Press, 1999.

McKemmish, Sue. "Evidence of Me." *Archives and Manuscripts* 24:1 (May 1996): 28–45.

McKemmish, Sue. "Placing Records Continuum Theory and Practice." *Archival Science* 1 (2001): 333–359.

McKemmish, Sue. "Traces: Document, Record, Archive, Archives." In *Archives: Recordkeeping in Society,* edited by Sue McKemmish et al., 1–20. Wagga Wagga, Australia: Center for Information Studies, 2005.

Mey, Chum. Interview with Sim Soraya, March 23, 2006. Documentation Center of Cambodia, Phnom Penh, Cambodia.

Mey, Chum, with Documentation Center of Cambodia. *Survivor: The Triumph of an Ordinary Man in the Khmer Rouge Genocide,* translated by Sim Sorya and Kimsroy Sokvisal. Phnom Penh: Documentation Center of Cambodia, 2012.

Millar, Laura. "The Death of the Fonds and the Resurrection of Provenance: Archival Context in Space and Time." *Archivaria* 53 (2002): 1–15.

Millar, Laura. "Touchstones: Considering the Relationship between Memory and Archives." *Archivaria* 61 (Spring 2006): 105–126.

Mitchell, W. J. T. *What Do Pictures Want? The Lives and Loves of Images.* Chicago: University of Chicago Press, 2005.

Mony, Say. "Survivors Sell Books at Prison That Once Held Them." Voice of America, August 3, 2012. http://www.voacambodia.com/content/survivors-sell-books-at-prison-that-once-held-them-138139178/1359237.html.

Moorthy, Elizabeth, Youk Chhang, Putheara Lay, Dara Peuv Vanthan, and Beth Van Schaack. "Memorandum: A Preliminary Evaluation of Evidence Held by the Documentation Center of Cambodia." November 1998, Phnom Penh, Cambodia. David Chandler Cambodia Collection at Monash University Library. http://arrow.monash.edu.au/vital/access/manager/Collection/monash:64226.

Mydans, Seth. "Faces from Beyond the Grave." *New York Times,* May 25 1997, BR21.

Mydans, Seth. "Word for Word / Torturers' Archive: Cambodia's Bureaucracy of Death: Reams of Evidence in Search of a Trial." *New York Times,* July 20, 1997, sec. 4, 7.

Mydans, Seth. "Death of Pol Pot: The Analysis." *New York Times,* April 17, 1998.

Mydans, Seth. "Coming Khmer Rouge Trial Rouses Jail's Ghosts." *New York Times,* June 30, 1999, A4.

Mydans, Seth. "Out from behind a Camera at a Khmer Torture Center." *New York Times*, October 27, 2007, A3.

Mydans, Seth. "Legal Strategy Fails to Hide Torturer's Pride." *New York Times*, June 21, 2009, A12.

Mydans, Seth. "Torture and Death Recounted at Cambodian Trial." *New York Times*, July 15, 2009, A4.

Mydans, Seth. "Khmer Rouge Figure Is Found Guilty of War Crimes." *New York Times*, July 26, 2010.

Nath, Vann. *A Cambodian Prison Portrait*. Bangkok: White Lotus Press, 1998.

National Archives of Cambodia. "Introduction to the Collection of the National Archives of Cambodia." http://www.camnet.com.kh/archives.cambodia/English/naccoll.htm.

Neary, Ouk. "Transcript of Trial Proceedings." The Extraordinary Chambers in the Courts of Cambodia, August 17, 2009, 54–55, as made available on Cambodia Tribunal Monitor. http://www.cambodiatribunal.org/multimedia/trial-footage/archive/2009-08.

Nesmith, Tom. "Still Fuzzy but More Accurate: Some Thoughts on the 'Ghosts' of Archival Theory." *Archivaria* 47 (1999): 136–150.

Nicholson, Joseph. "The Identification of Criminals." Congress of the National Prison Association at Pittsburgh, October 10–15, 1891.

Nickell, Joe. *Camera Clues: A Handbook for Photographic Investigation*. Lexington: University of Kentucky Press, 1994.

Noble, Andrea. "Traveling Theories of Family Photography and the Material Culture of Human Rights in Latin America." *Journal of Romance Studies* 8:1 (2008): 43–59.

Okazaki, Steven. *The Conscience of Nhem En*. DVD. HBO Documentary Films, 2008.

Osman, Ysa. *Oukoubah: Justice for the Cham Muslims under the Democratic Kampuchea Regime*. Phnom Penh: Documentation Center of Cambodia, 2002.

Owen, Taylor, and Ben Kiernan. "Bombs over Cambodia." *The Walrus* (October 2006): 62–69.

Panh, Rithy. *S21: The Khmer Rouge Killing Machine*. DVD. Human Rights Watch, 2003.

Panh, Rithy. *About My Father*. Phnom Penh: Bophana Center, 2009.

Panh, Rithy, et al. Bophana Audiovisual Resource Center (undated). http://www.bophana.org/site/index.php?option=com_content&task=view&id=13&Itemid=57.

Pearce-Moses, Richard. "Provenance." *A Glossary of Archival and Records Terminology*. Society of American Archivists, Chicago. http://www.archivists.org/glossary/term_details.asp?DefinitionKey=196.

Peschoux, Christophe. "Interview with Kaing Guek Eav, Also Known as Duch, Chairman of S-21, April–May 1999." David Chandler Cambodia Collection, Monash University Library. http://arrow.monash.edu.au/vital/access/manager/Collection/monash:64226.

Pham, Phuong, Patrick Vinck, Mychelle Balthazard, Sokhom Hean, and Eric Stover. *So We Will Never Forget: A Population-Based Survey on Attitudes about Social Reconstruction and the Extraordinary Chambers in the Courts of Cambodia*. Berkeley: Human Rights Center, University of California, Berkeley, 2009. http://hrc.berkeley.edu/pdfs/So-We-Will-Never-Forget.pdf.

Pinney, Christopher. *Camera Indica: The Social Life of Indian Photographs*. London: Reaktion Books, 1997.

Pluralizing the Archival Curriculum Group. "Educating for the Archival Multiverse." *American Archivist* 74:1 (2011): 69–101.

PoKempner, Dinah. "The Tribunal and Cambodia's Transition to a Culture of Accountability." In *Bringing the Khmer Rouge to Justice*, edited by Jaya Ramji and Beth Schaack. Lewiston, NY: Edwin Mellen, 2005.

Poole, Deborah. *Vision, Race, and Modernity: A Visual Economy of the Andean Image World*. Princeton: Princeton University Press, 1997.

Pran, Dith. "Return to the Killing Fields." *New York Times*, September 24, 1989, SM30.

Public Affairs Section of the Extraordinary Chambers in the Courts of Cambodia. "An Introduction of the Khmer Rouge Trials." Phnom Penh (undated).

Punzalan, Ricardo. "All the Things We Cannot Articulate: Colonial Leprosy Archives and Community Commemoration." In *Community Archives: The Shaping of Memory*, edited by Jeanette Bastian and Ben Alexander, 197–219. London: Facet, 2009.

Richie, Richard. Untitled lecture. Global Resources Network Conference and Forum, Yale University Center for International and Area Studies, March 24, 2005. http://www.library.yale.edu/mssa/globalrecord/new_web/kiernan_richie.html#text.

Richie, Richard. "Preserving Khmer Rouge Archives." *Focus: Critical Resources for Research and Teaching in the Humanities, Sciences, and Social Sciences* 25 (Fall 2005). http://www.crl.edu/focus/article/493.

Riley, Chris, and Doug Niven. *The Killing Fields*. Santa Fe: Twin Palms, 1996.

Robertson, Craig. "The Archive, Disciplinarity, and Governing: Cultural Studies and the Writing of History." *Critical Studies, Critical Methodologies* 4:4 (2004): 450–471.

Robinson, Mike, and David Picard, eds. *The Framed World: Tourism, Tourists and Photography*. Burlington, VT: Ashgate, 2009.

Rose, Gillian. *Visual Methodologies: An Introduction to the Interpretation of Visual Materials*, 2nd ed. London: Sage, 2006.

Rosenberg, Tina. "Cambodia's Blinding Genocide: A Web Site Exhumes the Faces of Death." *New York Times*, April 21, 1997, A14.

Ryan, James R. *Picturing Empire: Photography and the Visualization of the British Empire*. Chicago: University of Chicago Press, 1998.

Schwartz, Joan M. "The Archival Garden: Photographic Plantings, Interpretive Choices, and Alternative Narratives." In *Controlling the Past: Documenting Society and Institutions*, edited by Terry Cook, 69–110. Chicago: Society of American Archivists, 2011.

Secrets of S-21: Legacy of a Cambodian Prison. VHS. BBC Films for the Humanities and Sciences, 1998.

Sekula, Allan. "The Body and the Archive." *October* 39 (Winter 1986): 3–64.

Sekula, Allan. "The Traffic in Photographs." *Only Skin Deep: Changing Visions of the American Self,* edited by Coco Fusco and Brian Wallis. New York: International Center for Photography, 2003.

Ser, Sayana, Savina Sirik, Farina So, Dacil Keo, and Sarah Jones Dickens. "A Response to Brinkley's Writing about the DC-Cam Outreach Activities." E-mail from Sarah Jones Dickens to author, May 5, 2011.

Shawcross, William. "Lessons of Cambodia." In *The New Killing Fields: Massacre and the Politics of Intervention,* edited by Nicolas Mills and Kira Brunners. New York: Basic Books, 2002.

Sim, Sorya. "Chum Manh: An S-21 Survivor." *Searching for Truth* 22 (October 2001): 13.

Sivan, Eyal. "Archive Images: Truth or Memory? The Case of Adolf Eichmann's Trial." In *Experiments with Truth: Transitional Justice and the Processes of Truth and Reconciliation,* edited by Okwui Enwezor et al. Ostfildern, Germany: Hatje Cantz, 2002.

Sleuk Rith Institute. http://www.cambodiasri.org/.

Slocomb, Margaret. *Colons and Coolies: The Development of Cambodia's Rubber Plantations.* Bangkok: White Lotus, 2007.

Slyomovics, Susan. *The Performance of Human Rights in Morocco.* Philadelphia: University of Pennsylvania Press, 2005.

Smith, Shawn Michelle. *American Archives: Gender, Race, and Class in Visual Culture.* Princeton: Princeton University Press, 1999.

Sontag, Susan. *On Photography.* New York: Picador, 1997.

Sontag, Susan. *Regarding the Pain of Others.* New York: Picador, 2003.

Spivak, Gayatri Chakravorty. "Can the Subaltern Speak?" Reprinted in *The Post-Colonial Studies Reader,* edited by Bill Ashcroft et al., 28–37. New York: Routledge, 1995.

Stanton, Gregory H. "The Call." In *Pioneers of Genocide Studies,* edited by Samuel Totten and Steven Leonard Jacobs, 401–428. New Brunswick, NJ: Transaction, 2002.

Stanton, Gregory H. "The International Campaign to End Genocide: A Review of Its First Five Years." Genocide Watch (undated). http://www.genocidewatch.org /reviewoffirstfiveyrs.html.

"State Department Clears Yale's Cambodia Program of Wrongdoing." *The Chronicle of Higher Education* 45:14 (November 27, 1998): A9.

Struk, Janina. *Photographing the Holocaust.* London: I. B. Tauris, 2004.

Tagg, John. *The Burden of Representation.* Amherst: University of Massachusetts Press.

Thion, Serge. "Genocide as Political Commodity." In *Genocide and Democracy in Cambodia,* edited by Ben Kiernan, 163–190. New Haven, CT: Yale University Press, 1993.

Thomas, Nicholas. *Entangled Objects: Exchange, Material Culture, and Colonialism in the Pacific.* Cambridge, MA: Harvard University Press, 1991.

Trace, Ciaran B. "What Is Recorded Is Never Simply 'What Happened': Record Keeping in Modern Organizational Culture." *Archival Science* 2 (2002): 137–159.

Transcultural Psychosocial Organization. "Justice and Relief for Survivors of the Khmer Rouge Project." http://tpocambodia.org/index.php?id=justiceandrelieffor survivors.

Trebay, Guy. "Killing Fields of Vision." *Village Voice*, June 3, 1997, 34.

Trouillot, Michel-Rolph. *Silencing the Past: Power and the Production of History.* Boston: Beacon Press, 1995.

Tully, John. *Cambodia under the Tricolour.* Clayton, Australia: Monash University, 1996.

Tully, John. *France on the Mekong.* Lanham, MD: University Press of America, 2002.

Upward, Frank. "Structuring the Records Continuum Part I." *Archives and Manuscripts* 24:2 (1996): 268–285.

Upward, Frank. "Modelling the Continuum as Paradigm Shift in Recordkeeping and Archiving Processes and Beyond." *Records Management Journal* (December 2000): n.p.

Upward, Frank, and Sue McKemmish. "Teaching Recordkeeping and Archiving Continuum Style." *Archival Science* 6 (2006): 219–230.

Urry, John. *The Tourist Gaze.* London: Sage, 1990.

Vannak, Huy. *Bou Meng: A Survivor from Khmer Rouge Prison S-21.* Phnom Penh: Documentation Center of Cambodia, 2010.

Van Schaack, Beth, Daryn Reicherter, and Youk Chhang, eds. *Cambodia's Hidden Scars: Trauma Psychology in the Wake of the Khmer Rouge.* Phnom Penh: Documentation Center of Cambodia, 2011.

Vanthan, Dara P. "Want to Know the Truth." *Searching for the Truth* 14 (2001): 48.

Veneciano, Jorge Daniel. "Tuol Sleng, Abu Ghraib, and the Discourse of Torture." In *Night of the Khmer Rouge: Genocide and Justice in Cambodia,* edited by Jorge Daniel Veneciano and Alexander Hinton. Newark, NJ: Rutgers University Press, 2007.

Wallace, David A. "Locating Agency: Interdisciplinary Perspectives on Professional Ethics and Archival Morality." *Journal of Information Ethics* 19:1 (Spring 2010): 172–189.

Wallis, Brian. "Black Bodies, White Science: Louis Agassiz's Slave Daguerreotypes." In *Only Skin Deep: Changing Visions of the American Self,* edited by Coco Fusco and Brian Wallis, 163–182. New York: International Center for Photography, 2003.

Weitz, Eric D. *A Century of Genocide: Utopias of Race and Nation.* Princeton: Princeton University Press, 2003.

Wexler, Laura. *Tender Violence.* Chapel Hill: University of North Caroline Press, 2000.

Wheeler, David. "Documenting Genocide in Cambodia, One Face after Another." *Chronicle of Higher Education* 45:38 (May 28, 1999): B2.

White, Hayden. "Historiography and Historiophoty." *American Historical Review* 93:5 (1988): 1193–1199.

Williams, Paul. "The Atrocity Exhibition: Touring Cambodian Genocide Memorials." In *On Display: New Essays in Cultural Studies*, edited by Anna Smith and Lydia Weaver, 197–214. Wellington, New Zealand: Victoria University Press, 2004.

Williams, Paul. "Witnessing Genocide: Vigilance and Remembrance at Tuol Sleng and Choeung Ek." *Holocaust and Genocide Studies* 18:2 (Fall 2004): 234–255.

Wurl, Joel. "Ethnicity as Provenance: In Search of Values and Principles Documenting the Immigrant Experience." *Archival Issues* 29:1 (2005): 65–76.

Yeo, Geoffrey. "Concepts of Record (1): Evidence, Information, and Persistent Representation." *American Archivist* 70 (2007): 315–343.

Yerushalmi, Yosef Hayim. *Zakhor: Jewish History and Jewish Memory.* Seattle: University of Washington Press, 2005.

Zinoman, Peter. *The Colonial Bastille: A History of Imprisonment in Vietnam, 1862–1940.* Berkeley: University of California Press, 2001.

Index

Page numbers in italics indicate illustrations.

absence and presence tension, 21–22, 31, 51, 58–60, 93, 109–112, 131

access to records: Cambodian Genocide Justice Act and, 79–80; DC-Cam and, 6, 9, 74, 81, 83–85, 88, 90, 92, 103, 189n152; digitization challenges in, 88, 188n140; National Archives, 83; Photo Archive Group's activities and, 76; provenance in context of, 19–20; Tuol Sleng Genocide Museum and, 71, 72, 92, 183n58, 188n151. *See also* archivization of Tuol Sleng mug shots; records

acquisition of records, by DC-Cam, 81–82, 186nn112–113

activation of records, 16–17, 98, 132, 165, 196n107. *See also* narratives about Khmer Rouge, and Tuol Sleng mug shots

aesthetic objects (art works), and Tuol Sleng mug shots, 4–5, 74–76, 88, 184n67, 184n69

agency: community of records around Tuol Sleng mug shots in reassertion of, 7, 12, 58–60, 180n136; photographs and, 15; social life of records and, 15, 16–17, 58–60, 180n136; of survivors in context of tourist photographs, 152–155, 199n43; and victimhood tension, 21–22, 58–60, 147, 154, 180n136

agency and silence (silence and agency): within archival theory, 21–22; as complementary, 21–22, 58–60, 180n136; tension in

narratives about Khmer Rouge between, 109–112, 131, 134–135; Tuol Sleng Genocide Museum in context of, 180n136; Tuol Sleng mug shots in context of, 21–22, 58–60, 180n136. *See also* silences as encoded/framework in historical production

anthropological classification, and French colonial police policies as legacy in Cambodia, 175n56, 176n65, 177n72

Appadurai, Arjun, 14–17, 132

archival theory and scholarship: archival multiverse in, 21, 171n68; co-creatorship and, 18, 19–20, 58–59, 171n64; inalienability principle in, 18, 171n57; provenance in, 18–21, 77, 171n57, 171n64; records continuum model in, 13, 169n30; records life-cycle model in, 169n30, 169n34, 170n50; silence and agency as complementary within, 21–22; transformation of records and, 13; Trouillot's four silences compared with, 12–14, 21, 161, 169n29; voices heard through silence of photographs and, 18, 20–21, 59

archivists, archives, and archival institutions: community of records around Tuol Sleng mug shots as, 7, 12, 167n11; DC-Cam and, 90; digitization of records in context of, 88; ECCC reparations and, 198n9; narratives about Khmer Rouge and, 107, 111–112, 133; political factors in

commodities making: global context for human
rights and, 140–141, 143; income/liveli-
hood for survivors and, 140–141, 143–146,
197n4; local context for human rights
and, 140–141, 143; participant observa-
tion and, 139–140, 164; performance of
human rights through, 144; reparations
from ECCC in context of, 141, 143–144,
147; sales of memoirs/biographies of sur-
vivors of Tuol Sleng and, 136–139, *137,
138,* 141, *142,* 191n22; traumatic memories
relief and, 145; Tuol Sleng Genocide
Museum items for sale and, 141, *143. See
also* tourist photographs, and commod-
ities making
Communist Party of Kampuchea (CPK), 65.
See also Khmer Rouge (Democratic Kam-
puchea or DK)
community of records around Tuol Sleng
mug shots, 7, 12, 20–21, 58–60, 134, 158,
167n11, 180n136, 197n112. *See also* family
of victims; records; survivors of Tuol
Sleng
confession statements: in DC-Cam records, 9;
historical context for, 47, 177n82; missing
or destroyed records and, 64, 66–67;
narratives about Khmer Rouge and, 105,
111–114, 118; political factors in archiviza-
tion and, 70; social function of, 57–58;
totalitarian regimes' documentation in
context of arrests and, 55; truthfulness
of, 55, 172n17; Tuol Sleng and, 3–4, 8–9,
28–29, 172n17; voice and silence tension
in context of, 51
Conscience of Nhem En, The (documentary
film), 107, 108–109, 195n75
conservation efforts, 4, 63, 67, 71–73, 76, 183n53
contextualization/decontextualization of
records, 74–77, 147–151, *150,* 153–154,
163–164, 184n72, 185n85, 198n25, 200n7
Conway, Paul, 84–85, 87
CORKR (Campaign to Oppose the Return of
the Khmer Rouge), 78
Cornell University's microfilming project, 62,
69–71
co-witnesses, to violence of Tuol Sleng, 130,
152, 154, 164
CPK (Communist Party of Kampuchea), 65.

See also Khmer Rouge (Democratic Kam-
puchea or DK)
Crane, Susan A., 162–163
creatorship/co-creatorship: provenance and,
18, 19–20, 58–59, 158, 171n64; subjects of
Tuol Sleng mug shots in context of, 18,
19–20, 58–59, 153, 158, 180n136; tourist
photographs in context of commodities
making and, 152–153
crimes against humanity, 4, 6, 9, 66, 79–80,
89, 99. *See also* human rights
criminal classification, and identification:
French colonial police policies as legacy
in Cambodia and, 34, 36, *37–40,* 175n53,
175n56; state's discursive creation of
criminal body through Tuol Sleng mug
shots and, 48–52, 57–59, 178n86, 178n89,
178nn91–92, 178n98, 179n103; US pro-
cessing of criminals and, 41, 48, 175n54,
176nn66–67, 177n72, 178n91. See also
bertillonage (signaletics)
criminalistique (criminal science), and *bertil-
lonage,* 36, 41, 49
criminal science *(criminalistique),* and *bertil-
lonage,* 36, 41, 49
Cross, Nereida, 81, 85
cultural and religious functions of Tuol Sleng
mug shots, 33, 69, 104, 110, 120–121, 191n23,
193n46

"dark" tourism, 146, 151. *See also* tourist gaze;
tourist photographs, and commodities
making
DC-Cam (Documentation Center of Cambo-
dia). *See* archivization of Tuol Sleng mug
shots; Documentation Center of Cam-
bodia (DC-Cam)
Dean, John F., 70
decontextualization/contextualization, of
Tuol Sleng mug shots, 74–77, 147–151,
150, 153–154, 163–164, 184n72, 185n85,
198n25, 200n7
Democratic Kampuchea (DK or Khmer
Rouge). *See* French colonial police poli-
cies, as legacy in Cambodia; Khmer
Rouge (Democratic Kampuchea or
DK); Tuol Sleng (S-21); Tuol Sleng mug
shots

denial of mass murders by Khmer Rouge, as countered by DC-Cam, 83, 187n121, 187n123

Desmond, Jane C., 199n43

destroyed or missing records. *See* missing or destroyed records

digitization of records: accessibility challenges and, 88, 188n140; archivization of Tuol Sleng mug shots and, 6, 9, 12, 62, 82, 85, *86*, 87–88; DC-Cam database of Tuol Sleng mug shots and, 6, 9, 12, 62, 82–83, 85, *86*, 87–88, 187n126; ethical challenges/ consequences of, 17, 87; memorialization in context of, 88; political challenges/ consequences of, 17, 87; social life of records in context of, 17; victim identification and, 85, *86*, 87, 188n140

DK (Democratic Kampuchea or Khmer Rouge). *See* French colonial police policies, as legacy in Cambodia; Khmer Rouge (Democratic Kampuchea or DK); Tuol Sleng (S-21); Tuol Sleng mug shots

documentary films: narratives about Khmer Rouge in context of interviews and, 106–116, 192n34, 192nn36–37, 192n44, 193nn46–47, 193n50, 193n56, 193n59, 194n60, 194n64; with people looking at Tuol Sleng mug shots images, 126; at Tuol Sleng Genocide Museum, 5. *See also specific documentary films*

Documentation Center of Cambodia (DC-Cam): overview of, 9, 62, 77, 80–81, 81–82, 90, 199; access to records and, 6, 9, 74, 81, 84–85, 88, 90, 92, 103, 189n152; acquisition of records by, 81–82, 186nn112–113; challenges for, 82–83, 188n147; Chhang as director of, 9, 80–84, 90, 188n147; community of records in context of, 134, 197n112; contextualization of Tuol Sleng mug shots by, 74, 163, 200n7; database and digitization of Tuol Sleng mug shots by, 6, 9, 12, 62, 82–83, 85, *86*, 87–88, 187n126; denial of mass murders by Khmer Rouge as countered by, 54, 83, 187n121, 187n123; documentary films and, 114–116, 118, 193n59, 194n64, 195n74, 197n112; ECCC and, 77, 89–90, 106, 188n144, 188n147, 192n31; educational

projects and, 97–98, 114–116, 126, 193n59, 194n64, 195n93; funding for, 80–81, 83–84, 90; mass gravesite mapping by, 81, 85, 90; memoirs/biographies of survivors of Tuol Sleng and, 22, 23, 24, 136, 136, *138*, 141, *142*, 145, 185n90, 191n22; microfilmed records and, 9, 77, 82, 84–85, 186n115; negatives of Tuol Sleng mug shots in, 69; as NGO, 89–93, 133–134, 188n144, 188n147, 197n111; paintings by survivors in, 192n37; political factors in archivization and, 77, 94, 134, 197nn113–114; on prisoner statistics for Tuol Sleng and, 27; *Searching for the Truth* newsletter of, 6, 9, 116–126, *122–124*, 194n66, 194n68, 194n71, 195n73, 195n85, 195n88; security precautions for records in, 84, 92, 189n152; staffers described at, 9, 168n19; Tuol Sleng Genocide Museum relations with, 93; on Tuol Sleng prisoners' executions, 28–29; unknown victim identification and, 85, 117; victim identification and, 85, *86*, 87, 96, 188n140; Yale University's relation with, 9, 62, 68, 77, 80–86, 88–89, 94, 187n130. *See also* archivization of Tuol Sleng mug shots

Documentation Unit, in Tuol Sleng, 4, 8, 29, 172n16

Douglas, Jennifer, 18

Doyle, Peter, 50

Duch (Kaing Guek Eav): apologies to family of victims and, 104–105; biographical information about, 56, 63; crimes against humanity and, 6; ECCC trial for, 6, 100, 104, 116, 190nn12–13, 192n31; ethics and, 55–57, 180n121; as head of Tuol Sleng, 8, 28, 54, 66; records at Tuol Sleng as evidence in trial of, 6, 63; Sen and, 28, 29, 172n10; totalitarian regimes' documentation in context of orders for mass murders and, 53–55; on truthfulness of confession statements, 55, 172–73n17; truth in context of recordmaking by Khmer Rouge and, 104–106; on Tuol Sleng mug shots system, 53, 179n110

Duch on Trial (television show), 106, 192nn30–32

Duff, Wendy, 169n29

Duguid, Paul, 14
Dunlop, Nic, 51, 52–53, 63–64, 74, 76, 173n25, 184n69, 195n85
Dy, Khamboly, 97

East German documentaries, 72, 73, 183n58
Eav, Kaing Guek (Duch). *See* Duch (Kaing Guek Eav)
ECCC (Extraordinary Chambers in the Courts of Cambodia). *See* Extraordinary Chambers in the Courts of Cambodia (ECCC)
economics, and archives, 80–81, 83–84, 90, 91–92. *See also* income (livelihood)
educational projects, about Khmer Rouge: DC-Cam and, 97–98, 114–116, 126, 193n59, 194n64, 195n93; ECCC and, 98, 126, 195n93; narratives about Khmer Rouge, Tuol Sleng mug shots and, 109–111, 114–116, 126, 192n44, 193n59, 194n64, 195n93; tourist photographs and, 150, 199n34; US and, 62. *See also* Khmer Rouge (Democratic Kampuchea or DK)
Edwards, Elizabeth, 15
Edwards, Penny, 51, 179n103, 185n94
Eichmann trial, 54, 56, 192n32
En, Nhem: biographical information about, 29–30, 173n21; in documentary film on Tuol Sleng, 108; ethics of looking in context of, 162–163; grey zone of staffers and, 30, 173n29; income/livelihood from connections with Khmer Rouge and, 108, 173n21; legal testimonies at ECCC and, 100; on looking at Tuol Sleng mug shots, 184n69; MoMA exhibition of Tuol Sleng mug shots and, 74; as photographer at Tuol Sleng, 29, 30, 51; remorselessness of staffers in Tuol Sleng and, 30, 108; on Tuol Sleng mug shots, 184n69
Etcheson, Craig, 54, 80–82, 85, 88, 90, 94, 180n121
ethics of looking, 77, 139–140, 162–163, 200n7
Europe, and criminal identification, 41, 176nn65–66
exhibitions of Tuol Sleng mug shots: aesthetic approach to, 4–5, 74–76, 88, 184n67, 184n69; collective memory in context of, 64; MoMA and, 4–5, 74–75, 88, 121, 164, 184n67, 184n69, 184n72; in Tuol Sleng Genocide Museum, 4, 62, 64, 92
Extraordinary Chambers in the Courts of Cambodia (ECCC): overview of, 99, 190n11; Cambodia Tribunal Monitor website and, 106, 191n17, 191n23, 192n31; collective memory and, 17; crimes against humanity trials and, 6, 9; DC-Cam and, 77, 89–90, 188n144, 188n147; disillusionment over, 116, 194n60; documentary filmmakers' interviews about, 115–116; Duch's trial in, 6, 100, 104, 116, 190nn12–13, 192n31; economic cost of, 145, 198n18; educational projects and, 98, 126, 195n93; genocide trials and, 9; justice/legal accountability and, 6, 9, 102, 104, 106, 109, 115–116, 122, 125–126; mug shots as evidence in trials of, 6, 9; narratives about Khmer Rouge in context of legal testimonies at, 99–106, *101*, 118–119, 159, 190n11–13, 190n15, 191n17, 191nn22–23, 191n26, 192nn30–32; reconciliation efforts and, 9; reparations from, 141, 143–144, 147, 198n9; Tuol Sleng prisoner statistics and, 27; UN–Royal Government of Cambodia jointly run, 6, 9, 89, 141, 188n144; war crimes trials and, 9

fact assembly of archives, 10–12, 61–62, 65, 73, 93, 96
fact retrieval/narrative making in archives: Trouillot on, 10–12, 99; Tuol Sleng Genocide Museum and, 65, 182n19, 182n22; Tuol Sleng mug shots and, 21, 65, 73, 96. *See also* narratives about Khmer Rouge, and Tuol Sleng mug shots
family of victims: Buddhist rites performed by, 104, 110, 191n23, 193n46; community of records and, 20–21; family tracing efforts and, 117, 119–121, 122, 125, 194n68, 195n88; ghosts/ghostly voices of victims and, 104, 191n22; provenance and, 20–21; victim identification in archivization of Tuol Sleng mug shots and, 64–65, 66, 71, 85, *86*, 87; voices heard through silence of photographs and, 20–21. *See also*

community of records around Tuol Sleng mug shots

Fawthrop, Tom, 67, 79

Felman, Shoshana, 98, 107, 190n7, 192n36

final instance in history making (history making in final instance) in archives, 10–11, 13–14, 65, 89, 93, 96

former guards memories, and narratives about Khmer Rouge, 112–114

Fosdick, Raymond B., 41

Foucault, Michel, 48–49, 52, 61, 156, 178n86

French colonial police policies, as legacy in Cambodia: overview of, 32–33; anthropological classification and, 175n56, 176n65, 177n72; *bertillonage* and, 41, 43–45, *44–45*, 177n77, 177n80; criminal classification and, 34, 36, *37–40*, 175n53, 175n56; legal and penal systems in historical context and, 33–34, 174n43, 174n45, 174n49, 174n51; photographs of criminals and, 34–35, 175nn54–55; Pot and, 174n49; Tuol Sleng mug shots and, 45, *46–47*, 47, 157–158, 177nn81–82. *See also* Bertillon, Alphonse

French colonial police policies, as legacy in Vietnam, 33, 34, 174n43, 174n49, 174n51. *See also* French colonial police policies, as legacy in Cambodia

full frame prints, and Tuol Sleng mug shots, 73

funds/funding, and archives, 80–81, 83–84, 90, 91–92. *See also* income (livelihood)

Gech, Norng Kim, 118, 120–121

genocide (mass murders), and Khmer Rouge bureaucracy. *See* justice (legal accountability) for Khmer Rouge; mass murders (genocide), and Khmer Rouge bureaucracy

ghosts/ghostly voices, of victims of Khmer Rouge, 66, 104, 191n22

Gillespie, Alex, 199n42

Gilliland, Anne, 171n68

global (international) context: for archivization, 71, 79, 82–83, 134, 197n114; for human rights, 24, 125–126, *127*, 129, 134, 140–141, 143, 197nn113–114; income/

livelihood for survivors and, 140–141, 143; medical needs of survivors and, 144, 198n15; political power imbalance in, 155; social life of Tuol Sleng mug shots and, 158–159; tourist photographs as commodities making in, 155

Goffman, Erving, 52

Great Britain, and criminal identification, 41, 176nn65–66

Green-Lewis, Jennifer, 177n72

grey zone, 30, 112–114, 173n29

Guerin, Frances, 129–130, 196n105

Hallas, Roger, 129–130, 196n105

Harris, Verne, 22, 94–96, 134, 145, 169n29

Hawk, David, 4, 27, 67–70

Herman, Edward S., 79, 83

Hinton, Alexander, 48

history making in final instance (final instance in history making) in archives, 10–11, 13–14, 65, 89, 93, 96

hoax rumors, about Tuol Sleng Genocide Museum, 65, 182n22

Holocaust: banality of evil and, 56; Eichmann trial and, 54, 56, 192n32; ethics of looking in context of, 162–163; income/livelihood for survivors and, 144; legal testimony and, 192n36; memorial sites for, 65; people looking at atrocity images and, 196nn95–96; performance of human rights and, 196n96; witnessing/voice of witnessing and, 98, 107, 129–130, 190n7, 196n105

Hughes, Rachel, 53, 63, 136, 146–147, 151–152

human rights: crimes against humanity and, 4, 6, 9, 66, 79–80, 89, 99; global context for, 24, 125–126, *127*, 129, 134, 140–141, 143, 197nn113–114; injustices records in context of tourist photographs and, 140, 147, 152–154, 156; justice/legal accountability for Khmer Rouge through records and, 67–69, 78–79, 89, 163–164, 185n99, 188n144; local context for, 24, 125–126, *127*, 129, 131, 140–141, 143. *See also* mass murders (genocide), and Khmer Rouge bureaucracy; performance of human rights

Human Rights Watch, 74
Hurley, Chris, 19, 171n64
Huxley, Thomas Henry, 176n65
Huy, Him, 73

Iacovino, Livia, 19–20
identification system, for Tuol Sleng mug shots, 30–31
immoral actions (thoughtlessness culture), in context of mass murders by Khmer Rouge, 55–57, 180n121
inalienability principle, in archival theory, 18, 171n57
income (livelihood): for En as Tuol Sleng photographer, 108, 173n21; for survivors, 140–141, 143–146, 197n4. *See also* economics, and archives; funds/funding, and archives
indexing projects, and DC-Cam, 81
individuals' identity, and totalitarianism in context of Tuol Sleng mug shots, 53, 179n110
injustices records, and tourist photographs, 140, 147, 152–154, 156. *See also* justice (legal accountability) for Khmer Rouge; mass murders (genocide), and Khmer Rouge bureaucracy
international (global) context. *See* global (international) context
interviews, and narratives about Khmer Rouge, 106–116, 118, 195nn73–75; narratives about Khmer Rouge in context of interviews and, 192n34, 192nn36–37, 192n44, 193nn46–47, 193n50, 193n56, 193n59, 194n60, 194n64

Jarvis, Helen, 67, 79–81, 85, 89–90
justice (legal accountability) for Khmer Rouge: Chhang on, 61; ECCC and, 6, 9, 102, 104, 106, 109, 115–116; human rights documentation for, 67–69, 78–79, 89, 163–164, 185n99, 188n144; narratives about Khmer Rouge and, 65, 102, 104, 106, 109, 115–116, 119–122, 125–131, *127–128*, 134, 182n22, 196n102; reuse of Tuol Sleng mug shots and, 12, 64, 104, 106, 133; US and, 78, 79–80; Vietnamese-backed

PRK's show trial and, 64, 67, 168n20, 181n11. *See also* injustices records, and tourist photographs; mass murders (genocide), and Khmer Rouge bureaucracy

Ket, Ouk, 100–104
Ketelaar, Eric, 16–17, 19, 105–106, 116, 133, 167n9, 196n107
Khin, Min, 67
Khmer Rouge (Democratic Kampuchea or DK): overview of, 7–8, 168n13, 168n15, 168n17; classification of population by, 51–52; ethnicity in context of, 51; Nol regime backed by US versus, 7–8; "Original Khmers" in context of, 51–52; Pot as ruler in, 8, 168n15; prisoners in Tuol Sleng as members of, 8, 27, 28; provenance of Tuol Sleng mug shots and, 18, 19, 171n57; reconciliation efforts and, 9, 112, 115–116; Santebal under, 8, 28, 81, 84; secrecy about, 8; Tuol Sleng in context of bureaucracy of, 27–30, 158; Tuol Sleng's role in, 27–30; US bombing of Cambodia in context of, 7–8, 79, 168n13; Vietnamese-backed PRK show trial of leaders in, 64, 67, 168n20, 181n11. *See also* educational projects, about Khmer Rouge; French colonial police policies, as legacy in Cambodia; Tuol Sleng (S-21); Tuol Sleng mug shots
Khmer Rouge records at, 9
Kiernan, Ben, 7, 61, 67–68, 78, 80–86, 94, 168n13
Kimmelman, Michael, 97
Kissinger, Henry, 79
Kosal, Sea, 119–120
Kress, Gunther, 199n41
Kuy, Nancy, 148

LaBahn, Joel and Whitney, 148, 149–151, *150*
Lam, Mai, 64, 65, 73
Latour, Bruno, 16–17, 170n49
Laub, Dori, 98, 107, 129–130, 190n7, 192n36
Leab, Phan Srey, 126, *128*, 129
Ledgerwood, Judy, 63, 64–65, 69–71, 181n4
Leeuwen, Theo van, 199n41
Lefeuvre, Martine, 100–104

legal accountability (justice) for Khmer Rouge. *See* injustices records, and tourist photographs; justice (legal accountability) for Khmer Rouge; mass murders (genocide), and Khmer Rouge bureaucracy

legal and penal systems, in historical context, 33–34, 174n43, 174n45, 174n49, 174n51

Lim, Chan, 120

Linfield, Susie, 163–164, 184n72, 200n7

livelihood (income). *See* income (livelihood)

local context: for human rights, 24, 125–126, *127*, 129, 131, 140–141, 143; income/livelihood for survivors and, 140–141, 143; NGO status of DC-Cam and, 89–93, 133–134, 188n144, 188n147, 197n111; social life of Tuol Sleng mug shots and, 158–159

Los Angeles County Museum, 75

Maguire, Peter, 30–31, 73, 76, 173n21, 183n58, 185n85, 191n22

Man, Nam, 105

mass gravesites, 4, 9, 29, 68–69, 80–81, 85, 90, 134

mass murders (genocide), and Khmer Rouge bureaucracy: overview of, 22–23, 26; archives in context of, 53; banality of evil in context of, 55–56; Choeung Ek and, 4, 9, 29, 80; denial of mass murders as countered by DC-Cam and, 83, 187n121, 187n123; ethical/unethical actions in context of, 55–57, 180n121; Paris Peace Accords' omission of, 78, 185n94; statistics on, 83, 187n121; totalitarian regimes' documentation in context of, 52–58, 179n110, 180n121; Tuol Sleng prisoner executions and, 9, 27–29; US education projects and, 62; US politics in context of, 78, 185n99. *See also* injustices records, and tourist photographs; justice (legal accountability) for Khmer Rouge

Math, Chim, 108, 109

McKemmish, Sue, 13, 133, 151, 167n9, 169n34, 196n107

measurements, of prisoners, *35*, 35–36, *37–38*, 41, 43–44, *44–47*, 47, 173n26

memoirs (biographies) of survivors of Tuol Sleng: DC-Cam publication of, 22, 23, 24, 136, 136, *138*, 141, *142*, 145, 185n90, 191n22; Meng and, 136, *137*, 141, 191nn22–23; Mey and, 136, *138*, 141, *142*; Tuol Sleng mug shots as inspiration for, 189n5

memorialization (remembering victims): digitization of records in context of, 88; Holocaust and, 65; through narratives about Khmer Rouge, 107, 111–12, 120–21, 133; reuse of Tuol Sleng mug shots for, 12, 98, 100, 104, 165, 189n4; tourist photographs in context of, 149

Meng, Bou: agency of survivors and, 152–155; in documentary film on Tuol Sleng, 108–109, 195n75; income/livelihood for survivors and, 140–141; legal testimony in ECCC by, 100, 104, 108–109; memoir/biography of, 136, *137*, 141, 191nn22–23; as outspoken survivor of Tuol Sleng, 172n7; paintings by survivors of Khmer Rouge and, 118; reuse of Tuol Sleng mug shots and, 118; tourist photographs as commodities making and, 144, 149–152, *150*, 153–154, 198n25; traumatic memories relief and, 145; as Tuol Sleng Genocide Museum staffer, 66; Tuol Sleng mug shot experience of, 31–32, 47

methodology and research, 22, 24, 139–140, 147, *148*, 151

Mey, Chum: agency of survivors and, 152–155; in documentary film on Tuol Sleng, 108, 111–112, 118, 195n74; income/livelihood for survivors and, 140–141, 197n4; memoir/biography of, 136, *138*, 141, *142*, 195n73; on memorialization, 165; as outspoken survivor of Tuol Sleng, 172n7; tourist photographs as commodities making and, 136, *138*, 139, 144, *148*, 148–149, 151–152, 153–154, 198n25; traumatic memories relief and, 145; Tuol Sleng mug shot experience of, 31, 47

microfilmed records, and archivization of Tuol Sleng mug shots, 9, 62, 69–71, 77, 82, 84–85, 186n115, 187n130

migrant laborers in Cambodia, and *bertillonage*, 41, 43, 177n77

Millar, Laura, 18, 190n6

missing or destroyed records: archivization of Tuol Sleng mug shots in context of, 64, 66–67, 72–73, 95, 183n53; collective memory in context of, 95; confession statements and, 64, 66–67; narratives about Khmer Rouge in context of, 134–135; negatives of Tuol Sleng mug shots in context of, 95, 107

Mitchell, W. J. T., 15–17, 59–60, 132, 158

MoMA (Museum of Modern Art), 4–5, 74–75, 88, 121, 164, 184n67, 184n69, 184n72

morals: ethics of looking and, 77, 139–140, 162–163, 200n7; grey zone and, 30, 112–114, 173n29; thoughtlessness culture and, 55–57, 112–114, 180n121

mug shot, as term of use, 41, 167n3, 177n72. See also Tuol Sleng mug shots

Museum of Modern Art (MoMA), 4–5, 74–75, 88, 121, 164, 184n67, 184n69, 184n72

Museum of Modern Art in San Francisco, 75

Mydans, Seth, 61, 172n17, 191n22

Mysliwiec, Eva, 69

NAGPRA (Native American Graves Protection and Repatriation Act), 162

Nan, Nay, 113, 193n56

narratives about Khmer Rouge, and Tuol Sleng mug shots: overview of, 23–24, 97–99, 132–135; activation of records and, 98, 132, 196n107; Buddhist rites performed by family of victims and, 104, 110, 120–121, 191n23, 193n46; collective memory and, 109, 111–112, 116, 120, 132–133; collective/national narrative of suffering under Khmer Rouge and, 65, 99, 109–111, 114, 118, 125; community of records in context of, 134, 197n112; confession statements and, 105, 111–114, 118; co-witness to violence of Tuol Sleng, 130; documentary filmmakers' interviews and, 106–116, 192n34, 192nn36–37, 192n44, 193nn46–47, 193n50, 193n56, 193n59, 194n60, 194n64; documentary films with people looking at Tuol Sleng mug shots images and, 126; educational projects and, 109–111, 114–116, 126, 192n44, 193n59, 194n64, 195n93; fact retrieval in archives

and, 99; family tracing correspondence and, 117, 119–121, 122, 125, 195n88; former guards memories and, 112–114; ghosts/ghostly voices of victims and, 104, 191n22; global context for human rights and, 24, 125–126, 127, 129, 134, 197nn113–114; interviews and, 118, 195nn73–75; justice/legal accountability for Khmer Rouge and, 65, 102, 104, 106, 109, 115–116, 119–122, 125–131, 127–128, 134, 182n22, 196n102; legal testimonies at ECCC and, 99–106, 101, 118–119, 159, 190n11–13, 190n15, 191n17, 191nn22–23, 191n26, 192nn30–32; local context for human rights and, 24, 125–126, 127, 129, 131; memorialization through, 107, 111–112, 120–121, 133; missing or destroyed records in context of, 134–135; people looking at Tuol Sleng mug shots images and, 126–135, 127, 128, 194n71, 195n93, 196nn95–96, 196n102, 196nn104–105, 196n107, 197nn111–114; performance of human rights and, 7, 98, 130–131, 133, 168n12, 190n8, 196n96, 196n102, 198nn104–105; performance of records and, 116; presence and absence tension in, 109–112, 131; reconciliation efforts and, 112, 115–116; records continuum model in context of, 132–133, 196n107; reuse of Tuol Sleng mug shots and, 98, 100, 104, 106, 118, 121–122, 122–124, 126, 127–128, 132–134, 141, 195n85, 196n107; Searching for the Truth newsletter and, 116–122, 122, 123, 124, 125–126, 194n66, 194n68, 194n71, 195n73, 195n85, 195n88; silence and agency tension in, 109–112, 131, 134–135; silences as encoded in historical production and, 99, 132–133, 135; social life of records and, 98, 106, 132, 192nn30–32, 196n107; spacial mobility and, 106, 192n32; survivors' interaction with records and, 108–109; temporal mobility and, 106; touchstones and, 98, 190n6; transformation of Tuol Sleng mug shots and, 133; traumatic memories and, 111, 193n59; truth in context of recordmaking by Khmer Rouge and, 104–106; unknown

victim identification and, 114–115, 117; victimhood narratives and, 7, 12; witnessing/voice of witnessing and, 7, 12, 22, 66, 98–100, 103–104, 107–109, 126–134, *127–128*, 182n27, 192n36, 196n105. *See also* fact retrieval/narrative making in archives

Nath, Vann: in documentary film on Tuol Sleng, 108, 111–112; on En as photographer of mug shots, 29; illness and death of, 144, 198n15; on Khmer Rouge members in Tuol Sleng, 27; paintings by, 6, 108, 144, 192n37; paintings by survivors of Khmer Rouge and, 6, 108, 192n37; as survivor or Tuol Sleng, 65–66; as Tuol Sleng Genocide Museum staffer, 65–66; Tuol Sleng mug shot experience of, 32, 47

National Archives of Cambodia, 43, 64, 83, 177n77, 177n80, 187nn125–126

National Library of Cambodia, 8, 69, 187n125

national (collective) narrative of suffering under Khmer Rouge, 65, 99, 109–111, 114, 118, 125. *See also* collective memory

Native American Graves Protection and Repatriation Act (NAGPRA), 162

Neakong, Ruy, 66

Neary, Ouk, 100, 102–104

negatives of Tuol Sleng mug shots: in DC-Cam, 69; missing or destroyed records and, 95, 107; security precautions for, 4; silence created by missing, 95; in Tuol Sleng Genocide Museum, 9, 64, 66, 68–69, 71–73, 183n53. *See also* archivization of Tuol Sleng mug shots; Tuol Sleng mug shots

Nesmith, Tom, 18

NGO status, of DC-Cam, 89–93, 133–134, 188n144, 188n147, 197n111

Nicholson, Joseph, 41, 176n67

Nickell, Joe, 175n54

Niven, Doug, 71–76, 107, 183n53, 185n85, 195n85

Noble, Andrea, 131, 168n12, 190n8, 196n102

Nol, Lon, and US-backed regime, 4, 7–8, 82

Norodom, 33

Northwestern University, 106, 192n31

Okazaki, Steven, 108

Owen, Taylor, 7, 168n13

ownership of records, and archivization of Tuol Sleng mug shots, 18–20, 75–76

paintings, by survivors of Khmer Rouge, 6, 108, 118, 192n37

Panh, Rithy, 5, 111, 165, 193n47

Paris Peace Accords in 1991, 78, 185n94

participant observation, 139–140, 147, *148*, 164. *See also* research and methodology

Pech, Ung, 65–66

penal and legal systems, in historical context, 33–34, 174n43, 174n45, 174n49, 174n51

people looking at Tuol Sleng mug shots images, and narratives about Khmer Rouge, 126–135, *127*, *128*, 194n71, 195n93, 196nn95–96, 196n102, 196nn104–105, 196n107, 197nn111–114

People's Republic of Kampuchea (PRK), 62–65, 70, 77–78, 168n20, 181n4, 181n11

People's Revolutionary Tribunal, 64, 67, 168n20, 181n11

performance of human rights: commodities making and, 144, 147, 151–152; narratives about Khmer Rouge and, 7, 98, 130–131, 133, 168n12, 190n8, 196n96, 196n102, 198nn104–105. *See also* human rights

performance of records, 15, 17, 48, 50–52, 116, 168n12

personal (traumatic) memories, 111, 145, 193n59. *See also* memoirs (biographies) of survivors of Tuol Sleng; memorialization (remembering victims)

Peterson, David, 79

Phal, Norng/Nong Chan, 31, 100, 104–105, 173n34, 190n15, 191n26

Photo Archive Group, 62, 67, 71–77, 185n85

photographs: overview of, 3; as agents, 15; of criminals in context of French colonial policies, 34–35, 175nn54–55; of mass gravesites, 68–69; performance of records and, 15, 17, 55, 167nn9–12; as records, 6–7, 55, 167nn9–12; social life or "wants" of, 15–16, 59–60, 170n49; Tuol Sleng and, 29, 55, 68; voices heard through silence of, 11–12, 20–22, 51, 95–96, 158. *See also* bertillonage

Sleng mug shots; social life of records; Tuol Sleng (S-21); Tuol Sleng mug shots

records read "against the grain" (voices heard through silence of photographs), 11–12, 20–22, 51, 95–96, 158

religious and cultural functions of Tuol Sleng mug shots, 33, 69, 104, 110, 120–121, 191n23, 193n46

remembering victims (memorialization). *See* memorialization (remembering victims)

remorselessness, and Khmer Rouge, 30, 104–105, 108, 114

reparations, and ECCC, 198n9

reparations, from ECCC, 141, 143–144, 147

research and methodology, 22, 24, 139–140, 147, *148*, 151

reuse of Tuol Sleng mug shots: overview of, 159–161; archivization of Tuol Sleng mug shots and, 64, 93, 133; Bophana's mug shot and, 4–6, *5*; for justice/legal accountability for Khmer Rouge, 12, 64, 104, 106, 133; for memorialization, 12, 98, 100, 104, 165, 189n4; narratives about Khmer Rouge and, 98, 100, 104, 106, 118, 121–122, *122–124*, 126, *127–128*, 132–134, 141, 195n85, 196n107; Srun's mug shot and, 92, 118, 121–122, *122–124*, 126, *127–128*, 134, 141, 195n85. *See also* Tuol Sleng mug shots

Riley, Christopher, 71–76, 107, 183n53, 185n85, 195n85

Robertson, Craig, 178n98

Rose, Gillian, 14–15, 170n39

Royal Government of Cambodia, 6, 97, 141

S21 (documentary film), 107, 111–114, 193n50, 193n56

Samsara (documentary film), 107, 109–111, 192n44

Santebal, and records, 8, 28, 81, 84

Sar, Van, 119

Saron, Sek, 121, 195n88

Sary, Ieng, 64, 143–144, 181n11

Sath, Sek, 121

Say, Sek, 121–122

Schwartz, Joan M., 3

science and politics binary, in context of archives, 94

Sea, Poeung Kim, 118, 119–120

Searching for the Truth (newsletter), 6, 9, 116–126, *122–124*, 194n66, 194n68, 194n71, 195n73, 195n85, 195n88

secrecy, and Khmer Rouge, 8, 28, 52

Secrets of S-21 (documentary film), 71–72, 107–108

security precautions, for collection in DC-Cam, 84, 92, 189n152

Sekula, Allan, 43, 48–50, 178n91

selective operations, in archives making, 93–94

Sen, Hun, 186n113

Sen, Son, 27–29, 53–54, 172n11

signaletics (bertillonage). See Bertillon, Alphonse; *bertillonage (signaletics)*; criminal classification, and identification

silence and agency (agency and silence). *See* agency and silence (silence and agency)

silences as encoded/framework in historical production: as countered by archivists, 22, 24, 96, 159–160; narratives about Khmer Rouge and, 99, 132–133, 135; Trouillot on, 10–12, 21, 26, 58, 168n21, 169n23; Tuol Sleng mug shots in context of, 10–12, 23, 26, 30–31, 160. *See also* agency and silence (silence and agency)

Sim, Sorya, 118

Sisowath, 34, 168n15

Slocomb, Margaret, 43

Slyomovics, Susan, 131, 168n12, 190n8, 196n104

Smith, Shawn Michelle, 178n91

social and political power, 26, 61–62, 93–95, 155. *See also* global (international) context; local context

social function, of Tuol Sleng mug shots, 48–52, 57–58

social-life-of-objects approach, 14–17, 33, 132, 169n36, 170n50

social life of records: activation of records in context of, 16–17, 98, 132, 165, 196n107; agency and, 15, 16–17, 58–60, 180n136; digitization in context of, 17; narratives about Khmer Rouge and, 98, 106, 132, 192nn30–32, 196n107; photograph's "wants" and, 15–16, 59–60, 170n49; records continuum model in context of,

social life of records (*continued*)
16, 132–133, 170n50, 196n107; silences as encoded in historical production and, 21–22; social life of objects approach in context of, 14–16, 169n36, 170n50; Tuol Sleng mug shots in context of, 17, 33, 87, 106, 157–163, 192nn30–32. *See also* records

societal provenance (provenance), of Tuol Sleng mug shots, 18–21, 58–59, 77, 153, 158, 171n57, 171n64

Sontag, Susan, 26, 88, 139, 157, 162–163, 200n7

Sophera, Chey, 72

spacial mobility, and narratives about Khmer Rouge, 106, 192n32

Spivak, Gayatri Chakravorty, 20

Srien, Jun Chhoun, 107

Srun, Chan Kim, *46*, *47*, 92, 118, 121–122, *122– 124*, 126, *127–128*, 134, 141, 195n85

staffers: at DC-Cam, 9, 168n19; grey zone and, 30, 112–114, 173n29; at Tuol Sleng, 29, 30, 172n16, 173n29; at Tuol Sleng Genocide Museum, 66. *See also specific staffers*

Stanton, Gregory H., 67–68

Star, Susan Leigh, 17

state's discursive creation of criminal body, and Tuol Sleng mug shots, 48–52, 57–59, 178n86, 178n89, 178nn91–92, 178n98, 179n103

Struk, Janina, 196nn95–96

survivors of Tuol Sleng: impossibilities in context of tourist photographs and, 139, 151–152; interactions with records by, 108–109; Tuol Sleng mug shots and, 28, 172n7; voices heard through silence of photographs and, 20–21. *See also* community of records around Tuol Sleng mug shots; Tuol Sleng (S-21)

Tagg, John, 48–50

temporal mobility, and narratives about Khmer Rouge, 106

Thap, Seak, 111

Thirith, Ieng, 143

thoughtlessness culture (immoral actions), in context of mass murders by Khmer Rouge, 55–57, 112–114, 180n121

Thy, Suos, 29, 32, 73

torture facilities, for traitorous act confessions, 3–4, 8–9, 28–29, 172n17

totalitarianism, and recordmaking by Khmer Rouge, 51–58, 177n82, 179n110, 180n121

touchstones, and narratives about Khmer Rouge, 98, 190n6

tourist gaze, 153–154, 199nn41–43, 200n45

tourist photographs, and commodities making: overview of, 24, 136–140, *137*, *138*, 155– 156, 159; agency and victimhood tension and, 147, 154; agency of survivors and, 152–155, 199n43; blogs by travelers and, 140, 147–152, 159; contextualization/decontextualization of records and, 147– 151, *150*, 153–154, 198n25; co-witnesses to violence of Tuol Sleng and, 152, 154; creatorship and, 152–153; "dark" tourism and, 146, 151; educational projects and, 150, 199n34; ethics of looking in context of, 139–140; global context and, 155; impossibilities of survivors in context of, 139, 151–152; injustices records and, 140, 147, 152–154, 156; participant observation and, 139–140, 147, *148*, 164; performance of human rights and, 147, 151–152; tourist gaze in context of, 153–154, 199nn41– 43, 200n45; visual analysis of, 24, 147; witnessing/voice of witnessing and, 146– 147, 149, 151. *See also* commodities making

Trace, Ciaran B., 57–58

transformation of records, 7, 17, 133

traumatic (personal) memories, 111, 145, 193n59. *See also* memoirs (biographies) of survivors of Tuol Sleng; memorialization (remembering victims)

Trebay, Guy, 74

Trouillot, Michel-Rolph, and topics: archival theory compared with four silences, 12– 14, 21, 161, 169n29; fact assembly of archives, 10–12, 73, 93, 96; fact retrieval/ narrative making in archives, 10–12, 99; history making in final instance in archives, 10–11, 13–14; selective operations in making archives, 93; silences as encoded in historical production, 10–12, 21, 26, 58, 99, 132, 133, 135, 168n21, 169n23;

Tuol Sleng mug shots (*continued*)
　　religious and cultural functions of, 33,
　　69, 104, 110, 120–121, 191n23, 193n46;
　　silence and agency as complementary
　　in context of, 21–22, 58–60, 109–110,
　　180n136; silences as encoded in histori-
　　cal production and, 10–12, 23, 26, 30–31,
　　160; social function of, 48–52, 57–58;
　　social life of, 17, 33, 87, 106, 157–163,
　　192nn30–32; state's discursive creation of
　　criminal body and, 48–52, 57–59, 178n86,
　　178n89, 178nn91–92, 178n98, 179n103;
　　statistics on, 6, 9, 13, 167n7, 169n25; sur-
　　vivors of Tuol Sleng and, 28, 172n7; Tuol
　　Sleng's function in context of, 30–32;
　　voices heard through silence of photo-
　　graphs and, 20–21, 59–60. *See also* family
　　of victims; Khmer Rouge (Democratic
　　Kampuchea or DK); negatives of Tuol
　　Sleng mug shots; photographs; records;
　　records, and recordmaking by Khmer
　　Rouge; reuse of Tuol Sleng mug shots;
　　survivors of Tuol Sleng; Tuol Sleng
　　(S-21); *and specific Tuol Sleng mug shots*
Twin Palms Publishers, 75

UNESCO, 188n151
unethical/ethical actions, in context of mass
　　murders by Khmer Rouge, 55–57,
　　180n121
United Nations (UN): Khmer Rouge status
　　and, 77–78, 82; UN Group of Experts
　　and, 89, 188n144; UN-Royal Government
　　of Cambodia jointly run ECCC and, 6,
　　9, 141
United Nations Transitional Authority in
　　Cambodia (UNTAC), 78, 185n94
United States: archivization of Tuol Sleng
　　mug shots and, 62, 67–77; archivization
　　of Tuol Sleng mug shots involvement of,
　　9, 62, 67–77, 80–86, 88–89, 94, 185n85,
　　187n130; *bertillonage* system in, 41, 48,
　　176nn66–67, 177n72; bombing of Cam-
　　bodia by, 7–8, 79, 168n13; Cambodian
　　Genocide Justice Act and, 78, 79–80;
　　criminals identification/processing in,
　　41, 48, 175n54, 176nn66–67, 177n72,

178n91; decontextualization/contextual-
　　ization of Tuol Sleng mug shots in, 74–
　　77, 184n72, 185n85; genocide as term of
　　use in context of politics in, 78, 185n99;
　　justice/legal accountability for Khmer
　　Rouge through records and, 67–69, 78–
　　80, 185n99; Khmer Rouge relations with,
　　74, 77–78; Nol regime backed by, 4, 7–8,
　　82; political factors in archivization and,
　　71, 79, 82–83; portraits compared with
　　mug shots in, 178n91; prisons system in,
　　33; Tuol Sleng Genocide Museum for-
　　mation and, 62; Tuol Sleng mug shots as
　　aesthetic objects in exhibitions in, 4–5,
　　74–76, 88, 184n67, 184n69
University of Pennsylvania Press, 64
unknown victim identification, 85, 114–115,
　　117. *See also* victims of Khmer Rouge
UNTAC (United Nations Transitional Au-
　　thority in Cambodia), 78, 185n94
Upward, Frank, 13, 16, 167n9, 169n34
Urry, John, 153–154, 200n45

Vannak, Huy, 136, *137*, 141, 191nn22–23
Veneciano, Jorge Daniel, 51
victims of Khmer Rouge: agency and victim-
　　hood tension and, 21–22, 58–60, 147,
　　154, 180n136; ghosts/ghostly voices of,
　　66, 104, 191n22; unknown victim iden-
　　tification and, 85, 114–115, 117; victimhood
　　narratives and, 7, 12, 147. *See also* narra-
　　tives about Khmer Rouge, and Tuol Sleng
　　mug shots
Vietnam: archivization of Tuol Sleng mug
　　shots and, 62–63, 181n4; French colonial
　　police policies as legacy in, 33, 34, 174n43,
　　174n49, 174n51; People's Revolutionary
　　Tribunal and, 64, 67, 168n20, 181n11;
　　political factors in archivization of Khmer
　　Rouge records by, 64–65, 181n4, 181n11;
　　PRK government backed by, 62–65,
　　70, 77–78, 168n20, 181n4, 181n11; Tuol
　　Sleng Genocide Museum formation by,
　　63–67
visitor statistics, for Tuol Sleng Genocide
　　Museum, 64–65
visual analysis, 24, 147

voice of witnessing (witnessing). *See* witnessing (voice of witnessing)

voices heard through silence of photographs (records read "against the grain"), 11–12, 20–22, 51, 95–96, 158

Wallace, David, 95

Wallis, Brian, 49

White, Hayden, 3

Williams, Paul, 198n21

witnessing (voice of witnessing): overview of, 165; co-witnesses to violence of Tuol Sleng and, 130, 152, 154, 164; Holocaust in context of, 98, 107, 190n7; narratives about Khmer Rouge and, 7, 12, 22, 66, 98–|100, 103–104, 107–109, 126–134, *127–128*, 182n27, 192n36, 196n105; tourist

photographs as commodities making and, 146–147, 149, 151

women prisoners: with child in Tuol Sleng mug shots, 73, 92, 118, 121–122, *122–124*, 126, *127–128*, 134, 141, 195n85; rape as war crime and, 4, 6; in Tuol Sleng, 28, 73, 88. *See also specific women prisoners*

Wurl, Joel, 19

Yale University, 9, 62, 68, 77, 80–86, 88–89, 94, 187n130

Yeo, Geoffrey, 168n10

Yerushalmi, Yosef Hayim, 164

Yoeun, Ma, 100, 104

Zinoman, Peter, 33, 34, 174n43, 174n49, 174–75n51

Critical Human Rights

Memory's Turn: Reckoning with Dictatorship in Brazil
Rebecca J. Atencio

*Archiving the Unspeakable: Silence, Memory, and the Photographic Record
 in Cambodia*
Michelle Caswell

Court of Remorse: Inside the International Criminal Tribunal for Rwanda
Thierry Cruvellier; translated by Chari Voss

How Difficult It Is to Be God: Shining Path's Politics of War in Peru, 1980–1999
Carlos Iván Degregori; edited and with an introduction by Steve J. Stern

*Innocence and Victimhood: Gender, Nation, and Women's Activism in Postwar
 Bosnia-Herzegovina*
Elissa Helms

Torture and Impunity
Alfred W. McCoy

The Human Rights Paradox: Universality and Its Discontents
Edited by Steve J. Stern and Scott Straus

Human Rights and Transnational Solidarity in Cold War Latin America
Edited by Jessica Stites Mor

Remaking Rwanda: State Building and Human Rights after Mass Violence
Edited by Scott Straus and Lars Waldorf

*Beyond Displacement: Campesinos, Refugees, and Collective Action in
 the Salvadoran Civil War*
Molly Todd

The Politics of Necessity: Community Organizing and Democracy in South Africa
Elke Zuern